### Katrin

*To John, who always seems to have just the right strap, camera bag, cable, extra battery, advice, and encouragement to reduce my techno-anxiety, which allows me to enjoy exploring and taking pictures with you.*

### Seán

*For my mother Betty Duggan, who gave me my first 35mm SLR camera as a high school graduation present, shifting my interest in photography into high gear, where it has been ever since. Thanks, Mom!*

### Tim

*To Amber, my 10-year-old niece, who has already earned blue ribbons for her photography and has made this uncle very proud.*

# Acknowledgments

We often receive emails or are stopped at conferences or at workshops by people saying, "Thank you for your book" or "I use your book as a textbook." Of course we appreciate this, but these brief encounters are never enough time to explain that writing, designing, producing, and distributing a book is only possible with the help, support, contributions, and inexorable patience of many, many people.

To the photographers and artists whose work we were allowed to feature to enrich these pages—thank you. You inspire us to be better photographers:

*Mark Beckelman, Dan Burkholder, Jack Davis, Robert Anthony DeRosa, John Donich, Iuliia Gorbachenko, Greg Gorman, Stephen Johnson, Julieanne Kost, Geoff Scott, Jeff Schewe, Simone Müller, John McIntosh, John Parsekian, Jack Reznicki, Judith Tanzman, Reid Elem, John Shaw, Mike Shipman, Lindsay Silverman, Matthew Smith, and Wayne Palmer*

To the many people who answered an email or phone call—usually with a plea for *as soon as possible* regarding a technical issue—thank you. Your knowledge and real-world insights made this book better:

*Tom P. Ashe, Allen Furbeck, Tom Hogarty, Chris Murphy, John Nack, Bryan O'Neil Hughes, Mark Segal, Tom Swan, Seth Resnick, and John Warner*

To the team at Peachpit who really stand for patience, support, cajoling (you have another deadline, keep going, you're almost done)—thank you. We really needed your tough love to finish!

*Nikki McDonald, Sara Todd, Anne Marie Walker, Hilal Sala, Liz Welch, and our technical editor, Jeff Greene*

Digital photography wouldn't exist without the engineers, software developers, and manufacturers who listen to honest feedback and continue to make better and better products. Thank you for your support:

*Adobe Systems, B&H Photo & Video, Canon USA, Epson America, Gary Fong, Lensbaby, Nik Software, onOne Software, Really Right Stuff, SunBounce, and X-Rite*

Finally, to our families who kept the coffee coming and looked the other way as another sunny day was spent alone while we worked on "the book"— thank you! Your willingness to model for illustrations, ability to listen to us ramble about page count, and endless patience were often the only things that kept us going!

To our students and readers, your questions and comments make us better teachers and authors. To let us know your thoughts about the book, please email us at authors@digitalphotobook.net. Note that we do not offer technical support or assist in making purchasing decisions. To notify the publisher of any errors or omissions, please email errata@peachpit.com.

These acknowledgments are our way of saying thank you to everyone. We couldn't have completed this book without a lot of people who simply make the field of digital photography better. It is an honor to be a part of such a generous and inspiring community. Now get out there and take some pictures!

—Katrin Eismann, Seán Duggan, and Tim Grey

# Contents at a Glance

# Table of Contents

## Chapter Eight: Working in the Digital Darkroom                    403

# Preface

Photography has a rich history, from the personal family snapshot to Earth rising over the moon's horizon. In its brief 170-year history, photography has played many roles to a wide variety of people—from memory keeper to human condition revealer to personal exploration companion. Photography reveals how we perceive and is so important that we are compelled to capture, process, and share our experiences with family and friends, and now—via social media—with complete strangers. Digital photography allows us to take more pictures, more easily, and more quickly. But before we delve into the nuts and bolts of digital photography with the third edition of *Real World Digital Photography*, allow us to address some of the essential assumptions and desires that come with the act of creating images out of light and shadow.

## What Is Predictable

Taking pictures is fun; taking good pictures is gratifying; consistently taking great pictures can be both a lifelong passion and a rewarding profession.

The foundation of contemporary digital photography remains rooted in the nineteenth century brilliance of George Eastman, inventor and founder of the Eastman Kodak Company and the company's slogan—*You take the picture, we do the rest.* Eastman realized that if the time-consuming technical aspects of making a photograph were provided as a service, more people would enjoy taking pictures—billions and billions of pictures.

Of course, Eastman's premise would only work if the resulting photographs were acceptable and reasonably priced. In essence, for millions of people to enjoy photography, it had to provide more than fun, and it had to produce successful and pleasing results, time after time.

The sale of each roll of film was based on the following assumptions. The great majority of photographers would take pictures outside, during the daylight hours, with clear, brightly scattered clouds. The subject matter would most likely be a portrait, a group of people, a landscape, or a close-up. When photographers worked within these basic assumptions, chances were greater for photographic success and personal enjoyment, which led to the taking of even more pictures.

Of course, photographers are more than button pushers. To increase the rate of success, a photographer carried the responsibility of choosing a subject, composing the shot, focusing, and setting the exposure relative to the light conditions and film sensitivity, all while working with a steady hand and an eye for the moment. From the hundreds of thousands of miles of exposed and processed amateur roll film to the Kodak Instamatic cameras to the disposable cameras still sold near every international tourist attraction, the rate of photographic and personal success has been incredibly high and gratifying.

# What Is Anticipated

Successful, repeatable, and reliable results are also at the core of the digital photography experience. Being a photographer in the digital age echoes Eastman's premise made more than a century ago. But as echoes pass, they change to express the times. Today, the assumption is: *I take the picture. The rest is already done.* Taking, seeing, and sharing pictures is now a split second of instant gratification with nearly instant distribution.

In all honesty, all we really want is for the picture to look like the subject we perceived and photographed. The closer the photograph resembles our point of view or memory of a moment, the more successful the photograph is and the more satisfied we are. Of course, we still do our best to hold the camera steady and point it at a meaningful subject, but the settings required for a successful exposure and a sharp image are all calculated by the camera much more quickly than we can even press the shutter. On occasion, we read the camera instruction manual, but just as often, most of us figure out through trial and error how to make the camera work. Actually, unless we really put effort into making the latest digital cameras fail by overriding the recommended settings, the cameras will perform very well, resulting in a well-exposed and in-focus rendition of the scene in front of the camera.

When you pick up a digital camera—be it in your cell phone or a professional digital camera—and then press the shutter button, you are relying on countless scientists, engineers, and software developers whose goal is for you to get optimum and repeatable results in a variety of situations. As digital camera development advances, the greater the manufacturers' baseline predictions in terms of light, color, motion, exposure, and whether to shoot stills or video footage must be. If you work within the manufacturers' predictions, your results will be as good as the equipment you have chosen.

If, however, you want to get the optimum quality from your equipment or you want your images to be more expressive of your experience, you must understand that the defaults and digital imaging Auto settings are only starting points. For your images to be uniquely yours, you have a world of options to choose from and from which you can create.

If you opt to just take the pictures and let others do the rest, you can stop reading these pages. If you create a photograph *and* you want to do the rest—to be part of the creative process—then please do continue reading and growing through learning, experimentation, and being open to seeing what your photographs show you about the world and yourself.

# What Is Desired

During the writing of the first edition of *Real World Digital Photography* in 1999, the authors approached digital photography with the (somewhat naïve) enthusiasm for the imaging technologies that were clearly the future, but the potential certainly outweighed the tangible results. The cameras were cumbersome, limited, and expensive, and quite frankly the pictures weren't very good either.

With the release of the second edition in 2004, the technical issues of resolution, dynamic range, and color rendition of digital in comparison to film were close to being settled but at an extreme cost that primarily professional photographers with hefty client lists or dedicated amateurs with disposable income were able to delve into.

Now, with the third edition of *Real World Digital Photography* in 2010, we no longer compare digital with film. For most photographic processes, digital is the clear winner in terms of quality, ease of use, reliability, and price

performance. Many photographers working today have never even bought a roll of film. The quality, performance, and price ratios are refreshingly balanced. Cost is relatively low, and digital image quality is very high.

*Real World Digital Photography* serves photographers who want more from their experience of taking pictures than simply pressing the shutter. With *Real World Digital Photography* you will learn the vocabulary, technical considerations, and skills to improve your photography. This is an essential introduction to a wonderfully complex and creative endeavor that is written by three artists, educators, and passionate photographers—Katrin Eismann, Seán Duggan, and Tim Grey. Each author has taken the time to consider and condense what each feels are the essential skills and considerations for you to be a highly successful photographer who appreciates and enjoys the idea of: *You take the picture. You gladly do the rest.* This book guides you to create compelling images with the confidence that your technical decisions are sound and your creative results best reflect your unique vision. Taking pictures is a positive endeavor that allows you to see yourself and the world more clearly.

—Katrin Eismann with John McIntosh

# Digital Photography Essentials

# Nuts and Bolts of Digital Imaging

1

Before you run out and start capturing images with your digital camera (OK, before you go out and take *even more* photos), you should understand the nuts and bolts of digital photography. The more you understand about digital imaging, the better equipped you'll be to make the most of your digital photographs. The essential concepts to understand are resolution, bit depth, color modes, and file formats.

## Resolution = Information

Resolution is one of the most important concepts to understand in digital imaging and especially in digital photography. The term *resolution* describes both pixel count and pixel density, and in a variety of circumstances these concepts are used interchangeably, which can add to misunderstanding.

Camera resolution is measured in *megapixels* (meaning millions of pixels); both image file resolution and monitor resolution are measured in either pixels per inch (ppi) or pixel dimensions (such as 1024 by 768 pixels); and printer resolution is measured in dots per inch (dpi) (**Figure 1.1**). In each of these circumstances, different numbers are used to describe the same image, making it challenging to translate from one system of measurement to another. This in turn can make it difficult to understand how the numbers relate to real-world factors such as the image detail and quality or file size and print size.

**Figure 1.1** *Different devices use different units for measuring resolution, which can cause some confusion for photographers. Understanding how resolution is represented for each device will help you better understand the capabilities of each in your workflow.*

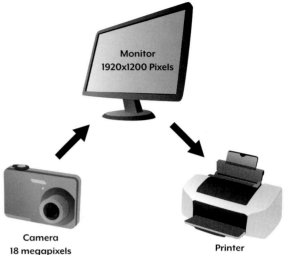

## PPI vs. DPI

Purists will draw a careful distinction between ppi and dpi. Pixels are the dots on your monitor, and dots are, well, the dots on paper. The distinction between the two is subtle, but we feel it's important to use the most clear and accurate terminology. Therefore, we use the term ppi when referring to pixels on a digital camera or display device and dpi when referring to dots in printed output.

If you hear people using dpi as a general term for resolution, understand that they may mean ppi when they say dpi (and then recommend that they buy and read this book!).

The bottom line is that resolution equals information. The higher the resolution, the more image information you have. If we're talking about resolution in terms of total pixel count, such as the number of megapixels captured by a digital camera, we are referring to the total amount of information the camera sensor can capture, with the caveat that more isn't automatically better. If we're talking about the density of pixels, such as the number of dots per inch for a print, we're talking about the number of pixels *in a given area*. The more pixels you have in your image, the larger that image can be reproduced. The higher the density of the pixels in the image, the greater the likelihood that the image will exhibit more detail or quality (**Figure 1.2**).

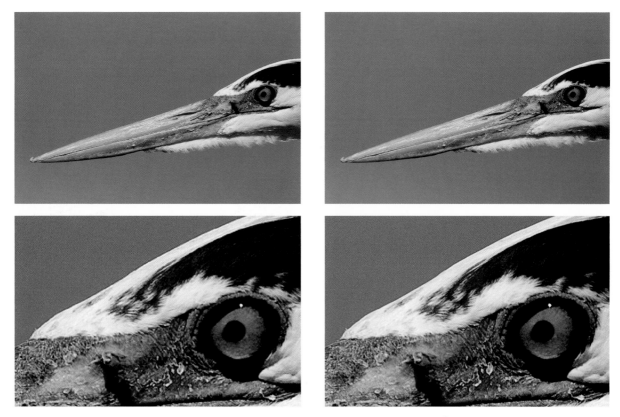

**Figure 1.2** *The resolution of a digital camera determines how much information it is able to capture. The photo on the left was captured at 1 megapixel and contains less detail and minimally defined edges compared to the image at right. The photo on the right was captured at 6 megapixels and contains considerably more detail and smoother edges.*

The biggest question to consider when it comes to resolution is—How much do I *really* need? More resolution is generally a good thing, but that doesn't mean you always need the highest resolution available to get the job done. Instead, you should match the capabilities of the digital tools you're using to your specific needs. For example, if you are a real estate agent who is using a digital camera only for posting photos of houses on a Web site and printing those images at 4 by 6 inches on flyers, you really don't need a multi-thousand-dollar, 22-megapixel digital camera to achieve excellent results. In fact, a 4–6-megapixel point and shoot camera would handle this particular need, although having more image information would be beneficial in the event you needed to crop an image or periodically produce larger output.

We'll discuss in future chapters which resolutions you should have with the various tools you'll use to capture, edit, and print your images.

---

### Megapixels vs. Effective Megapixels

Digital cameras are identified based on their resolution, which is measured in megapixels. This term is simply a measure of how many millions of pixels the camera's image sensor captures to produce the digital image. The more megapixels a camera captures, the more information it gathers. That translates into larger possible image output sizes.

However, not all the pixels in an image sensor are used to capture an image. Pixels around the edge are often masked, or covered up. This is done for a variety of reasons, from modifying the aspect ratio of the final image to measuring a black point (where the camera reads the value of a pixel when no light reaches it) during exposure for use in processing the final image.

Because all pixels in the sensor aren't necessarily used to produce the final image, the specifications for a given camera generally include the number of effective megapixels. This indicates the total number of pixels actually used to record the image rather than the total available on the image sensor.

---

## Where Resolution Comes into Play

Resolution is a factor at every step of the photo-editing process. The digital camera you use to record the scene, the monitor you use to view those images, and the printer you use to produce prints all have a maximum resolution that determines how much information they are able to capture, display, or print. Understanding how resolution affects each of these devices will help you determine which tools are best for you and how to use them.

### Camera resolution

Camera resolution defines how many individual pixels are available to record the actual scene. This resolution is generally defined in megapixels, which indicates how many millions of pixels are on the camera sensor that is used to record the scene. The more megapixels the camera offers, the more information is being recorded in the image.

Many photographers think of camera resolution as a measure of the detail captured in an image. This is generally true, but a more appropriate way to think of it is that resolution relates to how large an image can ultimately be reproduced. **Table 1.1** shows the relationship between a camera's resolution and the images the camera can eventually produce. If sensor size was the only thing that defined image quality and detail, it would be child's play to pick out a camera—with bigger being better—but sadly this simple formula will not serve you well. In addition to sensor size, image detail and quality are affected by such factors as lens quality, file formats, image processing, and photographic essentials such as proper exposure.

**Table 1.1** *Megapixel Decoder Ring*

| Approximate Megapixels | Printed Output Size | Uncompressed 8-bit File Size |
| --- | --- | --- |
| 1 | 3"x4" | 3 MB |
| 2 | 4"x6" | 6 MB |
| 5 | 6"x9" | 15 MB |
| 10 | 9"x13" | 30 MB |
| 15 | 10"x16" | 45 MB |
| 20 | 13"x19" | 60 MB |
| 30 | 16"x24" | 90 MB |
| 40 | 18"x26" | 120 MB |

Chapter 2, "How a Digital Camera Works," explains how to choose the best digital camera for your needs.

## Monitor resolution

The primary factor in monitor resolution is the actual number of pixels the monitor is able to display. For desktop or laptop LCD displays there is a "native resolution" that represents the actual number of physical light-emitting pixels on the display, and this is the optimal resolution to use for the display. Any other setting will cause degradation in image quality, which is discussed in more detail in Chapter 7, "Building a Digital Darkroom."

The actual resolution is often described not just as the number of pixels across and down, but also with a term that names that resolution. For example, XGA (Extended Graphics Array) is defined as 1024 pixels horizontally by

768 pixels vertically. SXGA (Super Extended Graphics Array) is 1280 by 1024 pixels. There are a variety of such standard resolution settings. In general it's best to choose a monitor with the highest resolution available so you can see as much of your image as possible at once. However, keep in mind that the higher the resolution, the smaller the screen's interface elements will appear on your monitor (**Figure 1.3**).

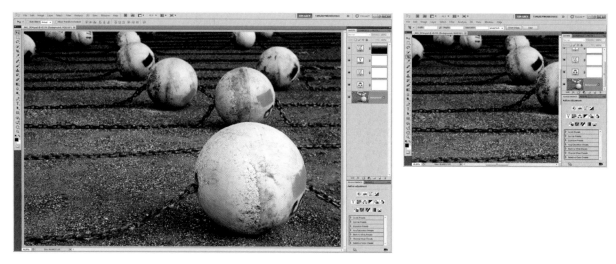

**Figure 1.3** *The monitor resolution you use determines how much information can be displayed. A high-resolution display of 1920x1200 (left) shows more information than a lower-resolution display of 1024x768 (right).*

## 72 PPI?

One of the most common misconceptions about monitor resolution is that monitors display at 72 ppi and that all Web graphics need to be set to 72 ppi. This simply isn't the case. Back in the early days of personal computing, Apple had a 13-inch display that did indeed operate at 72 ppi. Most monitors these days display at a range between about 85 ppi and 125 ppi. The exact number depends on the pixel dimension resolution and the physical size of the monitor. Again, this number is a measure of pixel density, so it relates to the overall image quality of the display. The higher the ppi value, the crisper the display and the more capable the monitor is of showing fine detail without as much magnification.

In terms of Web display, the monitor that is used to view the Web page determines the final pixel distribution, meaning you don't need to make sure that every image you post to the Web is set to 72 ppi.

## Printer resolution

For photographers, the digital image's defining moment is when ink meets paper (**Figure 1.4**). The final print is the culmination of all the work that has gone into the image, from the original concept, the click of the shutter, and the optimization process to the final print. The quality of that final print is partly determined by the printer resolution.

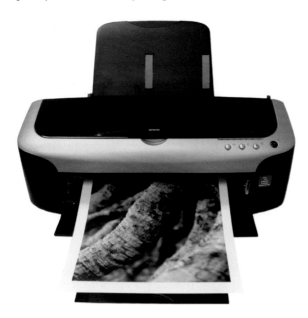

**Figure 1.4**  *For most photographers, a high-quality print is considered the ultimate goal for an image.*

Once again, just to keep things confusing (we mean interesting) there are two numbers that are often labeled "print resolution"—output resolution and print resolution, and this is a major source of confusion. The marketing efforts of printer manufacturers only contribute to this confusion (see the following section, "Marketing Hype").

*Output resolution* in the image file is simply a matter of how the pixels are spread out in the image, which in turn determines how large the image will print and to a certain extent the quality you can obtain in the print.

*Printer resolution* is the measure of how closely the printer places the dots on paper. This is a major factor in the amount of detail the printer can render—and therefore the ultimate quality of the print. Note that the printer's resolution is determined by the number of ink droplets being placed in a given area,

not by the number of pixels in your image. Therefore, there won't necessarily be a direct correlation between output and printer resolutions, because multiple ink droplets are used to generate the individual pixels in the image.

Each type of printer, and in fact each printer model, is capable of a different resolution. We'll discuss the capabilities of each type of printer and how to prepare your image files for those printers in Chapter 9, "From Capture to Monitor to Print."

## Marketing Hype

It's bad enough that the term resolution is defined in a variety of ways, making it potentially a confusing topic. But to us it seems as if the manufacturers of digital photography tools are trying to confuse everyone even further. It doesn't help that there aren't definitive definitions for many of the terms being used to describe various products. For example, the term *resolution* is used to describe the quality a printer is capable of. However, the number by itself is meaningless because so many other factors go into the final image's quality. Therefore, the only way to use the number is to compare it with the numbers presented for competing printers and to put those numbers in context with other factors, such as the number of inks, the accuracy of dot placement, the dithering patterns, and more. What manufacturers are really trying to do is convince you that their numbers and products are the best, but as we all know the truth can get lost in the hype.

Digital camera manufacturers are quick to boast about the number of megapixels a camera is able to capture. This is an important factor to consider, but other important factors also impact final image quality, as we'll discuss in Chapter 2. Keep in mind that you may not necessarily need the camera with the most megapixels for your particular needs. Also, you can generally push digital images to large output sizes (see the next section) even if you don't have the highest resolution to begin with. Other factors, such as lens quality and choices, sensor quality, and special features—such as video or a high ISO or frame rate—are also important when you're deciding which camera is best for you or whether to upgrade from your current camera.

The most marketing hype seems to revolve around photo inkjet printers. There is a constant barrage of claims of how many dots per inch the latest printer can produce. Repeated testing has convinced us that photographic output above 1440 dpi as set in the printer driver produces no benefit in terms of image quality.

By understanding what the various specifications mean and determining which factors are important to you, you'll be able to see through the hype and make the best purchasing decision.

# Bit Depth

*Bit depth* describes the number of bits used to store a value, and the number of possible values grows exponentially with the number of bits (**Table 1.2**). A single bit can store two values (ostensibly zero and one, but for our purposes it is more useful to think of this as black or white), whereas 2 bits can store four possible values (black, white, and two shades of gray), and so on (**Figure 1.5**). Digital image files are stored using either 8 or 16 bits for each of the three color (red, green, blue) channels that define pixel values (see "Color Modes" later in this chapter), and HDR (high dynamic range) images are processed and stored as 32-bit images, which we'll address in Chapter 6, "Multiple Exposures and Extending the Frame."

**Table 1.2** *Bit Depth*

| Bits | Tonal Values Possible |
| --- | --- |
| 2 | 4 |
| 4 | 16 |
| 6 | 64 |
| 8 | 256 |
| 10 | 1024 |
| 12 | 4096 |
| 14 | 16,384 |
| 16 | 65,536 |

**Figure 1.5** *As the bit depth increases, the number of possible tonal values grows exponentially.*

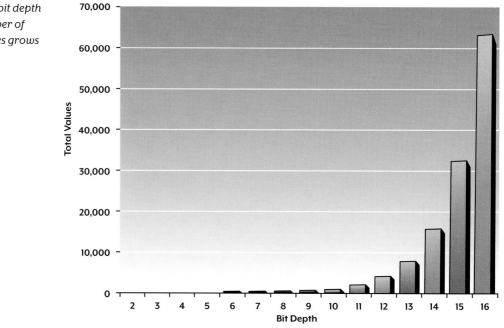

## 8 Bit vs. 16 Bit

The difference between an 8-bit and a 16-bit image file is the number of tonal values that can be recorded. (Anything over 8 bits per channel is generally referred to as *high bit*.) An 8-bit-per-channel capture contains up to 256 tonal values for each of the three color channels, because each bit can store one of two possible values, and there are 8 bits. That translates into two raised to the power of eight, which results in 256 possible tonal values. A 16-bit image can store up to 65,536 tonal values per channel, or two raised to the power of 16. The actual analog-to-digital conversion that takes place within digital cameras supports 8 bits (256 tonal values per channel), 12 bits (4,096 tonal values per channel), 14 bits (16,384 tonal values per channel), or 16 bits (65,536 tonal values per channel) with most cameras using 12 bits or 14 bits. When working with a single exposure, imaging software only supports 8-bit and 16-bit-per-channel modes; anything over 8 bits per channel will be stored as a 16-bit-per-channel image, even if the image doesn't actually contain that level of information.

When you start with a high-bit image by capturing the image in the RAW file format, you have more tonal information available when making your

adjustments. Even if your adjustments—such as increases in contrast or other changes—cause a loss of certain tonal values, the huge number of available values means you'll almost certainly end up with many more tonal values per channel than if you started with an 8-bit file. That means that even with relatively large adjustments in a high-bit file, you can still end up with perfectly smooth gradations in the final output.

Working in 16-bit-per-channel mode offers a number of advantages, not the least of which is helping to ensure smooth gradations of tone and color within the image, even with the application of strong adjustments to the image. Because the bit depth is doubled for a 16-bit-per-channel image relative to an 8-bit-per-channel image, this means the actual file size will be double. However, since image quality is our primary concern we feel the advantages of a high-bit workflow far exceed the (relatively low) extra storage costs and other drawbacks, and thus recommend always working in 16-bit-per-channel mode.

# Color Modes

A digital image file contains numeric values for each of the pixels in the image. The color mode defines which system is used to describe the pixel values in an image and how the pixel values are organized. Images in grayscale mode can only be black and white, whereas color images generally use RGB, CMYK, or Lab color mode.

## Grayscale

As its name implies, the grayscale color mode is for images that don't contain any color. An 8-bit grayscale image can contain 256 possible shades of gray, and a 16-bit grayscale image can theoretically contain up to 65,536 shades. You may think that fine-art black and white photography is just black and white, but close inspection reveals that the prints have subtle tones that enhance the shadows and midtones. For this reason we recommend processing and storing black-and-white images in RGB to maximize the tonal range of the image. Even if a digital camera offers a grayscale option, we never use it. We don't trust the camera to make appropriate image-editing decisions as to how to produce the best grayscale interpretation of an image, and for RAW capture the grayscale option won't actually

change the information captured by the camera. If you want to produce a grayscale image, wait to convert the RGB file to grayscale in the editing stage. There are also excellent options for producing black-and-white prints from an RGB file that rival traditional silver gelatin prints in tonality, sharpness, and vibrancy. We use Adobe Photoshop Lightroom to produce a black and white interpretation of our RAW captures, as addressed in Chapter 8. We also talk about printing images, including issues related to printing in black and white, in Chapter 9.

# RGB

The RGB color mode is the most common for photographic images. It stores information about the image based on the three additive primary colors of red, green, and blue (RGB). These are the primary colors for *emitted* light and are also the colors that most digital camera sensors are filtered to read. In addition, monitors use the RGB color mode to create the display image. These additive primary colors are referred to as additive because each color adds a wavelength of light to produce the final color.

A file stored in RGB color mode will actually contain three individual grayscale channels in perfect registration (alignment) that describe the values of red, green, and blue for each pixel in the image. These values can range from 0 (black) to 255 (white) for 8-bit images. If all three color channels have a value of 0 for a given pixel, that pixel will be pure black; if all three are 255, that pixel will be pure white. If all three have the same value anywhere in between, the pixel will be a shade of gray. By mixing different values for each color channel for a given pixel, over 16.7 million possible colors for 8-bit images can be created. For 16-bit-per-channel images, the pixels on each channel can have a value of between 0 and 65,535, for a total of over 281 *trillion* possible color values. Note that standard LCD monitors cannot render (show), nor can we see, trillions of colors, but once again manufacturers love to claim these values—as if they are a meaningful unit of measure. As a general rule, you'll want to save all color images in the RGB color mode, because converting to grayscale, CMYK, or Lab unnecessarily may degrade the file and result in the loss of critical tonal and color information.

# CMYK

The CMYK color mode is built on the subtractive primary colors of cyan, magenta, and yellow. These are the colors used to produce color from *reflected* light, such as ink on paper. Black (K) is added to the mix so that true black can be produced on paper. CMYK is referred to as the subtractive primary color space because the inks absorb some of the light, subtracting certain wavelengths from the light that illuminates the print.

Many photographers are not familiar with CMYK files. Unless you are preparing files for offset printing (as the images in this book were), you generally don't need to worry about working with CMYK color mode. In most situations it's best to keep the images in the RGB color mode. The only time you need to convert an image to CMYK is to apply specialized image rescue techniques or for offset press output, and being a photographer who knows that it is best to capture the finest initial exposure, you won't need to resurrect poor images. In addition, in many cases you can leave the CMYK conversion to the printing lab.

# Lab

The Lab color mode is relatively abstract. It stores image data in three channels, much like the RGB color mode. However, the information contained in each channel is structured differently than in RGB.

The RGB and CMYK color modes define color based on how the colors are produced by a physical device—such as a monitor or a printer. The Lab color mode is a device-independent color mode that describes color based on how it looks. It describes the color in the way the human eye distinguishes it in terms of luminosity (brightness) and color defined along two axes of red-green and blue-yellow.

The first channel in the Lab color mode (or "L") is luminosity, which describes the relative brightness of each pixel. The "a" channel describes color on an axis of red and green, and the "b" channel describes color on an axis of blue and yellow.

The Lab color mode is used as a reference color space for converting colors between color modes and spaces. It provides the ability to make adjustments that will affect only brightness values of the pixels in an image without risking color shifts.

# File Formats

In an imaging workflow there are four primary areas where you need to make informed file format decisions: in the camera, with image-editing software, with the output, and when storing your master image files. After looking at the list of possible file formats Adobe Photoshop can save an image file as, you may have (we have) felt overwhelmed by the number of names and acronyms. Fortunately, you only need to know a few standard formats to work efficiently and maintain image quality.

## In the Camera

Two basic file format options are available to you when working with a digital camera to capture still images. Each has its strengths and weaknesses, and each can impact the final image quality.

### RAW capture

The RAW file format is not a file format in the traditional sense. In fact, RAW is not an acronym. It is capitalized only to resemble the other file formats.

Rather than being a single file format, RAW is a general term for the various formats used to store the raw data recorded by the sensor on a digital camera. Each camera manufacturer has developed proprietary file formats for RAW capture modes. Because none of the proprietary file formats are standard image file formats, you must convert RAW files before you can edit the image. You can convert RAW images to a file you can work with in Photoshop or print by using the camera manufacturer's software or as we recommend and practice by using Adobe Camera Raw or Adobe Photoshop Lightroom.

Multiple RAW file formats are created by many camera manufacturers, and often new versions are included with each new camera model release. As a result, literally hundreds of RAW file formats exist. Adobe has responded to this by providing an open industry standard for RAW capture called the DNG (digital negative) file format. DNG has been adopted by several digital camera manufacturers but hasn't managed to stem the tide of new RAW file formats. You can convert proprietary RAW captures into the DNG file format to ensure compatibility well into the future with the free Adobe DNG converter, Adobe Bridge, or Adobe Lightroom.

The file size, in megabytes, of RAW captures for most cameras is approximately the same as the megapixel count of the camera. There is some variation in this from camera to camera, and some formats offer the option to further compress the data. Regardless, the files that result from RAW capture will be considerably larger than JPEG captures but smaller than never used or recommended TIFF captures.

The advantages of the RAW format include the ability to capture high-bit data; no in-camera processing; and options for adjusting the exposure, white balance, and other settings with great flexibility during the conversion process. The disadvantages are the relatively large file sizes, files that must be converted before you can retouch, composite, or post them on the Web, and the need to work with high-bit files to obtain all the benefits of the high-bit capture.

We highly recommend RAW capture and use it for the vast majority of our photography. The tools for working with RAW captures have become sophisticated enough that there are no longer many strong arguments against RAW capture. We very much want to maintain the benefits of high-bit data, post-processing flexibility, and lack of lossy image compression that are among the benefits of RAW capture.

## JPEG

The major advantage of the JPEG (Joint Photographic Expert Group) format is convenience. Just about any software application that allows you to work with image files supports JPEG images. Also, the files are small because compression is applied to the image when it's stored as a JPEG. This compression is *lossy*, meaning pixel values are averaged out in the process and the image will lose detail and color, if you use the highest quality (lowest compression) settings, image quality is generally still very good. But again we don't use the JPEG file format when image quality is the most important final criteria. Admittedly, we do use JPEG for quick party pictures or snapshots that are only destined for eBay or Facebook display and also when capturing multiframes for stop motion and time-lapse projects as addressed in Chapter 6.

When selecting the JPEG format in the camera, you will generally have the option of size and quality settings. We always recommend capturing the most pixels possible, taking advantage of the full resolution of the image sensor in your camera. This size option is generally labeled Large, and we

recommend using the highest possible quality setting. We discuss these options in more detail in Chapter 4, "Digital Photography Foundations."

# In the Computer

If, like us, you're using Lightroom to manage and optimize your images, you don't need to think about file formats until you export images to use elsewhere. If you're not using Lightroom, you'll need to save the initial RAW conversions in a different file format. Regardless, at some point you'll need to choose a file format for various derivative images you'll produce. The following are the most common formats.

## JPEG

The JPEG file format is by nature an 8-bit file that utilizes lossy compression to minimize file size, which represents a compromise when it comes to image quality. As a result, it is a file format best suited for situations where minimum file size is your paramount concern.

JPEG is an excellent choice for saving images that will be displayed on a Web page or sent via email (see Chapter 10, "The Digital Portfolio"). Because the JPEG file format utilizes lossy compression, repeatedly resaving a JPEG image you have applied changes to will result in a compounded loss of image quality.

## TIFF

The TIFF file format has grown more robust, offering support for layered documents and a variety of other advanced options. It is an excellent choice for archival storage of your optimized images. In fact, we think it may ultimately replace the Photoshop PSD format, since TIFF is more universally supported and offers virtually all the benefits of the Photoshop PSD format.

TIFF files take up more space than some other formats—JPEG files, for example—but the space consumed is worth it. If you want to save all the various layers used to adjust an image in Photoshop (and we highly recommend doing so), you need to use PSD or TIFF as your file format. Although PSD does use non-lossy compression by default, if you use LZW or ZIP compression on TIFF files, you'll end up with an even smaller file. They are still large compared to a JPEG, but that is a price the photographer should be willing to pay. Besides, hard drive storage is incredibly cheap!

### Photoshop RAW

Since capturing images in RAW mode with digital cameras offers some advantages in terms of ultimate image quality, it would seem to make sense to save your images in the RAW format. But you can't. You may even have seen the RAW file format listed in the Save As dialog in Photoshop's Format drop-down menu. However, the RAW file format in Photoshop is not the same as the RAW capture mode on your digital camera.

The Photoshop RAW file format is provided as a way to send images as raw data to another application that doesn't support other file formats. Trust us—you'll never need to save a file in this format.

### Photoshop PSD

Many photographers use Photoshop to optimize their images. We used to be in favor of saving all archival images in the Photoshop PSD format, because it enabled you to save all the layers you used to modify an image.

However, as mentioned previously, the TIFF file format offers all the capability of the PSD file in a nonproprietary format. But unless Adobe enhances the Photoshop PSD format's compatibility and functionality, the TIFF format might ultimately make it obsolete. Just keep in mind that layered files, whether saved in the Photoshop PSD or TIFF file format, often can't be opened with layers intact in other software.

## Output

Your images don't need to be in a particular file format to be printable. As long as you can open them with your photo-editing software, you'll be able to print them. Once the file is opened, the file format is largely irrelevant, because pixels are just pixels.

Of course, not all file formats are created equal when it comes to printing. The same issues that govern your decision about which file format to save your images in will impact the final printing. For example, if you save your images as highly compressed JPEG files, the final prints will reflect the loss of image quality that occurs when compressing the image data.

In general, you'll get your best prints from files saved in the TIFF or Photoshop PSD file formats. JPEG files that are saved at a high-quality setting can

also be used to obtain good prints. The key factor is the quality of the image you have saved. If the saved file looks good, so will the print, provided you follow an appropriate sharpening and color management workflow, both of which we delve into in Chapters 8 and 10.

## Email and Web

So now that we've convinced you to save your digital photos as TIFF files to ensure the best quality, we need to mention the exception to the rule: Don't even think about sending those large files via email! When you send images through email (even when the recipient has a high-speed Internet connection), you need to strike a compromise between image size and quality if you want your recipient to receive the file sometime this century. That means using JPEG to compress the files to a manageable size.

# Understanding the Concepts

Throughout this chapter we've presented topics to help you gain a better understanding of the concepts that are important in digital imaging. This knowledge provides a foundation for you to build on as you continue to explore the world of digital photography. In the next chapter we'll delve into the components of a digital camera and how they work.

# How a Digital Camera Works

There's more to creating a great photograph than pushing a button while standing in front of a beautiful scene. We photographers are passionate about the cameras and lenses we work with, and our enjoyment of the craft is apparent in the many hours we spend pursuing the perfect image and working to improve our photography.

While developing a keen eye for lighting, composition, and image aesthetics is certainly important, you must also understand the tools you work with (namely, the camera) to produce the best image possible. Knowing how the camera captures the image allows you to respond to the scene more instinctively.

## Lens to Image Sensor to Media

Photography—whether film or digital—is all about light. The light reflects off the scene in front of the lens, then passes through the lens and the open shutter. This process is similar to the way light passes through the lens of your eye to the cones and rods at the back of the eye and on to the optic nerve. It's after the light passes through the open shutter that film and digital cameras start to work differently.

With film photography the light that passes through the lens exposes the light-sensitive film. The film records the light through photo-molecular

reactions that embed a latent (nonvisible) image in the film. The latent image becomes visible when the film is chemically processed.

With digital photography the flow of light is the same, but the flow of information is not. When the light passes through the open shutter, it hits the image sensor, which translates that light into electrical voltages. The information is then processed to eliminate noise, calculate color values, produce an image data file, and write that file to a digital memory card. The camera then prepares to take the next exposure. This all happens very quickly, with a tremendous amount of information being simultaneously processed and written to the memory card.

Let's follow the path of light to see how each component functions and what issues affect the final quality of the image (**Figure 2.1**).

**Figure 2.1** *In a digital camera, light follows a path through the lens to an image sensor.*

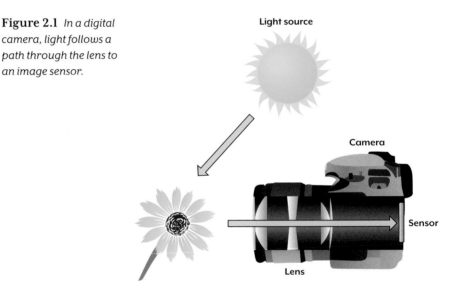

# The Lens

Camera lenses are surprisingly complex and sophisticated in their construction and design, containing a series of elements—typically made of glass—that refract and focus the light coming into the lens. This allows the lens to magnify the scene and focus it at a specific point.

After many years of working with digital cameras, we've come to the conclusion that digital photography requires higher-quality lenses than film photography. Film has a variable-grain structure, whereas pixels are all the same size; this means that digital cameras operate at a disadvantage when it comes to capturing fine detail. In addition, an image sensor is more sensitive to light hitting it directly as opposed to hitting it at an angle, resulting in a slight loss of sharpness particularly around the edges of wide-angle lenses. The resulting loss of sharpness can be compensated in part by using a lens of the highest quality. We've also learned that although you can correct one or two less than sharp images within reason, it is absolutely not enjoyable to correct hundreds and thousands of them. A bright, sharp lens is something you will never regret photographing with.

## Focal Length

Different lenses provide different perspectives, and what makes those lenses different is their focal length.

*Focal length* is technically defined as the distance from the rear nodal point of the lens to the point where the light rays passing through the lens are focused onto the focal *plane*—either the film or the sensor (**Figure 2.2**). This distance is typically measured in millimeters. From a practical point of view, focal length can be thought of as the amount of a lens's magnification. The longer the focal length, the more the lens will magnify the scene. At longer focal lengths the image circle projected onto the image sensor contains a smaller portion of the scene before the lens (**Figure 2.3**).

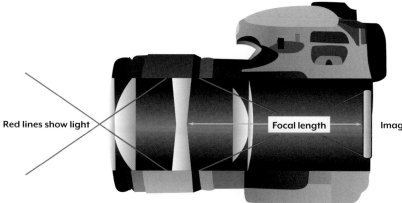

**Figure 2.2** *The focal length of a lens is measured as the distance from the lens to the point where the light rays passing through the lens are focused onto the focal plane.*

Red lines show light     Focal length     Image sensor

Lens
(artist's rendition)

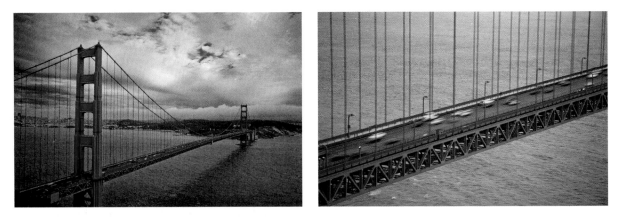

**Figure 2.3**  *Increasing focal length effectively magnifies the scene. The image on the left was photographed with a 28mm lens, and the image on the right was photographed at 135mm.*

In addition to determining the magnification of a scene, the focal length affects the apparent perspective and compression of the scene. In actuality, the focal length isn't what changes the perspective. Rather, the change in camera position required to keep a foreground subject the same size as with another focal length is what changes the perspective. For example, if you put some objects at the near and far edges of a table and then photograph the scene with a wide-angle lens, the background objects will appear very small. If you photograph the same scene with a telephoto lens, you'll need to back up considerably to keep the foreground objects the same size as they were when photographed with a wide-angle lens. This changes the angle of view of the subjects, so that the distance between foreground and background objects appears compressed (**Figure 2.4**).

**Figure 2.4**  *Both images were captured to maintain the same size of the fore-ground subject. Changing focal length required that the distance between camera and subject be changed, which changed the relative size of background objects.*

# A Common Reference for Focal Length

The focal-length measurements used for lenses in 35mm film photography are well-known standards. To approximate the standard field of view on a 35mm camera, a photographer would use a 43mm lens. But as any photographer knows, a 50mm is considered the "standard" focal length. In fact, the 50mm lens is slightly narrower than standard human perspective, but it does maintain the spatial relationship of objects in the image very closely to the way we see the world. A 20mm lens provides a wide-angle perspective, and a 500mm lens magnifies the scene a great deal.

With digital cameras, there is tremendous variation in the focal length required to produce a given magnification due to the range of sensor sizes (more on that shortly). Because the sensors in most digital cameras are smaller than a single frame of 35mm film, the lens's focal length can be much shorter and still produce the same angle of view you would expect from a lens for a 35mm film camera (**Figure 2.5**).

**Figure 2.5**  *A typical image sensor from most digital cameras is smaller than a 35mm film frame.*

Because of the different sensor sizes and because the focal length measurements used in 35mm film photography are recognized standards, 35mm focal length equivalents are often used to provide a common reference for digital cameras.

As one example, the Canon PowerShot G11 digital camera has a lens that can zoom from 6.1mm to 30.5mm. While that is the actual focal length measured in the lens, it doesn't provide a useful reference for most photographers as to how the lens will behave. If you've ever used a 15mm fish-eye lens, you can imagine the unusual scene you'd capture with a so-called 6.1mm lens! Such a wide-angle lens would result in an incredibly distorted perspective if applied to existing 35mm camera standards. However, because of the relatively small size of the sensor in this camera, the equivalent focal-length range compared to that of a 35mm camera would be 28mm to 140mm. This is a measurement that photographers will be much more familiar with. Fortunately, most camera manufacturers include the 35mm equivalents in their technical camera specifications.

# Fixed Lenses

Fixed lenses are permanently attached to the camera and can't be exchanged with different lenses (**Figure 2.6**). Such lenses obviously make the camera simpler to operate and also help to keep camera size small. The main disadvantage is the lack of flexibility. Because the lens is fixed, you can't simply swap in a new lens when you need a different focal length. The only option is to zoom in or out to change the effective focal length of the lens, or to use accessory optics that attach to the front of the lens to produce a more wide-angle or telephoto effect. Fortunately, most digital cameras with fixed lenses offer zoom capabilities, allowing you to change the composition of the scene quite easily with the push of a button.

**Figure 2.6**  *Compact digital cameras have fixed lenses that cannot be changed, although add-on accessory lenses can often be used to provide a wider or more telephoto view. (The light rubber grip strip on this camera was added by the photographer for a more reliable grip surface.)*

# Zoom

A zoom lens is a variable focal length lens. Zooming in or out enables you to change the composition of your photograph and influence the spatial relationship of the subjects in the scene without changing your physical location. With digital cameras, you can accomplish this with optical or digital (not recommended) zoom.

### Optical zoom

Optical zoom lenses have a series of lens elements that move within the lens, altering the focal length by changing the relative position of those elements. The photographer can choose from a range of focal lengths, so that the scene can

be framed in a variety of ways. Some zoom lenses may produce images that are slightly less sharp than a prime (non-zoom) lens would, primarily because of the compromises that must be made in the design of the lens elements, such as adding glass elements to produce the range of magnification. However, zoom lenses can still produce excellent results and offer great flexibility.

As mentioned earlier, the zoom range of a particular digital camera may be referenced as a range of focal lengths equivalent to that of a 35mm film camera. Another common way to express zoom is with an *X* factor. This factor describes the ability of the lens to magnify the size of a subject between the minimum and maximum focal lengths. For example, if you used a camera with a 3X zoom, the subject of your photo would be three times bigger.

## Digital zoom

Many cameras offer a feature known as digital zoom to supplement the optical zoom capabilities of the lens. This is pure marketing hype, and the result is the equivalent of cropping and enlarging the image in the computer.

Digital zoom operates by simply cropping the image that is captured at the maximum optical zoom; it then interpolates the image size up. Unfortunately, this interpolation produces images that are soft and lacking in fine detail. We recommend avoiding digital zoom altogether. Many digital cameras even offer the ability to turn off the digital zoom so you don't use it by mistake. The apparent "extra zoom" may be tempting, but a serious side effect is usually a significant loss of overall image quality (**Figure 2.7**).

> **TIP** Move your position before making use of the zoom. We see many photographers use the zoom feature instead of taking a few steps forward. By moving to the optimal photographic position and then using the zoom feature to fine-tune the composition, you improve your options in composing the picture.

**Figure 2.7** *The first image shows a picture shot at maximum optical zoom. If digital zoom is used to provide more reach, the quality suffers, as the second image shows.*

If the optical zoom offered by the camera isn't enough to create the image you're looking for, try getting closer to the subject. There are other methods for enlarging the photo, and although they may impact the quality of the image, doing image cropping and resizing in the digital darkroom will result in better image quality than using the digital zoom. Whenever possible, it is always best to get the image right in the camera rather than trying to fix it later.

## Interchangeable Lenses

While many digital cameras with fixed lenses offer a good range of effective focal lengths, they simply don't offer the flexibility of a camera with interchangeable lenses (**Figure 2.8**).

**Figure 2.8** *DSLR cameras allow you to change lenses as the photographic situation requires.*

**TIP** While we do our "serious" photography with DSLR cameras, none of us would be without a compact digital camera. Having a point-and-shoot digital in our pocket means we can document all those situations where we don't need (or want) to carry all the extra gear involved with a DSLR.

Being able to change lenses as the situation warrants gives you tremendous creative control. Standing in the same spot, for example, you can capture a wide-angle image that shows the full environment of the location and then switch to a telephoto lens to compose an image of a particular element from the scene. Many compact digital cameras let you modify the lens with accessory lenses, converting it from a normal focal length to a telephoto or a wide-angle lens. But these add-on lenses also add problems, such as softening of the image and color fringing. A digital single lens reflex (DSLR) camera gives you maximum flexibility by allowing you to use a wide variety of interchangeable lenses (**Figure 2.9**). The primary drawbacks are that you can expect to pay considerably more for a DSLR with interchangeable lenses than you would for a compact digital camera, and the DSLR is likely to be a heavier weight at the end of your camera strap.

**Figure 2.9**  *The ability to change lenses on a DSLR camera gives you great flexibility. The image on the left was taken with a wide-angle lens, and the image on the right was taken of the same scene using a telephoto lens, focusing on the model boats in the window.*

## Lens Speed

Lens speed refers to the maximum aperture (minimum $f$ number) of the lens. A "fast" lens has a large maximum aperture, allowing the lens to gather more light—a very useful feature in low-light situations such as in the early morning or in candlelight (**Figure 2.10**). A "slow" lens has a maximum aperture that is smaller and lets in less light. A fast lens might have a maximum aperture of $f1.4$ or $f2.8$, whereas a slow lens might have a maximum aperture of $f5.6$. A fast lens is more desirable and is usually more expensive.

We'll talk about obtaining proper exposure in Chapter 5, "Seeing the Light," but for now it is enough to know that a proper exposure depends on the camera ISO setting, the aperture size, and the shutter speed to allow an appropriate amount of light to reach the digital sensor. Opening the aperture allows you to use a faster shutter speed. A fast lens with a larger maximum aperture means that you can use a faster shutter speed than would be possible with a slow lens—a significant factor in low-light situations and fast-moving situations.

A fast lens also helps the camera focus. Because the lens transmits more light, the camera will be better able to acquire proper focus, even in relatively low-light situations.

**Figure 2.10** *When photographing with low-light levels, a fast lens can help achieve a fast shutter speed to ensure a sharp image.*

# Lens Quality

Regardless of whether you are using a compact digital camera with a fixed lens, or a DSLR camera with interchangeable lenses, the lens plays a critical role in overall image quality. The sharpest, most accurate images—those that maintain maximum detail from highlights to shadows—always start with high-quality lenses.

When selecting a compact digital camera, choose one with the highest quality lens possible. With a DSLR camera you can choose from a wide variety of lenses for a given camera. And whenever possible, test a camera and lens combination to check for overall image quality. The quality of the lens can make all the difference in the final photograph.

## Recognizing lens problems

To evaluate the quality of a lens, you need to take a picture with that lens and then evaluate the results. Since other factors can also affect overall image quality—such as photographic technique, image sensor quality, and

environmental conditions—this isn't a foolproof method, but it's the only practical way for a photographer to test the quality of a lens.

Using a lens test target is the best method for evaluating quality (**Figure 2.11**). One of the most common targets provides fine lines that gradually get closer along their length, which allows you to evaluate the relative resolution of a lens. Unfortunately, these lens resolution charts can be expensive. For example, the commonly used I3A/ISO Resolution Test Chart, available from Edmund Industrial Optics (www.edmundoptics.com) and other sources, typically sells for about $185.

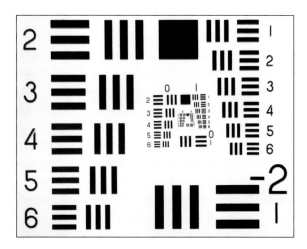

Figure 2.11 *Photographing a lens test chart can help determine the sharpness of a particular lens.*

Figure 2.12 *When you don't have access to a lens test chart, you can photograph real-world objects to get a basic sense of the quality of a lens. This nautical chart of Chesapeake Bay has lots of fine lines that can be used to evaluate lens sharpness.*

 **TIP** If you want to evaluate the power of a lens to resolve (differentiate) fine detail and you don't have an official resolution test target, consider photographing the front page of a newspaper, map, or sheet of music from a few feet away (**Figure 2.12**) (or as close as your lens will focus). By evaluating the resulting image at a large zoom setting in your photo-editing software, you can see how well the lens was able to render the fine detail, edge to edge sharpness, and exposure evenness, as well as check for other problems such as color fringing.

When doing any kind of lens testing, always use a tripod and the lowest ISO setting to minimize camera shake and noise. You should also ensure that the target is still, mounted flat, evenly lit, and positioned so that it is perpendicular to the camera.

## Sharpness

Sharpness is the ability of the lens to resolve fine detail and maintain edge contrast in those details. Lens resolving power is measured by the number of line pairs per millimeter that the lens is able to resolve. To test a lens, photograph the lens test chart and examine the image to see at what point you can still discern individual line pairs of black and white. As the lines get closer together, they will at some point blend into each other.

When evaluating the digital image file for lens sharpness, you have to inspect the image at 1:1 or 100 percent in your software to see the information accurately. Also, make sure you check for edge-to-edge sharpness. We've seen many lenses that are sharp in the image's center but degrade significantly at the corners and edges. There is nothing more frustrating than taking an important photograph that is well composed and a good exposure but is just on the wrong side of sharp.

## Lens distortion

The elements of a lens bend and focus the light to produce the final image. This process can distort the image. Sometimes this distortion can be a good thing, such as when using a fish-eye lens to provide a unique effect (**Figure 2.13**). Other types of distortion can produce effects that may be undesirable:

**Figure 2.13**  *A fish-eye lens provides the ability to capture images with a truly unique perspective.*

- **Pincushion distortion.** Pincushion distortion is where the edges of an image bend inward. It can occur on zoom lenses in the range of maximum magnification and on shorter-focal-length lenses when telephoto adapters are added. This type of distortion is easiest to see when there are straight lines near the edges of an image (**Figure 2.14**). The appearance of pincushion distortion can be corrected with photo-editing software.

**Figure 2.14** *Pincushion distortion is most easily seen when straight lines are near the edges of an image, where they can be seen to bend inward. (See the vertical dotted lines added for reference on either side of the door.)*

- **Barrel distortion.** Barrel distortion is the opposite of pincushion distortion. With barrel distortion the image appears to bulge, with straight lines bent outward (**Figure 2.15**). It occurs with zoom lenses at the shorter-focal-length end of their range or with wide-angle lenses. Again, straight lines near the edges of an image will make the effect more obvious. As with pincushion distortion, barrel distortion can be corrected with photo-editing software.

**NOTE** Just because you can fix pincushion or barrel distortion and chromatic aberration in software, don't ignore them when evaluating lens quality. Fixing one or two photos isn't daunting, but fixing 100 or more images gets old fast.

- **Chromatic aberration.** Chromatic aberrations are caused when light of different wavelengths doesn't get focused to the exact same focal point. Shorter wavelengths of light get refracted more than the longer wavelengths, causing the light of different colors to be out of alignment in the final image. It is most common in the lower-end consumer digital cameras, which tend to use lower-quality lenses. Most professional lenses use low-dispersion glass that minimizes chromatic aberrations.

  The most common traces of chromatic aberration are colored halos along bright contrast edges in an image. The colored halos often appear as red and cyan fringing along the edges of elements in the scene (**Figure 2.16**). This is typically more apparent on the outer edges of an image and is more likely to appear with wide-angle focal lengths or with less expensive wide-angle zooms. Fortunately, you can quickly test for this problem by taking a photo of a high-contrast scene such as tree branches in winter and looking for color fringing along high-contrast edges. Chromatic aberration can be corrected with photo-editing software.

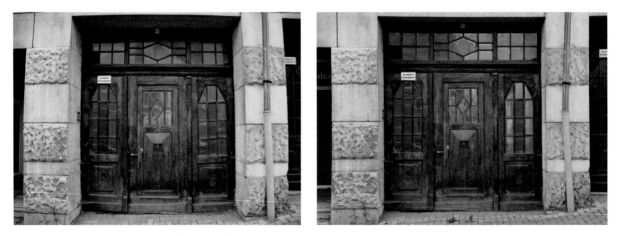

**Figure 2.15** *Barrel distortion is a "bulging" of the scene and is most easily seen when straight lines near the edge of an image are bent outward. The image on the left was photographed at a focal length of 24mm, and the barrel distortion is very apparent. The focal length for the image on the right is 60mm, a more normal focal length that does not cause barrel distortion.*

**Figure 2.16** *Chromatic aberrations are most likely to occur at high-contrast edges in a picture, as you can see in this image of Hoover Dam.*

# The Viewfinder and the LCD

The viewfinder is aptly named; it enables you to find the view you want of a scene and compose the shot. This is the essence of photography. Although seemingly a simple aspect of a camera, not all viewfinders are alike, and it's important to know the differences between them and how a viewfinder can affect your photography. With many cameras, the viewfinder is a small window you look through to see how the scene looks. This is referred to as an optical viewfinder. Not all compact digital cameras include an optical viewfinder, but nearly all of them feature an LCD that serves double duty as a viewfinder and as a way to review your photos. The smallest cameras frequently do not have an optical viewfinder and rely entirely on the LCD for this purpose (**Figure 2.17**). On most DSLR cameras the LCD is only for reviewing photos and changing camera menu settings, though some newer cameras offer a live view feature that adds viewfinder functionality to the LCD screen.

**Figure 2.17** *The LCD on a compact digital camera can be used to compose the image, making digital photography much more accessible to even the youngest photographers.*

## LCD: Advantages and Disadvantages

We all love instant gratification, and that is the primary advantage of the LCD display on a digital camera. It allows you to preview the photo you are about to take and review the one you just took to check for exposure and composition or to share with everyone around you. In addition, you can also look at any of your images at any time after you've taken them.

With the non-SLR digital cameras, the LCD display adds another dimension by allowing you to use the display as your viewfinder. Instead of putting your eye to the camera to compose the scene, you can hold the camera in front of you and compose based on the preview display on the LCD. This provides a little more freedom of movement, but also provides the opportunity to take images with unique perspectives. We've all seen the crowds of photographers trying to take pictures of the same subject, with those to the back holding their camera over their head, clicking the shutter release, and hoping for the best. The LCD display on a digital camera takes the guesswork out of that situation. You can take pictures up high, down low, around the corner, or elsewhere, and still know what you'll end up with (**Figure 2.18**).

**Figure 2.18** *Using the LCD live preview to compose the shot enables you to create images that might otherwise have been impossible.*

One of the big disadvantages of the LCD is that it can be very difficult to compose a shot or review your images outdoors on a bright, sunny day. For composing a photo, you'll find yourself shading the LCD with your hand, and when reviewing images, you may have to seek the shade of a tree, hold the camera inside your camera bag, or even put a jacket over your head to get a good look at your images.

Turning up the brightness of the LCD display may make it easier to see in bright light, but it also changes the appearance of the image; so you can't really judge proper exposure based on the LCD preview alone. Your best bet is to shade the display as best you can to review your images, and use the histogram feature for exposure evaluation. We'll talk about using the histogram to ensure the best exposure in Chapter 5.

Some cameras may provide a built-in pop-up hood to shield the LCD from ambient light and improve the quality of the view. There are also a variety of accessory products designed to shade your LCD display so you can see it better in bright light. In their various forms these are basically hoods or tubes that you place against the LCD display to help shade it. Ideally, you want to be able to put your eye against the shade device to block as much light as possible. However, with many of the shades available, the tube is so short that putting your eye up to it will put you too close to be able to focus on the image. Others have magnifiers built in, but these tend to overemphasize the individual

**TIP** Accessory view-finder hoods or loupes are available to help you see a clear view of the LCD screen even in the brightest light. We use the Hoodman Loupe for this purpose. See Chapter 3 for more on this and other accessories.

pixels in the image rather than allowing you to view the image itself. The best LCD hoods have a viewfinder lens that is somewhat wide angle, allowing you to see the entire screen without magnifying the pixels, and that can also be adjusted to your own eyesight (see Chapter 3, "Essential Accessories").

# Compact Camera Viewfinders

Even with all the benefits of the LCD display on a compact digital camera, you'll still find yourself using the viewfinder at times. Sometimes it will be because the battery is running low and you don't want to waste power on the LCD. Other times it will be out of preference. Whatever the reason, the viewfinder still offers an important alternative to the LCD display when composing a photograph.

### Optical viewfinders

Viewfinders on compact digital cameras come in two flavors: optical and electronic. An optical viewfinder is simply a small viewing window on the top of the camera, typically just above the lens, but also sometimes offset a bit to one side. Since the viewfinder is not located in the same position as the lens, there is a displacement factor between what you see in the viewfinder and what the lens records. This difference is referred to as *parallax*. For distant subjects this does not translate into any visible difference between the viewfinder and the recorded image. When you are close to your subject, however, the difference between what you see in the viewfinder and what you capture through the lens can be considerable (**Figure 2.19**).

**Figure 2.19** *On compact digital cameras the view-finder does not provide an accurate view of the image to be photographed, particularly when the subject of the photo is close to the camera.*

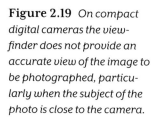

Most optical viewfinders have framing guide lines to help you compensate for the differences caused by parallax, giving you some indication of how to compose the shot based on how close you are to the subject (**Figure 2.20**). A lot of this comes down to learning how the image in the viewfinder translates to the final photograph. You can get a feel for this by comparing the scene in the viewfinder with the display on the LCD to see how they differ. Katrin uses this technique by framing a door in the viewfinder and then seeing how it appears on the LCD. Such a technique can tell you immediately if the display through the viewfinder is centered or skewed.

**Figure 2.20** *Parallax occurs with close-up subjects because the optical viewfinder does not show you what is being photographed by the camera's lens. Parallax correction guides in the viewfinder let you see where the real edge of the frame is, as opposed to what you're seeing in the viewfinder.*

## Electronic viewfinders

An electronic viewfinder is very similar to an optical viewfinder, and until you actually look through it, may appear to be the same. But where an optical viewfinder lets you look directly at a scene, an electronic viewfinder is essentially a video feed from the sensor to the viewfinder eyepiece. In this regard it has much more in common with the viewfinder on a video camera than a traditional still camera.

The main advantage to an electronic viewfinder is that it shows you the view as seen by the lens, so there are no parallax corrections to worry about when

composing the photo. The primary disadvantage is a phenomenon known as *image latency*. This refers to the fact that when photographing fast-moving subjects, the electronic display lags a bit when it translates the signal from the sensor to the viewfinder, resulting in blurring or ghosting of the subject. Another disadvantage is that you cannot really see the natural quality of the light in the scene, and the view can look like an inexpensive video recording. If you are used to working with video cameras, this may not be a big deal for you, but many photographers who have spent years framing their images through a traditional optical viewfinder dislike the video quality of electronic viewfinders.

## DSLR Viewfinders

DSLRs have an optical viewfinder that shows the exact view from the lens. Although the viewfinder is not on the same plane as the lens, a mirror and a pentaprism are used to reflect the light from the lens up into the viewfinder. From a photographic perspective, this method has some key advantages, chief among them is the fact that you are viewing the same quality of light that you would be seeing if you were viewing the scene without a camera up to your face (**Figure 2.21**). There is also no image latency effect that can often be seen in electronic viewfinders. This type of viewfinder also allows you to more effectively block out the rest of the scene so you can concentrate on composing the image. Additionally, the depth-of-field preview feature on DSLRs lets you see exactly the depth of field that will appear in the finished photo.

**Figure 2.21** *With a true SLR viewfinder, you see the same scene and the same light that is being photographed by the lens.*

One detail to keep in mind, however, is that the viewfinder may not show you 100 percent of the image. In fact, most viewfinders on SLR cameras only show you about 95 percent of the actual scene that will be photographed. That means a small area around what you're able to see will still be included in the final image. Typically, the more "professional" (and expensive) the camera, the more the area shown by the viewfinder will match the area that is actually photographed.

### LCD live preview

Historically, DSLRs did not have the LCD live preview capabilities that have been common for many years on compact digital cameras. This is because traditional DSLRS are not built the same way as smaller digital cameras. The light from the lens does not reach the image sensor until the instant of exposure, when the mirror flips out of the way and the mechanical shutter opens. This aspect of DSLRs is changing, however, and as of this writing many new DSLR cameras on the market offer live preview LCD capability.

Live preview on the LCD is achieved by either using a second image sensor that is dedicated to the live view or by flipping the mirror out of the way during composition. Although this might seem like a really cool development, there are always trade-offs. Using live preview often slows down the auto focus function, which, of course, can slow down the entire photographic process. In locations with bright ambient light, it can also be difficult to view the image. While it may be useful for more sedentary subject matter and controlled studio situations, such as studio work, product photography, or still lifes, it is not well suited for photography that demands a quick response to changing conditions. We suspect that most photographers who are used to shooting with an SLR style camera will still prefer the optical viewfinder for most of their photography.

# The Shutter

The shutter in a traditional camera design is a complicated mechanism that precisely controls how long the light passing through the lens is exposed to the film or digital sensor.

With a film camera, the shutter remains closed to prevent light from exposing the film until a picture is taken. With a digital camera—depending on

the type of sensor used—a shutter in the traditional sense may not even be necessary. Because the image sensor in a digital camera is an electronic device rather than a light-sensitive piece of film, it can be turned on and off electronically, eliminating the need for a mechanical shutter to control the flow of light. Some sensors still require the use of a shutter, but many digital cameras don't use a mechanical one.

Whether or not there is a mechanical shutter in a particular digital camera, there still needs to be a mechanism to control the exposure of the image, and you still need a shutter release button.

## Pushing the Button

Pushing the shutter release button activates a series of events that culminates in the final picture. The image sensor must be charged so that it is ready to receive the light from the lens. The memory card must also be activated so that it is ready to receive data.

Besides getting ready to capture the photo, the camera must also establish the settings it will use for the exposure. That includes activating the auto focus if enabled, calculating the exposure if auto exposure is selected, and selecting an appropriate white balance setting to ensure the colors in the scene are rendered properly based on the type of lighting in the scene. The response times of cameras are always improving, but a $100 point-and-shoot digital camera will typically be slower to respond than a more expensive DSLR.

Once all of these tasks have been accomplished, the camera is ready to trigger the shutter so the image sensor can read the light and capture the image. That's a lot of work to do in less than a second—generally milliseconds. Unfortunately, depending on the camera, this whole process can cause irritating delays when you're taking the picture.

### Shutter lag time

One of the most frustrating experiences in digital photography, especially with compact cameras, is pressing the shutter to photograph your dog running on the beach, only to find yourself waiting for the camera to actually take the picture. In the meantime, the dog has moved out of the frame and you're left with a picture that is missing the very subject you intended to photograph (**Figure 2.22**). This delay is generally referred to as *shutter lag time*, but

it's actually caused by more than just a lack of responsiveness in the shutter. As mentioned previously, the camera is calculating the combination of settings to take the best picture. You can sidestep the shutter lag by using the following technique to help you get the picture exactly when you want to.

When trying to photograph that dog running on the beach, hold the shutter release button halfway down as you compose the shot so the camera can prepare itself; then you'll be all set to press the button down the rest of the way the moment you want to take the picture (**Figure 2.23**). Depending on the capabilities of the particular camera, there still may be some infinitesimal delay, but we doubt you'll even notice it. Or you can teach your dog to sit.

**Figure 2.22** *Shutter lag and a moving subject can cause you to miss the photo you were after.*

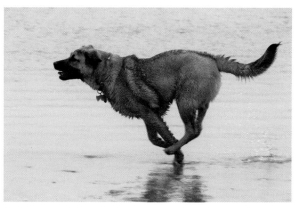

**Figure 2.23** *By pressing the shutter release button in halfway before taking a picture, you can minimize shutter lag and get the image you were trying to achieve.*

# The Image Sensor

Film does the job of both recording and storing the image photographed. With digital cameras these jobs are split between the image sensor and digital media (we'll talk about digital media later in this chapter). The image sensor replaces film as the recording medium. The sensor actually consists of millions of individual light-sensitive sensors called photosites. Each photosite represents an individual pixel. These photosites, or pixels, generate an electrical voltage response based on the amount of light that strikes them. The analog voltage response values are then translated into digital values in a process called analog to digital conversion—or in geek speak,

*A to D conversion*. The voltage information that has been translated to discrete digital numbers represents the tonal and color values in the photographic image. There is a certain irony in the fact that at the very instant of its creation a digital image is not really digital at all!

Even though digital cameras take pictures in full color, the sensors are unable to see color. They can only read the luminance, or brightness, values of the scene. Colored filters are used to limit the range of light that each pixel can read so that each pixel records only one of the three colors (red, green, or blue) needed to define the final color of a pixel. *Color interpolation* is used to determine the remaining two color values for each pixel.

## Types of Sensors

There are different types of image sensors technology, but the most widely used image sensors in digital cameras are CCD (charged coupled device) and CMOS (complementary metal oxide semiconductor).

### CCD

CCD sensors capture the image and then act as a conveyor belt for the data that defines the image. These sensors use an array of pixels arranged in a specific pattern that gather light and translate it into an electrical voltage. When the voltage information has been collected by each pixel as an image is taken, the data conveyor belt goes into action. Only the row of pixels adjacent to the readout registers can actually be read. After the first row of data is read, the data from all other pixels is shifted over on the conveyor belt so that the next row moves into position to be read, and so on (**Figure 2.24**). The CCD sensor doesn't process the voltage information and convert it to digital data, so additional circuitry in the camera is required to perform those tasks.

**Figure 2.24**  *The data captured by a CCD sensor is read one row at a time, with the data moving along a "conveyor belt" to be read at the output row.*

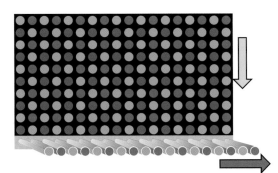

## CMOS

CMOS sensors are named after the process used to create the components—the same process used to manufacture a variety of computer memory components. Like CCD sensors, the CMOS sensors contain an array of pixels that translate light into voltages. Unlike on the CCD sensor, the pixels on a CMOS sensor include additional circuitry for each pixel that converts the voltage into actual digital data. Also, the data from the sensor can be transmitted to the camera's circuitry in parallel, which provides much faster data transfer from the sensor to the camera circuitry (**Figure 2.25**). Because of this significant difference in how the data is processed from the sensor, CMOS sensors are also known as APS sensors (active pixel sensors).

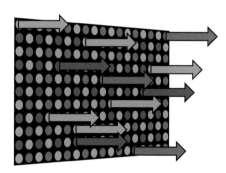

**Figure 2.25** *Data can be read from all pixels on a CMOS sensor at one time, providing a much faster flow of the image data than with a CCD sensor.*

Because circuitry is used at each pixel site in a CMOS sensor, the area available to capture light is reduced for each pixel. To compensate for this, tiny micro lenses are placed over each pixel on CMOS sensors to focus the light and effectively amplify it so that each pixel is able to read more light. Because sensors using CMOS technology are able to integrate several functions on the actual image sensor, they use less power and generate less heat than their CCD counterparts.

## CCD vs. CMOS sensors

The important fact to keep in mind about digital image sensors is that there will always be changes and new advances (not to mention marketing propaganda). The prevalent sensor type in use today may not be the dominant system ten years from now. The design specifications of the camera (size, speed, power consumption, etc.) will also determine which type of sensor is used. Such is the nature of technology. What you need to be concerned

about as a photographer is how a given type of image sensor may affect the performance of the camera and the quality of the images it produces.

In terms of how a different sensor type will affect overall camera performance and image quality, the main issues are power consumption, ISO sensitivity, and noise. CCD sensors consume considerably more power than CMOS sensors, but they also have better light-gathering properties since there is not as much circuitry used at each pixel. This is one reason CCDs are still the primary sensor used in compact cameras; until very recently it has been much more difficult to engineer CMOS sensors in the smaller sizes required in compact cameras. For very small image sensors, the CCD technology generally produces images with less noise. This is likely to change, however, as smaller CMOS sensors continue to improve.

For the larger sensors used in DSLRs, CMOS is the most common sensor type in use today. They are faster, more power efficient, and less expensive to produce, which makes them attractive to camera manufacturers. The larger pixel size on DSLR sensors improves the CMOS light sensitivity, which in turn improves the ISO performance. This, combined with noise reduction processing in the camera, creates excellent low-noise image quality from the current generation of CMOS sensors.

While the differences in image sensors are certainly important from a camera design and engineering perspective, both systems perform their essential function very well, which is to capture a digital image. We do not necessarily advise that you base the entire camera-buying decision entirely on the type of image sensor under the hood. Image quality produced by the camera is definitely an important consideration, but it can also be influenced by other factors beyond the sensor. Rather, you should view the camera system as a whole, including the overall image quality, other camera features, and lens compatibility, and determine if it will serve the type of photography that you want to pursue.

# Other Sensors

CCD and CMOS technology represent the majority of image sensors found in digital cameras, but there are other types of sensors that are used to capture digital images:

- **Fuji Super CCD EXR sensors.** For several years Fuji has produced sensors that have advanced the standard CCD technology. The current incarnation of the Super CCD line is the Super CCD EXR. This sensor uses a three-way capture technology that changes the behavior of how the sensor captures information based on the shooting conditions in the scene. The different capture modes place priority on high resolution, high sensitivity and low noise, and wide dynamic range.

- **Foveon X3 sensor.** While most image sensors record only a single color for each pixel, the Foveon X3 sensor actually reads all three color values at each pixel site by having three layers of sensors, with the top layers allowing the light to pass through to be read by underlying layers, similar to how film works. This helps to provide higher-image quality because interpolation is not needed to produce the final image. The difference is slightly higher detail in the final image. The effect is subtle but visible on close examination. Foveon was acquired by Sigma in 2008 and at this writing, the only consumer digital cameras in production that use the Foveon X3 sensor are made by Sigma.

- **Scanning backs.** Another type of image sensor often used in medium- and large-format digital photography is the scanning back. Unlike the sensors used in most cameras, scanning backs do not record the full scene in a single shot. Rather, they scan the image projected by the lens, recording the information line by line and for each color value. This provides a digital image of exceptional quality but requires that the camera and the subject remain motionless during the exposure, which can last many seconds. This is a compromise that reduces the scanning back's utility for many photographers, but the image quality is compelling for still-life studio work, high-end reproduction, fine-art landscape images, and scientific photography.

# How Sensors Work

Regardless of the specific circuitry involved in a particular type of sensor, the basic function is the same. An array of light-sensitive pixels or photo-sites, representing each pixel in the final image, is exposed to light when the picture is taken. When light hits each of these pixels, an electrical charge builds up proportionate to the intensity and amount of light.

The strength of that electrical charge determines the brightness level for each pixel. More light reaching each pixel results in a stronger signal and a brighter image. If too little light reaches the sensor, the image will be dark.

## Blooming

Each pixel is limited in how much charge it can hold—when the voltage capacity has been reached, the pixel cannot hold any more and extra exposure doesn't mean more image information. When too many photons hit a particular pixel and the electrical charge becomes more than it can handle, the charge starts to overflow into surrounding pixels. This is referred to as *blooming*. Anti-blooming gates in the image sensor can help minimize blooming, but even then it can still occur in very high-contrast areas of the image. Blooming generally appears as a halo or streaking near those contrast edges (**Figure 2.26**).

**Figure 2.26** *Blooming causes a loss of detail in areas where pixels can't store enough data to record the amount of light that reaches them.*

Proper exposure will eliminate most blooming, although in situations with extreme contrast it can still appear. Once a pixel exceeds the limit on the amount of charge it can hold, image detail will be lost in that area of the image.

## Analog to Digital Conversion

The sounds you hear in the real world are analog. That means the sound has an infinite amount of variation, with very smooth transitions and no discrete steps from one tone to another—picture a sound wave. If you convert that sound to a digital form, only a specific number of possible values exist, so the transition from one tone to another won't be as smooth. The analog data is smooth, whereas the digital data, such as music played on a CD, is in discrete steps (**Figure 2.27**).

**Figure 2.27** *Analog data (top) represents an infinite number of possible values with smooth transitions. Digital data (bottom) contains a finite number of possible values and results in transitions that are not as smooth.*

The light coming through the lens to the image sensor is information that's in analog form. For an image, analog means smooth transitions between tones and colors, with an infinite number of possible values within a given range. When represented in a digital form, the image information is represented by specific values. The bit depth of the image file determines how many possible values are stored, but it will always be fewer possible values within a given range when compared to analog data. When the sensor captures the scene projected by the lens, it must convert the analog information into digital values that can be stored in an image file.

Analog to digital (A/D) conversion is the process by which analog signals are converted into discrete digital values. This is one of the most critical steps in the photographic process, determining the amount of detail retained and the overall quality of the image. A/D conversion is the essence of digital photography, translating the image before the lens into digital data.

## Conversion quality

The number of bits used to define the possible digital values is the primary factor that determines the A/D conversion quality. If an 8-bit number is used to define each value as it is processed, a total of 256 (2 to the power of 8) possible values are available. At 10 bit that number increases to 1024, at 12 bit there are 4096 possible values, and at 14 bit there is the potential of 16,384 possible tonal values. When more values are available during the A/D conversion, the transitions between tonal values are smoother and there's more detail from bright highlights to dark shadows. An important detail to remember is that a JPEG file is only capable of storing 8 bits of information (256 tonal levels). To access the high-bit capabilities of your camera, you must be shooting in RAW.

## Noise

Noise in digital images is often compared to film grain in traditional photography. The two share some similarities, but their appearance and causes are quite different.

Film uses light-sensitive silver-halide particles to capture an image, and these particles form the grain structure of the film. This structure is critical to the ability of film to actually record a scene, but it also gives the image a visible texture (**Figure 2.28**). This effect is sometimes considered undesirable, but it can also add to the mood of an image. Film grain is larger in films with higher ISO ratings and is more visible when the image is enlarged.

Digital cameras cause a similar noise problem. However, noise is not caused by the physical structure of the image sensor, but rather by electronic errors or interference. Signal interference from other components within the camera can confuse the voltage information recorded by each pixel. Amplification of the signal, such as when photographing at higher effective ISO settings, also increases the likelihood of noise in the final image. Noise will also be more noticeable in underexposed shots, especially if those shots are lightened with photo-editing software (**Figure 2.29**).

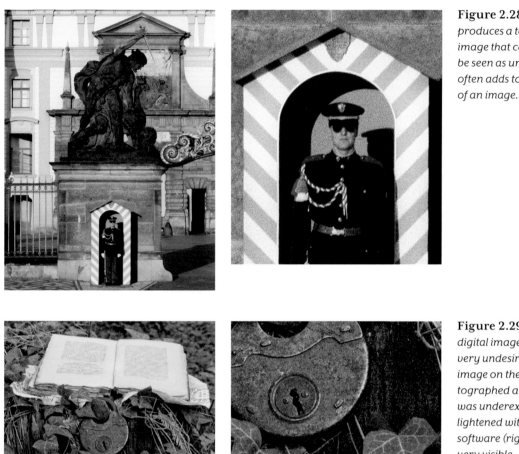

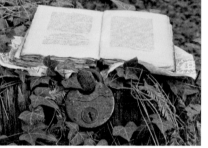

**Figure 2.28** *Film grain produces a texture in the image that can sometimes be seen as undesirable but often adds to the character of an image.*

**Figure 2.29** *Noise in digital images produces a very undesirable result. The image on the left was photographed at ISO 3200 and was underexposed. When lightened with photo-editing software (right), the noise is very visible.*

Some cameras will minimize this noise by checking the noise pattern of the sensor with a *dark capture*. Either before or after a shot, the camera reads the values from the sensors with the shutter closed, creating a "map" that defines the noise being caused by the pixels. This noise can then be subtracted from the final image.

In our experience digital camera noise is much less pleasing than film grain and should be avoided. Working at the lowest ISO setting possible as well as ensuring that your shots are well exposed will make a big difference. Fortunately, the newest professional DSLR cameras are capable of producing very serviceable images, even when rated at 25,000 or higher ISO—they accomplish this by pre-exposing the sensor before the actual image exposure.

# ISO

An ISO (International Standards Organization) rating measures the light sensitivity for film or an image sensor. One of the advantages of digital photography is that you can change the ISO sensitivity of a digital camera from shot to shot. With a film camera you would have to change the roll of film to change the ISO rating.

A given image sensor has a particular sensitivity to light. The actual sensitivity of the sensor can't be changed, so to produce a higher ISO rating, the signal from the pixels must be amplified. This amplification effectively allows the pixels to "see" better under low lighting by adding *electronic gain* to the signal, which bumps up the pixels' response to the low light. This is why you see more noise artifacts in the darker image areas.

When amplifying the signal from the pixels, the chance of noise greatly increases and final image quality decreases. Modern cameras are very good at minimizing noise at high ISO settings, allowing you to photograph images all the way up to the maximum ISO setting with good results. Not all cameras are created equal when it comes to noise, however, and some are not as effective at minimizing noise. Using even moderate ISO settings can result in images that have an unacceptable level of noise in them.

## When to change ISO

To take the cleanest image with the least amount of noise, we recommend using the lowest ISO that your camera is capable of, which, depending on the camera, can be anywhere from 100 to 400 ISO. If you are not able to get a fast enough shutter speed with the low ISO setting under the current lighting conditions, try using a tripod, choosing a larger aperture, or as a last resort increasing the ISO to achieve a faster shutter speed. For example, if you visit a historical site and take a picture outside, you can use the minimum ISO setting (**Figure 2.30**). If you go inside and take pictures of the interior, you will probably need to increase the ISO setting to get a good exposure with the available light (**Figure 2.31**). We'll discuss more about selecting an appropriate ISO setting in Chapter 4, "Digital Photography Foundations."

**Figure 2.30** *A low ISO setting can be used when there is plenty of light, such as outdoors in bright sunlight—and is preferred for the best image quality. This image was made at 100 ISO.*

**Figure 2.31** *In low-light situations, such as interior scenes, a higher ISO can help obtain a picture that might otherwise have been impossible, but it also increases the risk of noise in the image. This photo was a handheld shot at 800 ISO.*

# Physical Size of the Sensor

The number of pixels and the size of those pixels determine the physical size of the image sensor. The higher the resolution and the larger the pixels, the larger the overall sensor must be to fit all those pixels. Sensors on DSLRs are typically larger than those found in compact cameras, which are often quite small. This is a key reason for the image quality difference seen between compact and SLR cameras (**Figure 2.32**).

**Figure 2.32** *The physical size and format of image sensors vary depending on the type of camera.*

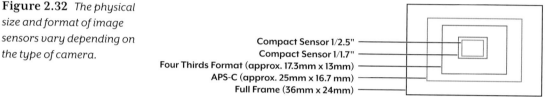

## APS-C format sensors

Many DSLRs today use a sensor format that is based on the size of Kodak's APS (Advanced Photo System) film format (approximately 25.1x16.7mm, though the actual active sensor areas are somewhat less than this). The APS film format never really caught on with professional photographers, and Kodak ceased production of APS cameras in 2004, but its initials live on as a designation for digital camera image sensors. This sensor format is referred to as APS-C (the "C" stands for "classic," a reference to the 3:2 aspect ratio, which is the same as 35mm film). Some manufacturers use other names for it. Nikon, for example, uses the term DX to refer to its APS-C size sensors (the Nikon DX sensor format is approximately 1mm larger than the Canon APS-C format). A variation on APS-C is the APS-H sensor format found in Canon's EOS 1-D Mark IV. At 27.9x18.6mm, this sensor is slightly larger than the standard APS-C format but offers the same 3:2 aspect ratio.

## The Four Thirds system

The Four Thirds system is an entire camera and lens design standard that offers some interesting advantages for cameras that occupy a niche between deluxe point-and-shoot cameras and full-sized DSLRs. Developed by Olympus and Kodak, it created a new class of smaller and lighter DSLR cameras that share a common lens mount and an image sensor with a 4:3 aspect ratio (**Figure 2.33**). The 4:3 aspect ratio is very similar to the 8x10 proportion, as well as the 6x4.5cm and 6x7cm formats used in any medium format cameras. The active area of a Four Thirds sensor is approximately 17.3x13mm, which is between 30–40 percent smaller than the APS-C sensor format but still quite a bit larger than the small sensors used in most compact digital cameras. Many of the cameras that currently use this system feature Live MOS sensors, so named for their ability to provide a live preview on the LCD. Developed by Panasonic, Live MOS sensors are designed to combine the quality of CCD technology with the lower power consumption of CMOS sensors.

**Figure 2.33** *The 4:3 aspect ratio of the Four Thirds format sensor is closer to the classic 8x10 proportion and not as rectangular as the 3:2 aspect ratio used in cameras based on the 35mm format. Photo by John Donich*

Although the sensor area is smaller than the APS-C sensors, a key advantage of the Four Thirds system is that the lenses are designed specifically to produce an image circle that fits the size and aspect ratio of the sensor. This

allows for lenses that are much smaller and lighter than equivalent lenses that are available for DSLRs that use APS-C and full-frame sensors. When compared to the result produced by standard 35mm lenses, the Four Thirds sensor has a focal length multiplier factor of 2, so a 200mm lens on a Four Thirds would provide the same level of magnification as a 400mm lens on a standard SLR camera but in a design that is more compact and much lighter. If you want to shoot with an SLR system but don't want to lug around the weight and bulk associated with these cameras, a Four Thirds camera may be a viable alternative for you to consider (**Figure 2.34**). Lenses designed for the Four Thirds mount can be interchanged with any Four Thirds SLR camera regardless of manufacturer. At the present time, cameras from Olympus, Panasonic, and Leica use this system.

**Figure 2.34** *Cameras and lenses designed for the Four Thirds specification are smaller and lighter than regular DSLRs, making them a good choice for photographers who want the benefits of an SLR along with the convenience and spontaneity of a smaller camera. Photos by John Donich*

### Full-frame sensors

Some DSLRs offer sensors that are the same size as a frame of 35mm film (36x24mm). These are generally referred to as full-frame sensors, though manufacturers may also use other names. Nikon, for example, uses FX to refer to its full-frame sensors. Full-frame sensors are much more expensive to manufacture so the price tag of cameras that feature them will be higher.

Advantages of full-frame sensors include the ability to use larger pixels, which have better light-gathering properties, and in turn lead to images with excellent low-noise characteristics. Full-frame sensors also have no focal length crop factor when used with standard lenses (see "Impact on focal length," next).

## Impact on focal length

Depending on the type of lens being used, the size of the image sensor may impact the effective focal length of the lens. This typically results in an apparent extension of the telephoto aspects of the lens but at the expense of the wide-angle capabilities, which are greatly reduced. Whether this impact is good or bad is a subject of frequent debate. Some people such as bird photographers appreciate the effective extension of the focal length of their lenses, whereas others perceive the changes to focal length as a limitation.

This change in effective focal length occurs when a lens that is designed for a 35mm film or full-frame sensor camera is used on a camera with a smaller sensor. Lenses are designed to focus the light into an image circle of a specific size. The size of that image circle is calibrated to the size of the medium that will record the image. When an image sensor is smaller than what the lens is designed for, it is only recording a portion of the image circle projected by the lens (**Figure 2.35**). Because it is seeing a smaller portion of the overall image circle, the net result is an image that is cropped as though it were captured at a longer focal length.

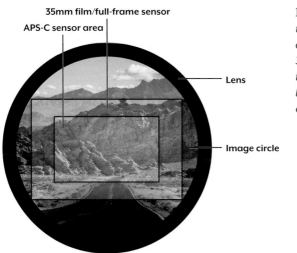

**Figure 2.35** *The sensors used in most digital cameras are smaller than a piece of 35mm film, cropping the image circle projected by the lens and resulting in a longer effective focal length.*

Unfortunately, this also means that wide-angle lenses will behave as though they weren't exactly wide angle but rather more of a "normal" focal length without as much angle of view (**Figure 2.36**).

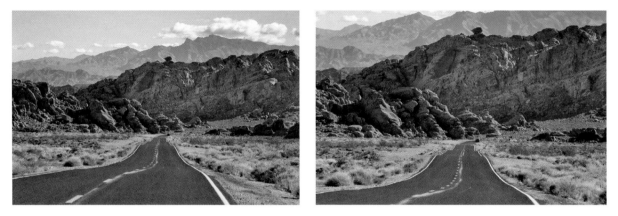

**Figure 2.36**  *A lens of a given focal length used with a 35mm film camera or a DSLR with a full-frame sensor will produce one image (left), whereas the same lens used on a digital camera with a smaller sensor will result in a longer effective focal length (right). While this may be useful for some scenes, it does limit the wide-angle capability of some lenses.*

This behavior is referred to by various terms, such as the crop factor, field-of-view (FOV) crop, or focal length multiplier. For example, a camera may have a crop factor of 1.5x. This means that if you multiply the focal length of a standard lens by 1.5, you will get the effective focal length when the lens is used on that camera.

## Impact on image quality

When a standard lens is used on a camera with an APS-C size sensor, there is actually the potential for improved image quality in terms of sharpness. Lenses are sharpest near their center, with the edges tending to be less sharp. Because an APS-C format image sensor is cropping the final photo from the center of the image circle, it is capturing the image from the sharpest portion of that image circle.

However, just because the sensor is capturing the image from the sharpest area of the lens does not guarantee improved image quality. The actual size of the pixels in the image sensor, as well as other factors, also play a role in the overall image quality.

## Digital lenses

Some lenses are designed to work only with cameras that have APS-C format image sensors. These lenses are often referred to as "digital" lenses since they are designed specifically for use on DSLRs with the smaller APS-C sensors. Because they create a smaller image circle that is designed to fit the smaller image sensor, they do not exhibit the same level of change in apparent focal length as when standard lenses are used on APS-C sensors. While these lenses cannot be used on most full-frame sensor cameras (some camera bodies have special modes that allow them to be used, but the resulting image is a smaller size from only the center of the sensor), they do offer certain advantages, including being smaller and lighter. Most lenses in this class are wide-angle zooms. Nikon lenses for this format sensor are labeled DX, and the Canon equivalent is designated as EF-S.

**NOTE** Although it may be tempting to choose a DSLR camera system because you have 30-year-old lenses from that manufacturer, sadly the lesser quality of the old glass will not do the digital sensor justice (not to mention the lack of auto focus and the electronic interface between the lens and camera body). The new lenses are manufactured to work with digital camera systems and will yield better results.

# Physical Size of Pixels

The size of the individual pixels impacts the light sensitivity of the sensor (also called the ISO) and the ability to maintain fine detail in the image.

## Impact on ISO

As previously explained, the ISO rating system has long been used to provide a benchmark for characterizing the relative sensitivity of film. The higher the ISO, the more light sensitive a film is. That means that higher ISO films require less light to record an image.

With digital cameras, a minimum ISO rating is defined by the sensitivity of the sensor. Larger pixels have more surface area to absorb light, giving them a higher sensitivity, or higher effective ISO. Small pixels are not able to gather as much light, which translates into a lack of sensitivity, or a lower effective ISO.

## Impact on image quality

The size of the individual pixels also affects the final quality of the image. Large pixels produce an image that is coarser, because they are not able to capture as much fine detail; smaller pixels resolve finer detail.

However, smaller isn't always better when it comes to overall quality. Because smaller pixels are also less sensitive, the signal they produce will generally need to be amplified more, resulting in more noise in the final image. The optimal pixel size is a compromise between the ability to photograph fine detail, minimize noise, and work at a reasonable ISO rating.

## Bit Depth

In Chapter 1, "Nuts and Bolts of Digital Imaging," we talked about bit depth as it related to digital image files. In that case, *bit depth* was a measure of how many possible numeric values could be used to describe one pixel, which determined how many tonal and color values could be represented by an image file at various bit depths. That same concept applies to the image sensor and the data it gathers and processes.

The image sensor does not have a strict limit on the range of values from light to dark the way film does. Instead, the limits are defined by the A/D conversion and the way the image data is stored. A higher bit depth in the A/D conversion means the image retains more tonal detail. When that file is written to the memory card (see "Storing the Image" later in this chapter), the bit depth defines how many tonal values the final image retains. For example, a 14-bit A/D conversion would provide 16,384 possible tonal values for each color channel, but an 8-bit JPEG photo can only store 256 of those values. This causes a loss of tonal information in the image and is one of the reasons we highly recommend RAW capture whenever possible (which we'll discuss later in this chapter).

An 8-bit-per-channel capture produces photographic-quality output, but it doesn't provide the overhead required to allow for substantial tonal and color image editing. If you are using a capture mode that supports only 8-bit-per-channel images, it's important that the exposure be as accurate as possible so that only minimal editing is required later to produce the perfect image. We'll show you how to achieve perfect exposures in Chapter 5.

In situations where the lighting is tricky or you otherwise anticipate the need to do considerable editing to optimize the image, we recommend capturing at higher than 8-bit-per-channel bit depth if your camera offers such an option. This is generally only available as a RAW capture mode. Depending on the specifications of the camera's image sensor and the A/D conversion, this high-bit mode allows you to capture images at up to 14 bits per channel.

# Capturing Color

Earlier in this chapter, we commented on the irony that at the moment a digital camera captures the light for a shot, that information is analog (electrical voltage responses) and not even digital. Another irony is that image sensors are color-blind—they can see only relative brightness levels of light. To determine color values, each pixel has a colored filter in front of it, which means it can only see one color. (An exception is the Foveon X3 sensor, which is able to read all three colors for each pixel. See the sidebar, "Other Sensors," earlier in this chapter.)

Because the primary colors for emitted light are red, green, and blue, these are the colors generally used for the filters that are placed over each pixel. Since only one of the three can be placed over each pixel, the filters of different colors are arranged in a pattern so that each captured color is represented adequately in the data to produce the final full-color image for virtually all digital cameras.

## Filter patterns

Most digital cameras use the Bayer pattern for arranging the pixels to capture red, green, and blue. This pattern uses twice as many green pixels as red or blue, because our eyes are more receptive to light frequencies close to green, which falls in the middle of the visible spectrum. If you look at a 4-pixel grid from a sensor that uses the Bayer pattern, the two green pixels would be diagonal from each other, with a red and blue pixel on the opposite diagonal (**Figure 2.37**).

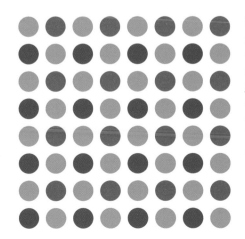

**Figure 2.37** *Because each pixel on an image sensor only records luminosity values for a single color, the filters that define the color seen by each pixel must be arranged in a pattern. This illustration shows the Bayer pattern.*

Although each pixel reads only one color, all three values (red, green, and blue) are required to determine the actual color of each pixel. To determine the other two color values for each pixel, color interpolation is used. In effect, this technique calculates the missing values based on surrounding values for each of the colors. For example, when determining the red and blue values for a green pixel, the values of surrounding red and blue pixels are taken into consideration to calculate the final values (**Figure 2.38**).

**Figure 2.38** *The values captured for the red, green, and blue pixels in an image sensor must be interpolated to produce the final image.*

When the camera is effectively guessing at what the other two color values should be for each pixel, there are bound to be situations where the values are not as accurate as they could be. When this happens, a variety of problems can arise.

Color artifacts appear when areas of the image have inaccurate colors that don't match surrounding pixels. For example, you may have a random green area in a clear blue sky. These artifacts are not the same as noise, because they generally happen with neighboring groups of pixels rather than individual pixels, and they are caused by different factors. Moiré patterns are visible artifacts that appear as herringbone or checker patterns, caused by interference between the pixels and fine textures in the image (**Figure 2.39**). They can occur when a photograph includes such items as finely spaced patterns, barren tree branches, and fine cloth patterns. You can often minimize moiré patterns by moving the camera slightly closer or farther away from the subject, or by using a larger aperture.

**Figure 2.39** *Moiré patterns show as patterns in an image when fine textures interfere with the pixel layout on the image sensor.*

# Dynamic Range

Dynamic range is the ability to capture an image with full tonal detail from bright highlights to dark shadows.

For example, if you're photographing a bride and groom in daylight, a camera with low dynamic range will increase the chances that details in the white dress will be blown out to pure white (**Figure 2.40**). If you photograph the couple using a camera capable of a wider dynamic range, the brightest areas of the wedding dress will maintain detail with excellent texture detail in the tuxedo and dark hair. A high dynamic range can help maintain the detail in both bright highlights and dark shadows. A variety of factors affect the dynamic range of a digital camera, including the sensitivity of the image sensor, the pixel size, the signal to noise ratio, and the quality of the analog to digital conversion.

In-camera processing can also affect the dynamic range of the final image. For example, increasing contrast via the camera settings effectively decreases the overall dynamic range by reducing the number of tonal values present in the image. To maximize the dynamic range, we recommend that you not use any in-camera options to increase image contrast or saturation. If the camera adds contrast or saturation to a file, there is very little you

can do to offset the change. In other words, don't let the camera make such important decisions without your knowledge. In-camera settings such as contrast, brightness, and saturation will only be applied to JPEG files; they do not apply to RAW files. See Chapter 4 for additional information on optimizing your camera settings to capture the best file possible.

**Figure 2.40** *When an image sensor isn't able to capture the full range of tonal values in a scene, detail can be lost in the highlights and shadows. Photo by Wayne R. Palmer / Palmer Multimedia Imaging*

When a scene contains a broader tonal range than your camera is able to capture, all hope is not lost. We'll show you how to combine multiple exposures to retain information for more tonal values than your camera sensor is capable of in Chapter 6.

# Storing the Image

Once the image sensor has recorded the scene projected by the lens, the camera processes the information gathered by each pixel. It performs a variety of tasks to optimize the image based on the current camera settings. This information then needs to be stored for future use. That means the data must be saved to a digital memory card and written in a file format that can be opened later for editing and printing.

## Digital Media

The storage capacity of digital media has come a long way over the past several years, with capacities of several gigabytes being the norm. Some cards can even hold up to 64 GB. To put this into some historical perspective, consider the first consumer digital camera, the Apple Quick Take 100, which was released in 1994 and boasted an internal memory capacity of 1 MB!

Different cameras use different types of digital media. Some cameras even provide the option to use more than one type of card, providing additional flexibility. The media type should be one of the factors you consider when choosing a digital camera, and there are advantages and disadvantages to each type. All of the current digital media options are solid-state devices (meaning no moving parts) that use nonvolatile flash memory for storage. That eliminates the risk of moving parts wearing out, but the components used in these media cards still have a limited life. The average life expectancy is measured in hundreds of thousands of cycles, so for most photographers they will remain reliable until replaced by a new, higher-capacity card.

- **CompactFlash.** The CompactFlash format is currently used by many DSLR cameras (**Figure 2.41**).

  There are actually two types of CompactFlash cards. Type I cards are the most common and measure 36 x 43 x 3.3mm. Type II cards are the same length and width but are slightly thicker (5mm). Both types of CompactFlash cards can be used in a Type II slot, but only Type I cards can be used in a Type I slot. Most cameras that use CompactFlash cards offer a Type II slot for maximum compatibility. The Type II format was originally used for microdrives—actual miniature hard drives that have been surpassed by flash memory and are no longer in mainstream use

for digital cameras. The data is transferred to the CompactFlash card through a series of pins.

CompactFlash cards tend to be one of the least expensive options on a per-megabyte basis. At this writing they range in capacity from 1 GB at the low end to 64 GB at the high end. Although they are larger than other types of digital memory, at about the size of a book of matches, their dimensions still can be considered petite when compared to most of your camera gear. We feel that the slightly larger physical size of CF cards is actually a plus, since they are not as easy to misplace as their more miniature cousins!

- **Secure Digital (SD) / MultiMedia (MM) cards.** These very small cards (24 x 32 x 2.1mm) are some of the most widely used types of digital memory, especially in compact cameras, though they are also used by some DSLRs. Standard SD storage capacities range up to 2 GB and SDHC (high capacity) can accommodate up to 32 GB. The main difference between Secure Digital and the MultiMedia format is that SD cards have a tiny switch that can protect the data on the card from accidental erasure. In addition to digital cameras, may other types of digital devices, such as cell phones and PDAs, can accept this type of memory (**Figure 2.42**).

- **Memory Stick.** The Memory Stick format was developed by Sony and is currently used only in Sony digital cameras (**Figure 2.43**). The original memory stick was about the size of a stick of gum, but there are now a variety of different formats and form factors, including the Memory Stick Duo line, which is slightly smaller than an SD card. The Memory Stick format is currently available in capacities up to 32 GB.

**Figure 2.41** *CompactFlash card.*     **Figure 2.42**  *Secure Digital (SD) card.*     **Figure 2.43**  *Sony Memory Stick card.*

## Size and speed do matter

The two most important issues to consider when comparing various digital media are capacity and speed. We don't consider price to be an important consideration because when it comes to our photographs, we just feel that quality is more important than price. The prices of these cards are always decreasing, and in general they are quite affordable. We focus on capacity, speed, and the reputation of the manufacturer to deliver products of the highest quality.

## Storage capacity

The larger the capacity of the card you purchase, the more pictures you'll be able to take on that card before you need to delete or download files, or change to another card. Using compression settings when taking pictures helps to make the most of the available space on a card, but you pay a price in image quality.

When you head out on a photography excursion, make sure you have enough storage capacity for the images you will take. By using a laptop or portable storage device (we'll talk about those in Chapter 3, "Essential Accessories"), you can maximize the use of your digital cards by clearing them off and reusing them to take more pictures.

The simple approach to the issue of storage is to purchase the largest capacity card available (or several of them). For a more practical approach, consider how many images can be stored on a digital card of a given size. Your camera manual likely has a chart showing how many images can be taken with a specific card capacity using the various capture settings. You can use this as a basis for deciding how much capacity will work for you in a given situation. Just keep in mind that a higher-capacity card also means the potential to lose more images if a card fails (or if the card falls out of your camera bag).

## Write speed

The speed of the digital media determines how fast files can be written to the card. But the camera using the card has to be able to take advantage of that speed. If you are using a camera that can't write data very fast, don't pay more for a card with high-performance capabilities. Photojournalist and digital photography consultant Rob Galbraith maintains a database of

CompactFlash card performance with different cameras on his Web site at www.robgalbraith.com.

Your style of photography also impacts the importance of the speed of your digital media cards. Digital cameras include a buffer that stores images before they are written to the memory card. The size of this buffer determines how many pictures you can take before the camera needs to stop and write data to the card.

When your photography involves taking many pictures in rapid succession—such as with wildlife, sports, or other fast action—you can quickly fill up the buffer in the camera with a sequence of images (**Figure 2.44**). Once you fill the buffer in the camera, you have to wait for the images to be written to the memory card before you can continue taking more pictures. In those situations, you'll want to be sure your digital media can easily write data as fast as the camera can send it.

**Figure 2.44** *When you need to capture a series of action shots in sequence, a digital camera with a large and fast buffer and speedy digital media cards are critical to shoot high-speed motion successfully.*

## File Formats

When the camera writes the image data to the memory card, it must do so in a file format that can be read later. This is generally a standard image file format, but it can also be a file format that stores the raw capture data. We

discussed file formats in Chapter 1, but let's look at how the various options affect your need for higher-capacity digital media.

Most digital cameras offer the same file formats as photographs: JPEG and, on some cameras, RAW. The final file size will vary based on the camera settings and sensor resolution, so for comparison purposes we'll reference the files produced by a 12.7 megapixel DSLR. With a pixel dimension of 4368x2912, a full-color RGB image from this camera would take up 36.5 MB if saved in the TIFF or PSD format. Fortunately, even the largest file formats utilized by digital cameras are much smaller than a full-sized image.

## JPEG

The JPEG file format is a standard image file format that can be opened by virtually any image-viewing or -editing software. It also uses compression that reduces the file size. While the compression is *lossy*, meaning it causes a loss of information and quality in the image, the results are very good for prints that don't require significant interpolation when minimal compression is applied.

The option to use minimal compression, which results in the best quality possible for a JPEG image, is generally referred to as Fine or Best mode in the camera menu. If you're going to capture in JPEG mode to minimize the file size, be sure to use the highest quality setting. It still takes advantage of JPEG compression to considerably reduce the size of the file—down to an average of about 5 MB for a 12.7 megapixel camera. This translates to approximately 820 images on a 4 GB memory card.

## RAW

For many people the JPEG file format is a good choice for general photography. If you're a photographer who is interested in capturing and retaining the highest image quality, however, then the RAW format is the best choice.

The RAW file format allows you to exercise the maximum amount of control over your image. When you use this option, the camera stores the raw data gathered by the image sensor, with virtually no in-camera processing of the image data. This file retains the full bit depth the camera is able to process, which is generally 14 bits per channel rather than the 8 bits per channel available with the JPEG file format.

The primary disadvantage of the RAW format is workflow. Because it isn't a standard image file format, you need to first convert the file from RAW to a file format your image-editing software recognizes before you can start working with it (**Figure 2.45**). We'll talk more about these workflow issues and processing RAW files in Chapter 8.

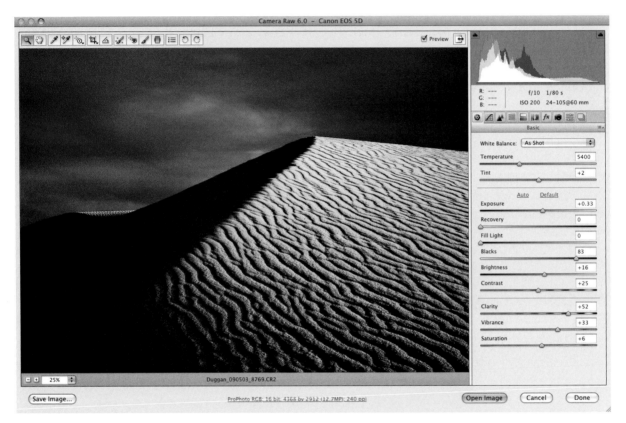

**Figure 2.45** *Capturing in RAW mode adds the step of converting your files to a standard image format, but it provides the maximum amount of tonal information in your images, as well as control over that information, to ensure the best quality.*

Remember that most image sensors record only one of the three primary colors for each pixel, with the other two values for each pixel determined through interpolation. Because the RAW file represents this partial color interpretation of the scene rather than the final interpolated color values, only one-third of the final pixel values actually need to be stored. This results in

a smaller file size than would normally be required. However, because lossy compression is not applied, the file is still larger than a JPEG file.

With the 12.7 megapixel camera mentioned earlier, that translates into an average file size of about 12.5 MB. Though this is much larger than a JPEG file, you can still fit approximately 327 images on a 4 GB card. That's less than half the number of images that you could store if you were using JPEG, but JPEG does not allow you to access the high-bit data that is captured by your camera's image sensor. We feel that the larger file size when shooting in RAW is a relatively small price to pay to obtain a file that offers the best possible quality and tonal range.

## Video

This book is mainly about using digital cameras for still photography, but video is becoming more of a factor in digital still cameras. Compact cameras have been capable of recording short video clips for many years, and recent developments have brought excellent HD video capabilities to the latest DSLRs. The video quality offered by compact cameras certainly does not replace a quality dedicated video camera, but many photographers are creating impressive video documentaries using the HD video capabilities in DSLRs. We'll take a look at the video aspect of digital cameras in Chapter 6. In terms of how video affects storage capacity, the main thing to remember is that these clips, even low-resolution ones, require a lot of storage capacity, so if you are planning to shoot video clips on your camera, you'll want to use the highest capacity card.

# Flash

Many photographic situations require the use of flash to produce a well-exposed image. It can be used as a primary light source in dark environments, a way to freeze action, or as a fill flash to soften harsh lighting and open up shadowed areas.

Fortunately, nearly every digital camera worth considering includes a built-in flash (the exceptions are the "professional" DSLRs that lack the convenient pop-up flash). Many digital cameras also offer the ability to use accessory flashes by including a standard hot-shoe mount so you can take advantage of the wide range of flash units available on the market.

# Built-in Flash

The built-in flash on the vast majority of digital cameras is certainly a convenient option, because we often need more light than the ambient conditions provide. However, that built-in flash is a feature we love to hate.

Part of the problem is a lack of control. Most digital cameras don't offer the ability to fine-tune the strength of the flash, so you must rely on the camera to decide how much light is enough.

The lack of control over flash strength and position becomes a serious problem as the distance to the subject is reduced. When the subject is very close, the flash has a tendency to overpower the scene, resulting in a blown-out image (**Figure 2.46**).

**Figure 2.46**  *The built-in flash on many compact digital cameras doesn't offer adequate control and is likely to produce an overexposed image when the flash is used too closely to the subject of the image.*

Because the flash is often positioned very close to the lens, red eye can also be a common problem with on-camera flash. We'll talk about how to avoid red eye in the first place in Chapter 5.

# Off-camera Flash

The use of accessory flashes gives you much more control over the exposure of the image and the effect of the lighting. Some compact and deluxe point-and-shoot digital cameras feature a hot-shoe connection for external flashes, a standard feature on SLR cameras for many years (**Figure 2.47**).

**Figure 2.47** *A hot-shoe attachment on a digital camera enables you to use a wide variety of accessory flashes that ensure the most flexibility.*

Using a separate flash unit allows you greater control over the power output and the positioning of the light. On many flashes, the head can be adjusted to bounce the light off of the ceiling or a reflector, creating a softer, more natural light (**Figure 2.48**). With some flashes you can even use additional flashes that are positioned off camera and controlled via infrared or wireless units. This enables you to use one flash as a main light source and one or more as fill lights or backlights. The options are limited only by your imagination.

**Figure 2.48** *By using accessory flashes, you can control the lighting to produce better results. This image was made by adjusting the head of the flash to bounce the light off the ceiling as well as a small white fill card.*

We'll cover accessory flash units as well as reflectors and other light modifiers in Chapter 3 and the use of them in Chapter 5.

# Choosing a Digital Camera

Choosing the right digital camera requires an understanding of the different kinds of cameras available, the type of photography you want to do, and a grasp of both photographic and digital terms. If you're new to digital photography, you might be experiencing information overload and feel like you're facing a vast and impenetrable wilderness of new terminology and concepts. In this section we'll look at some important details to consider when choosing a digital camera and organize the decision-making process so that it's less mysterious and intimidating.

## Types of Digital Cameras

Several different categories of cameras are available. The one you choose will depend on a number of factors including price, features, available accessories, and last, but not least, what kind of photographs you want to create with it. Understanding the different types of digital cameras and the kind of photography they are capable of will help you choose the best camera for your needs.

At first glance, the most obvious difference in the family of digital cameras is size. Cameras range from the size of a credit card (and even smaller if you consider cheapie keychain cams) to big and heavy professional level SLRs and medium format cameras. There is a lot of overlap in terms of features and image-making capability, and we'll examine the possibilities offered by each group. For the purpose of simplicity, we'll begin with four primary groups of digital cameras: compact cameras, bridge cameras, DSLRs, and professional DSLRs.

### Compact cameras

Compact digital cameras are the most common and the way that most people experience digital photography. A wide range of features are available, and the small size makes them easy to carry most anywhere, an important factor that can extend your enjoyment of photography to places and situations where you don't want to lug a heavy DSLR.

In terms of image-making capabilities, these cameras range from simple entry-level models to more sophisticated deluxe point-and-shoot models.

Good compact digital cameras offer sensors that deliver from 8 to 10 megapixels of information, as well as a host of features like zoom lenses, a large LCD screen, close-up capability, and special scene modes (shooting modes designed for specific types of photography, such as fireworks or night photos). Most compact cameras even feature video capabilities for shooting short video clips.

Cameras in this category are a great good choice for novice photographers looking to take snapshots of family and friends, post photos on a personal Web site, or make prints for the family album. They're also a solid choice for anyone who is interested in exploring the fun and creativity of digital photography without being weighed down with too much gear (**Figure 2.49**).

**Figure 2.49** *Entry-level digital cameras don't offer the technical controls of more expensive cameras, but they are capable of producing images of excellent quality, and the small size makes them very convenient.*

The primary disadvantage of a compact digital camera is that it doesn't leave room for growth if your casual interest in photography deepens to more of a passion (or obsession!). Some of the important features that most cameras in this class lack are the ability to shoot in RAW, to manually adjust exposure settings, and to use common accessories such as filters or external flash.

## Bridge cameras

A bridge camera serves as a "bridge" between compact and deluxe point-and-shoot cameras and the more sophisticated DSLRs with interchangeable lens capability. Bridge cameras offer all the common features found in

smaller and less expensive cameras, but also feature more flexibility and control, including the very important capability of shooting in RAW. Many cameras also include a hot-shoe or PC cord connection so you can use external flashes to better control the lighting in a scene. Although these cameras include built-in zoom lenses, they typically do not offer the ability to change lenses—an important feature for serious amateurs and professionals. Exceptions are cameras that use the Four Thirds lens system described earlier in this chapter.

A bridge camera is an excellent choice for those who have more than a beginner's interest in and commitment to photography but still want a camera that is not too large and offers a full range of manual and automatic features. These are excellent cameras for those who are not professional photographers but who still want excellent image quality (**Figure 2.50**).

**Figure 2.50**  *Deluxe point-and-shoot digital cameras bridge the gap between compacts and DSLRs. Their advanced features make them a great choice for the serious amateur or even the professional photographer who wants a more compact camera to carry along.*

## DSLRs

For many photographers, the SLR experience is integral to how they learned photography. Flexibility and control are the hallmarks of the DSLR, which makes it the perfect camera for serious amateurs and professionals who need high resolution, full manual exposure control, multiple focus points, and metering modes, and the ability to use a wide array of interchangeable lenses and accessory flash units. Many DSLRs now provide the capability to record HD video (**Figure 2.51**).

**Figure 2.51** *The advanced features, excellent image quality, and technical control offered by DSLRs make them an excellent choice for those who want a full-featured camera system with the ability to use a wide variety of lenses.*

The primary disadvantage of a DSLR is size and weight (and, depending on your budget, cost). Though there are some fairly petite and lightweight DSLRs on the market, they are considerably larger and heavier than deluxe point-and-shoot and bridge cameras. There are times when this can be an impediment to creative photography simply because you may not feel like carrying the larger camera (or the additional gear associated with it), or it may not be appropriate for situations where you want to have a more low-key presence. This is one reason most photographers who use a DSLR also carry a smaller digital camera.

Although DSLRs are the primary tool of most professional photographers, there are some image makers who need even more capability. If you routinely need to make very large prints or shoot bursts of multiple shots at high shutter speeds, or if you spend considerable time photographing in rugged terrain and extreme weather, you might want to opt for a professional DSLR.

## Professional DSLRs

A professional DSLR camera meets the needs of the working professional photographer, with excellent image quality and superior control over all aspects of the camera. These cameras feature the highest resolutions possible in a DSLR—currently 12 to 24 megapixels.

Many professional DSLRs also feature a full-frame image sensor that's the same size as 35mm film. As mentioned earlier, with a full-frame sensor

there's no effective focal length multiplier to worry about. That means lenses will produce the same results many photographers have grown accustomed to from years working with 35mm SLR cameras (**Figure 2.52**).

**Figure 2.52** *The professional DSLR camera offers all the advanced features of regular DSLRs, plus a more rugged construction designed to meet the demanding requirements of professional photographers. Photo by Jack Reznicki*

Professional DSLR cameras typically feature a more rugged and robust construction, better sealing against weather and moisture, and are more likely to survive the routine "punishment" that professional photographers inflict on their gear.

The primary drawbacks to these cameras are their high price compared with that of other DSLRs, as well as the fact that they are considerably larger and heavier than most DSLRs.

## Medium format digital cameras, digital backs, and 4x5 scanning backs

When you require the highest resolution possible, a medium-format digital camera or a medium- or large-format digital back offers a solution. Medium format is a term that harkens back to the film era and refers to the size of the film that was originally used by cameras such as those from Hasselblad and Mamiya. Both companies currently offer digital versions of their cameras, and many studio and commercial photographers, as well as fine-art landscape photographers, rely on these cameras for the high quality and large file sizes they produce.

A *digital back* is a device that attaches to a medium- or large-format film camera body in place of a film back and allows you to use that camera to take

digital images (**Figure** 2.53). Current medium-format digital cameras and digital backs for that camera format offer resolutions ranging from 16 megapixels to the present high end of 60 megapixels. The high-end version of the Better Light 4x5 *scanning back* (often referred to as a digital view camera) scans a whopping 144 megapixels for maximum files size of 397 MB (794 MB as a 16-bit file). These higher-resolution digital backs produce huge files that allow you to produce very large prints of exceptional quality (**Figure** 2.54).

**Figure 2.53** *A digital back attaches to a standard medium-format camera, allowing you to photograph digitally with a camera body designed for film photography.*

**Figure 2.54** *The Better Light 4x5 scanning back is the digital equivalent of a large format view camera. Here, landscape photographer Stephen Johnson (sjphoto.com) captures a scene in Antarctica (note the laptop computer platform attached to the tripod). Photo by Jeff Schewe*

Of course, all those pixels come at a price. At this writing, medium-format digital systems start at around $10,000 and go up to $38,000. And a digital back doesn't include the camera body or lenses required to actually take photographs. The 4x5 scanning backs from Better Light range from $6500 all the way to $23,000 (that's just the scanning back; you still have to provide the view camera, lenses, and tripod). Clearly, digital backs and scanning backs are reserved for the serious professional photographer who demands the very best image quality and resolution for the largest prints (**Figure 2.56**).

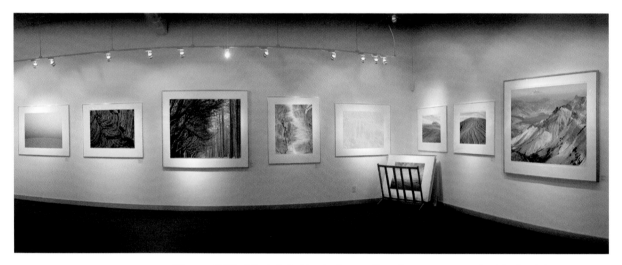

**Figure 2.56** *What digital backs for medium-format cameras lack in flexibility they make up for in resolution. They allow you to capture large, incredibly detailed image files from which you can produce exceptionally large prints. Above is the gallery for Stephen Johnson Photography, displaying prints from his Better Light scanning back camera. Photo by Stephen Johnson*

# How to Decide on a Camera

Making a decision about what type of camera is right for you is really a process of elimination and involves taking a look at a number of factors. By identifying the type of photography you will be doing and the camera features and physical characteristics that are important to you, you can narrow the list and hone in on a camera that will meet your needs and, ideally, leave room for technical and creative growth. Also, keep in mind that a single camera may not satisfy all your photographic requirements. For some, the perfect camera may actually be two cameras: a full-featured DSLR and a compact camera that can be easily carried in a pocket or purse.

# iPhone Photography

Some cell phones have doubled as low-resolution cameras for many years, but it has only been recently that the quality of the images has improved to the point where people can actually make pretty decent images with them. The one product that has ushered in a true renaissance in creative cell phone photography is Apple's iPhone. The convenience of having it with you all the time, plus the ability to take a 5-megapixel image makes it great for casual snapshots or simply documenting all sorts of things that you encounter in your daily life. Photographer Chase Jarvis celebrates the with-you-all-the-time aspect of iPhone photography in his book *The Best Camera Is the One That's With You* (New Riders, 2009). Jarvis has also created the Best Camera app that allows iPhone users to creatively edit and share their photos via Twitter, Facebook, and email, and to a Web site focused on iPhone photographs (thebestcamera.com).

Numerous iPhone applications allow you to edit and enhance the image right on the phone. Fine-art photographer Dan Burkholder (danburkholder.com) creates visually rich imagery using his iPhone and a selection of apps that he has installed on it. For many of his iPhone photos he works on them on location moments after he has taken the image, bringing the practice of "en plein air" painting to digital photography. The ability to take many images, combined with an app that stitches them together, allows him to create panoramic prints up to 15 inches wide (**Figure 2.55**).

**Figure 2.55** *"Tree and Pond in Fall" by Dan Burkholder. A panorama created from fifteen photos that were photographed, stitched together and processed on an iPhone. Photo by Dan Burkholder*

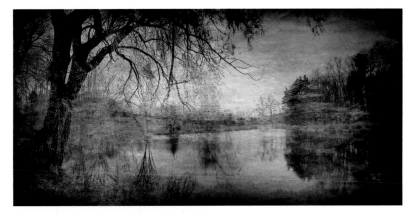

# Road Map to a Camera Purchase

Our map is based on our experiences with digital cameras and those of colleagues who also have made the journey many times. We break down the decision-making process into the following ten issues:

1. What are you photographing?

2. What will you do with the pictures?

3. What are your immediate photographic needs?

4. How much photographic and computer experience do you have?

5. What are the "must have" features and qualities you need in a digital camera?

6. What can you afford to spend?

7. Evaluate and compare the top three cameras on your wish list.

8. Make your decision and commit to it.

# What Are You Photographing?

Before you buy a camera, you need to consider what you want to do with it to help you narrow down your choices. Will you be photographing birthday parties, family vacations, and Little League games? Will you be using it for your business to create photos for a catalog or newsletter, or to document laboratory research, or for product development? Are you a photojournalist who travels the world in search of groundbreaking images for news and stock agencies? Are you a wildlife, landscape, or fine-art photographer interested in creating prints for gallery and museum exhibitions (**Figure 2.57**)? Or are you a person who is passionate about photography and just wants a cool camera that will enhance your exploration of the creative image?

Each of these purposes suggests a different group of cameras; knowing how you will use the camera streamlines the list of potential models you have to choose from.

Photo by John Shaw / johnshawphoto.co

**Figure 2.57** *The type of photography you do will greatly influence the type of camera that is best suited for your needs.*

## What Will You Do with the Pictures?

Determining how you will use the photos, your intended audience, and your own exacting standards are fundamental to selecting the right camera. Do you need to email family photos and make small, snapshot-sized prints for a scrapbook or photo album? Will your images be viewed only on Web sites, or will they be published in newspapers and magazines? Do you want to make large exhibition prints that require quality and sharpness on par with traditional photographs? Does the camera require special capabilities, such as close focusing for macro work or extended exposure times for night photography (**Figure 2.58**)?

**Figure 2.58** *Macro and night photography both require cameras (and lenses) with special characteristics.*

# Assess Your Immediate Photographic Needs

Because digital cameras get better every year, with improved image quality and reductions in price, it makes sense to take stock of your immediate needs. We suggest purchasing a camera that not only fulfills those needs, but also gives you room to grow as you learn more about digital photography. Buying a camera that is "one size larger" than you need now ensures you will be happier with it longer.

# How Much Photography and Computer Experience Do You Have?

Once you've figured out what kind of photographs you'll be taking and what you'll do with them, it's time to take stock of your experience level. Have you been photographing regularly for several years, with different cameras, or are you upgrading from a point-and-shoot film camera? Do you understand all the photo jargon, computer terminology, and technical concepts, or do you just want to be able to take great pictures without having to worry about too many details? Your comfort level with the basic principles of photography, not to mention your familiarity with computers, should factor into your camera-buying decision.

# Determine the Minimum Requirements

Before you begin looking at cameras and comparing prices, you need to figure out what your camera's minimum features have to be to satisfy your photographic needs. This is not the pie-in-the-sky approach to cool features that you may be craving, but rather a serious look at the "must haves" that you need to get the job done. Following are some other factors to consider.

### Features

- **Image sensor.** How many megapixels do you need? Do you require a full-frame sensor? Does the camera have the ability to also shoot HD video?
- **Lens options.** Is the lens fixed or a built-in zoom ? How much zoom do you require? Is there macro capability (**Figure 2.59**)? Can you use filters or accessory lens attachments for close-up or wide-angle shots? Do you require a camera with interchangeable lens capability?

**Figure 2.59** *Many compact cameras offer scene modes that allow for macro photography.*

- **Exposure options.** Is fully automatic enough, or do you need semi-automatic and full manual control?

## Performance

- **Response times.** How quickly does the camera respond when you turn it on and/or press the shutter button? How fast can you take a second shot?

- **Battery life and cost.** How many shots can you take on a single charge? What is the average time required to recharge a battery? How expensive are the batteries?

- **Continuous shooting.** Do you need to shoot images in rapid succession? How many frames per second can the camera deliver? What is the maximum shutter speed?

## Attributes

- **Size.** Are a compact profile and low weight important (**Figure 2.60**)?

**Figure 2.60**  *If a compact size is important to you, you'll find a wide range of small, pocket-sized cameras on the market.*

- **Ease of use.** Is it well designed? Does the layout of the controls and menus make sense?

- **Ergonomics.** Does it fit comfortably in your hands? Is it easy to hold on to? Can your eye locate the viewfinder quickly?

# The Informed Photographer

When you know how a digital camera works and the different types of cameras that are on the market, you'll be able to decide which type of camera is the right one for the kind of photography you want to do. Once you've found the perfect camera, knowing how the camera creates images can help you avoid common problems and take better pictures. This chapter has given you an understanding of how digital cameras work, as well as an overview of the various types of digital cameras that are currently available. In the next chapter we'll look at some essential accessories that can extend the functionality of your camera as well as your own enjoyment of photography.

# Essential Accessories

<span style="font-size:3em; color:gray;">3</span>

Today's digital cameras come with so many shooting modes and built-in exposure options that you might feel there are more than enough features in the camera to keep you busy for a long time. By adding other items to your photo gear, however, you can extend the functionality of your camera, especially for specialized photographic situations such as close-up or night photography.

In this chapter, we'll look at some indispensable accessories to expand and improve your photographic capabilities. These include everything from spare batteries and extra memory cards to additional lenses and flash accessories.

## Your Camera Bag

Let's start by taking time to look at that vital item that all photographers need—a bag to carry their gear in. The bag you choose should be large enough to carry the gear you have now, with a little extra room to accommodate any new equipment that you think you might be getting soon. If you have more than one camera or your gear requirements vary for different assignments, you'll likely end up with more than one bag. This usually starts as you outgrow your first bag but decide to keep it for those times when you want to travel light. A smaller bag certainly makes sense for those occasions when you don't need to lug all your gear with you.

We like camera bags that let us quickly and easily access all the essential items. This is known as "working out of the bag," and having a bag that

facilitates this practice makes photography in the field more efficient and more enjoyable. The bag should also have a separate area for extra batteries and memory cards that closes securely. Filters and stepping rings should be easily accessible, and a place for a portable storage drive is also nice to have.

Also, since you'll be carrying it on your shoulder for extended periods of time, it needs to be comfortable with an easily adjustable padded strap. To get a sense of how it will fit you, we suggest trying it on with all your gear stowed inside. This means bringing your existing camera bag to the store and loading it into the new bag. Don't worry about what the sales staff thinks; if you shop at a quality camera store, the staff is probably used to seeing photographers do this. The bottom line is that there's no way to accurately judge how the bag will feel on your shoulder or against your hip until you load it up and try it out.

If a traditional bag is not what you need, consider a modular belt system such as those by Think Tank Photo (www.thinktankphoto.com). With the addition of different-sized accessory pouches, you can customize the basic, padded belt for the configuration that works best for you. The practical functionality they provide may be perfect for certain types of assignments.

# The Camera Manual

An important item to carry in your camera bag is that often forgotten, sometimes lost, inevitably dog-eared instruction manual. Unless you purchased a used camera that didn't have one, all cameras come with a manual. Familiarizing yourself with it is one of the most overlooked yet most important parts of using your camera to its full potential. Although it may be human nature to pick up a new gadget and attempt to figure it out as you go, you should take the time to read the camera manual from cover to cover.

Ideally, you should sit down with the camera at your side as you read the manual so you can try out the features it covers and familiarize yourself with the controls. Even after you have read (not skimmed) the manual, until you know your camera's features inside and out, we recommend keeping it in your camera bag so you can easily refer to it if you need to.

Another great way to have your camera manual handy is to download the PDF version of your camera's user manual, which is searchable, allowing you

to find what you're looking for very quickly. For iPhone or iPad users, also download "Good Reader PDF," which lets you easily read large-sized PDFs on small screens.

# More Batteries

When you're out taking pictures, nothing is quite as frustrating as seeing the low battery indicator come on. To avoid this unpleasant situation, you need to have plenty of extra battery power at your disposal. Extra battery power is arguably one of the most important accessories, together with extra memory cards, that you can buy for your camera.

Most digital cameras use proprietary rechargeable lithium-ion batteries that are made by the manufacturer and usually come with the camera, along with a charging unit. Smaller compact and entry-level cameras may use disposable or rechargeable AA-size batteries. The ability to use a rechargeable battery is a very important feature because it means fewer batteries will end up in landfills, and that's good news for everyone.

## Rechargeable Batteries

Rechargeable batteries are more cost-effective over the long run than their disposable counterparts. We usually have at least two fully charged extra batteries in the camera bag in case the first battery runs out of power. When using the proprietary lithium-ion batteries that power most DSLRs, in most situations one or two will easily get us through a full day of photography. Depending on the camera, the type of battery it uses, the age of the battery, and how you use the camera, your mileage may vary.

Different types of rechargeable batteries are available that you may be able to use with your camera. Your camera's design will usually determine the type of battery you choose, so be sure to consult the manual before you buy. Here's a rundown of the most common types:

- **Lithium-ion.** This is the most common type of battery used for the proprietary batteries that come with many digital cameras. Recharging times are generally about 60 to 90 minutes to fully charge an exhausted battery. Lithium-ion batteries are good only for approximately 500 charge/discharge cycles, after which they must be replaced. If you find

**TIP** In the evening, be sure to charge all your batteries so they're ready for the next day. If you will be photographing in an area where access to electrical power will be infrequent, take more batteries with you to keep going between recharging opportunities.

 **TIP**  Many manufacturers are using the same model of batteries, which means that often a more reasonably priced generic model may be available at consumer electronic stores. For example, Katrin's Canon S-90 and PhaseOne P25+ both accept generic batteries found at Best Buy. Of course the battery needs to match the manufacturers' specifications!

that older batteries are not holding a charge for as long as they used to, it's a sign that the battery is nearing the end of its useful life and should be replaced. These batteries are relatively expensive, so you may experience some sticker shock when you go to buy a few backup batteries. As of this writing, prices for rechargeable lithium-ion batteries vary depending on the type of camera and range between $25 and $110. Batteries for smaller cameras typically can be found for under $50, and those for DSLRs typically start at about $45, with batteries for the large professional DSLRs costing the most. Offsetting the initial cost of lithium-ion batteries is that you will get lots of use out of them.

For cameras that use AA-size batteries, the two types of rechargeable batteries are NiMH and NiCd.

- **NiMH.** Nickel metal hydride batteries are probably the most popular choice for rechargeable batteries used in many consumer-level digital cameras. They come in the standard AA size and can be found at any good electronics store (**Figure 3.1**). The main drawback to NiMH batteries is that they do not provide the capacity of lithium-ion, and if your camera has a lot of features to power, they won't last as long. They are also notorious for poor performance in cold weather. NiMH batteries are good for approximately 500 charge/discharge cycles. Although the power charge that NiMH batteries can hold is not as much as with lithium-ion, they are more robust than equivalent NiCd batteries. Contrary to popular belief, NiMH batteries can also be affected by the "memory" issues that are more common in NiCd batteries (see the next bullet item). The effect is not as pronounced, but it can still be an issue.

**Figure 3.1** *If your compact camera uses AA-size batteries, using rechargeable NiMH batteries will save you a lot of money in the long run.*

- **NiCd.** Pronounced "Ni-Cad," nickel cadmium batteries are the most common type of rechargeable battery, though not necessarily for digital camera use. Although they are good for an average of 700 charge/discharge cycles, they do not hold as much power as NiMH or lithium-ion batteries, so they're not a great choice for a full-featured camera. Additionally, a phenomenon known as *memory effect* means that they should be fully discharged before they can be recharged. If a NiCd battery is charged before it has been fully exhausted, it will reduce the maximum capacity of subsequent charges. The effect is cumulative and becomes greater the more the battery is improperly recharged, hence the term *memory effect*. We recommend that you use either lithium-ion (the first choice if available for your camera) or NiMH batteries.

## Battery Grips

Many SLRs have optional accessory battery grips that provide extra battery life. A battery grip typically holds two of the camera's standard proprietary battery packs and is used in place of the camera's regular battery. The grip effectively doubles the amount of shooting time available to you. Although the extra power is great, the only potential downside is that you'll be adding extra weight and bulk to what is probably already a substantial camera body. If those factors are already an issue or if your camera bag is too small to accommodate an extra grip, you may want to check out a camera that's already equipped with a battery grip to see if it will be too heavy for you. Most makes of battery grips have a duplicate shutter release button, which makes taking vertical shots more convenient. Prices for extra battery grips vary, but an informal survey at the time of this writing shows you can expect to pay between $115 and $250.

## High-capacity Batteries

For those times when you need a lot of power for a long period of time, you might consider a high-capacity battery such as those sold by Digital Camera Battery (www.digitalcamerabattery.com) and Quantum Instruments (www.qtm.com). These high-capacity power packs are external batteries that can be worn at the waist, either attached to a belt or dropped into a pant pocket. A cord connects the battery to your camera's AC power connector. Although

these are certainly bulkier and heavier than the internal battery your camera normally uses, they are very useful for event photography where you need to be onsite taking numerous shots for a long period of time. An additional benefit for photographers using an external flash is that the same battery can power both the camera and the flash.

## Charging the Batteries

Even if you don't plan on taking pictures the next day, get into the habit of recharging the batteries after you return from a photo shoot. Fortunately, most proprietary batteries that come with cameras will fully recharge in 60 to 90 minutes. Having your batteries charged whenever you pick up the camera and head out the door means you'll be ready for any photographic opportunity.

> **NOTE** Many batteries will continue to discharge a low electrical current even when the camera is turned off. This can lead to excessive discharging and could potentially shorten the overall life of the battery. If you won't be using the camera for several days, it's best to remove the battery and store it with the protective cover on (if it has one).

Always use a separate charging unit, and do not recharge the battery while it's in the camera using the camera's AC power cord. If you're using the camera as a charging unit, it means you're not using the camera to take pictures. It's effectively out of service until the battery comes back to life. Another benefit to using a charger is that most units will display an indicator light to let you know what the level of the charge is.

### Voltage adapters

If you're planning an overseas trip, be sure to determine if the voltage specifications of your battery charger are compatible with the country you're traveling to. Different countries have different standards for the standard power voltage and for the outlet interface that you plug into. Most camera battery chargers (and laptop computers) are designed to work with an input of 100 to 240 volts, which means they can be used in many countries with no voltage adapters. You will have to invest in plug adapters, however, to be able to plug into the electrical outlets in another country. Any good travel or consumer electronics shop should be able to provide you with a selection of voltage adapters for either individual countries or specific regions.

Power adapters are also useful for tapping into your car battery via the cigarette lighter or accessory power outlet. If you'll be on an extended trip, away from the conveniences of electrical wall outlets, your car's battery may be your only option for recharging camera batteries or running a laptop for downloading and archiving purposes.

## Solar battery chargers

If you will be venturing far from regular access to the electrical power grid or the cigarette lighter in a car, you may have to take more drastic measures and look to the sun for recharging your camera or laptop batteries. Portable solar panels have been around for a long time, but now that batteries are such a vital part of digital cameras, photographers are using these panels when an assignment takes them to remote areas of the earth for extended periods of time. Although bright, sunny conditions might seem to be a necessity for recharging batteries via the sun, many current solar chargers have amorphous solar cells, which can gather power even in overcast or indirect light. Advancements in solar technology have also made panels lightweight and flexible, and some can even be rolled up to fit into a convenient carrying tube (**Figure 3.2**). Portable solar panels let you recharge your camera batteries and your laptop computer, even if your quest for a great photo takes you far from the power grid.

**Figure 3.2**  *The SolarRoll 14 by Brunton (brunton.com) is waterproof, features amorphous solar cells for effective low-light performance, has a maximum output of 14 watts (15.4 volts), rolls up to fit in a tube, and is ideally suited for backpacking. Photo courtesy of Brunton*

# More Storage

After extra batteries, additional storage space is probably the most important accessory you should invest in. Although you can delete bad shots as you go, the time will come when you've erased all the mediocre images you can but you're still running out of room on the memory card. Like the flashing low-battery indicator, a rapidly filling memory card with no spares available is sure to put a damper on your enjoyment of digital photography, especially when you have a lot more that you want to photograph.

## Memory Cards

Whatever type of removable storage your camera uses, buying additional memory cards is always a good idea. Fortunately, the storage capacities for memory cards is increasing, and the costs keep coming down, so finding a card that represents the right balance of storage space and price should be no problem. The number of cards you need to keep on hand will depend on the capacity of the card, the file sizes that your camera generates, and how many photos you're likely to take in a given outing. With JPEG, of course, you'll be able to fit more photos on a memory card than if you're shooting RAW, though RAW will give you greater post-capture flexibility in terms of improving the image.

Although memory cards that hold several gigabytes are more expensive, they may be better suited to your needs (depending on the type of photography you do) since they allow you to shoot for longer periods of time without changing cards. With larger-megapixel cameras, larger-capacity cards also make more sense. However, we don't feel comfortable using a single high-capacity card because we don't want to place all our photo eggs in one basket should the card fail. Although we've never had a problem with any of our CompactFlash cards, losing a 32 GB card full of images would really hurt. We'd rather cover 32 GB of storage with several 8 or 16 GB cards.

You should stick with known brands when purchasing extra memory cards. Your images are important, so paying a little more for an established name brand and a proven product is another way of ensuring that your photos will be safe until you can download them and create a backup copy. Plus, you should consider the speed of the media. The design of the internal controller

of some cards means that higher-end cameras can write data to them much faster than to other cards. Although the camera may process the data at the same rate no matter what card is used, at some point it has to hand the data off to the storage media, and the speed with which the media can accept the data will determine when the camera's buffer has emptied enough to be ready for the next shot. Using a cheap but slow card can add a lot of extra time to the write speeds that your camera can handle. Saving an extra $20 or $30 on an unknown maker of memory cards is not worth it if the card receives data at a glacial pace.

## Dedicated Card Readers

Although dedicated card readers are not storage cards, they enable you to easily download images onto a computer, and we can't recommend them enough. Instead of hooking the camera up to the computer to download your photos, which ties up the camera and uses camera battery power, you plug in a card reader to quickly download your photos from the memory card to your computer. At around $20 to $30, they're inexpensive enough that you can have one for your desktop machine and another for your laptop bag (**Figure 3.3**).

**Figure 3.3** *A card reader is an essential accessory that lets you download images without tying up your camera or using precious camera battery power. With a card reader and a laptop, you can work on your new images anywhere, even at 35,000 feet.*

# Pocket Drives/Multimedia Viewers

As the size of digital camera files has increased over the years, so has the need for compact, battery-powered external storage devices. Portable hard drives and multimedia photo viewers that can download images directly from a memory card are currently available in sizes up to 160 GB. These compact devices are an excellent solution if you need to be away from a computer and still want to take a lot of photos. You can insert your memory card directly into the drive (or via a USB card reader) and copy the photos with the push of a button. Many even feature an LCD screen for reviewing images (**Figure 3.4**). Since that feature consumes precious battery power that should be reserved for running the disk drive, however, we recommend saving your reviewing activities for when you're back at the hotel and hooked up to a power cord.

**Figure 3.4**  *The Epson P-7000 Multimedia Photo Viewer holds 160 GB and also features a 4-inch color screen for reviewing your images. Camera memory cards can be inserted directly into the P-7000 for downloading images. Photo by Jack Reznicki*

Having a portable drive or multimedia viewer in your camera bag, or back at the hotel if you're traveling light, means you can take as many photos as you want and simply download them to the drive at night. Even if you have plenty of memory cards in your bag so you don't have to reformat the cards, downloading the photos to a portable drive creates an all-important backup copy of the images.

# The Importance of a Tripod

For those times when you don't have to be concerned with split-second mobility and traveling ultra light, using a tripod is an excellent way to improve the sharpness and composition of your images. Trying to handhold a shot with a shutter speed below 1/30 of a second is a gamble at best. With longer focal-length lenses, the minimum shutter speed is even higher. The slower exposure will record even the slightest camera movement caused by unsteady hands or the downward motion of your finger pressing the shutter button. A tripod is also necessary for night photography or images where you need increased depth of field (**Figure 3.5**). To render a scene with a great deal in focus from foreground to background, you need to stop down the lens and use a smaller aperture. A smaller aperture produces a slower shutter speed, which may make a handheld shot impossible. Lenses that feature vibration reduction or image stabilization do give you a bit of an edge and allow for handheld exposures at slower shutter speeds, but in certain situations, a tripod is an essential accessory.

**Figure 3.5** *A tripod is mandatory for night photography, where long exposures are commonplace. For this photograph, which combines sharp areas with the motion of a Ferris wheel, the shutter was open for 20 seconds.*

A tripod provides you with a steady platform from which to survey the scene and compose your image. With the camera immobilized, long exposures that are sharply focused are possible. Using a tripod frees your hands from holding the camera, which helps you make your shots more consistent and gives you the time to refine the images. In our experience, slowing down is one of the best ways to take better photographs. When you take a more measured and deliberate approach to the scene you're photographing, you can consider it from different angles and decide if your initial composition is really the best one. Framing the image is a more meditative interaction with the elements you see in the viewfinder and less of a quick grab shot. If you use a tripod all day, even when there's plenty of light to easily handhold the camera, you will take fewer shots, but you may find that they are better images.

## Choosing the Right Tripod for Your Camera

There are almost as many different types of tripods as there are cameras, and it's important to choose one that will stabilize your camera and also offer smooth movements, easy controls, and a decent weight. Although none of us likes to lug around heavy photo equipment all the time, the weight of a tripod is important in ways other than how it feels slung over your shoulder. Since a tripod's main purpose is to steady the camera during long exposures, it needs to possess enough mass to counterbalance the weight of the camera and lens that are mounted on top of it. A feather-light compact aluminum tripod may feel great when you heft it in the camera store, but it's not the best choice if you have a sturdy magnesium alloy body DSLR with a big zoom lens. Additionally, the farther you extend the legs to raise the tripod higher, the less stable it will become. And if you expect to be photographing outdoors a lot, factors such as high winds can also thwart your efforts to record a sharp photo.

If you're using a lightweight, compact digital camera, a lightweight tripod might be sufficient. But buying a model that is slightly larger and heavier than you need may also be a good strategy. Since compact digital cameras are so small and lightweight, even when mounted on a light tripod, the very act of pressing the shutter button could transmit motion vibrations through the camera during the exposure.

For larger cameras, a sturdier tripod is better, especially if you'll be using zoom lenses. With a telephoto focal length, vibration is more noticeable when focusing on distance scenes, and you'll need a sturdy tripod to provide the most stable camera platform you can (**Figure 3.6**). Additional accessories such as an electronic cable release are also recommended for longer exposures in such conditions.

**Figure 3.6** *A heavy tripod is an asset when shooting in extremely windy conditions such as for this shot of the Suisun Bay Reserve Fleet near San Francisco. High winds at this overlook area are common, and earlier shots taken with a lighter-weight tripod were not as sharp as the ones made with this heavier tripod.*

In the end, you may find yourself with more than one tripod—each one being used for different situations and different cameras. Seán has four types of tripods that he uses regularly with his cameras: a small, lightweight aluminum tripod, perfect for compact cameras; two sizes of Gorillapods, a flexible tripod that can be wrapped around tree branches or other unlikely places for a unique vantage point (**Figure 3.7**); a medium-sized tripod he can adjust to eye level or down very low; and a large, heavier aluminum tripod for those times when he needs extra height and real stability. Also, keep in mind that you do not need to replace a good tripod every year or two. Katrin has a tripod that her husband John purchased 30 years ago; it was the best then, and it still is an excellent piece of equipment.

**TIP** When using a tripod, position it so that the third leg is facing away from you, not between your legs, where you're more likely to stumble over it.

**Figure 3.7**  *The Joby Gorillapod (joby.com) comes in different sizes and allows for unique possibilities for camera placement.*

## Aluminum vs. carbon fiber

The two primary materials used in the manufacture of tripods are aluminum and carbon fiber. Although the former is more common and less expensive, a carbon fiber tripod is the way to go if you'll be doing your photography far from the convenience of a parked car. The carbon fiber material is up to 30 percent lighter than aluminum and just as sturdy and durable. As an additional bonus, the legs of a carbon fiber tripod do not get as cold as those on an aluminum tripod—something to consider if your work takes you into cold climates. If you're a backpacker who enjoys hiking into remote areas in search of the photographic muse, a carbon fiber tripod is a good choice. If you've never shopped for one before, however, be prepared for sticker shock. Good carbon fiber tripods usually start at around $400 for the legs only; a head is extra. If you do spend a lot of time hauling all your gear, the investment may be well worth it. Gitzo, Manfrotto, and Induro each offer a carbon fiber line in addition to their standard aluminum tripods.

## Tripod heads

The tripod head is the part of the tripod that actually supports the camera and allows you to move it into position to compose your shot. Two types of tripod heads are commonly used today: those that are controlled by three levers or knobs, and ballheads that control movement via a ball that rotates in a socket. Both move the camera into various positions and keep it immobile while the exposure is made. Because both types provide this basic function, which one you choose is largely a matter of personal preference. For studio-based photography, the control handles on a standard head are often better suited to the more methodical approach that is common with still life and tabletop photography. Some photographers don't like handle-based heads because the handles can get in the way of your face. Some heads come with optional knobs instead of handles, which solves the problem and lets you get close to the tripod without endangering your eyes (**Figure 3.8**). If you've never used one before, a ballhead is initially harder to work with; once you become used to it, many photographers feel that it offers faster movement and allows a faster response to changing situations, such as wildlife photography. Among ballheads, the Bl made by Arca-Swiss is highly regarded as the ballhead by which all others, even the newer Arca Swiss Zl, are measured. Expect to pay $300 to $400 for a good ballhead (**Figure 3.9**).

**Figure 3.8** *This Manfrotto tripod head is a 3-axis, pan-tilt type of tripod head that features low-profile knobs instead of long handles.*

**Figure 3.9** *The Arca-Swiss Bl ballhead is a favorite of landscape photographers. Although not cheap (expect to pay around $400 just for the head), it's beautifully designed and machined, and is well regarded for its reliability and superb functionality.*

## Quick releases

Most tripods sold today come with some sort of quick release system. A quick release consists of two parts: a plate that mounts on the base of the camera and a clamp on top of the tripod head that you attach the quick release plate to. Quick releases are definitely an improvement over the old way of mounting a camera on a tripod, which meant tightening a screw with a knurled knob. Although the quick release system is found on nearly every tripod, each manufacturer has its own implementation, and not all quick releases are created equal. Here are a few things to check:

- **Plate stability.** Does the plate on the bottom of the camera feel solid and secure when you tighten it down? Does the screw mount allow for side-to-side movement of the plate if the tension loosens? If so, this could cause problems with the front of the camera not always being aligned with the front of the plate clamp.

- **Clamp stability.** When the camera is mounted on the tripod, do the clamp and plate hold the camera firmly in place with no movement? As you examine how the clamp holds the plate in place, does it appear solid and reliable? Your camera is an expensive investment, and all that holds it to the tripod is this piece of hardware. You need to be able to trust it.

- **Clamp release mechanism.** How does the clamp open and close? Is it easy or difficult? Does it hurt your hands when you open the clamp? Is there a lever that opens the clamp, and does the lever stick out so that it might catch on clothing or a camera strap and accidentally open?

## Custom quick releases

A few companies have recognized the deficiencies in some of the quick release systems offered by the major tripod manufacturers and have answered the requests of photographers by creating custom release plates that are designed to fit a particular camera body. The primary advantage of these custom plates is that, unlike most standard quick release plates, they feature a raised edge that hugs the front and back side of the camera base and prevents any side-to-side motion of the plate once it has been tightened in place. Since each plate is manufactured to fit a specific camera body exactly, the plate becomes an integral part of the camera rather than something that is screwed on using only the power of your thumbs.

## L-plates

Extending the concept of the quick release, an L-plate is a wonderful accessory for SLRs that we highly recommend. If you use a tripod a lot, this is definitely worth checking out. The L-plate features a quick release plate on the bottom of the camera and also on the side. This permits you to quickly switch from a horizontal to a vertical orientation without having to adjust the tripod head. With a standard tripod mount, switching camera orientation is less than ideal because it can drastically change your composition. Worse than that, the camera is laterally displaced and its new position is such that its center of gravity and all of its weight is no longer above the center point of the tripod. If you have a heavy camera and lens combination, this can be a cause for concern, since the tripod is unbalanced and more likely to tip over.

Since the L-plate allows you to change the orientation of the camera without moving the tripod head, your framing and viewpoint will be much closer to your original composition (**Figure 3.10**). The tripod head stays in an upright position, which means that the camera's weight is evenly and securely distributed over the center part of the tripod for maximum stability.

**NOTE** A tripod head that's good for a film camera may not work with a digital camera, because it may block access to the memory card door or a battery door. If you plan to use the camera in a studio tethered to a computer workstation, check to make sure that the ports for interface cords are accessible.

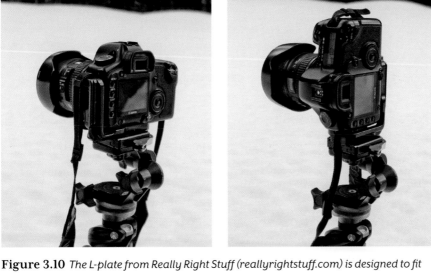

**Figure 3.10** *The L-plate from Really Right Stuff (reallyrightstuff.com) is designed to fit the Arca-Swiss ballhead (adapters are available to fit other tripod heads) and is custom made for specific cameras, which ensures a perfect fit to the base of the camera. Dual quick release plates mean that you can quickly change from a horizontal to a vertical orientation without moving the tripod head.*

## Monopods

For those situations when a tripod isn't feasible, either due to space constraints or the need to move around quickly, a monopod can bridge the gap between mobility and stability. Essentially a single, telescoping tripod leg, monopods are used regularly by sports photographers, wildlife photographers, and photojournalists. The single leg support is enough to steady the camera for use with slower shutter speeds or when photographing with long, telephoto lenses. Monopods can also help you position the camera into places that you may not be able to get into yourself.

## Remote Release and Mirror Lockup

Even though you have the camera mounted on a tripod, you can still transmit motion and vibration to the camera by the simple act of pressing the shutter release button. With a slow shutter speed and a telephoto lens, it's even more likely that the vibration will create an image that is lacking critical sharpness. To maximize the chances for a clear and sharp photo, use an electronic *remote release* to trigger the shutter when using a tripod. If you don't have one, you can use the camera's self-timer feature to take the picture without touching the camera at the instant the shutter opens.

*Mirror lockup* is not an accessory you can buy, but if your camera has this feature, it's one more thing you can do to ensure that a tripod-mounted shot is sharp. On an SLR camera, when you press the shutter button, the mirror that provides you with a view through the lens flips up out of the way to allow the light to pass through the lens and onto the image sensor. In some situations, even when the camera is mounted on a tripod, the motion of the mirror flipping out of the way can cause subtle vibrations in the camera body that can compromise image sharpness. The problem is especially noticeable with slower shutter speeds and when using lightweight tripods that do not adequately stabilize that camera.

A camera with mirror lockup capability allows you to raise the mirror before the shot is taken and lock it out of the way. With the mirror stabilized and motionless, you can make the exposure (ideally with a remote release) secure in the knowledge that you have done everything humanly possible to capture a sharp photograph. On Canon EOS DSLRs, mirror lockup is typically selected from the camera's custom function menu. With this enabled, you can focus, compose, and set the exposure, and when you press the shutter button, the mirror will flip out of the way (thus blacking out the viewfinder) and remain locked out of the light path. If you wait a few seconds for any vibration to stop, you then have up to 30 seconds to press the shutter button a second time to take the photo. Mirror lockup is another feature that we regard as essential on any pro digital camera (the mirror lockup functionality is also accessible on cameras that raise the mirror for Live View mode).

# More Light

As we pointed out earlier, photography is all about capturing the nuances of how light interacts with the scene in front of you. In an ideal world, you'd always have all the light you need, but this is not the case. Plus, there are some very interesting things you can do when you bring your own light to the party. Most digital cameras come with a built-in flash to cover basic illumination needs, but the light that it produces is less than subtle, and you're limited in what you can do with it. All in all, we're not wild about the built-in flashes that come with most cameras, and in most cases, we use them only as a last resort if we can't find a way to get the shot using existing light. If you're serious about using artificial light sources in your photography, you'll soon be considering adding a little extra light to your camera bag.

## External Flash Options

Whether or not you can even use an external flash unit with your camera will depend on the camera. To synchronize a flash with the camera's exposure, your camera needs to have either a hot-shoe mounting bracket on the top of the camera or a sync-cord outlet, which is usually found on the side of the camera. The hot shoe lets you mount an external flash directly to the top of the camera (**Figure 3.11**), and the sync-cord outlet lets you connect a flash mounted off the camera by means of a synchronization cord. There are other ways to sync an off-camera flash with your camera even if it doesn't have either of those options. We'll get to those in the next section.

**Figure 3.11** *The higher the flash, the lower it throws the shadows of your subjects down behind them instead of outlining them. It also provides additional opportunities for modifying the light by adding bounce cards or diffusers.*

External flashes come in a variety of sizes, and they offer different power output and a variety of features for controlling the light. The main advantage that is common to all external flashes is that they raise the light source higher above the camera, which solves the red-eye problem that is common with built-in flashes that are closer to the lens. If the flash is designed to work with your camera, you should also be able to take advantage of TTL (through the lens) metering features on your camera. With many modern flashes, the camera uses a pre-flash that evaluates the scene and sets a proper exposure and output level for the flash. Modern flashes are great at balancing their output to the ambient light levels in a scene or to the background light (**Figures 3.12** and **3.13**).

As flashes get bigger and more expensive, they typically offer the ability to swivel the flash head so that the light can be bounced off the ceiling or other reflector surfaces to soften the quality of the light and extend coverage over a broader area. Other advantages of using the more advanced flash units are that flash power output can be more precisely controlled, and wireless features are also available to control other flash units for background or fill lights. Auto zoom is also a common feature: The flash head can zoom within a specified range to fit the coverage angle of the flash to the focal length being used by the camera. A typical flash zoom range is 24mm to 105mm.

**Figure 3.12**  *Using a full-featured flash mounted on top of the camera opens up new possibilities for using flash creatively and subtly. In the first image of the man, no flash was used. In the second, the flash was balanced to the background ambient light. The depth of field between subject and background is the same, and the soft quality of the early evening light in the background has been preserved. Photos by Lindsay Silverman*

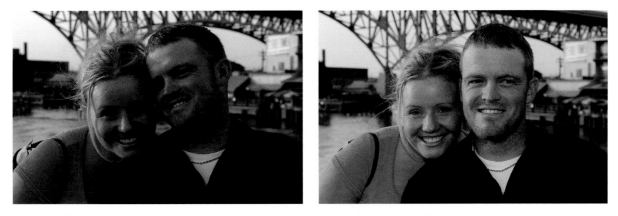

**Figure 3.13** *For this portrait of the couple, just a hint of flash was used to pop in a little twinkle in the eyes and open up the shadows. The warm sunset tones are still evident on the side of their faces. Photos by Lindsay Silverman*

## Off-camera flash

Using the flash in a location other than the top of the camera lets you direct light with more control. One of the drawbacks to a full frontal approach to flash photography is that the light often flattens out the contours of shapes in the photo, causing them to lose depth and dimensionality. By moving the flash slightly off to the side, either by using a special bracket or simply by holding it up with your hand, the flash is still part of the overall camera setup, but its output will not be as harsh and you can direct the light from different angles (**Figure 3.14**).

**Figure 3.14** *By removing the flash from the camera, either by using a sync cord, as shown here, or an infrared transmitter, you gain more creative lighting options. Flash brackets are available so the camera and flash can be carried as a single unit.*

An off-camera flash is also effective for adding fill lighting to outdoor shots, even when the primary light source is daylight. Fill lighting can also be used to reduce excessive contrast, and using a flash for this purpose is the only solution when reflector panels are not an option. With a long enough sync cord or wireless transmitter, you can even mount the flash on a separate tripod or light stand for more control over directional lighting. With this setup, the flash is used more like a studio flash. Unlike a studio flash, however, which has its own power pack for near-instantaneous recycle times, you'll still have to wait a few seconds for your flash to recharge after a shot.

## Sync cables and slaves

If you want to explore the wonderful world of off-camera flash, a sync cable is the least expensive way to do it. Sync cables come in a range of lengths, from the very short, designed for flash brackets where the flash is still close to the camera, to cords that are many feet in length.

*Slaves* are small sensors that trigger a flash unit when another nearby flash goes off. They are used in situations where you have a main flash at the camera position and want to use another flash for fill lighting. Slaves usually have a hot-shoe mount for attaching the secondary flash and can then be mounted on a tripod or a light stand. Using slaves is one way to get around the need for a sync cord, and they're helpful in places where flash placement may exceed the length of the sync cords in your camera bag.

## Wireless flash control

Infrared (IR) and wireless technology lets you position a flash or multiple flashes farther away from the camera without the hassle of running sync cables all over the place.

**Infrared transmitters**. A transmitter device is mounted to the camera's hot shoe and can trigger other IR-compatible flashes placed nearby (**Figure 3.15**). The Canon ST-E2 transmitter, for example, can trigger an unlimited number of remote Canon flashes in two separate groups with full TTL and flash ratio control. The effective range of the IR transmitter varies depending on the individual unit, the physical arrangement of the location (i.e., whether there are walls or corners involved), and whether you are indoors or outdoors; common working distances range anywhere from 25 to 50 feet. An IR unit can also serve as an autofocus assist when working in extreme low-light conditions.

**Figure 3.15** *An IR wireless transmitter mounted to the camera lets you control a flash that is positioned off camera, allowing for a great deal of flexibility when lighting a scene. Multiple flashes, including power output, can even be controlled via the IR transmitter.*

**Radio transmitters.** Radio wireless units consist of a radio transmitter mounted on the camera and a receiver unit that is attached to the remote flash (**Figure 3.16**). Radio signals are more effective at reaching flashes that are farther away from the camera and are not as affected by the presence of objects between the camera and the receiver. Ranges vary depending on the individual unit and the flash it is used with, as well as other factors, including the orientation of the antenna. But common working distances for TTL triggering range anywhere from 30 to 700 feet, and 30 to 1200 feet for basic non-TTL triggering. As the old saying goes, your mileage may vary.

**Figure 3.16** *A Pocket Wizard (pocketwizard.com) radio transmitter mounted to a Canon 580EX II Speedlite. Photo by Jack Reznicki*

## Flash brackets

*Flash brackets* attach to either the camera or the lens (for telephoto lenses that have a collared tripod mount) and allow the flash to be mounted off the camera's hot shoe. If you want to explore using off-camera flash with the camera and flash connected as a single unit, you'll need to get one of these. The most common type is a bracket that mounts to the base of the camera with the tripod mount, extends an arm out to one side, and then provides a vertical arm for mounting the flash. Wedding and event photographers use this type of bracket to minimize red eye and provide a more flattering light source. It also puts the shadow down behind the subject. If you use a quick release plate on your camera for a tripod, you will probably have to remove it to mount a flash bracket.

Another flash bracket that's used by wildlife, sports, and macro photographers attaches to the collared tripod mount on a telephoto lens. This is used for the same reasons you would use any off-camera fill flash: contrast reduction, adding catch lights to eyes on overcast days, and brightening colors. By mounting it to the tripod collar on the lens, the flash stays with the lens and the camera can be used in either a vertical or a horizontal position. Lens-mounted flash brackets from Really Right Stuff (www.reallyrightstuff.com) feature a tilting hot shoe for further control over the direction of the light—a feature that comes in handy for close-up photography (**Figure 3.17**).

**Figure 3.17** *The B85 manufactured by Really Right Stuff is designed to attach to the collared tripod mount found on some longer lenses. It provides more flexibility for using flash with telephoto lenses. The mounting plate for the flash unit can be swiveled downward for more directional control, making it also ideal for macro work.*

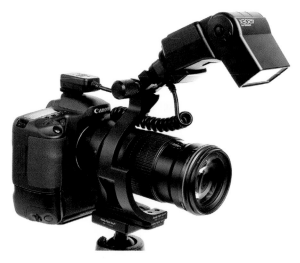

## Ring lights

For close-up, macro photography of very small objects, standard flashes can't illuminate the area the camera is focusing on. (*Macro photography* uses special lenses, called macro lenses, to get extremely close-up shots.) For these situations, a ring-light flash is essential. *Ring lights* fit onto the end of the lens and provide flash coverage from a circular flash tube. Since the flash originates right above the subject matter of the macro shot, the scene is given bright and even illumination (**Figure 3.18**). Canon also makes a flash unit with two small flash heads that mount at the front of the lens and can be positioned independently (**Figure 3.19**). The power output of each flash can be separately controlled to add more dimensional lighting to macro compositions. With different output levels, for example, you can easily configure a "main" and a "fill" light for even the smallest of subjects. That's the kind of control we appreciate!

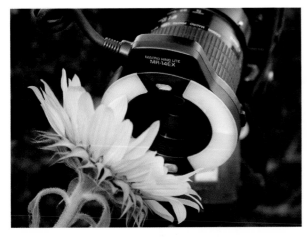

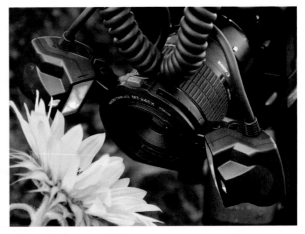

**Figure 3.18** *A Canon MR-14EX Macro Ring Lite is designed specifically for close-up photography. It uses twin tubes that can be fired together or independently.*

**Figure 3.19** *Canon makes the MT-24EX Macro Twin Lite for photographers who want the most control possible over flash lighting for macro photography.*

## Diffusers, bounce cards, reflectors, and colored gels

We often complain about the harsh quality of the light from the standard pop-up flashes on most cameras. Even with an external flash unit, the illumination, while much better than the small on-camera flashes, can still have a hard edge to it. Fortunately, adding a softer touch is relatively easy to do,

either through a little do-it-yourself ingenuity or with the following types of commercially manufactured products:

- **Diffusers.** These can be purchased at photo supply stores or online and usually consist of a white translucent fabric or plastic cover that slips over the head of the flash unit (**Figure 3.20**). The light from the flash passes through the diffusion material and is significantly softened by the time it reaches the subject. Small mini–soft boxes can also be purchased for flashes that have a silver reflective interior and a large white translucent front panel for diffusing the light. The Lightsphere Collapsible by Gary Fong (garyfonginc.com) is an innovative diffuser made of a soft plastic that can be easily collapsed into a smaller profile for a better fit in your camera bag (**Figure 3.21**). It creates a large and diffuse light source that provides a much softer and more flattering light than direct flash. Accessory domes are available for the Lightsphere to customize the color and hardness of the light.

**Figure 3.20** *Simple flash diffusers are inexpensive and serve to soften and spread the hard light from a flash unit.*

**Figure 3.21** *High-end flash diffusers such as the Lightsphere Collapsible provide additional ways to modify flash output to create a soft and flattering light source.*

- **Bounce cards.** Another way to soften the light from a flash is to use a bounce card. These are white cards that are angled forward and attach to the vertically raised flash head in a variety of ways, from rubber bands to adhesive materials, such as Velcro. When the flash goes off, the light bounces off the angled white surface of the card and then continues its journey down to the main subject of the photo. The bounce off the card creates a larger surface area of light with a softer quality. Since the light is coming from slightly above the subjects, the harsh, in-your-face floodlight quality of most on-camera flash is avoided. Although you can purchase bounce cards at camera stores, they're also one of the easiest accessories that you can make yourself, using a large white index card or a custom cut piece of poster board and a sturdy rubber band (**Figure 3.22**). Many flashes also have a built-in bounce card that can be pulled out from the flash head.

**Figure 3.22** *Flash accessories don't have to be expensive. You can rig a very effective bounce card with a rubber band and a piece of white poster board.*

- **Reflectors.** Reflectors can be purchased in a variety of shapes and sizes, and can be used to reflect any type of light, flash or natural light. Some of the most convenient are circular and can be collapsed to a much smaller size and slipped into a carrying case that can be clipped onto your belt or the bottom of your camera bag. Some reflectors also come with reversible covers that allow a single reflector to be configured for different purposes. The reversible cover on the Photoflex MultiDisc provides four different types of reflective surfaces, as well as a diffuser to soften the light (**Figure 3.23**).

**Figure 3.23** *The MultiDisc 5-n'-1 circular reflector by Photoflex (www.photoflex. com) combines a basic diffuser (shown here) along with a multisurface reflector cover offering four different types of reflective fabric.*

Other reflectors feature lightweight yet rigid frames and provide a much larger surface area for reflecting the light. The California Sunbounce system (sunbounce.com) uses aluminum frames that can be easily assembled and combined with different reflecting, light-reducing, or light-absorbing screens. These are more commonly used either with light stands and boom supports or held by a trusty assistant (**Figure 3.24**).

- **Colored gels.** The light from a flash is balanced for a color temperature that approximates daylight (5500K). Even so, it can appear cool and unflattering at times, particularly with fair-skinned people. To warm it up, you can use colored gel material that's available from camera stores or professional photo supply shops. This material usually comes in large sheets and can be found in standard photo filter ratings, such as 81A, which is a common warming filter. All you have to do is cut a piece to size so it can wrap over your flash head and be secured in place with a rubber band. If you're using a custom white balance, note that you'll need to set the white balance without the colored gel over the flash, or the warming effect (or whatever effect you're trying to achieve) will be cancelled out. You could also use the electronic flash white balance preset. We cover white balance issues, as well as working with electronic flash, in Chapter 5, "Seeing the Light."

**NOTE** Diffusers, bounce cards, and colored gels decrease the amount of light the flash effectively produces. When used with automatic TTL modes, the camera and flash will often automatically calculate the best exposure for the light produced through the diffusion modifier or bounce, but we recommend you test any flash modifiers before taking important pictures, for example, at your best friend's wedding.

# Lenses

If you have a DSLR camera that accepts interchangeable lenses, buying a new lens could certainly be considered an essential accessory. A new lens can give you a fresh viewpoint. In addition to the obvious choices of zooms and *prime*

(fixed focal length) lenses, there are other factors to consider with DSLRs in determining the right lens for the type of images you want to create.

For more compact cameras that don't have interchangeable lenses, you can often buy accessory lenses that attach to the front of the existing, fixed lens. Although these do not offer high optical quality in comparison to DSLR lenses, they do allow you to explore different fields of view, from telephoto and magnified close-ups to the super wide angle of a fish-eye lens.

## Focal-length Magnification

In Chapter 2, "How a Digital Camera Works," we explained that most DSLRs that accept interchangeable lenses have image sensors that are smaller than a frame of 35mm film, although most lenses being used on DSLRs were designed to project an image that fills a 35mm frame. This results in the image circle that is formed by the lens being cropped to the smaller area of the image sensor. Visually, the effect is the same as if you had simply cropped a photo to only the center section. Since the camera is using the entire pixel count to capture this "cropped" version of what the lens projects, however, you won't see the loss of quality that would normally occur with such a crop in a film image.

In terms of focal length, this cropping of the image circle means that the standard focal lengths that apply to a 35mm film camera are different when the same lens is used on a DSLR. This is commonly known as the focal-length magnification factor, but it is technically more accurate to refer to it as a field of view (FOV) crop since the image circle, and thus the field of view, is being cropped rather than magnified. In terms of the final image you end up with, the cropped image circle gives you the same result as if you had used a lens with a longer focal length—hence the common usage of the term *focal-length magnification factor*.

### Pros and cons of focal-length magnification

In terms of buying a new lens, you need to determine what you really want to do with the lens. If you need an all-purpose zoom that you also want to use for portraits or a telephoto lens for sports or wildlife photography, the magnification/FOV crop issue will actually have a positive effect. This is because you are essentially getting a free boost on the telephoto end of the

focal length. Instead of a 300mm lens, you're actually getting a 450mm or a 480mm, depending on the actual magnification factor on your camera.

The downside of this aspect of DSLR photography comes into play if you want to photograph with a wide-angle lens. Whereas telephoto lenses are extended at no extra charge by focal-length magnification, the other end of the focal-length spectrum suffers in comparison and has the *wide* unceremoniously removed from the words *wide angle*. On cameras with a 1.5x magnification factor, a wide 24mm lens is turned into a 36mm lens (**Figure 3.25**) and the ultra-wide-angle 20mm is downgraded to only a moderately wide 30mm lens. For photographers who consider the wide-angle view as an integral part of the way they see the world and capture it in photographs, focal-length magnification is a raw deal.

**Figure 3.25** *This photo was taken with a 24mm lens. If the same lens were used on a camera with a 1.5x focal length magnification factor, the same wide-angle view would not be possible.*

# Dedicated DSLR Lenses

If the wide-angle perspective is an important part of your photography and your DSLR uses a smaller APS-C format image sensor, you should look into lenses that are designed to produce an image circle for those smaller sensors. These lenses provide the more traditional wide-angle capability that is not available when using a standard lens. The focal lengths are much shorter, but equivalent 35mm focal lengths (the common standard that most photographers are familiar with) are typically provided. A 12mm to 24mm, for example, is approximately equivalent to an 18mm to 35mm zoom on a 35mm film camera, and a 10.5mm fish-eye provides an equivalent field of view of 15.75mm (**Figure 3.26**).

**Figure 3.26**  *This image was made using a Nikon 10.5mm f/2.8 DX fish-eye lens. The equivalent focal length on a 35mm camera would be approximately 16mm.*

# Zooms vs. Prime Lenses

When you buy a lens, you can either purchase a zoom lens that offers a range of focal lengths, or you can buy a prime lens, which is also known as a fixed-focal-length lens. Many photographers feel that prime lenses are inherently sharper than zooms since fewer glass elements are used in their manufacture. Modern zoom lenses are generally quite good, however (unless you're buying a real rock-bottom cheapie) and may offer you a better blend of convenience and image quality than you get with a fixed-focal-length lens.

In our opinion, the reason to buy a prime lens has less to do with sharpness (though that debate continues to rage among optical purists) and more to do with the speed of the lens. Lenses with a fixed focal length always have a wider maximum aperture than zoom lenses in a comparable price range. A wider aperture means three things in terms of how it affects your photography. The first is that since the lens lets in so much more light at its widest aperture, you can take photos handheld in much less light than you can with a standard zoom lens. Second, the additional light coming into the lens means that it yields a brighter view of a scene in low light, which makes it easier for the camera's autofocus system to detect and lock onto a focus point. Third, a wider aperture allows you to create images that have a very shallow depth of field (**Figure 3.27**). Depth of field is the area of the image that is in focus from foreground to background and is one of the most effective ways to direct the viewer's attention in a photograph.

**Figure 3.27** *This image was made with a 50mm f1.4 prime lens.*

# Lensbaby

The Lensbaby (lensbaby.com) is a unique selective focus accessory lens for SLR cameras that allows you to move the lens element around to shift the "sweet spot" of focus to different areas of the image. Visually the result it produces is similar in character to a tilt-shift lens but at a much lower price. The area around the focused sweet spot is transformed into a smooth and silky blur (**Figure 3.28**).

**Figure 3.28** *Boogie boarders on Waikiki beach get the Lensbaby treatment.*

Lensbaby offers three different types of lenses: the Muse, which is based on the original design and is basically a lens element on a flexible plastic hose; the Control Freak, which features a more precise way of locking in a specific blur effect and is well suited for the slower pace of macro and tabletop photography; and the Composer, which we feel is the most practical and easy-to-use model. A ring on the outer edge of the Composer lens lets you focus, and moving the focused sweet spot in the image is accomplished simply by pushing the front of the lens around. If you find a focus effect that you like, you can tighten a ring so the lens remains fixed at that particular style of blur.

All Lensbabies come with different aperture rings that can be quickly changed with a small magnet "pen" tool that is included with the lens. They also feature a very well-designed Optic Swap system, which allows you to

swap out different accessory lens optics for different effects, such as double glass (standard), plastic (also standard with the Muse and Composer) for the low-tech Holga look, Soft Focus, Fisheye, or even one that serves as a combination of a pinhole or a zone-plate (**Figure 3.29**).

**Figure 3.29** *The Lensbaby Composer and accessory optics.*

Lensbabies are popular with wedding and portrait photographers since they provide a different visual look that can work well for those types of images. But any photographer can enjoy using one, and they provide a fun way to step outside the box of your usual photographic routine and explore a different way of seeing. If you have ever been intrigued by the quality and character of blur in some of your photos, you may want to delve a little deeper and really embrace the beauty of the blur with a Lensbaby (**Figure 3.30**).

**Figure 3.30** *Lensbabies are well suited for adding a different look to portraits and wedding photos.*

# Leave Your Lens at Home: Exploring Digital Pinhole Photography

**Figure 3.31** *A digital pinhole photo taken with a Nikon D100 and a pinhole body cap.*

**Figure 3.32** *Digital pinhole images are soft and low contrast but with a very distinctive look that works well with some subjects.*

Digital imaging allows for precision and perfection. Sometimes we get so caught up in investigating the tiniest feature of a digital camera or tweaking a pixel that we forget about having fun, letting go, and seeing what will happen when the creative process has free rein. So if you ever feel burnt out by all the numbers, facts, and figures of digital imaging, try what many professional photographers do when they want to recharge their creative batteries. Take off the lens, set the camera to manual, screw on a pinhole, and see what happens, as shown in **Figure 3.31**.

Pinhole photography is photography without a lens. It is one of the oldest ways of making a photograph, and the basic technology behind it dates back thousands of years to before the time of Aristotle. Many photography students' first project was to take a picture using an oatmeal canister that had a tiny prick of a pinhole twirled through a piece of aluminum foil and a sheet of black and white film taped to the inside. The images were fuzzy and full of flare and unexpected distortions—all of which added to their appeal and idiosyncratic quirkiness. If pinhole photography appeals to you, you'll have to accept the following: long exposures from one-half to many seconds, not being able to compose the image through the viewfinder, images that are soft and low in contrast (**Figure 3.32**), and rainbow flare whenever sunlight falls directly onto the pinhole. On the intriguing and positive side, you're never quite sure what you're going to get, and the images have an unlimited depth of field (though in a very "soft" way).

To enjoy digital pinhole photography, you need a DSLR with removable lenses and a pinhole (**Figure 3.33**). The most common way to turn a DSLR into a digital pinhole camera is to use a modified camera body cap that has been fitted with a micro-drilled pinhole. These are available for different camera mounts at The Pinhole Resource (pinholeresource.com). You can also make your own.

If you decide to make your own, you'll need a black plastic camera body cap, a drill to drill a one-half-inch hole in the body cap, thin metal flashing (found at home improvement stores), and a sharp needle to spin carefully

through the flashing in as fine a spot as possible. After spinning the needle through the flashing, use fine sandpaper to smooth any ragged edges, attach it to the inside of the body cap with black photo tape, and head out on a bright, sunny day.

**Figure 3.33** *High-tech meets low-tech. With pinhole photography you can position the camera very close to the subject. A still life setup photographed with a Canon 5D and a pinhole body cap. The finished photograph is a 6-second exposure at 800 ISO.*

To take pictures with a pinhole, set your camera to manual mode, use 400 ISO or higher, start with a 1-second exposure, and either use a tripod or make do with stabilizing the camera on surfaces such as walls, stairs, or a car. At first use the best JPEG setting to experiment with. Once you feel confident, you can use the RAW format for additional control over the captured image. Being able to post-process the RAW file can be very beneficial for improving exposure, contrast, and brightness. Point the camera at your subject—you can get within inches of the subject—and press the shutter button. Check the exposure on your LCD. If the image is too dark, increase exposure by 50 percent; if the picture is too light, decrease the exposure by 50 percent. Repeat. Varying shutter speed and ISO is the only way to control image exposure. It's important to keep in mind that pinhole photography is full of surprises that can create beautiful and painterly images that can be wonderful, inspiring, and just plain fun.

# Zoom Lens Aperture Considerations

When speaking of lenses, the common standard for identifying their capabilities is to specify the focal length (or range of focal lengths if it's a zoom lens) and the maximum aperture. On many zoom lenses, however, you will find not one but two apertures listed. This simply means that as the lens zooms, the widest aperture setting is not available at all focal lengths of the zoom. In effect the maximum aperture will shift to a smaller opening (less light entering the lens) as the focal length changes.

On the Canon EF 28mm to 135mm zoom, for instance, the maximum apertures are given as f3.5 to 5.6. From 28mm to about 35mm, the aperture is f3.5; from 35mm to 50mm the aperture is f4.0; when zoomed above 50mm, the maximum aperture becomes f4.5; from 70mm to approximately 85mm the aperture is 5.0; and at any focal length above 85mm, the widest aperture available is f5.6 (these focal lengths refer to the markings on the lens, not the actual focal length as determined by the FOV crop factor on an APS-C format sensor).

If the speed of a lens (in other words, how much light it gathers at the widest aperture) is important to the type of photography you do, you might want to consider looking into a more expensive grade of zoom lens that offers a much wider, fixed maximum aperture.

# Accessory Lenses for Non-SLR Cameras

If your camera doesn't offer interchangeable lenses, you can still modify the lens by using accessory lenses that attach to the front of the existing lens. Although optical purists may feel that a solution that involves adding an extra chunk of glass onto the front of the primary lens will degrade the quality of the image, these lenses actually work pretty well. Given the alternative, which involves not being able to modify the lens at all, these accessory lenses can be a lot of fun to use and may even rise to the occasion and help you create a really good image, or solve a particular problem. Not all cameras can accept these optional lenses, and you usually have to purchase ones that are manufactured specifically for your camera. They come in a range of sizes and focal lengths, and vary from wide-angle converters and telephoto converters to the extreme view of a fish-eye lens (**Figure 3.34**).

**Figure 3.34** *This image was taken with a compact digital camera with an accessory fish-eye lens that attaches to the front of the existing lens. Although not the type of lens you'd use for every shot, it creates a pretty cool image!*

# Essential Filters

Although for some people programs such as Adobe Photoshop have reduced the need for filters, there are still some filters that we regard as being essential items in a well-stocked camera bag. Others that we'll mention here may not be totally essential, but they help modify the light in specific ways and let you create images that would be difficult or impossible without them. Not all digital cameras can accept filters, and some can only use proprietary filters designed by the manufacturer. To accept standard screw-on filters, the front of the lens must have a threaded ring. If your lens has this feature, there should be a number indicating the size of the filter that will fit on the lens. Here are filters to consider:

- **Skylight filters.** These filters are clear glass and are mainly used as protective covers for the lens. If there is an impact to the front of the lens or contact with an abrasive surface, the filter will take the brunt of the punishment and spare the front glass lens element from being damaged. We suspect that there's also a certain amount of add-on selling here by camera shops and online dealers, but the basic premise makes sense and we use them as lens protection. A $20 to $40 filter is less painful to write off than an expensive lens costing hundreds of dollars.

- **Polarizing filter.** Of all the filters that we carry in our camera bags, we'd have to say that a polarizer is the one filter we just wouldn't want to be without. Like all filters, a polarizer modifies the light as it enters the lens. Chief among these modifications is a polarizer's ability to remove some of the glare and reflections from the surface of glass and water. It also excels at darkening blue skies and boosting color contrast and saturation. The quality of light in a scene can be made clearer and less hazy. The amount of polarizing effect you get depends on a few variables, including the time of day, the angle of the light relative to the scene you are photographing, and the reflective properties of a given surface (**Figure 3.35**).

**Figure 3.35** *A polarizing filter can dramatically improve landscape images by reducing glare on water, darkening a blue sky, and increasing color saturation. On the left, a high-country lake with no filter; on the right the same scene improved with a circular polarizer.*

The best type of polarizing filter to use on an autofocus SLR camera is a circular polarizer. Don't use a linear polarizer with an SLR, because it can confuse the camera's autofocus and metering systems. A circular polarizer allows you to rotate a circular ring on the front of the filter and adjust the level of polarizing effect until you get it just right. Polarizers are darker filters that cut down on the amount of light entering the lens, and this usually means using a wider aperture or a slower shutter

speed. Since they reduce the light entering the lens, they are easiest to use on cameras that use TTL metering (through the lens) so you don't have to calculate a compensating adjustment. For rangefinder cameras that also feature an LCD screen that shows you a live preview of what the lens sees, circular polarizers can be used in much the same way as you would with a DSLR, by rotating the ring until the effect looks best. The only drawback is that these screens can be somewhat hard to see in bright light, which makes it more difficult to evaluate the polarizing effect. Seán has been able to use his larger circular polarizing filter on a smaller compact camera by simply holding it against the front of the lens (**Figure 3.36**). Since the preview on the LCD is sometimes hard to see, to judge which rotational angle is best, he first holds the filter up to his eye and turns it until the effect looks good. Then he places it in front of the lens, making sure to keep the filter rotation the same. Fortunately, his Tiffen (tiffen.com) circular polarizer has a small handle for turning the ring that makes it easy to use as a positioning marker.

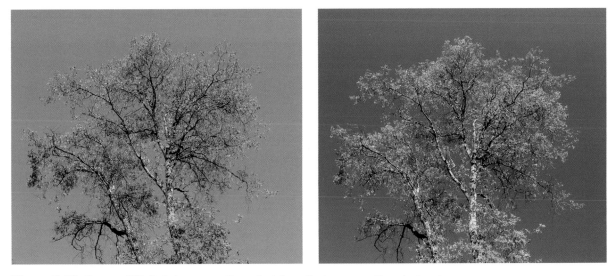

**Figure 3.36** *On non-SLR digital cameras, the polarizing effect can sometimes be hard to see on the LCD screen. It helps to hold the filter up to your eye first, to establish the correct rotation position, and then take note of that and mount it on the camera, or simply hold it tight against the lens, as Seán did here for the shot on the right, taken with a compact digital camera.*

If you're using a polarizer on a rangefinder camera that does not also have an LCD screen showing what the lens is seeing, you won't be able to see when the polarizing effect is best, so your success will be somewhat hit or miss. For this type of camera, especially if it does not use TTL light metering, a linear polarizer is best. You'll also need to factor in a plus-1 or plus-2 stop exposure compensation to adjust for the darker filter letting less light through the lens.

Few things liven up an outdoor shot on a sunny day like a polarizing filter. Although you can use image-editing software to darken a blue sky and add some saturation into the colors of an image, it doesn't replace a good polarizing filter.

**Figure 3.37** *Using a tripod and a special ND filter that cuts back 5 stops of light from entering the lens, Seán was able to use a very slow shutter speed of 20 seconds to render the rushing water as a silky blur.*

- **Neutral density (ND) filters.** These filters reduce the amount of light that enters the lens. Since they are neutral, they do not affect the color balance of a scene. ND filters are used for times when you want to achieve a certain effect, such as shallow depth of field produced by a wide open aperture, or a motion blur from a slow shutter speed, but the lighting conditions are too bright to allow the necessary settings. Flowing water is a classic subject for a slow shutter speed treatment, as is long grass blowing in the wind. By placing a dark ND filter on the lens, you cut down on the amount of light, making the wider apertures and slower shutter speeds accessible (**Figure 3.37**). ND filters are commonly available in 1-, 2-, and 3-stop increments, and darker ND filters can also be ordered that will cut back as much as 5 stops of light (**Figure 3.38**). For times when you need a really strong ND filter, you can stack them together to increase the darkening effect.

**Figure 3.38** *A Singh-Ray 5-stop ND filter shown in a Cokin P-series filter holder.*

- **Graduated ND filters.** Graduated ND filters are dark on the top half and then gradually fade to transparent along the middle of the filter. They are used in situations where the sky area of a landscape shot is much brighter than the terra firma below the horizon. By using the filter to darken the sky, a more balanced exposure can be made for both the earth and sky portions of the image. Standard graduated ND filters that screw onto the front of the lens are less than ideal since you can't adjust the placement of the horizon line; it's always right through the middle of the filter. A better approach is offered by Singh-Ray (singh-ray.com) with its Galen Rowell Graduated ND filters. Designed by the late, renowned nature photographer, these filters come in a range of densities and also feature either a hard-edged or soft-edged gradient transition from dark to transparent. Since the filter is a rectangular piece of acrylic that fits into a standard Cokin P-series filter holder, the photographer can adjust the graduated edge of the filter up or down to match the location of the horizon in the image. This makes them ideal for compositions where the horizon line is not centered (**Figure 3.39**).

A

B

C

**Figure 3.39**  *In images A and B a graduated ND filter can help to hold back the light of a bright sky and create a more balanced exposure, as shown in the second image. Image C shows Galen Rowell 2-stop graduated ND filters with hard and soft transition edges.*

The advent of digital cameras has introduced a new way of achieving this effect that involves shooting two (or more) exposures on a tripod, with each one exposed for a specific area in the image. The different exposures can be blended together in the digital darkroom either manually or via an HDR process. If multiple exposures and digital postproduction seem like too much hassle, or if you simply prefer to do as much as possible in the camera and on location, graduated ND filters are an

elegant solution to a common photographic problem. We'll cover the camera end of shooting multiple exposures for this technique in Chapter 6, "Multiple Exposures and Extending the Frame."

---

## What About Color-correcting Filters?

With film cameras, photographers often relied on special filters that were designed to correct for the color characteristics of common light sources so that the image recorded on film would not have an unwanted color cast. With digital cameras that offer user-defined white balance options, the need for these filters has all but evaporated because color temperature can be set for different light sources, and custom settings can also be created based on the actual lighting at the location. White balance controls also work for more aesthetic concerns such as adding a warming or cooling effect to an image.

The only instance where warming or cooling filters still have a place is when used as gels over flashes or studio lights. A warming effect created in the camera with a specific color temperature setting will affect the entire image. Since lights are directional, placing a warming gel on a light means that not all areas of the scene may be receiving the warming effect. If you're using colored gels over a flash or studio lights, you should set a custom white balance to the illumination of the light without the colored gels. That way, when the gels are added to the lights, you will still receive the coloring or warming effect that you want. We'll address color temperature and custom white balance issues in Chapter 5.

---

# Stepping Rings

Lenses come in many sizes, but not all filter rings are the same size. Instead of having to buy duplicate filters for each lens in your bag, which could be an expensive proposition, stepping rings are used to adapt a filter to a specific size of lens. Rings that adapt a larger lens size to a smaller filter are known as step-down rings, and those that adapt a smaller lens size to a larger filter are known as stepping or step-up rings.

Normally, when adapting a smaller filter to a larger diameter wide-angle lens, you would have to be concerned about *vignetting*. This effect is caused by the wide angle of view "seeing" some of the metal filter ring and causing the corners of the image to be darkened. If you are using a DSLR that has a

full-frame sensor that is the same size as a frame of 35mm film or a special digital lens like the Nikon DX series, you still need to be concerned about filter rings or step-down rings causing a vignette effect when used with a wide-angle lens. For standard lenses on DSLRs that have a focal-length magnification factor, however, the cropped image circle means that vignetting will not show up, even on a wide-angle lens.

## Seeing the Invisible: Digital Infrared Photography

Black and white infrared photos are hauntingly beautiful images with dark skies and ethereal, glowing white foliage. With certain digital cameras and an IR filter, you can photograph this "invisible" light and create your own infrared images (**Figure 3.40**).

**Figure 3.40** *The Byodo-In Temple on the island of Oahu in Hawaii. Photo by Julieanne Kost*

**Figure 3.41** *Using a TV remote to test a camera for IR capability.*

To do this, you first need to determine whether your camera's image sensor can record the infrared portion of the spectrum. Infrared light can cause image quality issues, and as cameras have improved, many manufacturers have added infrared cut-off filters over the image sensor to block the infrared light. An easy test to see if your camera can photograph infrared is to point the front end of a TV or VCR remote control at the lens, hold down one of the remote's buttons, and take a picture. If the infrared light is visible in the photo, that's a good sign that your camera will be able to take infrared images (**Figure 3.41**).

To make the most of your camera's infrared capability, you must use a special infrared filter that blocks all the visible light from entering the lens. With the visible light cut off, only the infrared portion of the spectrum is revealed to the camera's image sensor. Since these filters are so dark, they require long shutter speeds (1/4 to 1 second), so you will need to use a tripod if you want your images to be sharp. It's best to set up the tripod and compose your shot before adding the filter (since you won't be able to see much once it's on). Focusing needs to be done with the filter on the lens, however, since filtered light focuses differently than the normal, visible spectrum. You can help the camera out by framing the image so that there is detectable contrast on one of the autofocus zones. Set the exposure to auto and try an exposure compensation adjustment of plus-1 to plus-2 stops (exact exposures will vary from camera to camera and also depend on the type of filter used). After you take a shot, the image can be proofed on the LCD screen and additional exposure adjustments can be made if necessary. Although a screw-on filter works best since it blocks all the visible light, in a pinch you can get by simply by holding a filter tightly against the front of the lens. This works if you already have an existing filter that is too large for your compact digital camera.

Several IR filters are available and all may produce slightly different results, depending on the amount of infrared light your camera's image sensor can record. Common filters for infrared are the Kodak Wratten 89B, 87, and 87C filters. Hoya makes an RM90 filter and its Infrared R72 is roughly equivalent to the Kodak 89B. Harrison & Harrison also sells an 89B filter.

Also, infrared conversions are available for some compact cameras and DSLRs. This is accomplished by adding the IR filter over the image sensor, resulting in a camera that will only shoot infrared (**Figure 3.42**). The advantage to this approach is that you can use the camera normally without having a nearly opaque IR filter on the lens. The disadvantage is that the camera

has been permanently modified so that it can only create infrared images. If you really like the infrared look, that's not a disadvantage at all. A number of companies offer this service, and the price may vary depending on the camera being modified, but a basic conversion typically runs about $450. LDP LLC (maxmax.com) is one company that performs IR conversions on DSLRS, and it has a lot of very good information on the process at its Web site. Life Pixel (lifepixel.com) offers IR conversion on DSLRS as well as some compact digital cameras.

**Figure 3.42** *This image of Central Park was made by photographer Jack Davis using a Canon Powershot SD870 IS that had been converted to shoot in infrared by Life Pixel (lifepixel.com). Photo by Jack H. Davis / AdventuresInPhotoshop.com*

# Dealing with Dust

Dust has been a problem for photographers since long before the first digital camera was invented. But digital cameras with interchangeable lenses introduce a new reason to be concerned about dust. If dust or other contaminants get on the sensor, they can produce spots in every picture you take. Fortunately, although the problem is very annoying, there are a variety of solutions to address it, from in-camera sensor cleaning to special cleaning accessories that you can use to clean the image sensor yourself.

# Dust Prevention

The old saying that an ounce of prevention is worth a pound of cure holds especially true when it comes to keeping the sensor on your digital camera clean. You can start by always keeping a lens or body cap attached to your DSLR. When changing lenses, work quickly to minimize the time the camera body is open to the elements. We recommend having the new lens out of the camera bag and ready to go, with its rear cap already off so that you can mount it as soon as possible once the first lens is removed from the camera. And if a camera body will be without a lens for more than a few moments, attach a body cap to cover up the opening. If you are in conditions with considerable moisture and flying dust, or there's some other risk of getting contaminants inside your camera, make every effort to find a sheltered place or shield the camera while changing lenses.

Minimizing the dust that is on and around your camera is another way to prevent dust from finding its way into your camera. Keeping your camera bag clean and as dust-free as possible should be an item on your regular maintenance list. This goes for your lens caps and body caps, too. Although covering the lens mount opening with a body cap is a good idea when there is no lens on the camera, if the interior of that body cap is dusty, you may be inadvertently introducing particles into the camera. Many DSLRs have a range of features to help prevent and reduce the occurrence of sensor dust. The most common of these combine anti-static coatings with a low-pass filter that vibrates when the camera is turned on. Since the dust is actually on the low-pass filter, not the sensor, the vibration shakes the dust loose and it falls onto surfaces designed to absorb and trap the dust. Although this method is fairly effective for removing dust from the sensor, no system is 100 percent perfect and you will still encounter dust spots now and then.

# Checking for Dust

If the sensor on your DSLR is dirty, you'll probably notice it as soon as you review your images. The spots will be quite visible in lighter areas of similar tone and color, such as the sky. Even if you can't see the spots, it's good to check your sensor periodically to see if it needs cleaning. This isn't something you can do by simply looking at the sensor, because even tiny spots that cannot be seen with the naked eye can still show up in the final image.

To check for a dirty sensor, it is best to use a wide-angle lens stopped down to the minimum aperture so the depth of focus at the sensor plane is maximized. Point the camera at a blank, empty sky, or a similar featureless scene like a white wall. Adjust the focus so the sky or wall is slightly out of focus and take a properly exposed photo. Then bring the image into your photo-editing software and zoom in for a close look. Increasing contrast with a feature such as Auto Levels in Photoshop will help make any spots more visible (**Figure 3.43**). It is unlikely that you'll ever have a sensor with no spots at all, but if there are more than you can count, or some especially large and furry ones, it's certainly time to clean your sensor.

 **TIP**  If you really want to get a close view of your image sensor to hunt down dust, Visible Dust (www.visibledust.com) has a special illuminated Sensor Loupe that provides a well-lit magnified view of the sensor surface.

**Figure 3.43**  *A dust spotting test image. This sensor needs to be cleaned!*

## Cleaning the Image Sensor

When we refer to cleaning an imaging sensor, we're really talking about cleaning the filter in front of the sensor. As you can imagine, the interior of a DSLR contains many delicate components. It is critical that you exercise care if you clean the sensor on your camera. If you aren't comfortable doing it, have the work performed by an authorized repair facility.

To help protect your camera, it is important to use the Sensor Cleaning mode to access the imaging sensor, which is hidden behind the mirror and the shutter. In Sensor Cleaning mode the mirror will be raised out of the way and the shutter will open. Some cameras may require you to power the camera using the AC adapter to prevent the risk of the mirror dropping down if the battery gets low. Others allow you to work from battery power. Refer to your camera manual for specific instructions on activating this mode.

Cleaning a sensor involves either dislodging or removing dust specks. There are a number of ways to accomplish this, as well as several products designed for this purpose.

## Blowers

**NOTE** You should never use chemical-based "canned air" products for cleaning an image sensor. The possibility that some of the chemical compound will get onto the sensor is simply too great a risk to take.

For dislodging dust specks, you can use a simple bulb air blower that you squeeze with your hand. The main drawback to this is that in addition to blowing air out, these devices can also intake air (and dust) through the blower nozzle, so you might be actually applying more dust to the interior of the camera. Visible Dust has a product called a Zeeion Blower that creates opposite charges of air molecules to be blown at the sensor surface to neutralize static charges and reduce the occurrence of dust particles reattaching to the sensor. Additionally, a one-way valve and micro fine filters prevent dust intake into the blower.

## Charged fiber brushes

The Artic Butterfly Sensor Brush (also by Visible Dust) and BRUSHOFF by Photographic Solutions (photosol.com) use special fibers that have been treated to hold an electrostatic charge. The charged surface of the brush bristles attracts the dust away from the sensor as you brush over it. When using the Arctic Butterfly brush, after each pass over the sensor it is placed into a special attachment that spins the brush at a very high RPM, casting away any dust particles that were picked up, cleaning the brush, and recharging the brush fibers for the next use (**Figure 3.44**). The specially charged fibers in the brush are quite effective at removing all but the most stubborn dust spots; the advantage to this approach is that it is a low-impact way to remove dust that does not involve cleaning solutions and swabbing.

**Figure 3.44** *The Arctic Butterfly by Visible Dust (www.visibledust.com) uses an electrostatic charge that attracts dust. The image on the right shows the brush spinning to cast away dust particles removed from the sensor. Photos courtesy of Visible Dust*

### Swabs and cleaning solution

For those situations where the lighter touch of an air blower or a charged fiber brush are not successful, you may find that a more thorough cleaning is required. In these cases sensor-cleaning solutions are used with special swabs to remove dust and clean the sensor. Using swabs to clean the sensor requires a bit of finesse, and we think a little practice is required to get the best results. The technique involves placing a small amount of lens cleaning solution on the swab and wiping the swab across the sensor in one motion (**Figure 3.45**). Then use the other side of the swab to swipe the sensor in the opposite direction. You need to apply enough pressure to clean stubborn dust specks, but not so much that you leave excess solution on the sensor.

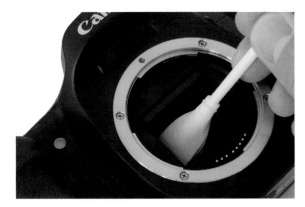

**Figure 3.45** *Cleaning the image sensor on a DSLR using a Sensor Swab from Photographic Solutions (photosol.com).*

Several companies manufacture sensor swabs and cleaning solutions, including Photographic Solutions and Visible Dust. Sensor swabs are manufactured to fit a specific format of image sensor, so make sure you choose the correct product for the sensor in your camera.

## Odds and Ends

Some accessories defy easy categorization, yet that doesn't diminish their importance. In this section we dig through the pockets of our camera bags and see what other handy items we can find.

### Exposure tools

Gray targets or color references that are placed in a shot can help you fine-tune the white balance once you begin working on the images in the digital

darkroom. Once a white balance setting is set for the test photo, it can be quickly applied to all other images shot in the same light. They are especially useful in scenes with mixed lighting. The following list describes some common exposure tools:

- **A white card.** This is the least expensive accessory you'll ever use. In digital photography, a white card, or simply a white piece of paper, is used to set a custom white balance for the lighting of a given location. Using this you can configure the camera to account for any color variances that may be present in the light you are shooting in. The card does not have to be large, since you just need to be able to fill the viewfinder frame (or the center of the frame on some cameras) with it in most cases. We've found that a sturdy piece of white poster board that is 4 by 6 or 5 by 7 inches works well and fits nicely in our camera bag. We use a plastic bag to keep the white surface from getting scuffed. If the card does get a bit beat up over time, it's easy enough to replace. We cover how to set a custom white balance in Chapter 5.

- **18 percent gray card.** A gray card can be used to help determine exposure settings in tricky conditions that might otherwise fool the camera's built-in light meter. It can also be included in a shot and used for setting a custom white balance (if your camera accepts a gray target for that purpose), or for providing a target tonal value that can be neutralized in Photoshop to remove any color casts present in the image. We discuss exposure situations that might fool a camera's light meter in Chapter 5.

- **X-Rite ColorChecker.** Like an 18 percent gray card, the ColorChecker has been a standard in the photographic industry for many years. With digital photography, it helps you set a neutral color balance in an image after you've opened it in Photoshop. By including it in a control image taken under each lighting setup, it provides a known reference of what the colors should look like and you can use the eyedropper features in Lightroom or Photoshop to set a specific neutral tonal balance using one of the neutral patches on the ColorChecker. Color checkers come in two standard sizes; the smaller ColorChecker Passport is ideal for carrying in the camera bag (**Figure 3.46**). Neutralizing the color balance in a photo in Lightroom is covered in Chapter 8, "Working in the Digital Darkroom."

- **X-Rite 3-Step Grayscale Card.** This card has precise tones of black, gray, and white, and can be used like the ColorChecker card to help determine a neutral black, white, and middle gray (**Figure 3.47**).

**Figure 3.46** *An X-Rite ColorChecker Passport (x-rite.com).*

**Figure 3.47** *The Grayscale balance card from X-Rite can be placed in test images and, similar to the ColorChecker, used to create a neutral black, white, and gray balance in a photo.*

## General camera care

For the most part the items in the following list are not "official" photo accessories, but that doesn't mean they are not very useful at times:

**NOTE** Although they are always available and easy to use, we don't recommend using mouth fog and the edge of your shirt to clean a quality optical lens. Rather, purchase a dedicated lens cleaning cloth, store it in a small plastic bag, and only use it for your lenses.

- **Lens cleaning supplies.** You can't take sharp photos with a big smudge on the front of your lens. If you have to photograph in wet weather, drops and small splashes on the lens are common occurrences. A stash of lens cleaning tissues, as well as a bottle of lens cleaning fluid, will keep your camera's view of the world clean and clear.

- **Plastic bags.** We find that it's good to have a few large "zippered" plastic bags stashed in an out-of-the-way compartment of our camera bag for those times when we need to photograph in wet weather. You can cut a hole in the bottom of the bag for the lens and use the open end to hold the camera and work the controls. While this won't protect you from all water splashes, particularly on the part of the lens that extends out of the bag, it can keep most of the camera nice and dry. If you're out in inclement weather often enough, you may want to look into some of the many products designed to keep your camera snug and protected from stormy weather.

**TIP** The next time you're in a hotel, grab the plastic shower cap and put it in your camera bag. It is compact, and the elastic band allows it to be an improvisational cover for sudden rain or dust. You may feel silly using it, but it sure beats a wet camera!

- **Tool kit.** Let's face it, things break. Screws work their way loose. A tripod's legs develop an annoying habit of slowly collapsing, rendering it unusable. Having a few key tools in your camera bag can mean the difference between fixing a problem on location and continuing with your photography, or waiting until you get back home. Here are a few useful items that have served us well in the past: a multitool, such as a Leatherman, with a screwdriver, a sharp knife, a pair of scissors, and pliers; or a Swiss army knife with several of the previous items, plus tweezers; small screwdrivers for lens screws (or those on your eyeglasses); and a special set of tools designed to make adjustments to tripods.

## "Assistants"

No, we're not talking about an actual human assistant (although they're great to have on a complicated project if the budget supports it) but about a collection of seemingly random items that often come in handy for certain photographic tasks. Not all of these may be high on an "essential" list, but for

some situations they can save the day and at the very least make your photographic journey a little less bumpy:

- **Sensor loupe/sun shade hood.** This is one accessory that we *do* consider an essential item for your camera bag. When photographing outdoors in brightly lit conditions, it can be difficult to impossible to see the image on the camera's LCD screen. A sensor loupe such as the HoodLoupe by Hoodman (hoodmanusa.com) makes it easy to see the LCD screen, and for some situations, that can be important. Once you've used one of these outdoors in bright sun, you'll always want to have one in your camera bag (**Figure 3.48**).

**Figure 3.48**  *Seán using a HoodLoupe to proof composition and exposure while photographing in very bright lighting conditions.*

- **A small flashlight.** Sometimes we're up before dawn or out after dark in the pursuit of interesting images. Having a bright light to help you see is essential. For night photography, a penlight is critical for changing some camera settings. Since autofocus does not work in the dark, this can illuminate the distance scale on the lens so you can focus manually. Flashlights can also be used as an additional light source for night photos, allowing you to "paint" with light onto a foreground object (**Figure 3.49**). For hands-free work, consider a battery-powered headlamp that fits on your forehead with an elastic strap. Don't forget extra batteries for the flashlight. For additional considerations for night photography, see Chapter 6.

**Figure 3.49** *The interior of this temple at Machu Picchu was illuminated entirely by painting with a small flashlight during the course of a 3-minute exposure.*

- **A small notepad.** Sure, digital cameras have EXIF data that records all the vital settings of a shot, but sometimes you need to take extra notes about details that the camera doesn't record—like how long you "painted" the foreground subject with your flashlight, what species of bird you photographed in shots 12 through 24, or general notes and impressions about a specific location. In the same vein as a notepad, many photojournalists carry a mini digital recorder to gather details for their stories or to interview the people in their photos.

- **Small bubble level.** These are designed specifically to fit onto a camera's hot shoe, and they're a great way to ensure that your tripod-mounted camera is level (**Figure 3.50**).

- **Velcro.** If you had enough of this material, you could probably move the world. We're not suggesting such a Herculean feat, but Velcro can be incredibly useful for routine tasks such as tying back small branches that get in the way of the perfect landscape shot, or helping to position impromptu reflectors for a macro shot. We like the kind that's about an inch wide and comes on a roll with peel-off adhesive backing.

**Figure 3.50** *A small bubble level that fits onto the hot-shoe mount can assist you in leveling the camera.*

- **Copper wire.** This can be used for any number of purposes. You can find it in the electrical department of any good hardware store. The best kind can be easily bent into shape as a prop to hold up small reflectors.

- **Aluminum foil.** This can be neatly folded and slipped into a side compartment where it doesn't take up much space. It can be used as small reflectors for macro work, and small, wadded pieces can be used as props for slight adjustments to everything from an external flash unit or a recalcitrant still life subject (**Figure 3.51**). For a larger "reflector" that is lightweight and can be folded into a very small package, try using a space blanket. If you're ever stranded, it'll also keep you warm!

**Figure 3.51** *Aluminum foil has many uses and is a handy item. Here, it's being used to prop up and position an external flash unit.*

- **Creature comforts.** Don't forget some personal items that might come in handy after a long day out with the camera. Katrin likes to carry aspirin, a few plastic bandages, lip balm, and some extra cash in her camera bag.

# What's in Your Photo Studio?

Photo accessories, whether they are for film or digital cameras, are designed to let you do different tasks with your cameras, or simply make certain tasks and procedures easier and faster. In the end, though, it all boils down to photographing the best images possible. For most of this chapter, we've concentrated on accessories that you take with you on location. Now, we'll shift our focus indoors to accessories that are designed to make shooting in a studio more effective.

Setting up a studio for digital photography is not very different than setting up a studio for conventional film photography. Other than the fact that you might choose to have a computer workstation near the shooting area, the basic elements are the same. If you're already familiar with studio photography, there won't be many surprises here.

This section of the chapter is designed to cover useful items and strategies for those photographers who are interested in setting up a small studio. Our focus is on small setups for still lifes, people photography, and tabletop work; we won't be covering large coves or cycloramas for photographing full-body fashion shots or car ads. Although larger subjects require more space, there's a lot of studio work you can do even in small studio areas.

## Lighting

Lighting is a key issue for an indoor studio setup, because unless you have a skylight, you can't rely on natural daylight to illuminate your set. Even if you do have a wall of large windows, or a skylight, that type of lighting is only appropriate for certain types of image making, and you'll still need to be able to provide light on demand.

## Flash

Flash is the most common and versatile type of studio lighting. If you're just starting out, you can do a surprising amount of work with just two small flash units: one for the main light and the other for the fill or backdrop light. Using sync cords, slaves, or an IR wireless setup, the flashes can easily be connected and synchronized. With a third, inexpensive flash unit, you can have a backdrop light as well as a fill light. Combining these basic flash units with light modifiers such as reflectors and diffusion panels lets you create a wide range of lighting effects without breaking the bank.

## Studio strobes

A step up from using multiple camera flashes is a compact studio strobe system either with lights that feature a built-in power source on each strobe head or with lights that are powered by a separate power pack. On both types of systems, the lights or the power pack is plugged into a grounded electrical outlet. Studio flashes provide more power and much faster recycle times than typical battery-powered flash units, and the power output for individual lights can be adjusted, either on the light itself or from the power pack. Depending on the setup, power packs can power from two to four lights. The camera is synchronized with the lights via a sync cord connected to the power pack. Although systems with the power source contained in the strobe head (uni-lights) are typically less expensive than those that are run from power packs, the latter system offers more flexibility if you need to use more than two strobe heads for your work.

Since the light from a flash system is a short burst delivered in a fraction of a second, working with it is not as easy as with lights that are on all the time. To help you visualize shadows and highlights, studio flash systems usually provide a modeling light so you can see how the light falls on the subject. Studio strobes do not interface with the camera's TTL light meter, so using them means you'll need to invest in a good flash meter. Flash meters start at around $70. Once the basic exposure is dialed in, you can use the camera LCD screen or computer monitor (for tethered shooting) to fine-tune the camera settings.

## Continuous light

Whereas flash or strobe systems emit their light in a fraction of a second, a continuous light system is on all the time, which can make it easier to see how the light is illuminating the subject. The drawback is that certain lights can generate a lot of heat, which warms up your shooting space. There are different types of continuous light sources:

- **Photo floods.** These lights are very similar to standard household light-bulbs. They tend to be very warm in color and generally don't provide enough light in the blue region of the spectrum to give accurate color rendition. With digital, of course, this is not a problem, since a custom white balance reading can be taken and the camera's color temperature can be "calibrated" to the specific light source. On the negative side, these bulbs have a fairly short life span of 3 to 5 hours, and their color shifts as they age. Although they're very inexpensive, we don't recommend them for any type of serious studio work.

- **Tungsten-halogen lamps.** These are much more useful for photographic purposes and are common in professional still-life studios. They provide a broader spectrum than photo floods and are more consistent in their output over their lifetimes. Halogen lamps can be used with a wide variety of light-modifying fixtures, including focusing spotlights and fiber-optic illuminators to create special effects.

- **HMI.** HMI (hydrargyrum medium-arc-length iodide) lights are the Rolls Royce of the continuous-light-source family. Normally used to light movie sets, these lights give a very bright, cool light with the same color temperature as daylight (5000K to 5600K). Although they are ideal for photographic applications, they are *very* expensive. A 125-watt HMI light (which is equivalent to a 650-watt quartz light) costs over $1000, and replacement bulbs are about $225 apiece.

- **Fluorescent lighting.** Also known as "cool lighting," fluorescents, once shunned by photo studios for their ghastly color casts and uneven, flickering light, have improved dramatically and have become quite popular in some digital studios because they are so easy to control and handle. Because they operate at much cooler temperatures and power levels than "hot" lights like HMIs and tungsten lamps, fluorescents are more

economical and provide a more comfortable environment to work in, especially for models and portrait subjects. They are best suited for providing a uniform, even light source over large areas, and they work well for flat copy work and fine art reproduction. Modern photographic fluorescents are available color corrected for both daylight (5500K) and tungsten (3200K), which makes it easy to mix fluorescents with other lighting systems, both natural and artificial. Although there are many modifiers and accessories available for controlling the light, fluorescents are not as versatile for directional light as tungsten-halogen and HMI lights.

## Reflectors

Reflectors are important tools for controlling where the light falls on your set. They can be as simple as a large piece of white foam-core board, or they can consist of professional photo umbrellas mounted to studio strobe heads. Fortunately, reflectors are one of the easiest items to make, and a little ingenuity can go a long way in creating an inexpensive system that will work just as well as the more expensive commercial offerings:

- **Foam-core board.** This is about as simple as it gets, yet it can create the same effect as a product you would pay a lot of money for at a professional photo supply shop. Start with a basic 30 by 40-inch sheet of 1/4-inch white foam-core board. This will provide a bright surface for soft fill light. You can also cover another sheet with the shiny side of common aluminum foil to create a reflector that is brighter and provides a fill light with more contrast.

- **Fabric reflectors.** These reflectors consist of reflective fabric panels that stretch around a collapsible frame made of PVC pipe. The main advantage over foam-core reflectors is that these can be collapsed for easy storage or travel, and different types of fabric can be used on a single frame. A gold reflective fabric will provide a warm fill, whereas a silver fabric will add a neutral fill light. Opaque white fabrics add a soft, even fill light, and translucent fabrics can be used as a large diffuser when the light source is directed through them at the subject. These are available from a variety of vendors (**Figure 3.52**).

**Figure 3.52** *Fabric reflector panels are lightweight, easy to move, and can be fitted with a variety of different fabrics, either reflective or translucent. Photo by Mark Beckelman and John Parsekian*

- **Umbrellas.** Reflector umbrellas are mounted to a studio light—either a strobe or a hot light—and serve to broaden the light coverage and diffuse the quality of the illumination. They are available in several reflective surfaces, including white, gold, silver, and translucent white.

## Backdrops

Many studio photographers plan their photos from the back to the front—deciding on a background first and then working their way forward. A backdrop can be anything, of course, from artfully draped fabric to an old piece of weathered wood. There are some common conventions used in photo studios, however, such as the seamless backdrop that creates a seamless transition from the floor to the background. Several products help you achieve this effect, and in many cases, you can also apply a little do-it-yourself energy and create something for much less money:

- **Seamless paper.** Photo supply stores sell large rolls of sturdy seamless backdrop paper in a variety of widths and colors. Common widths are 5, 9, and 12 feet. You mount the paper above the set and pull down enough to cover the shooting area to create a gentle, curving transition between

the vertical and the horizontal. When the paper gets scuffed and messed up, you just cut off the damaged portion and pull down some new paper. For hanging the seamless paper, you can purchase special backdrop stands that consist of two stands and a pole between them to hold the roll of paper (**Figure 3.53**). If you don't need the portability of backdrop stands, you can mount a pipe to the wall of your studio space and hang the backdrop paper from it. For tabletop photography, you can also create a smaller version of the seamless paper look by clamping a piece of poster board onto the edge of your table and curving it up against the wall.

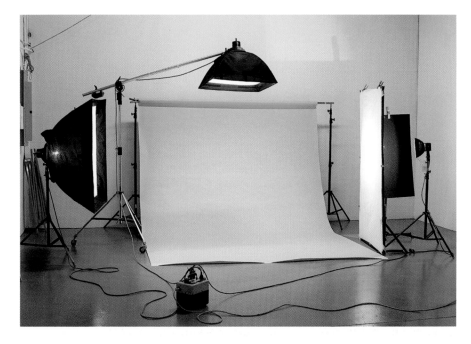

Figure 3.53 *Seamless photographic backdrop paper is used to create a gentle transition from foreground to background. Photo by Mark Beckelman and John Parsekian*

- **Cloth.** Cloth backdrops add a classic, traditional look to a photograph. They work especially well with formal portraits. You can buy backdrops of plain cloth, which can be draped into artful, flowing folds, or painted versions in a range of designs and colors, from professional photo supply shops. Muslin and canvas are the two main materials that are used for cloth backdrops. Muslin is much lighter than canvas and can also be draped around a model or shaped to a prop or a set. Canvas is better suited for backgrounds where a flat, even look is desired. For location work, muslin is the way to go since it can be folded and transported much more easily than canvas. You can also wad up painted muslin into

**TIP** When buying or painting a cloth backdrop, you have to realize that you're likely to have it for a long time and will use it in a lot of photographs. Although interesting patterns and bold designs may seem tempting, experience has shown us that it's the simple backdrops and the more muted tones that give us the most mileage.

a tight bundle so that the creases and folds from this treatment make interesting patterns the next time you use the backdrop. If you want to try doing it yourself, you can buy large quantities of muslin from theatrical supply houses and cut to size. You can either leave the muslin in an unaltered state (just the fabric) or it can be painted. Seán used this approach for two of his backdrops, with one that is plain muslin and the other that has been heavily painted. He uses these backdrops both indoors and outdoors in the open shade for an open-air natural light portrait studio (**Figure 3.54**).

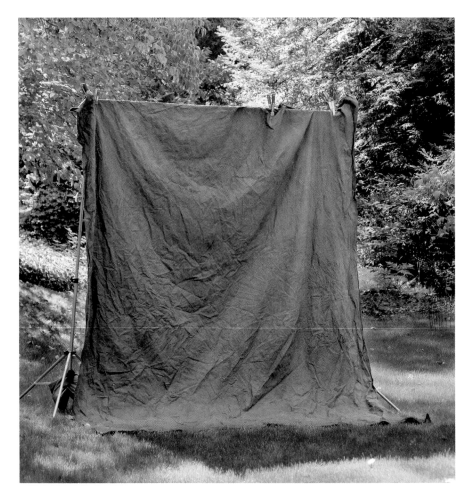

**Figure 3.54** *Cloth backdrops create a more formal, classic look for portraits. They can be used in the studio or outdoors for natural light portraits.*

- **Green screen.** Any time you see a process shot in a movie where an actor is interacting with something that is obviously a special effect, it was undoubtedly created using a process called green or blue screening. A character is photographed acting on an empty stage in front of a giant green or blue screen. In postproduction, the colored areas of the screen are replaced with special effects or computer-generated backgrounds. You can use the same principle for photographing people or objects that you plan to collage into a different image. Photographing against a flat, colored backdrop makes it much easier to extract the element from the background in Photoshop and add it to the other image. For this approach, you can buy seamless background paper in any number of bright colors. It doesn't necessarily have to be blue or green, but those are the traditional colors that work well for this effect. One thing to be aware of, however, is that if the backdrop is too close to your subject, there can be color spill from the colored paper that can contaminate the main subject. To avoid this it's best to have several feet between the subject and the backdrop. If you are photographing a person, use paper that is the opposite of the color of their clothing.

- **Textures.** For small product photography or still lifes, any textured surface can be used as a backdrop. Stone slabs from a landscape supplier, Formica tiles from the floor shop, and handmade paper from the art store are all fair game when you need to create an image with a textured background. Once you get your mind set on it and the more you look for creative backdrop solutions for the small set, the more you will find them.

## Tables and workstation carts

Special tables for still life and product photography, as well as mobile carts and platforms for computer workstations and other essential items that need to be handy near the camera position, can make your studio life easier and more efficient.

- **Sweep tables.** If you plan to do a lot of product photography, you might consider the benefits of a *sweep table*. These are adjustable tables with a shooting surface made of a single sheet of translucent frosted Plexiglas that curves upward in the back to create a seamless "cove." The table can be lit from above or below, or both, providing a range of lighting options for different assignments. Sweep tables are durable and provide

a consistent set for product shots (**Figure 3.55**). For the do-it-yourselfer, a sweep table can be rigged without too much hassle. All you need is a sturdy frame to which you can attach a curved sheet of Plexiglas.

**Figure 3.55**  *A sweep table is a studio accessory that is commonly used for product photography. You can purchase these in different sizes from photo supply companies, or if you're talented with tools, you can make one yourself using frosted Plexiglas and a wooden frame. Photo by Mark Beckelman and John Parsekian*

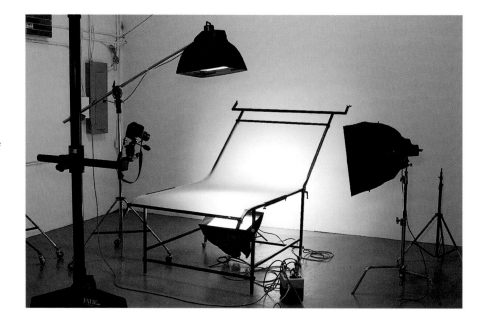

- **Photo workstation cart.** If you have a larger studio space and want to have the convenience of a computer nearby, wheeled workstation carts are available that can hold a tower computer, a monitor, and some extra room for miscellaneous accessories. For tethered shooting or larger studio cameras that are operated through the computer, this is almost a necessity, since you can easily wheel it to different locations in the studio.

- **Tripod-mounted laptop platform.** If you will be shooting tethered on location, you may want to consider a laptop platform that can be attached to a tripod. This is a more portable solution than lugging a cart on location.

# Essential Studio Odds and Ends

Commercial and fine art photography is all about image and has very little to do with reality. Anyone can press a shutter button, but what distinguishes a good photographer is the ability to craft a shot. If you watch food photographers at work, you'll see that they spend an inordinate amount of time looking for the perfect subject and props. For example, they sort through a five-pound basket of brussels sprouts to find just the right ones, then glue each sprout into place, and arrange the leeks and the tarragon with wires, pins, and gaffer's tape to make the shot look like a home-cooked meal.

From behind, a well-crafted still life often looks like a science experiment gone wrong, resting on a blob of Silly Putty with pins sticking out of it and wires holding it just so. But through the camera's viewfinder, it looks perfect—all the pins, wires, tape, and glue are hidden from view either behind the subject itself or blocked by other props. Here's a brief sampling of some of the humble yet essential studio "assistants" that can help prop up the façade of a carefully arranged studio shot:

• **Clamps.** No studio, either a professional one or the one in your garage, should be without a good selection of clamps of various sizes. They can be used for everything from holding backdrops and reflectors to propping up otherwise recumbent objects in the photo. Spring clamps are perhaps the most useful, but C-clamps also come in handy from time to time. And let's not forget that most humble of clamps for delicate items, the clothespin.

• **Hot glue gun.** The ultimate weapon of photographic persuasion is the electric hot glue gun. Use it to make objects defy gravity and guarantee that they stay where they're supposed to.

• **Silly Putty.** Yes, we do mean the very same Silly Putty that you got stuck in your hair when you were a kid. Such tenacious sticking properties may not be appreciated when you're trying to get it out of the rug or a child's hair, but it works wonders for helping to position items in a tabletop still life. Another product that works well for this is the household putty that you can buy to hold items in place in areas of the country that are prone to earthquakes.

**NOTE** Gaffer's tape is not just expensive duct tape—but special cloth-backed tape that holds firmly yet comes off without leaving that sticky duct tape residue. You can purchase it at film and video production supply shops or online at www.filmtools.com.

- **Wire, gaffer's tape, and Velcro.** Wire of varying rigidity and sturdy tape always come in handy on the set of any photo shoot. Like the hot glue gun, Velcro is also quite helpful for adding that "lighter than air" touch to certain objects.

# Adding Flexibility and Creativity

The list of photo accessories goes on and on. What we've covered here is only a small portion of what may be available for your camera system or what may be useful for the type of images you want to make. But it represents what we feel are some of the most important gear to consider as you begin to branch out and add items to your camera bag or photo studio. Photography is a huge field, of course, so we can't cover everything under the sun and still fit it within the page count of this book. Every photographer has different requirements for the type of work they do and the images they like to create.

Accessories extend the capabilities of your camera, increase your efficiency and productivity, and most important, open up new avenues for crafting successful photographs. By investing in them, you're not just adding new gadgets to your camera bag or photo studio; you're adding new possibilities for image-making flexibility and creativity.

# II

# Digital Photography
# Techniques

# Digital Photography Foundations 4

With most digital cameras, it's easy to begin taking photos as soon as you insert a battery and a memory card. But it's important to familiarize yourself with the different settings contained in your digital camera's menus and submenus. Human nature being what it is, of course, most of us probably take lots of pictures before delving too deeply into the instruction manual. The fully automatic mode on most cameras that handles every decision for you except where to point the camera makes this very easy to do. The Auto mode is great for those times when you need to take a picture quickly and don't want to think about which setting to use. But to achieve the photograph you're after, you'll more often need—and want—to take the camera off autopilot. Understanding the core concepts outlined in this chapter will make the difference between using your digital camera as a nifty gadget and using it as powerful creative tool.

In the first part of this chapter, we'll explain some important settings and menu options to help you know your camera better. In addition, we'll take the time to review some fundamentals of photography and how they relate to digital cameras. In the second part of this chapter, we'll look at some of the important concepts and practices that form the foundation of making good photographs.

# Setting Up Your Digital Camera

**NOTE** We highly recommend that you either read your camera manual from cover to cover before proceeding or have it within reach as you dive into this chapter.

The path to a camera's menu system differs from one camera to the next. With some you may be able to access it by simply pressing a Menu button on the back of the camera. With others, you might have to rotate a dial to a special position. Some cameras separate the menus into two sections: one for overall setup configuration that you access via a dial and another with specific shooting mode options that you access with a button. Depending on the camera you have, the order of the settings may vary, and some of the ones mentioned here might not be available to you, but many of them are standard on most digital cameras. We'll start with the items that are the most important for image quality.

## Choosing a File Format

The first setting to consider is what file format to use when saving the images to the camera's memory card. The two choices are JPEG and RAW. Depending on the type of camera you have, RAW may not be an option. Some cameras also offer the ability to record short video clips, but for this section we'll focus on still images. We'll discuss video capabilities in Chapter 6, "Multiple Exposures and Extending the Frame."

### JPEG

Most consumer-level digital cameras offer only one "choice" of file format: JPEG. If this is the case with your camera, then your choice is easy. Shooting in JPEG also offers you the ability to choose different image sizes and compression levels (how small the file size is when saved to the memory card). Image size and compression are important settings that affect how many images you can fit onto a memory card, as well as image quality. We'll take a closer look at those settings shortly. As you move into the world of deluxe point-and-shoot and more advanced models, an additional format will likely be available: RAW.

## RAW

As you saw in Chapter 2, "How a Digital Camera Works," a RAW file isn't really an image file format; rather, it contains the data gathered by the camera's image sensor *before* any post-capture processing is applied to it. A RAW file is a "recipe" to make an image. And just as you can modify or improve a recipe for a food dish, with RAW processing software you can also modify the RAW recipe and change certain aspects of how the image looks.

RAW gives you the most creative control and editing flexibility. Since the RAW format is "unprocessed," you can compensate (within reason) for exposure deficiencies in the capture during image processing. Although RAW offers unprecedented control in how you can process the captured image, for some people, RAW's primary disadvantage is that it adds additional steps to the workflow. You can't simply open the image directly into Photoshop or another program. You must convert the RAW file to a common image file format, using either the camera manufacturer's proprietary software or other products such as Adobe Lightroom, Apple Aperture, Adobe Camera Raw (which comes with Adobe Photoshop), or other programs. Many consumer-level photo sharing and editing applications, such as Apple's iPhoto, also offer the ability to view RAW files from some cameras as long as the software is up to date and offers support for your particular camera. We feel the extra conversion step is a small price to pay for the considerable creative choices and nondestructive workflow that RAW provides. If your camera supports a RAW format, and maximum quality and control over the image processing are important to you, we recommend choosing the RAW format over JPEG (see the sidebar "The Case for RAW"). For more on integrating RAW images into your imaging workflow using Lightroom, see Chapter 8, "Working in the Digital Darkroom."

## RAW + JPEG

For those times when the convenience of JPEG is still important, such as when you need to hand off files to a client right after a shooting session or for the simple reason that you're not totally confidant with RAW processing yet, many cameras offer the ability to shoot in RAW + JPEG mode. This mode saves a RAW file along with a JPEG version of each shot. The downside to this approach is that it reduces the number of photos that can be saved to the memory card. But for some situations it may be the perfect compromise between the ease of use that JPEG offers and the full control and image quality available in a RAW file.

## The Case for RAW

When faced with a choice between using JPEG and RAW for our photographs, we almost always choose RAW. Our bias here has less to do with JPEG compression issues and more to do with the "no turning back" nature of JPEG. Once an image is captured and recorded in the JPEG format, all the camera settings, such as sharpening, saturation, contrast, white balance, and exposure compensation, are irrevocably applied to the photo. With RAW, the image is left untouched by the camera, leaving you to apply these settings at your discretion in a RAW conversion program. This means, essentially, that you get a second chance to evaluate the image on a large monitor and decide which settings suit it best. And you can do this repeatedly, since the original RAW image remains untouched. Additionally, shooting in RAW gives you access to the higher bit depth captured by your camera's image sensor; JPEG files are limited to 8 bits.

We really appreciate the control and flexibility available in the RAW format. It's not that we have commitment issues, but few things in life are as flexible as a RAW digital capture combined with all the possibilities that programs like Lightroom and Camera Raw offer, and since that flexibility is there for us, we like to take advantage of it. With JPEG, you can never go home again. With RAW you can go home as often as you like and are always welcomed with open arms.

Despite our bias toward RAW, we do realize that this format is not ideal for everyone or every situation (for instance, fast-action photos that require shooting multiple frames per second for a sustained period or product shoots and event photography that involve hundreds of images and controlled lighting). But for most images, RAW is our format of choice.

## JPEG Settings: Image Size and Compression

If you are shooting JPEG, of all the menu settings you can make at the camera level, arguably the most important in determining final image quality are image size and compression. ISO and White Balance are two other important settings that can affect image quality, but they apply to both RAW and JPEG files and we'll cover them later in this chapter.

The image size in pixel dimensions is the primary determinant of how large a print you can make, and the compression level affects the quality of the image once it's written to the memory card in the JPEG format. Other settings, such as sharpening, saturation, and contrast adjustments, can also affect the quality of a JPEG image, of course, but they usually show up farther down in the menu system, so we'll cover them a bit later in this section.

## Image size

Most cameras offer a number of size settings to choose from. Cameras may identify image sizes in their menu as large, medium, and small; or they may use terms like *full* or specify an exact pixel size, such as "10M 3648x2736" (**Figure 4.1**). *Large* or *full* is typically the largest image size that the camera can produce and in most cases reflects the actual size of the camera's sensor in terms of pixel resolution. Some cameras may also offer a resolution that is slightly different than the largest size to provide a different aspect ratio. If the menu choices don't list a specific pixel dimension, you'll have to resort to your camera's manual to determine the exact pixel dimensions of each setting. If you're shooting in RAW format, you do not have a choice of image size, since RAW is always recorded at the largest size the camera can produce. What you plan to do with your image, as well as how many images you want to fit onto the memory card, will determine which settings you use.

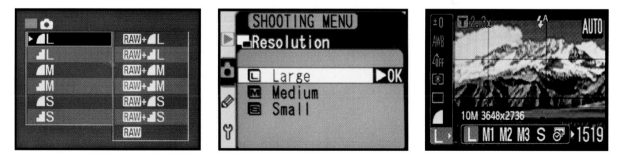

**Figure 4.1** *Cameras specify image size options using different terms.*

The intoxicating prospect of storing hundreds of images (or thousands, depending on the capacity of the card) on a single memory card might tempt you to choose a smaller image size. The only circumstances in which we would advise this approach is if you know you'll never need to make larger prints or if you find yourself pressed for space on the storage media and

have no choice at that moment. If making high-quality fine prints is your main concern, we recommend always setting the image size as large as the camera will allow (actually our recommendation for that goal would be to shoot in RAW). More pixels equal a larger file size, but more important, they also mean more detail and more flexibility if you have to make adjustments to the photo at a later time. As the saying goes, "It's better to have it and not need it than need it and not have it" (**Figure 4.2**).

**Figure 4.2** *Shooting with a larger image size (more pixel resolution; left) gives you greater flexibility and better quality if you need to crop the image later (right).*

Capturing images at the highest pixel resolution offered by your camera is crucial for making fine digital prints, but we realize you won't always have printmaking in mind. If you plan on using the image only for email or to advertise an item on eBay, you might choose a smaller size. Photographs for online catalogs or other uses that have a short shelf life are also candidates for a smaller image size. Even if your image is only destined for the Web, there's a lot to be said for photographing it at a larger size. This allows you to crop or enlarge it, as well as zoom in close to do fine detail work in an image-editing program. Another reason to shoot at larger image sizes is so you can use the image for other purposes at a future time where you may need a higher resolution. Shooting at a larger size gives you more options.

```
Date/Time       08/10/'10 14:10
Picture Style   Standard
Detail      ◐3, ◑ 0, ⚛ 0, ◐ 0
Color space     Adobe RGB
WB SHIFT/BKT    0, 0/±0
Register camera settings  P
⚡-⅓   📷 1 min.   📷On
🗀100 🗋4337           5200🄺
🗀1.8 GB available      🄸🄾200
```

**Figure 4.3** *Check to see if your camera provides quick access to an info summary screen so you can see all the important settings in a single screen.*

**❗ TIP** Because digital cameras allow you to change image size (as well as file format, compression, ISO, white balance, and so on) on a shot-by-shot basis, it's easy to select a small image size and then forget about it. If you move on to new images that require a larger image size, you may not realize that you've been shooting lower-resolution images until it's too late. To avoid such calamities, get in the habit of doing a quick "preflight" check of the camera settings each time you start photographing a new assignment or you move your location. Some cameras provide a summary of all the critical settings in a single screen (**Figure 4.3**). Better yet, check whether your camera allows you to save a group of specific settings as a user-defined preset.

## Compression: JPEG

When using the JPEG format, one crucial decision is how much compression to apply. The decision is always a compromise between image quality and the number of files you can fit on the memory card. Unless you need to cram as many images as possible onto the card or the final quality is not that crucial, we recommend always using the setting that delivers the highest image quality (lowest compression level). JPEG compression degrades the image, and when applied at higher compression levels, the artifacts and flaws it introduces can wreak havoc with the fine details of an image (see the sidebar "The Lowdown on JPEG Compression"). In most cases, a high-quality compression setting produces excellent image quality and generates compact file sizes that allow you to fit many images onto a memory card.

Remember that the level of compression works hand in hand with image size in terms of final image quality. Seán once had a student in a basic digital photography class who conscientiously set the compression to high quality for her first trip through Europe. When she returned from her vacation, she realized that she had forgotten to check the camera's image size settings and all of her pictures had been recorded at the smallest size. She was dismayed to discover that the quality of the enlargements was below her expectations, and she had to be satisfied with slightly soft 5-by-7 inch prints instead of the 8-by-10s she was hoping for. Cultivating an awareness of your camera's settings and checking them often will ensure that you're always capturing the image quality you need.

# The Lowdown on JPEG Compression

JPEG achieves its incredibly small file sizes by using a clever compression scheme that modifies the pixels in an image so they can be described using less data. At the heart of this procedure is the way the JPEG format "sees" your image by breaking it up into sections. JPEG analyzes the pixels in the file in 8-by-8-pixel blocks (64 pixels at a time) and compares the color variation between pixels in the block to identify the average color. Once it determines the average, it examines the rest of the pixels in the block and throws out information that will be imperceptible to the human eye. If a pixel is close to the average color, for example, its color will be changed to match the average. Those pixels that are far from the average will be adjusted to make them a closer match. Taking advantage of the fact that human visual perception is less sensitive to changes in color than in luminance (brightness), the color values in the 8-by-8 blocks are changed more than the luminance levels. By averaging colors in this way, JPEG can write the file using less information, resulting in a much smaller file size.

In the magnified view of eight levels of JPEG compression (**Figure 4.4**), you can see how the color values have been altered from quality level 12 down to level 2. It should be noted that these JPEG samples were prepared using an uncompressed file in Photoshop to illustrate how JPEG compression affects the pixels in an image. Digital cameras do not offer this many levels of compression.

**Figure 4.4** *Eight detail views showing how JPEG compression changes the colors of pixels in an image. View A is the uncompressed image, and views B through H show progressively higher amounts of JPEG compression.*

For some people, the specter of *lossy* compression (meaning color information is irreversibly changed) is enough to steer them away from the JPEG format. Digital cameras, however, do a very good job of compressing their images as long as you select the best quality setting (the lowest level of compression). At high-quality settings, most digital cameras will produce images indistinguishable from an uncompressed shot of the same scene. With a properly exposed photo, high-quality JPEG can be an excellent format that provides good quality and convenience for the average photographer. For those who demand the ultimate in control over post-capture adjustments, however, the RAW format offers much more flexibility.

# ISO

The ISO setting determines a digital camera's sensitivity to light. As the ISO rating doubles, the light sensitivity of the image sensor also doubles—or it can be considered twice as "fast." This is similar to how the ISO rating works for film. Unlike with film, however, where the ISO is the same for an entire roll, digital cameras let you change the setting on a shot-by-shot basis. This provides you with tremendous flexibility in your photography. You could shoot at ISO 100 in the bright sunlight for most of the day, for example, and then quickly to switch to ISO 400 or much higher if you suddenly found yourself in heavy shade or went indoors.

With film, the chemical recipe used to create the light-sensitive emulsion determined the ISO sensitivity. As you saw in Chapter 2, even though a digital camera offers different ISO settings, the image sensor has a specific sensitivity that can't be changed. To increase the effective ISO setting, the sensor's signals are amplified as they are handed off for internal processing by the analog-to-digital converter. In this respect, the ISO setting on a digital camera has more in common with the volume control on your stereo, since it just "turns up" the signal from the sensor, allowing the camera to be more sensitive in lower light levels.

## Choosing an ISO setting

Most compact and point-and-shoot cameras have ISO settings that range from 100 to 1600. Many also offer an auto-ISO feature as the default setting. This setting is usually equivalent to 100 or 200 in well-lighted conditions, but it automatically rises when light levels are low. More advanced cameras offer a wider range of ISOs—up to 6400 along with an ISO expansion or "boost" feature that makes ISO ratings of 25,000 or more possible. Keep in mind that using a higher ISO setting, especially in low-light conditions, increases the likelihood that noise will appear in the image, although the noise levels on newer pro DSLRs at ultra-high ISO settings are still remarkably good. The amount of noise you will see in an image will be affected by the characteristics of the individual sensor (including the size of the sensor—expect to see more noise on images from compact cameras) and the camera's image processor (**Figure 4.5**). Proper exposure can also have an effect on noise levels, no matter what the ISO setting is, and noise is more likely to be visible in underexposed images. Like film grain, noise tends to rear its ugly

head more often in darker areas of the image (**Figure 4.6**). To see how image quality is impacted by ISO on your camera, take some test shots in a dark environment at different ISO settings and evaluate them on a computer to determine your personal tolerance for image noise. If you are shooting JPEG, be sure to use the largest image size possible and view the images at 100% to see the best display of fine details.

**Figure 4.5** *An old radio photographed with an inexpensive compact camera (left) and a full-frame sensor DSLR (right). Both images were shot at ISO 1600, but the smaller sensor of the compact camera yields an image with more noise.*

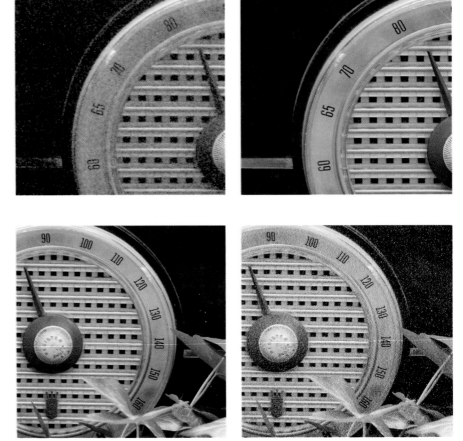

**Figure 4.6** *Two test shots from a Canon 5D: Though both were photographed at the same ISO (3200), the image on the right was underexposed by 2 stops, and after lightening it in Adobe Camera Raw the noise is quite apparent.*

Since the ISO setting you choose will be influenced by the type of photographs you're taking and the lighting conditions you're in, there's no "right" ISO setting, but there are some general guidelines you can follow:

- **Low ISO for minimal noise.** If your main concern is capturing the best image quality with the least amount of noise, use low ISO settings. Every

camera is different, of course, and this is where making test exposures at different ISO settings can be very valuable in helping you decide on the ideal setting for different types of images. If you find that the shutter speed at a given ISO is too slow for a handheld shot, choose a wider lens aperture or use a tripod. If you don't have a tripod, stabilize the camera by resting it on a table, the roof of your car, a tree stump or wall, or another object. When all else fails, try bumping the ISO up to a higher number.

- **Higher ISO for low light or fast capture.** For low-light photography or situations where you need to react fast to changing conditions or capture motion (and using a tripod is not an option), higher ISO settings will provide you with a wider range of exposure options. Most high-end and professional DSLRs produce excellent results with surprisingly low noise levels at ISO settings of 1000 to 3200. And the ISO expansion or boost feature on many cameras can produce very serviceable images even at ultra-high ISO settings of 25,000. Higher ISOs are appropriate for times when you must use a fast shutter speed that's not available with a lower ISO or if there simply isn't enough available light for hand-held photography.

- **Auto ISO.** Many cameras offer an Auto ISO setting where the camera will adjust the ISO as the lighting levels change. Most Auto ISO features base their choice of ISO on the ability to use a shutter speed that is fast enough for handheld photography. If you'd rather not worry about keeping track of the ISO, Auto ISO may be way to go.

## Using Noise for Creative Effect

Back when film was the primary medium used for making photographs, many photographers developed an appreciation for the look of certain film grain and would use a particular film stock not only for its increased sensitivity to light, but also for the aesthetic qualities of its grain pattern. Unfortunately, digital noise is not quite as attractive as film grain, and the presence of too much noise in an image may prove disappointing, especially if you're used to the look of film grain. We find it's better to capture images with little or no visible noise and then add a grain effect later in Lightroom, Camera Raw, or Photoshop where we have more control. Noise in a digital capture can be minimized to a certain extent by using image-editing software, but the result is never as satisfying as if the noise levels were low or nonexistent to begin with. The best noise-reduction strategy we can advise is to try to avoid it in the first place. For those times when circumstances beyond your control leave you with no choice in the matter, we cover noise reduction in Chapter 8.

# White Balance

Photography is all about light (the Greek word photography derives from phos and graphis meaning "light writing"), but not all light is created equal. Different sources of light produce illumination with different color characteristics. A digital camera's ability to record an image with an accurate color balance is largely determined by the *White Balance* setting. Before we delve into the nuances of white balance and digital photography, let's take a quick look at the science behind it.

## Color temperature

The term *color temperature* is used to describe the color of light, but it doesn't refer to the thermal value of the light (in other words, heat); rather, it refers to the visual appearance of the light. Color temperature is always measured in Kelvins, or K, a unit named for Lord William Thompson Kelvin, the 19th-century Scottish physicist who first developed the absolute temperature scale. In photography, the Kelvin scale describes the relative intensity of red to blue light. Lower temperatures describe light that is warmer, or redder in appearance; midrange temperatures refer to light that is white, or neutral; and the highest readings indicate light that has a cooler, or bluer, appearance (see the sidebar "Color Temperature: Don't Try This at Home"). On the warm end of the scale, you might find light created by candles or standard lightbulbs (1000K to 2500K). In the middle of the scale is typical daylight and electronic flash (5000K to 5500K). And on the cool side is open shade and overcast days (7000 to 10,000K). **Table 4.1** lists different lighting conditions and their approximate color temperatures.

**NOTE** Some light sources are by nature nonspecific and subject to influence from other factors (altitude, atmospheric conditions, and so on); therefore, the color temperatures given here are approximate.

**Table 4.1** *Approximate Color Temperatures for Common Light Sources*

| | |
|---|---|
| 1000K | Candlelight, firelight, oil lamps |
| 2000K | Sunrise |
| 2500K | Standard household lightbulbs |
| 3200–3400K | Tungsten photo lights: studio hot lights, photo floodlights |
| 5000K | Typical daylight, electronic flash |
| 5500K | Daylight-balanced films; electronic flash |
| 6000K | Bright sunlight, clear skies |
| 7000K | Slightly overcast skies |
| 9000K | Open shade on a clear day |
| 10,000K | Heavily overcast skies |

Although different sources produce light with varying color temperatures, the amazing thing about human vision is that our eyes and our brain continuously balance the colors, no matter what the lighting may be, so that we see a scene with a reasonably accurate color balance. If you leave an office building that is lit with ordinary fluorescent lights, which are closer to the green end of the spectrum, and walk out into the sunlight, you don't notice any major changes in the color balance of the objects you're viewing. Even with such a sophisticated visual system, however, there are still situations where we notice that some light sources produce illumination that's noticeably "warmer" (early morning, late afternoon, or candlelight) or "cooler" (shade or twilight).

Cameras, unfortunately, are not nearly as advanced as the human visual system, though the image sensors in digital cameras do have an edge over film. You've probably seen photos from film cameras that were taken inside under typical household lighting with no flash. An image made under those conditions usually exhibits a strong yellow color cast (**Figure 4.7**). The reason is that film emulsions are manufactured to produce a response that matches a general category of illumination, such as daylight. If daylight-balanced film is exposed in normal household lighting, the color balance tips toward yellow because the film is designed to produce a balanced response at 5500K, whereas the illumination indoors is a cooler color temperature (and has a warmer appearance) of about 2500K.

Indoor

Outdoor

**Figure 4.7** *In an indoor shot with no flash; typical household lightbulbs create a strong yellow color cast. When the same subject is photographed outside, the color balance is more neutral.*

With film, the choices for color balance were limited to daylight and tungsten lamps. If you needed to make further adjustments, you had to rely on color-correction filters. Digital cameras, on the other hand, make no assumptions about the type of light you're shooting in until the image data is processed by the camera's software. The decision the camera makes about how the colors in an image should be rendered is determined by the White Balance setting. At the most basic level, the camera uses white balance to accurately reproduce white. If you get the white balance right, all the other colors should also be accurate.

## Color Temperature: Don't Try This at Home

One of the most confusing aspects of color temperature is that light with a warmer appearance has a lower temperature, whereas light that exhibits cooler, bluer characteristics is said to have a higher temperature. This is, of course, completely counterintuitive to our normal association of cooler with lower temperatures and warmer with higher readings, but there is a method to this madness.

The key to this seemingly backwards scale can be traced back to 1899 and the German physicist Max Planck's experiments with thermal radiation and black body radiators. In physics, a black body is a theoretical object that absorbs all wavelengths of thermal radiation falling on it, reflecting no light and appearing totally black at low temperatures. When heated, however, a black body emits thermal radiation. At lower temperatures, this radiation is invisible to the human eye, but as the temperature increases, the radiation becomes visible as the black body begins to glow and give off its own light.

To bring this discussion into the realm of common experience, imagine a darkened kitchen and a black, cast iron frying pan on the stove with the burner turned up to high. Once the iron pan gets hot enough, it will begin to glow a dull reddish color (1000K). As the temperature increases, the color of the glowing metal shifts to orange and then yellow (2000K–3000K). As the pan becomes hotter still, the color of the superheated metal transforms into a yellowish-white (above 3000K). By the time the color of the frying pan reaches 5000K, it will be glowing white-hot. Continued color temperature increases past 7000K shifts the color of the glowing iron pan into the blues of the higher frequency regions of the visible spectrum.

The incendiary nature of this experiment moves us to caution you against trying it out in your own kitchen. It's much safer as an imaginary exercise to help you understand where color temperature comes from. Real experiments with black body radiators are better left to trained professionals who possess the necessary equipment and stylish blast furnace fashions to protect themselves.

## Choosing a White Balance setting

By setting the White Balance in a digital camera, you're specifying the type of light source that's illuminating the scene. There are a variety of different settings that affect the camera's interpretation of the white balance in a scene. Here is a rundown of how these settings work:

- **Auto White Balance.** All digital cameras offer an Automatic White Balance (AWB) feature. With AWB, the camera evaluates the scene and tries to find the brightest point that is close to white. From this reading it determines the White Balance setting for the scene. Some AWB systems perform a more advanced evaluation that factors in many different areas of the scene and performs complex calculations to arrive at a white balance decision.

  AWB works quite well in most situations, although this can vary depending on the image processor in the camera and the type of lighting. The main advantage of using AWB is the convenience of not having to remember to change the setting when the lighting changes. One of the advantages of shooting in RAW is that White Balance is not a "permanent" setting, and you can easily fine-tune the white balance of photographs in your RAW processing software.

  As with any auto feature, however, there are times when it can be fooled, especially if the image lacks any tone that is close to white, is dominated by one particular color, or when you're photographing in low-temperature illumination, such as with tungsten lightbulbs. Even in scenes that do have obvious white areas, the presence of very bright specular highlights (a highlight that is totally white) can also throw off the AWB and prevent it from determining the correct white balance for a scene (**Figure 4.8**). Subtle white balance color shifts can be hard to see and evaluate on the LCD monitor on the back of the camera, particularly in bright sunlight. If you are photographing under a controlled or consistent light source, such as in a studio, it's best to use a custom white balance to fine-tune color temperature settings.

**NOTE** Many cameras offer an AWB Bracketing feature. This will typically take three shots, one set to what the camera's AWB recommends and two others that are warmer and cooler. If you are unsure of the White Balance setting, this can help you decide which White Balance setting is best for the scene. We cover this in more detail in Chapter 5, "Seeing the Light."

**Figure 4.8** *In this photo, a tungsten light source and the presence of very bright specular highlights in the background prevent the AWB feature from finding a correct white balance.*

- **White balance presets.** Most digital cameras offer a choice of white balance presets that are designed for specific lighting conditions. Standard choices include Daylight, Shade, Cloudy, Tungsten (sometimes labeled Indoors or Incandescent), Fluorescent, and Flash. Although settings such as these are useful for those times when they match the lighting you are in, we've found that the AWB feature on most cameras does an excellent job of figuring out the approximate color temperature of the lighting and adjusting the camera accordingly. The one exception to this is tungsten lighting. Even with AWB the shot is likely to turn out too yellow for most people's tastes. In this case, choosing the tungsten white balance preset gives you a more balanced shot. The main drawback to using white balance presets is that it's easy to forget to change the setting back to auto if you move to another location where the lighting is different.

If you find you're shooting in tricky lighting, you can always make a few test shots with the camera set to the white balance preset that most closely matches the existing light. Fluorescent lights are likely to have

the most variance from the setting your camera offers, simply because so many different types of lights fall under this general category. As with any camera setting that can affect image quality, we recommend testing the white balance presets in the appropriate lighting before you're on an actual shoot. By making test photos and then evaluating them on your computer, you'll be better able to predict how a certain preset will perform under different lighting conditions (**Figure 4.9**).

**Auto White Balance**

**Daylight**

**Figure 4.9** *Besides AWB, standard color temperature presets included on digital cameras are Daylight, Shade, Cloudy, Tungsten, and Fluorescent.*

**Shade**

**Cloudy**

**Tungsten**

**Fluorescent**

**NOTE** Several useful products are designed to help in setting a custom white balance, either before taking the image or when processing the RAW file. You can find a listing of some of these products in Chapter 3, "Essential Accessories."

- **Custom white balance.** Some deluxe point-and-shoot cameras and nearly all DSLRs provide the capability to set a custom white balance based on the lighting at any given location. You usually do this by photographing a white object, such as a sheet of paper or a gray target, under the specific lighting conditions you want to adjust for. The goal is to shoot a normal exposure, since an underexposed or overexposed shot can give an incorrect white balance. In the camera's Custom White Balance mode, you then select this image as the source, and the camera calculates the custom white balance. The exact steps for determining a custom white balance may vary depending on your camera, and you may need to select custom white balance first and then point the camera at a target object and press the shutter button. If you don't have a sheet of white paper or a gray card handy, you can also get by using something that is a neutral tone, such as a gray sidewalk. Custom white balance is highly useful if you are in situations where the scene is illuminated by mixed light sources, such as daylight coming in through a window to blend with tungsten and fluorescent lights (**Figure 4.10**).

**Figure 4.10** *The image on the left was photographed using the camera's AWB setting. For the image on the right, a Custom White Balance setting was used based on the illumination at the location and results in a more accurate color balance.*

- **Setting a manual color temperature.** Some higher-end cameras let you select a specific color temperature. This can be useful if you're using a color meter to determine the accurate color temperature of the lighting in a scene and want to be sure that the camera matches it exactly.

At high altitudes, for example, the color temperature of the light is likely to be much higher, which produces photos with a cooler, or bluer, appearance. Although the Automatic or Custom White Balance feature may handle this condition with ease, if you're precisely measuring the color temperature using a color meter, you may find it useful to set a specific temperature. Even if you're not using a color meter, you can still make test shots and experiment with manual settings to determine which one gives you the color balance you need.

Understanding how your camera handles white balance and how to modify the settings is important because it can affect the appearance and color quality of your images. Shooting in RAW provides more flexibility for making changes to the white balance in the digital darkroom. We cover white balance as it pertains to crafting a well-exposed image in Chapter 5.

## Sharpening, Saturation, and Other Enhancement Options

Since some people may find the initial image as delivered by the camera too "soft," cameras typically have a sharpening option to produce JPEG images that look sharper and more finished. Fortunately, many cameras allow you to choose the level of sharpening applied, or even to turn it off completely. Our view on the sharpening feature is unanimous: If your camera provides you with a way to disable it, turn it off for good.

The reason for our impassioned view is that sharpening is a destructive process that permanently alters the color and contrast of edge pixels—areas of the image where light and dark colors are adjacent to each other. The camera just sees a bunch of pixels and applies a sharpening amount based on canned formulas that are hard-wired into it. A camera doesn't know what your photograph requires or how you might want to use sharpening, so the sharpening it applies may not be appropriate for the image. This is especially true if you plan to make prints, since the amount of sharpening that you apply is influenced by the subject matter and the size of the final print.

**NOTE** Camera settings that apply sharpening or modifications to image contrast, brightness, or color saturation only affect JPEG images and are not applied to RAW files.

We have the same philosophy when faced with options to alter contrast, brightness, and color saturation: Turn these features off! All of these decisions and enhancements are best applied later in an image-editing program, where you can apply them in a way that complements the specific image and in a flexible manner that doesn't harm the original (**Figure 4.11**).

**Figure 4.11** *The image on the left is a detail view showing a photo with no in-camera sharpening applied. The image on the right is the same subject with in-camera sharpening turned on. Although the sharper image may initially look better, it offers less flexibility in terms of image editing and printing.*

## Color Space Settings

Digital cameras, monitors, scanners, and televisions all create color using the RGB color model, which is based on red, green, and blue, the three additive primary colors of light. Within the range, or gamut, of RGB colors there can be different subsets of colors, known as *color spaces,* that describe different gamuts within the overall RGB color model. A simplified way to think of this is to imagine a large container that holds all the colors you can see. Within this container are several smaller containers, or color spaces, with each one describing a slightly different range of colors. Some of the containers might have more greens and cyans in them, for instance, whereas others have more oranges and reds. Some containers may also have more intense, or *saturated,* colors than others. Color spaces with a larger gamut can contain more colors than smaller-gamut color spaces.

Most entry-level, point-and-shoot digital cameras do not offer a choice of color space settings. They create color based on an industry standard color space known as sRGB. Microsoft and Hewlett-Packard developed sRGB, basing it on the color gamut of the average, inexpensive monitor (aka the lowest common denominator). Many deluxe point-and-shoot cameras and higher-end DSLRs offer a choice between sRGB and Adobe RGB for the JPEG files they create. The difference between these two color spaces is primarily gamut size; Adobe RGB has a much larger gamut than sRGB (**Figure 4.12**).

**Figure 4.12** *These two views from the 3D gamut-graphing feature of the program ColorThink (chromix. com) compare the gamuts of sRGB—shown as a solid color shape—with Adobe RGB (1998), shown as a wireframe.*

If your camera offers you a choice, the best choice depends on what you ultimately need to do with the image. If you're only concerned with emailing photos to friends and family, creating images for the Web, or making prints for scrapbooks or photo albums, there's nothing wrong with choosing sRGB. However, if your work consists of creating professional, exhibition-quality prints or if you're shooting images destined for reproduction on a printing press, Adobe RGB is the better choice. In reality, all color spaces involve compromise and there is no single ideal color space. But if you have to decide between the two, we recommend Adobe RGB. Camera color space settings only apply to JPEG images. Because RAW files are unprocessed, these settings do not affect them. Color space for a RAW file is assigned in the RAW conversion software.

> **NOTE** The question of which color space setting to use on your digital camera is moot unless you have a calibrated monitor with an accurate monitor profile and you use reliable printer-paper-ink profiles when you print. Selecting Adobe RGB in the camera's settings is not a magical cure-all for color problems you may be experiencing further down the image-editing pipeline. We cover calibration and printing issues in Chapter 9, "From Capture to Monitor to Print."

## Additional Camera Settings

Besides the basic settings we've already discussed, you should be aware of a few others:

- **LCD brightness.** Many cameras feature an LCD brightness control that allows you to increase or decrease the brightness level of the LCD screen. If you are in bright sunlight trying to review your images, bumping up the brightness of the LCD may help you to see the display better, although this can also throw off your perception of the actual tonal values in the scene. It's better to keep the LCD brightness at a set level and use other methods to get a better view of the LCD screen, such as using an LCD viewing hood or the jacket off your back to create shade.

- **LCD/system sleep.** This determines the length of inactivity (in other words, not pressing any buttons) required before your camera enters a sleep or standby mode. If you want to conserve your battery, choose a relatively short amount of time such as 15 to 30 seconds; if you want the camera to be always at the ready, set a longer interval. If your camera has a separate setting for LCD standby, choose the shortest time available. If you don't use the LCD for framing the image but rather rely on the optical viewfinder, see if you can turn off the display for all but reviewing purposes. The less the LCD is on, the longer your batteries will last.

- **Setting the date and time.** This is pretty straightforward, but it's definitely something you want to do before you take any photos. Digital cameras record the date and time of day you created an image, as well as other information, and include it with the image file (see the section "Metadata" later in this chapter). Computers can also use dates to sort images, so having an accurate date and time attached to your images is important. Although having the accurate time may seem like a trivial detail, it can be very useful to know the time of day a photograph was taken. For world travelers, see the sidebar "Managing Capture Times Across Different Time Zones."

- **File-numbering options.** Digital cameras name files using a combination of letters and sequential serial numbers (such as DSC_2051.NEF or IMG_0406.CR2). Although this filenaming scheme is hardly useful if you have to sort through countless folders of digital photos, it does provide a starting point. On many cameras you can specify how you want to handle the numbering sequence.

  Continuous Numbering continues the number sequence even after you've changed storage media. This setting ensures that all your shots will have discrete numbers, preventing you from accidentally overwriting an earlier image with the same file number. Cameras usually assign an upper limit to the numbering scheme, such as 9999, beyond which they'll start over again at 0001.

  Auto Reset, or Auto Renumber, automatically resets the file number to 0001 whenever you replace the storage media card. The main drawback to this system is that if you are not careful with how you organize your files, newer files could accidentally overwrite earlier images with the same name. If you store your images from each session in separate folders, there is less of a chance of conflicting filenames, but the possibility does exist.

We all use Continuous Numbering and batch rename the camera files when downloading or importing them into an image-management application, such as Lightroom. We'll cover using Lightroom to batch rename files in greater detail in Chapter 8.

## Managing Capture Times Across Different Time Zones

If you are shooting images in different time zones, you may be wondering whether it makes sense to change the camera's time to match the local time. You certainly could do this, but the primary drawback is that it's very easy to forget this setting when you get back home. As a result, all the new photos you take after returning will have an incorrect time stamp.

An easier way to deal with this is to change the time stamp using your image management program, assuming it offers such a feature. Although we may change the actual camera time stamp for extended multi-week trips to a single time zone, more often than not we simply take advantage of a very useful feature in Lightroom that provides an easy way to apply a time zone shift to the capture times for our image files. In the Library module, choose Metadata > Edit Capture Time to access this command. It allows you to shift the capture time by a set number of hours based on the time difference in the location where you took the photos. For example, when Seán returned from a short trip to Hawaii, he simply selected all the images he took there and used this feature in Lightroom to shift the capture time on all those files by minus 3 hours, which represented the time difference between Honolulu and California (**Figure 4.13**).

If you have lots of images from years past that need conversions and you're not sure of the exact time difference or you also want to factor in daylight saving time, check out the handy conversion calculator at www. timeanddate.com/worldclock/converter.html.

**Figure 4.13**

*Using Lightroom's Edit Capture Time dialog to adjust the capture times of images based on time zone differences.*

# Formatting the Memory Card

When you first use a memory card, you should format it using the camera's formatting option to prepare the card for use with that camera. Although some cameras let you shoot with an unformatted card, certain camera-specific features may not function properly until the camera has formatted the card. You should also reformat each time you need to erase a card—for instance, when you want to reuse it and take new photos. Formatting a card erases the directory structure on the card. The images are not removed from the memory card until new images replace them, but with no directory structure referencing the files, you can no longer view them. Since this action is irreversible (there's no Undo command), be sure you're not wiping out important images that have not been backed up yet. See the sidebar "Recovering Deleted Files from a Memory Card" in case you inadvertently reformat a card with important images.

When you hook up the card to your computer to download photos, either via a card reader (highly recommended) or directly from the camera, you may be tempted to delete the files you've already transferred by dragging the folders on the card to the computer's trash can or recycle bin. We caution against this and recommend formatting the card in the camera to delete the files. Although there may be no harm in deleting images on the card from your computer, it's best to format the card in your camera. Since the primary purpose of the card is to be the place where the camera saves its image files, it makes sense to let the camera do it so that the card is optimized for use in that device. If you have more than one type of digital camera, we recommend having dedicated media cards for each one. Not all cameras can read cards formatted in other cameras, so rather than risk losing images, we dedicate media cards to each camera to avoid the card formatting issue.

We also suggest that you reformat the card after every use instead of simply deleting the files using the camera's erase command, because the File Allocation Table (FAT) is regenerated with each new format. As with any computer file system, data corruption can slowly build up over time; formatting the camera media card after confirming that you have safely downloaded and backed up the images before each use ensures that you'll start with a clean slate.

To ensure that the photos you have downloaded are fine and do not suffer from any file corruption issues (rare, but it does happen from time to time),

import the images into your digital editing or file management program (e.g., Lightroom, Adobe Bridge, Aperture, BreezeBrowser, etc.) before you reformat the memory card. If the program can generate thumbnails and large previews, the files should be fine. You should also make a backup copy of the images on a separate hard drive before the card is reformatted. Hard drives do crash, so having duplicate copies of important images on a different drive is one way to guard against such hardware failures.

---

### Recovering Deleted Files from a Memory Card

In some cases, images that have been erased from a memory card, either by deleting files on the card or by formatting the card, may be able to be recovered using special software designed for this purpose. Programs such as Image Rescue by Lexar (lexar.com) and Card Rescue by WinRecovery (cardrescue.com) take advantage of the fact that in most cases deleting files or formatting cards only removes the directory structure that indexes what files are stored on the card, not the actual files. By inventorying the card and building a new directory structure, "lost" files can sometimes be recovered and saved to a specified folder on your computer.

Keep in mind that if you have deleted files or reformatted the card and then used it to store new photos, this will limit the number of files that can potentially be recovered since the newer files replace the previously saved files on the card. Depending on the problems affecting the files and/or the memory card, some recovered files may still have corruption issues that can render them unusable.

---

# Exposure Modes

Digital cameras usually provide several exposure modes for your photographing pleasure. Although most cameras do a pretty good job when left on autopilot, you gain more technical control and opportunity for creative image making when you explore the other exposure modes. Although the modes vary, some are common to nearly every camera. Typically, these include a semiautomatic mode where you make certain exposure choices and the camera handles the rest; a full manual mode; and possibly

a selection of scene modes that are designed for specific situations. Before considering what each exposure mode is and what it offers you, let's look at the basics of photographic exposure.

## What Is Exposure?

In photography *exposure* is the moment when the light strikes the film or sensor and the image is recorded. Three factors combine to determine the correct exposure for a digital image: the amount of light in the scene that strikes the image sensor (controlled by the lens aperture); the length of time that the sensor is exposed to the light (controlled by the shutter speed); and the sensitivity of the sensor (determined by the ISO setting). The importance of a good exposure cannot be overstated. If an image is overexposed, the highlights will be completely white without any tonal information (**Figure 4.14**). If an image is grossly underexposed, the image will be dark and lack shadow detail (**Figure 4.15**).

**Figure 4.14** *When an image is grossly overexposed, the brightest highlights are rendered as white with no detail. In the histogram for the image, the vertical bars representing the tonal values for the highlights are pushed up against the right side of the graph, indicating lost highlight detail.*

**Figure 4.15** *When an image is severely underexposed, the darkest shadows are rendered as black with no detail. In the histogram for the image, the vertical bars representing the tonal values for the darker parts of the image are pushed up against the left side of the graph, indicating lost shadow detail.*

Although it is possible to improve moderate exposure mistakes using image-editing software, no amount of digital darkroom magic can save a picture that is extremely overexposed or underexposed. Fortunately, camera light meters are very sophisticated instruments and do an excellent job of determining the settings for a proper exposure in most common photographic situations. However, by changing any of the three main settings, you can gain control over certain characteristics that can influence the look of the image. We'll examine in great detail how light meters see the world in the next chapter.

## Aperture

*Aperture* refers to the opening of the iris, or diaphragm, in the lens that can be adjusted to let more or less light hit the image sensor. One way to think of aperture is to imagine a funnel in which the large end is the lens gathering the light and the small end is the aperture that controls how much light reaches the image sensor in a given period of time. Aperture is measured in

f-stops, and each full stop represents a factor of two in the amount of light admitted. Thus, "opening up" a lens from f5.6 to f4 will admit twice as much light, and "stopping down" from f11 to f16 will cut the amount of light in half (see the sidebar "What's in an *f*-stop?").

## What's in an *f*-stop?

If you've ever been confused as to the origin of the term *f-stop* or what the numbers refer to, you're not alone. Although those numbers engraved on the lens ring (or illuminated on the LCD panel) may seem arbitrary, they really do mean something. The f-stop is the ratio of the focal length of the lens to the diameter of the opening in the aperture. On a 50mm lens, for example, when the aperture is opened up to a diameter of 12.5mm, this results in an f-stop of f4 (50/12.5 = 4). Standard f-stops used on lenses for film cameras are f1.2, f1.4, f1.8, f2, f2.8, f4, f5.6, f8, f11, f16, and f22 (**Figure 4.16**). Depending on the lens, the actual range of f-stops may vary. Large-format cameras typically have f-stops that go down to f-64.

**Figure 4.16** *An aperture consists of a bladed iris with an opening that can be made larger or smaller to let in more or less light. This illustration shows several standard lens apertures.*

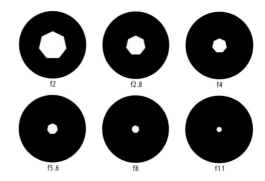

Each change in f-stop either halves or doubles the amount of light that enters the lens. In this admittedly unintuitive numbering system, smaller numbers indicate a larger opening and larger numbers indicate a smaller opening, and the presence of fractional numbers only complicates the matter. If you wanted to adjust the aperture one stop down from f4, to let in half as much light, common sense would tell you that the next stop should be f8, not f5.6. The reason for this seemingly odd number thrown in between f4 and f8 is that apertures are circular openings, and the mathematical realities of dividing the area of a circle in half sometimes produces a fractional number instead of a whole number.

Apart from controlling how much light passes through the lens, the aperture is also one factor that affects depth of field (the others are the focal length of the lens, the size of the image sensor, and the distance between objects in the scene). *Depth of field* is the area of the image that appears in focus from foreground to background and is one of the main ways that you can change the appearance of an image (**Figure 4.17**). We'll cover depth of field in more detail later in this chapter.

**Figure 4.17** *You can achieve a shallow depth of field (less area in focus) by using a larger lens aperture and deeper depth of field (more area in focus) by using a smaller aperture.*

## Shutter speed

If we continue with the same funnel analogy that was used to explain the aperture, the shutter is the valve that controls how long the light flows through the lens and onto the image sensor. The smaller the aperture, the longer it will take a given amount of light to flow through the funnel and the longer the required exposure will be. Shutter speeds are measured in extremely small fractions of a second, and speeds on DSLRs range from 30 seconds up to 1/8000 of a second. Every camera is different, of course, and your mileage may vary. The range of shutter speeds on compact cameras is not as large as those found in DSLRs. The function of the shutter is similar to aperture in that each successive change in the shutter speed either halves or doubles the exposure time. Using standard shutter speeds as an example, 1/125 of a second is half as much exposure as 1/60 but twice as much as 1/250.

In addition to controlling how long the light is exposed to the sensor, the shutter speed also impacts how motion is rendered in a scene. Speeds below 1/40 of a second are likely to result in motion blur when moving subjects are photographed, and very fast shutter speeds of 1/1000 or higher can do an excellent job of freezing even very fast movement in a scene. Just as depth of field can be used creatively to affect the look of an image, shutter speed is also an important creative control (**Figure 4.18**).

**Figure 4.18** *In the photo on the left, the shutter speed was 1.3 seconds, resulting in the water in the stream being blurred. For the photo on the right, the shutter speed was 1/800th of a second, freezing the movement of the bicyclists racing down the hill.*

## The beauty of reciprocity

Aperture and shutter speed work together to create a proper exposure in a given lighting situation. Because of the way they function, you could take several shots, each with a different aperture and shutter speed, and produce several images that all had equal exposure. You could use a wider aperture for a shorter amount of time, for instance, or a smaller aperture for a longer amount of time to admit equivalent amounts of light. Another way to look at this is that opening up the lens aperture by one stop is exactly the same as decreasing the shutter speed by one setting; each doubles the amount of light for the exposure. And increasing the shutter speed by one setting has the same effect on exposure as stopping down a stop to a smaller aperture. This give-and-take nature of the aperture-shutter speed relationship is known as *reciprocity,* and it's one of the most effective exposure tools available to photographers (**Figure 4.19**).

A

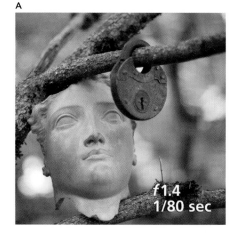

f1.4
1/80 sec

B

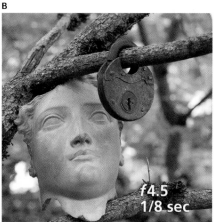

f4.5
1/8 sec

C

f8
1/3 sec

D

f22
2.5 sec

**Figure 4.19** *Reciprocity in action: Four photos of the same scene, each with a very different shutter speed and aperture, yet all have the same exposure (in other words, the same amount of light reached the sensor). The only noticeable difference in these images is greater or less depth of field, depending on the aperture. All images were photographed using a tripod.*

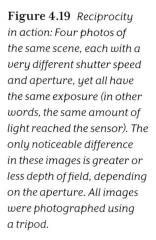

**NOTE** Many photographers who are familiar with film exposure know the term reciprocity from a phenomenon called reciprocity failure. This is essentially a breakdown of the normal reciprocal relationship between aperture and shutter speed that tends to occur at either very fast or very slow shutter speeds. This has nothing to do with the actual aperture or shutter speed in the camera, but rather how the film emulsion reacts to very short or long exposure times. Typically, the problem is more an issue with longer exposures, such as those that are more than a second in duration. With film, reciprocity failure can create exposure problems and color shifts due to the chemical nature of film emulsions. Digital cameras create images based on an electrical response as opposed to a chemical one, and although we can't speak for every image sensor now or in the future, in the tests we've made, we haven't noticed reciprocity failure with long digital exposures.

**NOTE** In an effort to make this example more straightforward, we chose to use an aperture-shutter speed scale similar to what you might find on a traditional film camera. In addition to standard 1-stop exposure adjustments, many cameras, film and digital, offer adjustments in increments of 1⁄2 to 1⁄3 of a stop. Computer-driven shutters on digital cameras can also generate unconventional shutter speeds, such as 1⁄729 of a second (try calculating reciprocity with that!).

The benefits of reciprocity come into play when your camera meter recommends a certain exposure, but you need to change either aperture or shutter speed to produce a desired creative effect. Let's say you're photographing a flower, and the camera's light meter indicates that it will use a shutter speed of 1/2 of a second and an aperture of f11. Although this might yield a correctly exposed image, an aperture of f11 would produce too much depth of field, making the background details too distinct and distracting. If you were using a manual exposure mode, you could take advantage of the reciprocity principle to quickly (well, reasonably quickly) calculate an equivalent exposure that would give you a wider aperture and throw the background out of focus. If you decided that an aperture of f2.8 would produce the desired shallow depth of field, you'd increase the aperture by 4 stops (f8, f5.6, f4, f2.8); that would require an equivalent adjustment of the shutter speed. Opening the lens aperture to f2.8 lets in more light (16 times as much in this case); so to balance out the exposure you would need to shorten the amount of time the shutter is open by 4 stops—to 1/30 of a second. For the final exposure of the flower, the shutter speed is at 1/30 and the aperture is at f2.8. This produces exactly the same exposure (in other words, the same amount of light reaches the sensor) as the initial camera meter's suggestion of 1/2 at f11, but the differences between the two images is significant (**Figure 4.20**).

**Figure 4.20** *In the photo on the left the exposure is a 1/2 second at f11. In the photo on the right, the exposure is 1/30 of a second at f2.8. The amount of light reaching the image sensor is exactly the same for both images.*

Fortunately, unless you're operating on full manual mode or you just enjoy the intellectual challenge, when used in Aperture or Shutter Priority mode, cameras will automatically calculate the reciprocal aperture and shutter speed values for you. This makes it easier to concentrate on the image and choose the settings that will give you the right creative look. We'll cover exposure considerations in greater depth later in this chapter and also in Chapter 5.

## Full Auto Mode

Nearly all modern cameras provide a fully automatic mode that does everything for you but compose the shot and decide when to press the shutter button. Full Auto mode evaluates the lighting; selects the ISO, white balance, aperture, and speed settings; and even decides whether the scene needs a little extra light from the built-in flash. This is a good mode to use if you're new to digital photography and you still don't know much about your new camera but you want to take pictures right away—or when you need to hand the camera to someone else to take a picture of you.

Keep in mind that some camera features, such as the abilities to change the ISO, adjust the exposure with exposure compensation, and shoot in RAW format, may not be available in Full Auto mode. To gain an extra level of control and customization while enjoying the ease of automatic operation, you may have to use another automatic mode that is commonly called Program.

## Program Mode

Program mode is similar to Full Auto mode in that the camera selects the appropriate aperture and shutter speed to deliver the correct exposure for the scene you're photographing. You also have the ability to modify the settings the camera has chosen by shifting the aperture–shutter speed combination to select a mix that better serves your creative goals (reciprocity in action). On DSLRs you usually make this adjustment by dialing a control wheel until you arrive at a desired aperture or shutter speed, something you can do without taking your eye away from the viewfinder. On compact cameras or deluxe point-and-shoot models, the procedure may be more cumbersome: You usually have to manipulate a series of buttons, requiring you to take your eye away from the camera. Program modes also offer access to more advanced features of the cameras, such as shooting in RAW format,

exposure compensation, higher ISO settings, and choosing a custom white balance. Because it offers the convenience of being fully automatic with the flexibility of changing some of the settings, you may find that Program mode works well for many situations.

## Aperture Priority Mode

Aperture Priority can be thought of as a semiautomatic mode because it relies on you to decide which aperture to choose while the camera supplies the appropriate shutter speed. Once you select a given aperture, the camera constantly adjusts the shutter speed in response to changing exposure conditions, but the aperture remains the same. This mode is an excellent choice for images where depth of field issues take precedence over shutter speed. A wider aperture causes the background to be more out of focus, and a smaller aperture yields a photo with more areas of the image in focus. Aperture Priority is excellent for portraits where you want only the subject in focus (use a smaller $f$ number for a larger aperture) and for scenic shots where you want good depth of field throughout the scene (use a larger $f$ number for a smaller aperture).

## Shutter Priority Mode

Like Aperture Priority, Shutter Priority is a semiautomatic mode. You decide what shutter speed you want to shoot with, and the camera chooses the correct aperture. Shutter Priority is ideal for situations where exposure time is more important than depth of field. If you need to freeze motion, such as with sports or birds in flight, using this mode allows you to select an appropriately fast shutter speed. If your aim is to use motion blur creatively, such as the classic rendition of moving water in a stream, you can also use Shutter Priority to choose a slow shutter speed. Depending on the speed of the object you're trying to blur, you may need to use a tripod so that stationary elements in the image remain sharp.

## Manual Mode

With Manual mode you have to do all the work. Well, maybe not all the work. The camera does provide a light meter to tell you if your settings will give you a properly exposed image, but you have to turn the dials or push the buttons and make sure that aperture and shutter speed are set correctly.

Although a Manual mode is essential for photographic control geeks (like the three of us) and those who want as many creative options as possible, it's not as spontaneous as some of the other modes, and realistically you may only need to control either aperture or shutter speed to achieve the effect you want. For some situations, however, such as night photography and in the studio, having a Manual mode is critical.

# Scene Modes

Scene modes are preset configurations that are designed for you to use under specific shooting conditions to achieve good results without having to think about the optimal camera settings. They're not exposure modes you would use all the time. You'll find these modes on many digital cameras, from compact point-and-shoot models all the way up through advanced DSLRs. The actual names and modes vary from camera to camera (other terms we've heard include Best Shot and Creative Assist modes), and depending on their features, some cameras may offer more sophisticated interpretations. But here's a rundown of some of the most common scene modes:

- **Portrait.** The main feature of this mode is that it will try to soften the focus of the background while keeping the main subject sharp. The degree to which the background is thrown out of focus depends on a number of factors, including the amount of light available, the distance between the subject and the background, the maximum aperture and focal length of the lens, as well as the size of the image sensor (compact cameras cannot create the same shallow depth of field that is possible from a DSLR). Some cameras may also use a Center-Weighted metering pattern to give emphasis to the center portion of the frame. Center-Weighted metering is common in portrait situations. See Chapter 5 for detailed coverage of how a camera's light meter works.

- **Night portrait.** This mode is for portraits of people or any photo where the subject is relatively close to the camera, at twilight or at night. If such a scene is photographed normally, the flash will fire and the camera will expose for the immediate foreground subject, leaving the background very dark and underexposed. In Night Portrait mode, the camera uses the flash and also chooses a slower shutter speed, creating a balanced exposure between the main subject and the darker background. The exposure for the main subject and the background will look good. Some cameras have a mode that is similar to this called Slow-Sync Flash (**Figure 4.21**).

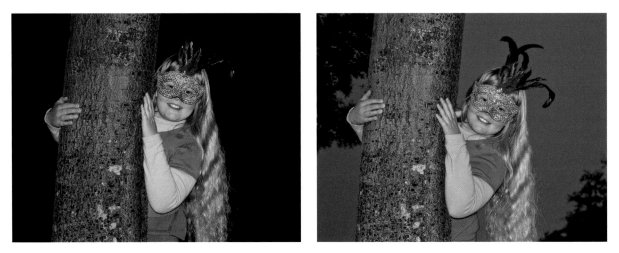

**Figure 4.21** *Night Portrait mode uses a longer exposure (slower shutter speed) to create a good exposure for a dark background, combined with a fill flash to properly expose the foreground. The photo on the left uses a regular auto flash and shows the dark background; on the right is the same scene photographed using Night Portrait mode.*

- **Landscape.** Whereas Portrait mode chooses as wide an aperture as possible for shallow depth of field, Landscape mode uses a small aperture to produce the deep depth of focus commonly associated with scenic images. Be aware, however, that some cameras may be doing a bit more behind the scenes than simply choosing an aperture for good depth of field. The manual for one of Seán's compact digital cameras claims that the Landscape mode will "enhance outlines, colors, and contrast in subjects such as skies and forests." This suggests that the camera is actually applying more aggressive sharpening, contrast, and saturation adjustments when it processes the image—and subsequent testing proved this to be true. Before you rely on any scene mode, it's a good idea to run some tests and see how it affects image quality.

- **Night Landscape.** This is useful when you want to photograph cityscapes at night or twilight views of grand vistas. It cancels any flash operation, sets the focus distance to infinity, and uses slow shutter speeds to gradually build up an exposure of a night scene. Due to the slower shutter speeds, a tripod or other stabilizing surface may be necessary.

- **Beach/Snow and Backlight.** These two modes are very similar and are designed to compensate for photographing very bright subjects.

When a camera light meter tries to evaluate a scene such as a beach or a snowy field on a sunny day, the brightness reflected from the sand or snow can confuse the meter and lead to an image that is too dark. A mode designed for photographs of beach and snow scenes adjusts the exposure so that the scene will be properly exposed (**Figure 4.22**). The Backlight mode does essentially the same thing but is used for situations where the light is coming from behind your main subject or the background is brightly lit. The Backlight mode chooses a shutter speed–aperture combination that creates a proper exposure for the foreground subject. On some cameras, the flash may fire in Backlight mode to fill in the shadows on a person's face. Although the name Beach/Snow Mode may suggest that it should only be used for those type of scenes, it can be effective in any situation where you are photographing a bright subject that reflects a lot of light.

**Figure 4.22** *The darker photo is a result of the camera's meter being fooled by the bright reflected light on the snow. When the Beach/Snow scene mode was used, a correct exposure was captured that better represented the real appearance of the scene.*

- **Close-Up/Macro.** This scene mode is typically offered on compact or deluxe point-and-shoot cameras (macro photography with DSLRs involves using a special lens that is designed for close focusing). Depending on the camera, this mode selects a range of settings designed to produce a better close-up photo. On compact cameras, all this may amount to is extending the zoom lens all the way and adjusting the AF (auto focus) sensors for close focusing. On some cameras the flash will

go off; on others it won't. Still other cameras may employ some form of camera-shake reduction to help with handheld shots. Even though the close-up capabilities of compact cameras are limited by the camera's built-in lens, the macro features on many compact models can be quite impressive (**Figure 4.23**).

**Figure 4.23**  *This iris was photographed using the Super Macro scene mode on an entry-level Canon Powershot A480.*

- **Sports.** This mode is optimized for photographs where you want to freeze the action at sporting events and on fast-moving subjects. The actual functionality that this mode offers greatly depends on the capabilities of the camera. Features such as auto focus speed, AF servo focus (the ability to track a moving subject), variable-focus sensors, and the speed of the continuous-shooting drive are all put to work when you use this mode on a DSLR. Compact cameras and deluxe point-and-shoots, which don't have the advanced focus and drive features of DSLRs, generally offer an exposure mode that is biased toward faster shutter speeds and a drive setting for taking a series of multiple shots.

- **Black and White/Monochrome.** For those times when you want to create a black and white photo with no hassle, this is the mode to use. On

some cameras the Black and White mode may only be available when shooting JPEG files. If you are shooting in RAW+JPEG, the JPEG file will be black and white and the RAW file will still retain all color and editing properties. But we prefer to take our images in color and convert to black and white using an image-editing program, since that gives us the most flexibility to creatively interpret the file The only reasons we can think of to use a Black and White or Monochrome mode is if you don't have the time or experience to make the conversion in another program, or if you're new to viewing the world in gray tones and actually seeing the image in black and white on the LCD helps with the composition and subject matter you've chosen. Otherwise, we don't recommend shooting in Black and White mode.

• **Other modes.** The variety of scene modes is limited only by the imagination of camera manufacturers. Some of the modes are useful in relatively limited circumstances, such as a Fireworks mode or a mode designed to copy documents (espionage mode?).

# Metadata

Metadata is not a setting or mode that you'll find on your camera, but your camera is generating lots of metadata every time you take a picture. To use a simple definition, *metadata* is information about information. More specifically, metadata is structured information about a collection of data—such as an image file—that makes accessing and using that file more efficient and productive.

Advances in the digital management of information have underscored the importance of metadata among different professional disciplines, but the concept has been around for a long time. Distance scales, notations, and legends on maps, for example, qualify as metadata since they are essentially information about the map, which in itself is just information about a specific geographic area (**Figure 4.24**). Dictionaries also feature metadata in the form of a dictionary guide that tells you how to interpret the different information you'll find listed in the word definitions.

**Figure 4.24** *This explanatory note on a nautical chart is metadata that provides further information about the symbols and markings found on the chart.*

For digital photographers, the metadata associated with image files represents important information about their photos that can be a very useful tool to aid in the management and organization of an image collection. Metadata allows you to sort and filter photos by a variety of criteria and, if you're taking advantage of the ability to add descriptive keywords to your files (which we strongly recommend), it can help you easily and quickly find specific images. The more information associated with an image file, especially in the form of keywords, the more potential value that file has—not just possible monetary value (though that is certainly an important aspect of putting metadata to work for you), but also the simple value that comes from being able to locate an image you're looking for. Though it may not be as exciting as a new lens, metadata is just as important as any other piece of gear in a photographer's camera bag.

## EXIF

For most digital cameras, metadata consists of a record of the settings that were in effect when an image was photographed. This information typically includes data such as the date and time the image was created, pixel resolution, shutter speed, aperture, focal length, ISO, white balance, metering pattern, and whether the flash was used. The information is saved using a standard format called Exchangeable Image File (EXIF).

At the most basic level, EXIF data can be a useful tool to help you improve your photographic technique. Because it keeps track of basic exposure information, you can study it to learn what the settings were on photos that worked and on images that had problems. For example, if you notice that several images from a session are slightly out of focus and others have sharp, clear details, a quick check of the EXIF data for the soft images might reveal that the camera used a slower shutter speed for them than it did with the sharp photos (see the sidebar "Accessing Camera EXIF Data"). This knowledge can help you make different exposure decisions the next time you're shooting in similar conditions.

Records of exposure information may be useful, but that's only the beginning of many possible uses for metadata. As mentioned previously you can also add descriptive keywords to facilitate faster searching and retrieval from an image database. Other uses for metadata include adding your contact and copyright information to all your images (many programs allow you to do this as the files are downloaded to your computer); adding captions, location details, and GPS coordinates, as well as specific client and job information; and tracking image usage for photographers who license their photos. For further discussion on adding keywords in Lightroom, see Chapter 8.

## Accessing Camera EXIF Data

The camera EXIF data for an image can be easily viewed using common image management and editing software, from the simple image browser application that comes with your camera to more full-featured programs such as Bridge, Lightroom, and Aperture. One thing to realize, however, is that all programs may not display every parameter recorded by the camera. This is due to the inclusion of proprietary "MakerNote" EXIF information that is specific to individual cameras. Common MakerNote EXIF data that is only displayed by software made by the camera manufacturer includes information such as which Custom Functions, white balance presets, or scene modes were used in an exposure. To see everything that the camera records, try using the imager browser software that came with the camera.

# Taking the Image

Once you've taken the time to configure the camera's settings so that the technical quality is assured, it's time to think about what else goes into making an interesting and successful photograph and how to use your camera to achieve those ends. If you're already a seasoned photographer, some, if not all, of the topics we're about to cover may be familiar to you. But it's worth noting that although traditional framing and compositional guidelines can be applied to all photos, with digital photography, certain aspects need to be treated differently than they would with a film image.

## Framing

When we view any scene, no matter what the lighting conditions may be, we have the benefit of the world's fastest and most advanced auto focus, as well as sophisticated light metering and white balance systems that have yet to be rivaled. We're talking about the human eye here, of course. The way a camera sees an image and the way we see it are very different, and what we view with our eyes is never exactly the same as what is recorded by the camera. Predicting how the camera will capture the lighting and the different planes of focus in a given scene is something that comes only with experience and knowing how your camera and lens will respond. Although you may be somewhat at the mercy of factors such as lighting, focal length, aperture, and shutter speed, you do have total control over how to frame the image.

The rectangle of the viewfinder is the canvas where you compose your photographs. It's been said that painters include, whereas photographers exclude. Painters begin with a totally blank canvas, which they proceed to fill in with brush strokes to render the scene they want the viewer to see. Photographers begin with the cluttered jumble of reality in their viewfinder and selectively exclude all but the most vital aspects of the photograph they see in their mind's eye. If there is something in a scene that painters don't want in the painting, they will simply not paint it. But if photographers are faced with the same situation, they must employ creative framing to exclude any elements they don't want in the final image (**Figure 4.25**).

**Figure 4.25** *By carefully considering how you frame an image in the viewfinder, you can eliminate distracting details, or find a better composition. In many cases, you can do this simply by moving closer to the subject (right).*

## Horizontal or vertical?

The rectangular or square aspect ratio of most camera viewfinders can be a blessing and a curse. In some regards, it can make composition easier since it defines the shape where you must compose the image. On the other hand, since our view of the world is not limited by rectangular constraints, we often find we must work around the narrow window on the world that the viewfinder provides.

If your image format is rectangular, the first choice you face is whether to frame the image horizontally or vertically. Many novice photographers use horizontal framing because most camera designs encourage you to hold the camera in a horizontal orientation. Until you become used to it, using vertical framing requires a conscious effort to rotate the camera. Depending on your photographic experience and your skill at seeing images amid the visual confusion of reality, deciding on a horizontal or vertical frame may come easily to you, or it may take some practice. Certain subjects will obviously lend themselves to one or the other, of course. But others are not so easy, and some may work well with both methods. Above all, try to be conscious of not falling into the routine of taking all your images as horizontals (**Figure 4.26**).

**Figure 4.26** *Horizontal or vertical? Both of these shots are good photos of the subject, but the vertical one is a stronger composition that fits the subject better and makes good use of the prominent diagonal element in the scene.*

When you look at a scene, put away any preconceived ideas about how it should be framed and try to distill it down to just the basic shapes and colors. Using this approach, you should be able to see whether elements in the image suggest a horizontal or a vertical view. Some scenes, such as landscapes and large group portraits, are obvious candidates for the horizontal frame. The vertical frame is ideal for images where there are strong vertical lines, such as soaring skyscrapers, towering trees, or the classic head and shoulders portrait pose. But even with images where the orientation of the frame seems clear, be open to trying a different approach, because you might find a new and better composition that didn't occur to you at first (**Figure 4.27**). When in doubt deciding which frame orientation will work best, go ahead and take the image as both a vertical and a horizontal.

**Figure 4.27** *Don't be afraid to break the rules if that results in a better photo. Some subjects are obvious candidates for a vertical composition, such as the photo on the left. But they might also work well as a horizontal. You'll never know unless you try!*

## Experiment with angles and different points of view

Don't think that just because the camera presents you with a rectangle that you are just limited to horizontal and vertical. Remember that you have 360 degrees of rotation available to you. Can you find anything interesting when you tilt the camera so you view the scene at a diagonal? Such a view may give the scene more of an abstract feeling, but there's nothing wrong with that if it creates an interesting image.

Change the point from which you view the scene, and you may discover new images that weren't apparent in your initial composition (**Figure 4.28**). If you first took the image from an eye-level standing position, get down low and see how it looks from closer to the ground. Look around you and try to imagine how the dynamics of the composition might change if you moved to the left or right. It's even easy for experienced photographers to fall into a

visual rut and automatically compose an image a certain way, or in the way they've done it in the past. If your first idea is to take the photograph with a specific composition, go ahead and do it, but then try to find at least two other compositions for the scene.

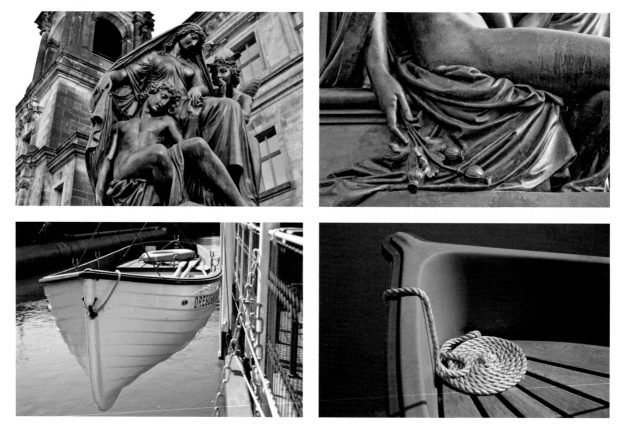

**Figure 4.28** *Two examples showing the initial photos of a scene and better compositions that were discovered after viewing the subject from different angles. Don't settle for the first composition that comes to mind. Explore different angles, framing, and viewpoints.*

If you're traveling through a scene, especially if you're on foot, don't forget to look back every so often to see how the view changes while you are walking away from it. There's an old saying: "You can't know where you're going unless you first know where you've been." We think this is great advice for life in general, but it also works well for photography. It's natural to concentrate on where you're going and to anticipate the new views and images

you may see around the next bend in the road. But we have found many great and often unexpected images simply by looking back over the path we have already walked. For one thing the lighting is likely to be different, and in many cases, that alone is enough to create a compelling new image. The dynamics of the scene will also change, and you may see new relationships between certain elements in the image or between the foreground and background that create an entirely different photograph than what you saw when you were only looking ahead.

# The Importance of Cropping in the Camera

Some photographers like to frame the image a little loose so they can have some extra room to apply a specific crop later when the image is printed. For example, when framing an architectural photo with a traditional film camera, a photographer may frame the initial composition and then step back one or two steps, or zoom the lens to a wider view, to allow for some straightening and cropping.

## Making every pixel count

With digital photography, however, cropping is not a practice we recommend. The reason is that cropping a digital photograph means that you are throwing away pixels and effectively lowering the megapixel resolution for that particular shot. If you shoot a horizontal photo with a 12-megapixel camera, for example, and then decide later on that it works better as a vertical, the act of cropping it to the different orientation will turn the original 12-megapixel images into approximately a 6-megapixel image. By halving the resolution of the image, you also halve the file size and drastically affect how large that image can be printed. To avoid this, don't waste any of the viewfinder area. Take advantage of every pixel that the image sensor has to offer and fill the entire frame with the image you want to capture.

If you're shooting image elements that will be composited into a separate multi-image collage, consider framing your shots to take advantage of the diagonal width of the viewfinder. This will give you more usable pixels than if you had filled the frame either horizontally or vertically. The difference is a small one, admittedly, but if you're trying to maximize pixel resolution and the image will be used in a collage where the diagonal orientation won't be an issue, this is one way to increase the pixel count (**Figure 4.29**).

**Figure 4.29** *By framing the Statue of Liberty so that she filled the diagonal width of the viewfinder, the maximum number of pixels was used to capture the statue. Although not an option for a "straight" photo of the statue, the diagonal slant to the image is no problem for photos that will be used in multi-image collages.*

## Get closer

Robert Capa, the famous photographer who covered many of the major armed conflicts in the middle part of the twentieth century, once said, "If your pictures aren't good enough, then you're not close enough." We think this is excellent advice, although if you're seeking the job title of combat photographer, you have to exercise caution at how literally you apply this motto to your own photography: Capa died in 1954 when he stepped on a landmine while he was covering a small regional conflict in a country called Indochina (later to become Vietnam).

If you are not in a combat zone, however, and you need to move closer to the scene, then by all means do so. One of the most common mistakes that even serious amateur photographers make is including more in the frame than is necessary. Get close to your subject, and then move closer still. Try to fill the frame with only the elements that are essential to the image. Pixels are precious in digital photography, so don't waste them on things that dilute the main subject (**Figure 4.30**).

**Figure 4.30** *Get closer! Use as much of the viewfinder as possible and distill the composition down to the essential elements.*

Don't be lazy and rely on the camera's zoom lens to do the job for you (unless you're standing at the edge of the Grand Canyon or some other equally formidable precipice). Move closer first. If you are photographing people, of course, there's a limit to how close you can get before the moment is ruined or the person you are photographing becomes ill at ease or downright annoyed. Once you are as close to the scene as you can get, then use the zoom lens for fine-tuning the composition to exclude any extraneous elements that detract from the primary image.

## Details, details, details

Getting physically closer to what you're photographing will also help you see details more clearly, and that, in turn, may lead you to discover new photographs and new relationships between different elements in the scene. One exercise you can do to remind yourself to look for the details in a subject is to take the initial shot and then make a point of moving much closer for a second shot, and then closer still for a third shot. Since you're shooting digital, if you chance to discover more interesting compositions from your close-up vantage point, there's nothing to stop you from taking even more photos (apart from a full memory card). **Figure 4.31** shows a photograph of two old tow trucks that have both seen better days and a close-up detail view of one of the trucks.

**Figure 4.31** *By moving in close to examine the fine details of one of the trucks, intriguing patterns and textures in the rusted metal and peeling paint are revealed.*

The closer you get, the more abstract the image may become, but that's a big part of the discovery process that makes photography so rewarding. Finding an interesting image where you weren't expecting it is one of the great joys of creating photographs.

## Image Relationships

Most photographs are pictures of scenes we view with our eyes, whether it's a child playing, a still life, an African landscape, kayakers on a lake, or a busy street scene in New York City. We say "most photographs" because extremely fast or slow shutter speeds can also reveal images that we can't see, such as star trails in the night sky or Dr. Harold Edgerton's ultra-high-speed photograph of a speeding bullet shooting through an apple. Beyond the concept of photography as a representation of what we can see, however, a photograph is also an arrangement of elements within a square or rectangular area (the frame). The relationship of these elements to one another—whether they are actual objects or simply areas of light, shadow, and color—is one of the factors that separates a photograph with a good, visually interesting composition from a photograph that's just another picture. Consider the following:

- **The importance of the frame.** The frame is the stage on which you present the performance of your image. How you use the stage can take an ordinary picture and turn it into a creative photograph. The frame can be busy and cluttered with lots of activity that gives it an edgy sense

of tension, or it can be quiet and orderly, imparting a feeling of calm and balance. How elements interact with the edges of the frame can also be very important to the composition, as can the use of white space or "empty" areas that can be used to create a frame within the frame.

- **Balance.** The rectangle of the viewfinder gives you a frame that contains the image. Within this frame the arrangement of image elements can be balanced using either a symmetrical or asymmetrical approach. Symmetrical balance is apparent in images where the subject is centered or where different areas of equal size, whether they are actual objects or simply areas of light and shadow, create a balanced arrangement within the frame. One way to use asymmetrical balance is to create a triangular arrangement that juxtaposes two smaller elements with a larger one. The two smaller elements create the counterbalance for the larger object or image area (**Figure 4.32**).

**Figure 4.32** *In the image on the left, the symmetrical design of the train station lends itself to a formal, balanced composition. In the image on the right, an asymmetrical balance is formed by the juxtaposition of the larger foreground tree with the road and smaller trees in the background.*

- **Foreground/background.** How the foreground and background elements relate to each other is one of the key factors in a photo. Does the background inform or comment on what is happening in the foreground? Or is it a distracting element that is unrelated to the foreground subject? The relationship between the foreground and the background can be subtly changed through effective use of depth of field. Whenever you compose a shot that has a distinct foreground element,

take a moment to survey what is happening in the background. This is good practice just to be sure that there is nothing in the background showing up that you don't want in the photo, but in some cases you may see something that would work well if it was included.

- **Size, position, and point of view.** The size of image elements and the way they are viewed contribute to their importance in the overall image, as does how they relate to each other. By composing an image so that certain elements are larger, for instance, you focus attention on those areas and give those elements more importance in the final image. This approach can often be successful in images that focus on smaller or more mundane objects that we usually don't pay much attention to (**Figure 4.33**).

**Figure 4.33** *The size of image elements and their relationship to each other can be used effectively in a composition to draw the viewer's attention to a specific area, to make a visual comment, or to give importance to ordinary objects that we may see every day.*

- **Line, form, and color.** The camera is ideally suited to examine the world and isolate intriguing compositions of form and color. In some photographs, the subject is not necessarily any specific object in the image but the lines, shapes, and colors that exist within the frame (**Figure 4.34**). Lines can be employed to direct the viewer's attention within the image, and they can also be used as a subject, creating abstract patterns. Cities are great places to look for images with strong lines (**Figure 4.35**).

**Figure 4.34** *In this photograph of a swimming pool at night, the image is not so much about the pool as it is an exploration of lines, shapes, and color.*

**Figure 4.35** *The lines in this architectural study create an interesting urban abstract.*

- **Light and shadow.** Photographs exist because of light, so the interplay of light and shadow can often make for compelling images, even with subject matter that might be thought of as ordinary (**Figure 4.36**). Whether the shadows are cast by recognizable objects or represent only a close-up detail of a larger shadow, you can usually find interesting images lurking in the shadows. High-contrast lighting, normally the bane of digital photographers, can be highly useful for creating intriguing relationships between light and shadow.

**Figure 4.36** *Harsh, high-contrast light, normally a very challenging condition for digital cameras, can be used to great effect when concentrating on the images formed by highlights and shadows.*

- **Use of motion.** Movement, either in the subject being photographed or movement of the camera itself, can affect an image in intriguing ways. If you cherish the idea of serendipity or random chance in the image-making process, incorporating the trails of movement as seen by a slower shutter speed is a great way to create images whose final appearance is a mystery until after the shutter has closed. For images where the motion of a moving subject is recorded as a blur but the background is sharp, you'll need to use a tripod, since these effects generally entail slower shutter speeds that are not appropriate for handheld photography. If you're using the camera to create the movement, however, no tripod is needed. Even images that would not be remarkable when photographed

in sharp focus with no motion can be transformed into very interesting and surprising compositions by using a slow shutter speed and moving the camera during the exposure (**Figure 4.37**).

**Figure 4.37**  *Using a slow shutter speed and moving the camera during the exposure (also known as drag shutter) can create interesting and unexpected images. In this 4-second exposure, the camera was panned to follow the man as he walked across the scene.*

- **Use of focus.** For the photographic purist, crisp, sharp focus is one of the standards by which any photographic image is measured. In the 1930s, Group f64, which included such visionaries as Ansel Adams, Edward Weston, and Imogen Cunningham, promoted "straight" photography (as opposed to the soft focus "painterly" or pictorialist photographs that were still popular at the time). One of the hallmarks of this approach was a sharply focused image with great depth of field. But images with incredible depth of field and tack-sharp focus represent only one type of photograph among many possible interpretations. The use of shallow depth of field, for instance, is one of the most effective ways to direct the viewer's attention to specific areas in a photo. Selective focus also is particularly well suited for visually conveying the vague and subjective sense of memory or emotion. And even though an image with crisp, sharp focus can be a thing of beauty, don't feel compelled to worship at the altar of precise image clarity if it doesn't serve your creative vision for an image (**Figure 4.38**).

**Figure 4.38** *Sharp focus certainly has its place in photography, but the use of soft focus, or even an image with no obvious point of focus, can be an effective creative tool. In the case of this image, a motion-blurred view of a praying mantis out for a twilight stroll is more an interpretive abstract than a representational study.*

- **Breaking the frame.** The first item in this section referred to the importance of the frame. Just as important, however, is realizing that the frame is not sacred. You should push the edges now and then to see what you find. Try composing an image that consciously violates all the principles of "good composition" and see if the results intrigue you enough to follow that road a little farther. The immediate feedback of the LCD, as well as the cost-free nature of digital exposures, gives you a safety net as you experiment with a radical framing idea. Do all portraits have to be centered? No. Do you even have to include the entire face of your subject? Not necessarily. By going out of your way to push and break the boundaries of the traditional frame, you may discover a new way of composing images that works quite well for certain subjects (**Figure 4.39**).

**Figure 4.39** *By "breaking the frame" and making a photo that violates all the traditional rules of photographic composition, you might discover an image that works well for a particular subject or that helps to create a certain feeling or emotion.*

- **Taking risks.** Chance, serendipity, and fortunate accidents are all important to any creative undertaking, whether that process involves industrial design, poetry, sculpture, painting, or photography. It stands to reason that if you always follow the same routine when taking pictures, chances are good that you will consistently make images that look similar. Although this is not negative in any way, and consistency is advantageous when learning any new discipline, there is much to be gained by trying new photographic techniques. When you change or, better yet, discard your routines, you unlock the potential for discovering something new and fresh. True, by taking risks with your image making there is the very real possibility of a card full of disappointing images that never quite got off the ground. But there's also the chance that you'll find an outstanding image where you least expected it or create a cool visual effect out of the ordinary ingredients of daily life. Besides, it's digital—it doesn't cost anything to experiment except a little of your time!

# Digital Photography Is Photography

In various places throughout this book, there are occasional comparisons between digital and film photography. In the end, the differences are really no more than technical and procedural details. Photography is point of view, framing, and timing. In that regard, digital photography is fundamentally no different than film photography. Only the tools have changed.

Digital tools have changed not only the technical aspects of photography, but the personal as well. For many people, digital photography has reignited their interest and passion for photography. With digital photography, it's much easier to explore the world visually with a camera and share your explorations with family, friends, and the rest of the world. Instant feedback and the ability to delete bad shots translates to a perfect learning environment for improving your photographic skills. Although you may not be keeping all your photos, don't be too quick to delete the bad shots. Take time to study the failed images so you can see why they didn't work. Everyone can recognize an image they are disappointed with, but knowing what went wrong is the key to taking better photos in the future.

Just as you can learn from the bloopers, so can you learn from the photos that do work—study your successful images as well. Remember what worked in those images as you look through the viewfinder. Make more images like them, and make better images, too. Above all, take more pictures! Photography is all about seeing, and the more you look, the more you will see. A practiced eye is one of the best tools a photographer can have. If you are used to looking for good images, you'll find them. Give your eyes plenty of practice. Digital photography makes this easier than ever.

# Seeing the Light

<span style="font-size:200%">5</span>

John Muir, the eminent naturalist and wilderness explorer, recognized the important part that light played in creating a memorable scene. In his book, *The Mountains of California*, he wrote, "It seemed to me the Sierra should be called not the Nevada, or Snowy Range, but the Range of Light." During his many years of travels in the Sierra Nevada, he had numerous opportunities to see how the high country light could transform a landscape. He recognized that, as powerful as the mountain vistas were, the light, ever changing, filtered by mist, clouds, rain, and snow, added mystery and majesty to the jagged peaks and sheer walls of granite.

In photography, light is everything. It brings a scene to life. It establishes a mood and influences the emotional impact of an image. Even photos made in the dark of night, far from artificial light sources, are the result of moonlight or starlight building up over time to form an exposure. The character and quality of light can have a great influence on a photograph, and understanding how a camera "sees" light is fundamental to producing a good image.

One of the most important skills a photographer needs is the ability to visualize the photograph—seeing the picture in your mind's eye and understanding how the camera will interpret the scene. Beginners see what they *know* is there and are often disappointed that the picture doesn't convey the mood or meaning that they saw when they took it; photographers learn to see what the camera sees and to work with the light and camera controls to craft the image they see in their mind's eye.

Digital cameras offer an impressive array of automatic features and can almost always be relied on to produce a decent picture. But making a *good* photograph requires an understanding of the principles of photography and knowing how a camera translates the light in the scene into the photo captured by the image sensor. The difference between an ordinary picture and a good photograph is the difference between just pointing and shooting, and consciously working with composition, light, and camera controls to create a memorable image.

# Measuring the Light

As you saw in Chapter 4, "Digital Photography Foundations," the proper exposure for a photograph is achieved through a combination of aperture, shutter speed, and the ISO sensitivity of the image sensor. A light meter, either in the camera or an external, handheld model, is used to determine the optimal exposure settings by evaluating how much light is being reflected back from the scene being photographed. Most cameras have built-in light meters that do a good job of calculating an adequate exposure setting, and higher-end cameras offer more sophisticated meters that produce excellent results. For photographers, this feature is definitely a case of "better living through technology"; you can concentrate more on the composition of the image and changing dynamics within the scene while knowing that you can rely on the camera's light meter to do a good job in most lighting situations. Although you may trust your camera's light meter when it comes to exposure decisions, it's still important to know *how* the light meter evaluates light, so you can better anticipate how the exposure settings it recommends will affect the image.

## How Light Meters See Light

The light meters found in modern cameras are very good at analyzing the light in a scene and selecting an aperture and shutter speed combination that will yield an image that is neither drastically underexposed nor overexposed. In most cases, the exposure may actually be quite good, but it's not necessarily the best exposure for a given scene. A light meter doesn't know what you're photographing, nor can it determine if you're using it the right way or even pointing it at the right place. A light meter doesn't give you the correct settings

to use; it just gives you the settings to create a certain type of exposure based on its very narrow interpretation of the scene before your lens. This limitation of the device is due to the fact that all light meters can see only *luminance (brightness)* in the form of how the light is being reflected from a scene. They can't see color, evaluate contrast, or even tell the difference between black and white, so the reflected light from every scene they analyze is averaged into a shade of medium gray. A light meter's view of the world is so limited that the gray tone seen by light meters is not just any gray, but a very specific, 18 percent gray. This precise percentage comes from the fact that most scenes tend to reflect approximately 18 percent of the light that falls on them. When you point a light meter at a scene—no matter if it's a snowy hillside, a dark cave, or a casual portrait—and you take a reading, the meter assumes that it's pointed at something that is 18 percent gray; the meter is calibrated to calculate an aperture and shutter speed that will record the average reflected luminance of the scene as a middle gray (**Figure 5.1**).

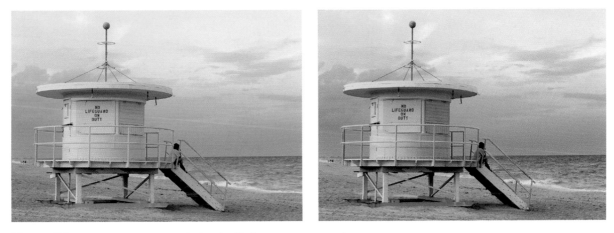

**Figure 5.1** *When you look through the viewfinder to compose an image, you may see a colorful scene. But light meters are color blind and only see the reflected brightness values in a scene.*

The meter's 18 percent gray "tunnel vision" works surprisingly well most of the time, especially if the reflected values in your image really should be rendered as a medium tone, as is the case with most "normal" scenes. But it can cause problems if you're photographing something that contains a preponderance of either very dark or very light tones. If you fill the viewfinder frame with a dark object and use the meter's setting, the image will turn out to be much

lighter than you expect, and with a light-toned object it will be much darker than you expect. This is because the light meter is just doing what it has been programmed to do (**Figure 5.2**). Real-world instances of this can be seen in photographs taken at the beach or in brightly lit snow scenes, or in shots that have a lot of dark values, such as photographs taken at night. We'll address how to deal with those situations a little later in this chapter.

**Figure 5.2** *In the close-up of the locomotive wheels, the light meter was influenced by the black metal, and the resulting exposure rendered the wheels as a washed-out gray instead of a rich black. In the photo of White Sands National Park, the meter's exposure settings recorded the brilliant, white dunes as a dull gray.*

## Types of light meters

There are two types of light meters used in photography: those that are built into the camera and external, handheld units. Handheld light meters usually can be set up to measure the light as either incident or reflective light. *Incident* refers to the light falling onto the subject, and *reflected* is light reflected off the subject. When used in reflective mode, handheld light meters are very useful for taking precise reflected light readings in landscape photography. Special spot meter attachments with viewfinders can be fitted onto some handheld meters to provide the capability to take measurements from very small areas in a scene (**Figure 5.3**). This allows a photographer to precisely calculate the contrast range in a scene, make an exposure that will contain the tonal information needed to make the best exposure, and create a file that is more easily processed and will also print well.

**Figure 5.3**  *A handheld light meter with a 5° spot attachment.*

With an incident light meter, you take a reading of the light illuminating a scene by positioning the light meter near the subject and facing the meter toward the light source (**Figure 5.4**). Taking an incident light reading is used in situations where you do not want the meter to be fooled by dramatic reflectance differences between your main subject and the background. In the example shown in **Figure 5.5**, in-camera Matrix metering overexposed the scene due to the darker areas of the background being factored into the exposure calculation. This caused highlight clipping (highlight tones being rendered as a total white with no detail) on parts of the flowers. When the same shot was taken using exposure settings calculated by an incident light meter reading, the exposure was better for all areas of the scene. Incident light meters are also common in studio situations to measure the output of professional off-camera flash systems, and for portraiture, both in the studio and on location.

**Figure 5.4** *A handheld light meter with an incident dome measures incident light (light falling on the subject).*

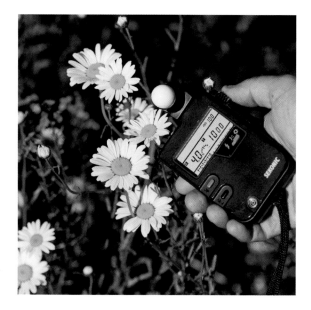

**Figure 5.5** *Image A was made using in-camera Matrix metering, and image B was made using exposure settings computed by the incident meter reading. The matrix metered image is overexposed, and the same scene as metered by an incident light meter is correctly exposed.*

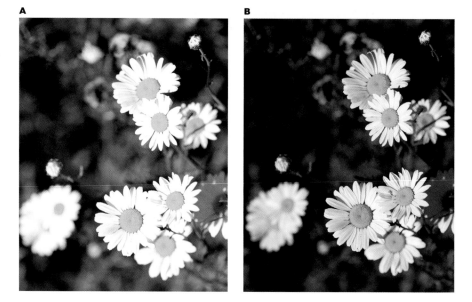

The light meters found in digital cameras are reflective meters, and that's the type we'll concentrate on in this book. Depending on the type of camera you have, the light meter will measure either the light that comes *through the lens* (also known as TTL) or via a small metering cell located on the front of

the camera. Although the basic principle of rendering the world as 18 percent gray has not changed over the years, light meters have become more sophisticated by increasing the number of different areas in the scene that they evaluate. In addition, the way the camera interprets the information collected by the meter has improved.

To see how your in-camera meter works, try this exercise:

1.  Gather three items to photograph. One needs to be white, one gray, and one black.

2.  Set the camera to Program mode, and make sure no exposure compensation is turned on. You should also try to use Program rather than Full Auto mode, because the camera may want to fire the flash in Auto mode.

3.  Fill the frame with the white item, and take a picture without adjusting the exposure (in other words, let the camera figure out what exposure to use). Repeat with the gray and the black items.

4.  Review the images on your camera or download the files to your computer. What do you see? If you followed the directions correctly, all three items should be rendered in middle gray tones—approximately 18 percent gray to be precise (**Figure 5.6**).

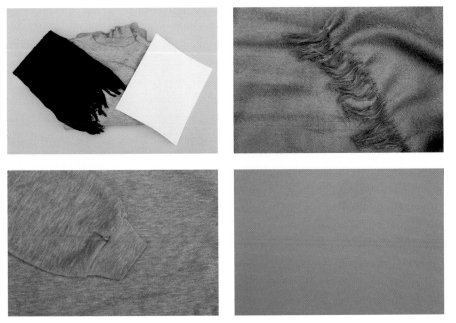

**Figure 5.6**  *When black, gray, and white subjects are photographed in Program mode, the resulting exposure for each is a middle gray.*

# Metering Modes

With the exception of entry-level compact models, most digital cameras offer a choice of metering modes. Metering modes tell the light meter to analyze the light in different ways. The three most common are Matrix, Center-Weighted, and Spot (**Figure 5.7**). Working with the appropriate metering mode allows you to get the best exposure in a variety of situations. You usually select metering modes either from within the camera's menu system or from a control button or selector switch located on the camera body.

**Matrix**

**Center-Weighted**

**Figure 5.7** *Viewfinder representations of Matrix, Center-Weighted, and Spot metering modes.*

**Spot**

## Matrix

Depending on your camera, this mode may be called Multi-segment, Pattern, or Evaluative metering. We feel it's the best mode to use for most situations, and it's the one that we use most often.

The Matrix metering pattern divides the image into sections, or zones (anywhere from 30 to well over 200, depending on the camera), and takes a separate reading for each zone. The camera then analyzes the different readings and compares them to information programmed into its memory to determine an optimal exposure setting. High-end digital SLRs that offer a range of different autofocus (AF) zones will also factor the active autofocus zone into the metering pattern, giving that area of the image more weight in the final exposure calculation. In most cases, Matrix metering works very well, and we use it for most images simply because it does such a great job of calculating an optimal exposure, letting us concentrate on image making. Matrix metering may not be the best choice in all situations, and recognizing when it's not can help you decide whether it's time to use another metering mode or adjust the exposure. Common situations where Matrix metering may be fooled include heavily backlit scenes, bright areas such as snow or the beach, and dark subjects that you want to record as dark. We'll address how to handle these types of exposure situations later in this chapter (see "Knowing When to Override the Meter").

To get a sense of how your Matrix metering system responds to different lighting situations, you should take a series of pictures in as many different lighting conditions as possible—a sunny day, a cloudy day, dawn, heavy shade, open shade, high contrast, low contrast, indoors—and carefully evaluate the results. Pay particular attention to the shots you take in very bright daylight where there is an extreme contrast range between deep shadows and bright highlights. This is the type of lighting that's most likely to cause problems for a Matrix metering system. To be fair, we should point out that this type of lighting could cause problems for *any* metering system, but since Matrix metering bases its exposure on many different areas of the scene, it may not be able to distinguish which area of a high-contrast scene is important to you (remember that a light meter has no idea what you're photographing). Your goal with these exposure tests is to try to determine how the meter handles the bright highlights and deep shadows. Does it tend

to preserve good shadow detail at the expense of blown-out highlights? Or does it do a good job of controlling bright highlights but fail when it comes to capturing detail in the deep shadows (**Figure 5.8**)? Using the histogram feature on your camera (covered later in this chapter) can help you evaluate problems on the highlight end, and to some extent, you can also use it to evaluate the shadows. To properly assess the integrity of very subtle shadow detail, however, you should view the images in an image-editing program on a calibrated monitor.

**Figure 5.8** *Even though a Matrix metering pattern measures the light from many different areas in the scene, it sometimes has trouble with high-contrast scenes that contain both deep shadows and bright highlights. In this image, the sunlit part of the road has been overexposed to a total white.*

Camera manufacturers have developed different metering systems over the years and any two cameras may interpret the same scene differently. By familiarizing yourself with the nuances of how your camera's Matrix meter responds to different scenes, you can develop your own "metering intuition" that will help you determine when to modify the exposure settings or use a different metering mode.

## Center-Weighted

The Center-Weighted metering pattern has been used in cameras for years and was around long before Matrix metering came on the scene. The mode meters the entire frame, but as the name implies, it gives more emphasis to the center area of the frame. The ratios will vary among different cameras. But typically, a Center-Weighted meter will base 60 to 75 percent of its metering calculations on the center circle (this is usually shown in the viewfinder) and the remainder on what's happening in the rest of the frame. Center-Weighted metering is common for use in portrait situations, since the reflectance values at the center of the frame have more influence in determining the exposure.

Although this is the most common type of light meter in more consumer-oriented digital cameras (if your camera doesn't offer a choice of metering patterns, then it probably uses a Center-Weighted meter), the main draw-back is that it makes the assumption that your subject is centered. While that may be the case for general snapshot photography, it certainly isn't true for all images, especially if you're a photographer who's already familiar with the major tenets of photographic composition—one of which emphasizes not centering the subject for every shot. For this reason, Center-Weighted metering often produces results that are adequate but not the best for many situations (**Figure 5.9**).

**Matrix**

**Center-Weighted**

**Figure 5.9** *In the photo made with Matrix metering, the brightness of the entire scene was taken into account, resulting in an image in which all areas, even the dark background, have received good exposure. In the shot made with Center-Weighted metering, most of the exposure was based on the little girl's shirt, making the background areas much darker.*

## Spot (Partial)

Whereas Matrix metering looks at many different areas of the image to evaluate the lighting in a scene, a Spot meter is designed to measure only the light in a very small area. The exact size of the spot may vary from camera to camera, but it's typically a 3-to-10-degree circle in the center of the frame (*degree* refers to the angle of view—3 degrees is about as large as a dime looks on the sidewalk between your feet). This can encompass anywhere between 2 to 10 percent of the entire scene. Some pro cameras also have Spot meters that link the metering spot to the active autofocus zone for more precise control where the metering will follow the subject that's in focus. On cameras that feature user-selectable AF zones, this allows an incredible degree of control for metering and focusing using the same area of the viewfinder.

Spot metering is appropriate when you want to measure a specific part of the scene, and you want the camera's exposure to be based on the luminance (brightness) of that area. Since meters want to place everything into a zone of 18 percent reflectance, keep in mind that a Spot meter is no different in this regard; it just measures from a much smaller area. A classic situation where you might use Spot metering is for a scene where a relatively small foreground subject is juxtaposed against a very bright or dark background. Matrix or Center-Weighted metering would factor a bright background into its calculations, causing the foreground subject to be underexposed. By framing the image so that the spot area is on the subject, a correct meter reading could be obtained for that area of the image (**Figure 5.10**).

Although we use Matrix metering for most images, we always try to pay attention to how the lighting is affecting the scene that the meter is evaluating in case a different metering mode may be more appropriate for a given scene. **Table 5.1** provides some recommendations for when to use different metering modes.

**Table 5.1** *When to Use Different Metering Modes*

| Mode | When to use |
|---|---|
| Matrix | Average scenes where you want all areas of the image to be factored into the exposure |
| Center-Weighted | Portraits; backlit scenes; main subject off center (used with exposure lock) |
| Spot | Any time the camera might be fooled: backlit scenes, main subject off center (used with exposure lock), dark subjects against light backgrounds, light subjects against dark backgrounds, or light on light and dark on dark compositions |

**Matrix**

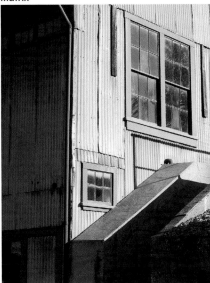

**Spot**

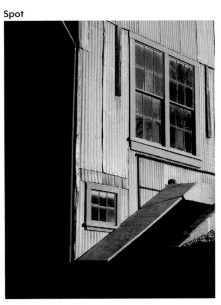

**Figure 5.10** *In the photo made with Matrix metering, the exposure is a balance between the bright highlights and the dark shadows. In the image made using Spot metering, the reading was taken from the bright side of the building, resulting in those areas being well exposed, with much darker shadows, which in our opinion makes for a more dramatic and effective image.*

## Using the In-camera Light Meter

The ease with which you can take good pictures in automatic mode on most digital cameras often seems to relegate the light meter to the role of a supporting player. A camera's light meter operates silently in the background, and unless you make a point of paying attention to what it's telling you about the scene, it's easy to forget about it. But apart from more obvious image aspects such as composition, focus, pixel resolution, and file format, the light meter—and the exposure it chooses—affects the final image quality more than any other camera setting. As we mentioned previously, a light meter has no idea what you are photographing or how you want the photograph to look, so an important skill is knowing how to use it properly, understanding what it's telling you, and knowing whether to follow the meter's recommendation or modify the exposure settings.

## What to meter

The first thing to consider is what area of the image to meter. This decision will be influenced by what your main subject is, how the existing lighting conditions are affecting the scene, and how you want the image to look. Understanding how your camera's metering system responds to different lighting situations is also key to deciding what area of the photo to meter.

If the average tonal reflectance in the scene you're photographing is similar to a medium gray, then relying on the built-in meter's recommendation is probably a safe bet. Humans view the world in color, of course, so if you're not used to making that conceptual tonal translation in your mind, evaluating the reflectance in a colorful scene may take some practice. One way to practice is to imagine the scene as a black and white photo (**Figure 5.11**). Would it be primarily middle gray tones, or are there large areas that would translate as dark grays or very bright tones approaching white? The beauty of digital cameras, of course, is that you can take a shot and immediately preview how the meter's interpretation affected the overall exposure, and then make on-the-spot decisions about modifying the camera settings to achieve a different result.

**Figure 5.11** *Imagine an image as black and white, and you'll be seeing the scene the way a light meter does.*

In lighting situations that contain a good deal of contrast between shadows and highlights, or when the background is significantly darker or lighter

than your main subject, you may have to override the meter to determine the best exposure for a specific scene that a "dumb" camera meter may not evaluate correctly. A photograph taken from a distance, showing a woman in a white dress standing before a very dark background, is a case where the meter is likely to be misled by the large expanse of darker tones in the image. True to its mission, the meter will choose an exposure that will render the dark background as middle gray, which in turn may overexpose the skin tones of the person and the white fabric of the dress (**Figure 5.12**). As you view the composition through the viewfinder, apply some of your own metering skills, together with what you've learned from testing your camera's meter, and evaluate the scene for areas that may confuse the meter and yield a less-than-optimal exposure.

**Figure 5.12** *In the lighter image, the meter was thrown off by the large expanse of dark tones that make up the trees, and the exposure is too light for the main subject. The woman's white dress is overexposed, and the image does not represent what the scene really looked like. By using exposure compensation to underexpose by 1I/2 stops, the trees are darker and the highlights in the dress are not overexposed.*

**TIP** When using DSLR cameras that allow you to choose a specific autofocus zone, keep in mind that the area of focus may be influencing the decisions the light meter makes. Even if you are using the default center focus zone, this can be an issue, because many SLRs, even when using Matrix metering, give more importance to the area of the scene in the active AF zone. If that part of the image is exceptionally light or dark, it can adversely affect the meter's choice. When photographing scenes that contain a significant brightness or contrast difference, try taking different shots using points of focus in different brightness areas to see how that affects the exposure the meter gives you (**Figure 5.13**).

**Figure 5.13** *With the autofocus point on the handle at the bottom of the window, the meter yielded a good exposure for the bright areas of the window frame, but the desk was too dark. When the autofocus was calculated from the items on the desk, a good exposure of the desk was created, but the bright areas of the window were hopelessly overexposed (mastering extreme exposures such as in this brightly backlit window scene is addressed in Chapter 6, "Multiple Exposures and Extending the Frame).*

If the average tone of your scene is quite different from a medium gray, such as would be the case with a snow scene; a sunny day at the beach; or a dark, rocky outcropping, there are strategies you can adopt to override the meter, or coax it into giving a reading that will produce great results.

One approach is to meter a gray target and use that light meter reading to calculate the best exposure. This technique works for any type of metering pattern. On most cameras, the light meter is roused into action by pressing the shutter button down halfway. On some models, you can also lock the exposure by keeping the shutter button at that halfway point and then recomposing to take the picture. Other methods of locking exposure also exist; we'll address them in the next section.

One approach, which works for any type of meter reading, is to meter a gray target and use that light meter reading to calculate the best exposure:

1.  Fill the viewfinder with something that is close to 18 percent gray. Ideally this would be a standard photographic gray card, but since many photographers don't carry one all the time, you can also use other items with similar reflectance properties such as a pair of faded jeans, a gray sidewalk, or a concrete wall. The object you are metering, known as the *metering target,* has to be in the same light as your subject.

2. Press the shutter button halfway down to activate the light meter, and hold it at that position to lock the exposure settings.

3. Frame the scene as desired, and carefully press the shutter button down the rest of the way to take the picture.

The only time you'll have a problem with this approach is if your proxy metering reference target is at a different distance from your camera than your subject. In addition to activating the light meter, pressing the shutter button halfway down on most cameras also turns on the autofocus system, and holding the shutter button halfway down to lock the exposure may also lock the focus. Unless you take this into account, metering off of a gray target may result in an excellent exposure of a blurry subject. For this technique to work best, you really need to have an exposure-lock function on your camera.

## Exposure lock

Many cameras offer an exposure-lock button, or a menu command, that is separate from the shutter button. With a dedicated exposure-lock feature that's independent of the focusing controls, you don't have to worry about metering off of a gray reference that is a different focus distance than your subject. We view this as an essential feature if you are interested in more than casual photography with your camera (**Figure 5.14**).

Figure 5.14 *By taking a meter reading from the subject's jeans, the exposure was locked and the portrait recomposed. Since the jeans are very close to a middle gray, the final meter reading and exposure are not influenced by the dark areas of foliage behind the woman.*

Exposure lock, sometimes called AE lock, can be found on many deluxe point-and-shoot cameras, and is a standard feature on most prosumer and pro digital cameras. On SLR cameras, the AE lock is usually a button that locks the exposure for as long as you hold it down. This allows you to take a meter reading, lock the exposure, and then reframe and focus the image to take the shot. On smaller cameras that don't offer as much physical area for additional buttons, exposure lock is more likely to be found in a menu as a command. Some exposure-lock controls let you lock the exposure for the first shot and use that setting for all subsequent shots until the AE lock is turned off. This can be very useful if you're taking several shots for a panoramic image that you will stitch together later using Photoshop's Photomerge (**Figure 5.15**).

If your camera doesn't have an exposure-lock feature but does have manual exposure, you can use that in place of exposure lock. In manual exposure mode, you would take a meter reading from an appropriate reference in the same lighting as your subject, adjust the settings to what the meter recommends, and then reframe, refocus, and shoot. When doing this, get close to the subject, so that it fills the frame, excluding any areas in the scene that contain significant tonal differences, and then take your meter reading. If you have a zoom lens, you can also use that to fill the viewfinder with your main subject. The one drawback to this approach is that it's hardly suited for fast, spontaneous photography or situations where the light is changing rapidly, but it does suffice as a workaround if no other methods are available. Remember that with a digital camera you can always check the LCD screen and histogram to verify a correct exposure after taking the shot. This aspect of digital photography is a wonderful "safety net" that makes experimentation and taking chances with your photography much easier. Evaluating the histogram is addressed later in this chapter.

**Figure 5.15** *Exposure lock, or manual exposure, can be useful when photographing multiple images that will be later blended together into a single panorama. By locking the exposure across all the exposures, you can be sure that the meter will not react to different reflective areas within each scene, and the individual images will match better when merged together.*

# Knowing When to Override the Meter

A good way to interpret the readings a light meter provides is to think of the meter as an advisor or consultant. When you hire a consultant or rely on the counsel of an advisor, you are making use of their expertise and experience in a specific field to help inform your own decision. They offer suggestions and advice, which you can then choose to follow, or not, based on the nature of each situation. There will be times when their recommendations are sound, and other times when you will choose to ignore their advice or use it as a point of departure for a more customized approach. Knowing when to use the settings recommended by the meter, and when to override them, is an important difference between just snapping pictures and consciously creating good photographs. Although you can read about when to override the meter in books such as this one, developing a real sense of when to modify the meter's settings will only come from practice and experience.

Although each scene is different, some situations have become known as classic examples of when to take the camera off autopilot. We have alluded to some of these previously, but now we'll take a look at them in greater detail.

## Backlight

In extremely high-contrast lighting situations, it's impossible to expose correctly for both dark and light areas of the image. Backlit conditions, where the dominant light source is coming from behind the subject, can be very difficult for even the "smartest" cameras. A good example of this situation is a portrait with a bright window in the background, or a scene with the main subject in the smooth, even lighting of open shade but with a large expanse of sunlit area or dazzling sky behind the subject. The bright light in the background will fool the camera's meter, and the resulting exposure will be too dark for the main subject (**Figure 5.16**). To correct for this, you can turn the flash on so that it fills in the darker areas of the image, or you can use exposure compensation to manually override the meter and give the shot additional exposure.

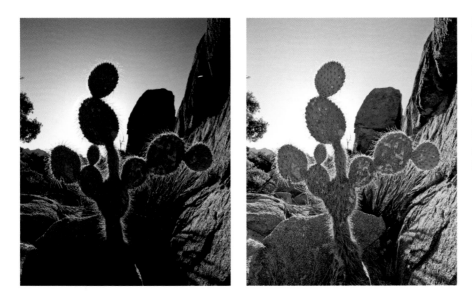

**Figure 5.16** *In this scene the sun is directly behind the cactus. In the first image, the bright back lighting has caused the cactus to be underexposed. By using exposure compensation to let in more light, the camera settings are adjusted for a better exposure of the cactus.*

## Snow and beach scenes

These subjects tend to reflect a lot of light and are often underexposed, with the snow and sand appearing as a disappointing dull and dingy tone (**Figure 5.17** on the next page). A common rule of thumb is to use exposure compensation to override your meter's recommendation, and increase the aperture by a half to a full f-stop to compensate for the meter's 18 percent gray tunnel vision. This will brighten up the light areas in the scene so that they look like they should, not like the muddy gray that the typical meter exposure will deliver. This type of exposure problem is such a common occurrence that many cameras offer a scene mode designed specifically to address photographs taken in the snow or at the beach. You can also use exposure compensation controls, which we'll cover later in this chapter, to add the additional exposure stops and arrive at a more appropriate setting.

A    B

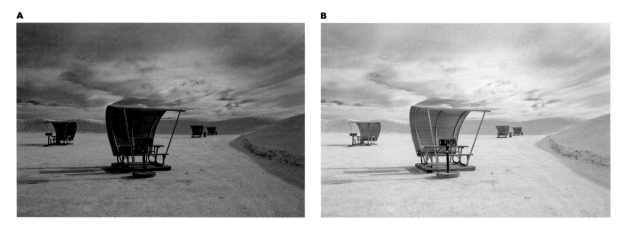

**Figure 5.17** *Any image containing large, bright areas that reflect a lot of light is likely to confuse a light meter and result in bright tones being underexposed (image A). By using an exposure compensation setting to add one to two stops of exposure, the bright areas in the scene are properly exposed (image B).*

## Nighttime

Taking photos in low-light conditions, such as twilight and nighttime, represent a special challenge for light meters. When set to automatic, the default behavior on most cameras will trigger the built-in flash, which will flood the scene with the harsh flash illumination that we love to hate. The problem with built-in flash at night, however, is that the effective distance range of the flash is dependent on the ISO setting and is usually limited to 8 to 12 feet on most cameras. So what you typically get is a foreground that has received enough light for an adequate, if uninspiring, exposure, and a background that is dark and underexposed. If you're taking night photographs and want to preserve the feel and mood of the existing light at the scene, the first step to take in overriding the camera's exposure system is to turn off the flash.

Even with the flash disabled, the meter's default inclination to try and place the tonal values in the scene at a reflectance level of 18 percent gray will overexpose any bright points of light in the image (such as twinkling city lights), and leave the dark areas, which should be dark, as an unsatisfying muddy tone that reveals too much noise. The same principle that works with snow and beach scenes can also be applied when photographing at night. Take your camera's meter reading as a starting point, and use it as a base from which to explore other exposure settings. Since the camera tells you an

exposure for reproducing a middle gray, the first thing to do is compensate for this by giving the shot less exposure than the meter recommends. You can achieve this by manually using a shorter exposure time or by stopping down the lens to a smaller aperture (**Figure 5.18**).

A                                B

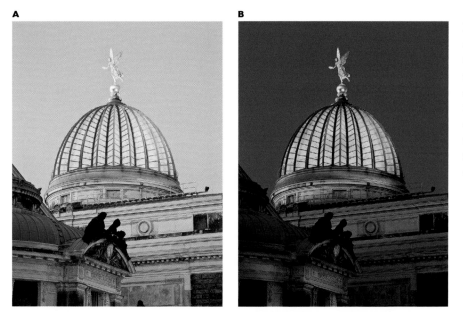

**Figure 5.18** *Image A shows the initial shot, which is much too light for what the scene really looked like. Image B is the result of underexposing by a stop and a half to create an image that more closely resembled the twilight conditions of the actual scene.*

Some night shots may be too dark for the meter to accurately calculate an exposure. If this is the case, you'll need to experiment with different exposure settings to find one that works for what you want to photograph. If you are shooting in RAW, what appears to be a slightly overexposed shot may actually be a better exposure, as long as there is still detail in the important highlights (see "Expose to the Right for the Best Histogram," later in this chapter). We cover long exposures and low-light photography in more depth in Chapter 6, "Multiple Exposures and Extending the Frame."

# Exposure Compensation

Exposure compensation is a great feature that lets you take the meter's recommended exposure setting and then consciously overexpose or underexpose the photograph to achieve a better result that is more customized for each scene. The wonderful thing about exposure compensation is that it

frees you from having to calculate a specific f-stop or shutter speed in your head, letting you simply specify that you want more or less exposure than the recommended setting. Although you can certainly accomplish what it does by manually adjusting the exposure settings, the presence of an exposure compensation control is easier and faster than making changes in manual mode, and it's one camera setting that we use all the time (**Figure 5.19**).

**Figure 5.19** *Exposure compensation is being used to underexpose this image by 1/2 stops to prevent the highlights on the rock from becoming too bright. The exposure compensation adjustment can be seen in the viewfinder information display.*

## How and When to Use Exposure Compensation

The ease of use and accessibility of exposure compensation controls vary from camera to camera. On some compact models you may have to go into the camera's menu system and use the input buttons to select the desired setting. Other cameras provide buttons on the exterior body that may be easier to use than the menu, but you still may have to take the camera away from your eye to see which setting you're choosing. Such usability bottlenecks may make taking advantage of this feature too cumbersome when you need to react quickly to a spontaneous photo opportunity. For slower-paced photography, however, this is not a problem.

Our favorite exposure compensation controls are those found on our DSLRs that we can quickly access by manipulating a rocker switch or a wheel without taking our eye away from the viewfinder. This allows us to respond quickly to changing situations, and it feels more natural and intuitive than stopping to cycle through a selection of menus.

## Know your light meter

The key to using exposure compensation properly is in knowing how your camera's light meter will treat the scene in front of the lens. You need to evaluate the image in your viewfinder and then evaluate what the light meter tells you before deciding whether an exposure compensation adjustment is appropriate. Although the light meter may recommend a good setting for an adequate exposure of the scene, you may decide that you will get a better result if you underexpose slightly to deepen the shadows and improve the contrast and color saturation. Making a test shot and then evaluating the histogram can also tell you if such an exposure modification is warranted (see "Evaluating Exposure: Using the Histogram," later in this chapter).

The main thing to look for when deciding whether exposure compensation is needed is to compare the brightness levels of your main subject with those of the rest of the scene. If you notice a big difference in brightness, the scene could probably benefit from some exposure tweaking or from a recomposition of the picture. If the background is substantially darker than your subject, underexpose a bit, and if it is significantly lighter than your subject, overexpose a bit.

But you don't need to restrict your use of exposure compensation to scenes with discrete foreground and background elements. Any scene that is predominantly bright and reflects a lot of light can be greatly improved by controlled overexposure. Keep in mind that the meter sees everything as 18 percent middle gray. If you are photographing something that is substantially darker or lighter than middle gray reflectance, using an exposure compensation setting can make the difference between an average exposure and an outstanding one (**Figure 5.20**). A good general guideline to follow is that if the scene you're photographing is bright, you should use exposure compensation to add exposure of 1/2 to 2 stops so that the meter won't expose it as a middle gray tone (**Figure 5.21**). If the scene is dark, you should subtract exposure of 1/2 to 2 stops so that the darker tonal characteristics are preserved (**Figure 5.22**).

A

B

**Figure 5.20** *Image A was photographed at the meter's recommended settings. Image B was underexposed by one stop using exposure compensation, which improved the contrast and color saturation.*

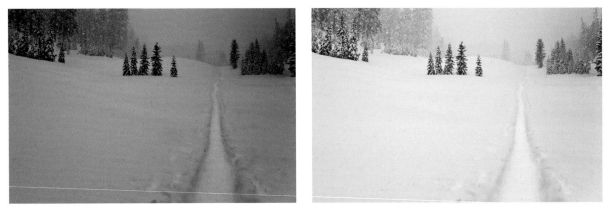

**Figure 5.21** *With no intervention on the photographer's part, bright white subjects, such as this cross-country ski trail in the High Sierras, are often underexposed by the camera's light meter. To ensure that the bright white scenes are being recorded accurately, use exposure compensation to purposefully overexpose the image. In this example, the brighter image was overexposed by two stops to capture the scene the way it actually appeared.*

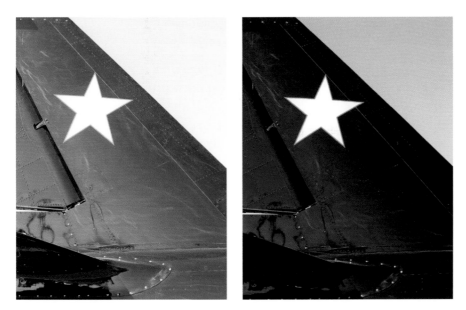

**Figure 5.22** *When photographing very dark subjects, use exposure compensation to subtract exposure and preserve the dark characteristics of the scene. The image on the left was shot at the meter's default normal setting, and the image on the right was purposefully underexposed by two stops to faithfully capture the deep black tones of the plane's tail.*

# Getting the Most from Digital Exposures

Understanding how your light meter evaluates the scene and knowing how to use exposure compensation to make adjustments to how the image is exposed are only two factors needed to master the art of digital exposure. The other important component is understanding how a certain type of exposure affects the quality of the data that is recorded by the image sensor.

## Digital is not film

If you are coming to this book from a film background, note that digital is not film and should not be exposed using the same set of guidelines that most film photographers are familiar with, especially as they relate to transparency (slide or chrome) film.

If you're used to making images with film, you may have heard the advice that stipulates, when in doubt, it's better to slightly underexpose transparency film than overexpose. An overexposed slide appears too bright, with low contrast, blasted highlights, and washed-out colors. Underexposure may

yield good contrast and punchy color saturation, but it may come at the cost of lost shadow detail in the darkest areas of the image.

With color or black & white negative film, the opposite is true; when in doubt about exposure, it's better to slightly overexpose negative film than underexpose it. This stems from the fact that with an underexposed negative, the light-sensitive silver crystals have not received enough exposure to form a good image on the film. A print made from an underexposed negative is marked by lack of detail in the shadows, flat contrast, dull color saturation, muddy dark tones, and more noticeable film grain. An underexposed negative is difficult to print in the darkroom, and although an experienced printer can make definite improvements, the print will never be as good as one made from a negative that was properly exposed.

## Overexpose rather than underexpose

One area where an exposure corollary can be drawn between film and digital is in the exposure guidelines for negative film. With digital, a similar approach will often yield the best image data, which will in turn provide more flexibility when modifying the photo in the digital darkroom.

In digital's early days, an oft-repeated guideline suggested slightly underexposing to preserve highlight detail. While such an approach will certainly prevent highlights from being rendered as a total white with no detail, if the situation allows it, a much better strategy is to expose so that the image is as bright as possible without totally overexposing the bright highlights. This means making sure that the recorded tonal values fill as much of the right side of the histogram as possible without falling off the right edge into a total white. This exposure practice ensures that there is maximum data in the most important areas of the tonal range (the right side of the histogram) and will help keep noise to a minimum. The midtones and shadows will almost certainly appear much too light for your tastes, but you can adjust and darken them later as needed. Underexposing a photo will force you to open up (lighten) the exposure, which is likely to reveal ugly noise in the shadows. Exposing the scene a bit lighter, however, allows you to darken the image and conceal noise. This approach is best suited for RAW images, where you can fine-tune the exposure before opening the image in the digital darkroom. See "Expose to the Right for the Best Histogram," later in this chapter.

## Controlled overexposure in practice

One of the easiest ways to accomplish any intentional overexposure is to use your camera's exposure compensation feature to enter a plus exposure value that's appropriate for the lighting conditions you're shooting in (if you're shooting in all manual mode, exposure compensation doesn't apply; simply modify either the aperture or the shutter speed to adjust exposure). The tendency of digital exposures to record very bright highlights as totally white is most noticeable under bright sun and high-contrast situations, especially if the camera's meter is calculating its exposure based on darker areas of the scene, so there may be limitations to how much you can overexpose the shot. Careful review of the histogram as you adjust your exposures will indicate when there is no clipping in the highlights.

In scenes where the lighting is soft, diffuse, and low contrast—such as images made on an overcast day or in the open shade—highlight clipping is much less likely to occur. Overexposing by 1/3 stop on cloudy days can provide a little extra exposure boost on the bright side of the histogram that will result in a better exposure with more data recorded by the sensor. Taking some test shots at the start of your photo shoot and evaluating the histogram is a good way to ensure that you're getting the best exposure for all areas of the scene.

## The big picture

One important aspect of exposing for digital is that the exposure data recorded by the image sensor is more important than how the image looks on the preview of the back of the camera. If you are shooting in RAW, it is assumed that you are doing so to have all the control and flexibility over modifying your exposures that this format allows. A RAW image may look a bit too washed out on the camera's LCD preview, but the histogram may reveal that is a very well exposed photo. With RAW images, the goal is to record the best set of image data possible, and this often results in an image that appears a bit too light.

The JPEG format is much closer to slide film in that you really must be more precise in your exposures so that you can capture a shot that requires little or no significant modification in an image-editing program. Even with JPEGs, however, slight overexposure, as long as highlight details are retained, is still better than underexposing the shot. It's always easier to

make a slightly light image darker than it is to lighten up an underexposed image. For the convenience of JPEG along with the safety net of RAW, you can always shoot in RAW + JPEG if your camera has this feature.

**TIP**  Using the camera's RAW format is another way to maximize the exposure possibilities of any lighting situation you might find yourself in. With RAW you typically have an additional plus or minus two stops of exposure that you can take advantage of in the digital darkroom after the photograph has been taken. Although this won't help you in cases where the highlights are definitely blown out or shadow detail is nonexistent, it can provide great flexibility for adjusting the majority of the tonal range. RAW also gives you access to the high-bit-depth data of the digital capture, and the additional tonal levels offered by a 14-bit capture can be very useful when trying to perform complicated adjustments on images with exposure problems.

# Evaluating Exposure: Using the Histogram

The histogram is the primary means for evaluating exposure, allowing you to check exposure either before or after (depending on your camera's features) you take the picture. It is incredibly useful for deciding whether or not you need to retake the shot with corrected exposure settings. Although the histogram may not be offered on the least expensive digital cameras, it is available on all DSLRs and many deluxe point-and-shoot cameras as well. For serious image making with a digital camera, the histogram is essential for making better exposures, which leads to better photographs.

The histogram shows how the brightness values in the image are distributed along the tonal range. Essentially, a histogram is a bar graph with the horizontal axis representing the tones from total black on the left (level 0) to total white on the right (level 255). The vertical bars indicate the number of pixels at a given location on the tonal scale. With underexposed or darker low-key images, the vertical bars tend to bunch up on the left side of the graph; for photos that are overexposed or that contain mainly lighter high-key values, the vertical bars congregate on the right side. An exposure that exhibits a good tonal range with neither underexposure nor overexposure has data that covers the full range of the histogram (**Figure 5.23**).

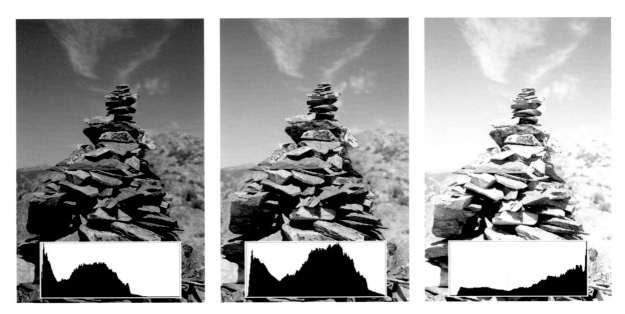

**Figure 5.23**  *Learning how to interpret your camera's histogram feature is essential to capturing a good exposure. From left to right, the images of the rock cairn are underexposed with lost shadow detail, a good exposure that fills the tonal range, and an overexposed shot with blown-out highlights.*

The most common type of histogram usually displays only on the luminance (brightness) values of the image. Some cameras also have the ability to display individual histograms for the red, green, and blue color channels. If the colors in a single channel are overexposed to the point where there is no image data, the luminance histogram may not show this. Or, it could show up at the far right side of the luminance histogram as a spike that is caused by an extremely bright red value from a specular highlight in the image (*specular* highlights are the only highlights that are appropriate to be recorded as totally white). For practical purposes relating to general exposure decisions, the luminance histogram is the most useful because when you change exposure, you are making the image either darker or lighter. In some cases, viewing the three colored histograms can be used to determine that only one color is causing highlight clipping, and there is still useable detail recorded in the other colors.

## The Camera Histogram: What Are You Really Seeing?

In most cameras, the image you see on the LCD is not the actual full-resolution photo, but instead is a separate low-res thumbnail image, or a low-res display that is generated on the fly from the actual image data. This means that the histogram you see displayed may not be 100 percent accurate in terms of exposure details on the endpoints, the all-important highlight and shadow regions. Slight highlight clipping on the camera's histogram may be less severe when viewing the file in a program such as Lightroom or Camera Raw. This is especially the case with RAW files. To get a sense of how accurate your camera's histogram display is, make a series of test exposures that include traces of slight highlight and shadow clipping, and then compare the camera histogram with one generated from the actual RAW file in an image-editing program.

Other qualities, such as color saturation, accuracy of the color rendition, *posterization* (banding) along color transitions, and noise levels, are not addressed by the histogram and are generally too subtle to notice on the camera's small LCD screen, even with the ability to zoom in on the image. Although posterization is not likely to show up on the camera's histogram, in extreme cases it may be revealed in the histogram when the image is viewed on the computer (**Figure 5.24**). To properly evaluate noise and color issues, you'll need to download the image onto a computer and review the full-sized file in an imaging program such as Lightroom or Photoshop.

**Figure 5.24** *The top image shows heavy posterization in the sky (so heavy, in fact, that it does show in the inset histogram), and the bottom image was photographed with an older camera at ISO 1600 under low light and is very noisy. Subtle posterization and severe noise cannot be evaluated by looking at the histogram.*

## Expose to the Right for the Best Histogram

Earlier we mentioned that the ideal digital exposure is often created by slightly overexposing the shot, making it brighter than what the camera's light meter recommends. This may seem counterintuitive, but there is a definite reason behind this exposure advice. With digital cameras, especially those that can capture RAW high-bit files, not all tonal values are created equal, and some areas of the tonal scale are more important than others.

The far right side of the histogram that represents the brightest tones in the image is by far the most important, because it contains most of the image's tonal data. To create the most optimum exposure, therefore, the tonal values should be as far to the right side of the histogram as possible without being jammed up against the edge of the scale (which would indicate overexposed, blown-out highlights). To understand the reasoning behind this theory, let's look at the dynamic range of a DSLR and examine the behavior of the image sensor.

The typical DSLR has a dynamic range between 6 and 8 stops. For the purposes of this discussion, however, we'll round it down to a more conservative 6 stops. At the time of this writing in 2010, most DSLR cameras record a 14-bit image (when shooting in RAW format). A 14-bit image can contain up

to 16,384 separate tonal values (as opposed to the relatively meager 256 tones that you get with an 8-bit JPEG file). If you spread 6 f-stops across the 4,096 tonal values of a 14-bit image, the natural inclination would be to divide them evenly across the histogram, so that each f-stop of the 6-stop dynamic range would contain approximately 2,730 (16,384/6) tones. Unfortunately, this is not how it works out. In reality, the brightest stop of information recorded by the image sensor contains 8,192 of the tonal steps, which represents half of the total tonal values available in the image!

The reason for this lies with the fundamental behavior of the image sensor and an f-stop. If you remember how f-stops work, you know that when changing to a smaller aperture, each full f-stop records half as much light as the previous one. The image sensors on digital cameras are linear devices; half as much exposure translates into half of the remaining data slots on the tonal range. So if the histogram was divided into six segments, the far right section representing the first f-stop and the brightest tones, would contain 8,192 values, and the next section, representing the second f-stop, would contain half that many, or 4,096 values. The third f-stop, representing the middle tones, would contain 2,048 tonal levels. The fourth would contain 1,024 levels; the fifth f-stop, representing darker tonal values would contain 512 tonal values; and the sixth f-stop, which held the information for the darkest details in the image, would contain only 256 tonal values (**Table 5.2**).

**Table 5.2**  *Linear Tonal Distribution in a 14-Bit Image with a 6-Stop Dynamic Range*

| | |
|---|---|
| 1st f-stop/ brightest tones | 8,192 tones |
| 2nd f-stop / bright tones | 4,096 tones |
| 3rd f-stop / brighter midtones | 2,048 tones |
| 4th f-stop / darker midtones | 1,024 tones |
| 5th f-stop / darker tones | 512 tones |
| 6th f-stop / darkest tones | 256 tones |

The moral of the story is that you need to be using as much of the far right of the histogram as possible. If not, you're squandering fully half of the available recording levels that your camera is capable of. To achieve this, check the histogram after taking a shot. If it's a bright day and you've shot your image slightly underexposed to ensure that the highlights don't blow out (see, "Controlling the Highlights" later in this chapter), check to see how much empty space is on the far right of the histogram. If there's a gap

between the data and the right side (**Figure 5.25**), increase your exposure, take another shot, and review the histogram again. The goal is to have the data bars grouped as closely as possible toward the far right edge without actually running into the end of the scale (**Figure 5.26**).

**Figure 5.25** *A "normal" histogram with too much empty space in the vital right side.*

**Figure 5.26** *A histogram that has been "exposed to the right" to take advantage of the most important part of the tonal range.*

When the image is opened using Lightroom, Adobe Camera Raw, or another RAW conversion program, the tonal values can be redistributed to achieve the overall brightness and contrast that you desire (**Figure 5.27**). The main benefit to exposing and then adjusting the RAW image this way is that it will maximize the signal-to-noise ratio and minimize the possibility of posterization (banding) and noise that can occur in darker areas of the image.

**Figure 5.27** *The same histogram from Figure 5.26 after the 14-bit values were modified in Adobe Camera Raw to fill the entire tonal range.*

It should be noted that although this exposure practice is great for capturing the best collection of tonal data in an image, it may not be ideal for some types of photography. Because "exposing to the right" requires more exposure, this means that either a larger aperture or a slower shutter speed must be used, and slower shutter speeds are often not viable for photographing fast-moving subjects, for handheld shooting in low light, or for shooting in quickly changing conditions, as photojournalists and sports photographers do. However, for slower-paced subjects—such as landscapes, still life, and portraiture where you can adopt a more considered approach—this technique is an excellent way to improve your exposure to capture the best possible information.

## Expose to the Right in Action

The images in **Figure 5.28** show the concept of Expose to the Right in action. Clear differences in the noise and detail in the darkest parts of the image can be found in the interior of the small store. In the first exposure (image A), the overall image is dark. The histogram shows that almost the entire right half is empty with no tonal detail recorded there.

In the second shot (image B), the exposure was increased to lighten the image and push the data farther to the right side of the histogram. The overall image is brighter, and even the dog knows that things are moving in the right direction!

In the final exposure (image C), the tonal data fills most of the histogram, especially the all-important right side. When viewed on the camera's LCD, the third exposure appeared too bright and washed out, but the histogram revealed that it was a good exposure.

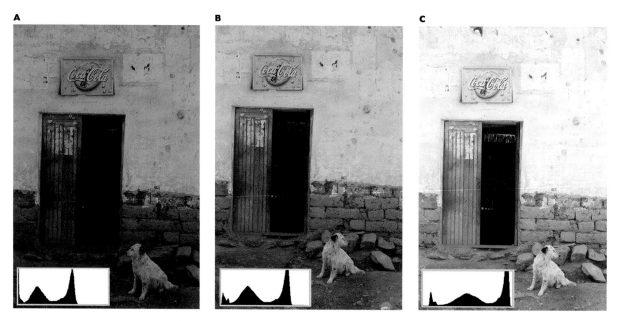

**Figure 5.28** *Three images, each with more exposure than the last, culminating in the third shot, which uses the Expose to the Right approach.*

When the shadow areas in the interior of the shop are lightened, it becomes clear that the lighter exposure made using the Expose to the Right approach yields much better tonal quality and less noise in the darkest areas of the image (**Figure 5.29**).

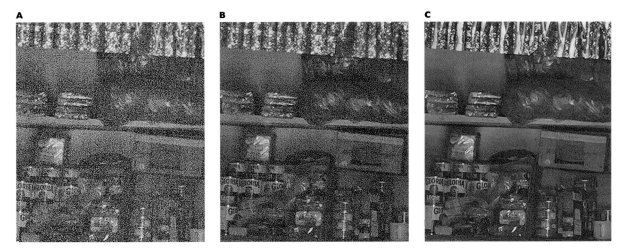

**A**    **B**    **C**

**Figure 5.29** *The quality of tonal detail is much better, and there is less noise in the image that has been exposed to the right.*

## Controlling the highlights

If you review the histogram after taking a shot and you see the mountain silhouette of the histogram running smack up against the right side of the display, this is a sign that the bright highlights have been clipped, or recorded as a total white with no detail (**Figure 5.30**). Most cameras will even display the image with a flashing overlay to indicate where the over-exposed highlights are in the photograph (**Figure 5.31**). If you notice clipped highlights in the histogram, you need to retake the photo and adjust the exposure to prevent the highlights from being rendered as a total white.

If your camera offers a full range of exposure modes, you could modify the settings in several ways. But exposure compensation is usually the quickest way to achieve this end, and it's the method we use most often (just remember to keep an eye on the exposure compensation setting you use because it may not be appropriate for every shot). You may not think there is a contrast problem in a scene, but remember that the camera's eye sees the world

differently than you do. Taking a test shot and checking the histogram will reveal whether there is a problem. If the photographic situation allows for more contemplative and considered exposure, you can use the Expose to the Right practice recommended previously.

**Figure 5.30** *The highlights at the top of this image are overexposed to absolute white with no detail. The histogram shows this where it runs up against the right side.*

**Figure 5.31** *A flashing black overlay, indicating the areas in the image where highlights are clipped to a total white, is visible in the top portion of this image.*

Katrin's exposure compensation formula is usually 1/2 stop overexposed for a low-contrast day with no hard shadows, 1/3 stop over for a bright day with shadows, and scene dependent compensation for exceptionally bright and contrasty days with deep, sharp shadows (and if that doesn't do the trick, then it's time to go home!). These settings are subject to review, of course, since we are photographing and checking the histogram for each shot. Although these exposure compensation settings can serve as a starting point, we never totally rely on a rigid formula and are always modifying our exposure to get the best possible histogram. We recommend that you check the histogram frequently, because the lighting, composition, subject brightness, and metering method changes, to ensure that you're capturing a good tonal range in your photographs.

For most photographic images, the only highlights that should be recorded as a total white are specular highlights, such as bright reflections on glass, water, or polished metal (**Figure 5.32**). Highlights with detail, such as a white jacket or the puffy, white textures of clouds on a summer day, are usually better when exposed to be slightly darker than total white. By making sure the tonal levels are grouped as far to the right edge of the histogram as

possible without running right up against the edge of the histogram, you can be sure that the highlights are not being recorded as total white and that you're utilizing the vital right fifth of the histogram (see "Exposing for the Best Possible Histogram"). The tonal value of a blasted highlight can be reduced and slightly darkened with imaging software. But if the detail was not captured in the original exposure, it is lost forever.

**Figure 5.32** *Specular highlights, such as the bright reflections in the headlights of this classic car, are the only photographic highlights that are appropriate to be totally white.*

## Preserving shadow detail

Although histogram displays typically do not have a flashing overlay feature for underexposed areas of the image that have been rendered as a total black with no detail, you can still see how shadow detail is being exposed by how the histogram bars look on the left side of the graph. As with the highlights, if the vertical bars run right up against the left side and appear cut off, this is a sign that the dark shadows do not have a gradual progression from dark to total black. Since shadow tones are darker than highlights, *shadow clipping* (which is when detail is cut off and rendered as a total black) is harder for the eye to see. Zooming in on the LCD screen may tell you if detail has been captured in important shadow areas, but you'll probably need to throw your jacket over your head or use an LCD viewing hood to properly evaluate this. In any case, the zoomed view that you see on the LCD either is rendered on

the fly or is a separate thumbnail image and does not represent the full resolution data of the photograph, so evaluating shadow detail this way is questionable. However, if your photo does contain subtle shadow details that you want to be sure are recorded so that you can work with them in the digital darkroom, the histogram can help you keep track of these tones as you photograph. Using exposure compensation is the easiest way to increase exposure so that the shadows are not too dark. In **Figure 5.33**, the darkest tones on the plane's tail section are being recorded as a total black. In this case, we would gradually increase the exposure with a plus exposure compensation setting and review the histogram after each shot until we saw that the shadows were not clipped to black.

**Figure 5.33** *When the tonal data runs up against the left side of the histogram, it means there is clipping (tones forced to a total black with no detail) in the shadows.*

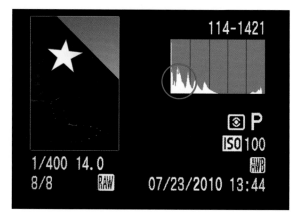

## Dealing with impossible contrast

If you're photographing under harsh, bright lighting, you may face a situation where the contrast range in the scene exceeds what your camera is able to capture in a single exposure. If you can only take a single shot under these conditions, such as with photojournalism, sports, or wildlife subjects, you have to decide which area of the tonal range is more important to the shot. Generally, it's preferable to expose so that the highlights are not blown out to a total white. As stated previously, darker midtones and shadows can be lightened, but there is no good fix for a completely blasted highlight. If the subject can be moved, such as with a portrait, try to find a place where the lighting provides more even coverage with no harsh extremes. For subjects where you don't have that luxury, you can try to reframe the shot so that a different composition provides an image with less challenging contrast. As with all good photographic

composition, search for the view that distills the image down to the essentials. By excluding extraneous and distracting elements, you might also end up with a contrast range that is easier for the camera to deal with.

For photographs such as landscapes or architectural scenes, where shooting quickly is not a major factor, you may be able to take two or more shots of the same scene with different exposure settings. The different exposures could be merged together using an HDR process, or manually, to create an image with the extended contrast range you couldn't capture in one shot. This approach works best when the camera is mounted on a tripod to ensure that the different exposures will line up precisely. However, carefully bracing yourself and using Auto Exposure Bracketing can work for handheld shots in some situations (**Figure 5.34**). We'll cover camera technique for multiple exposure and HDR photography in more detail in Chapter 6.

**A**

**B**

**C**

**Figure 5.34** *By making two separate exposures on a tripod, one for detail in the brightly lit pool (A) and the other for the darker tiles around the pool (B), the two images were combined into a single, perfect exposure (C).*

## In search of the perfect histogram

Keep in mind that there is no "perfect" histogram shape that is appropriate for all images. The histogram is merely a graphical picture of how the tones in the photo are spread out from black to white, and it will be different for each image and also for how you want to portray each scene (**Figure 5.35**). The perfect histogram for a landscape photo is not the same as for a dark and mysterious portrait. For some photos, such as night shots that contain large areas of dark sky, it's natural to have the shadows appear clipped, since significant areas of the image are black with no detail. On flat, low-contrast images, such as fishing boats in the early morning fog, it's also natural for the histogram to contain very few tones in the brighter highlight areas.

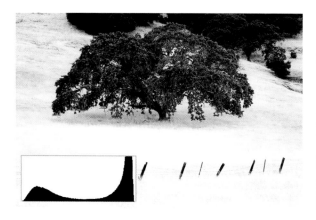

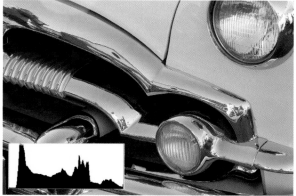

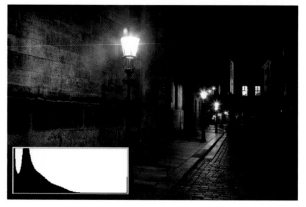

**Figure 5.35** *These three photographs all have good exposures, yet their histograms are very different. There is no perfect histogram shape that is appropriate for all images. Every scene will generate its own tonal signature.*

The important thing to glean from reviewing a histogram is that it captures a full range of tones, especially in the far right side of the scale, and that highlight values are not being clipped, or recorded as a total white. If detail in the deep shadow values is important to the image, you should check that they are not being recorded as a total black (values slammed up against the left side). Don't worry if the image appears a bit flat or low contrast on the LCD screen; you can fix this later in the digital darkroom. It's better to have a slightly flat photo than one with excessive contrast that suffers from clipping in either the shadows or the highlights.

# White Balance

The White Balance setting tells your camera what type of light (for example, tungsten, fluorescent, daylight, flash, and so on) is the primary source of illumination for the scene. We covered the technical aspects of choosing a white balance, as well as the scientific background behind color temperature, in Chapter 4. But because this chapter deals with seeing the light, and because the color characteristics of light affect the look of the image, we'll revisit it here so we can view it from a different perspective.

At the most basic level, the White Balance setting determines how the camera interprets the light in a scene as it relates to the color temperature of the light. All digital cameras offer an Auto White Balance option, and many others provide several presets that are designed for specific lighting conditions such as standard household lights, fluorescents, flash, cloudy days, shade, and so on. Understanding what setting to use depends on the type of lighting at hand, as well as on how you want to record the scene.

For most situations, we find that Auto White Balance works quite well. For some scenes, however, you may want to consciously choose a specific white balance that is more appropriate to the existing lighting, or even ignore the "correct" white balance in favor of one that will produce a desired effect. If you're taking a photo meant to convey a nostalgic feeling about childhood memories of home, for example, and only the light of a single table lamp or a fire crackling on the hearth lights the scene, the color balance of the image will tend to be very yellow. To correct for this, you could rely on the camera's Auto White Balance, or even choose a tungsten setting, to shift the colors to

**TIP** If you do decide to experiment with the preset White Balance settings, get into the habit of reviewing all camera settings every time you turn on the camera or when you move to a different location. It's very easy to choose a White Balance setting that works well indoors, for instance, and then forget about it when you move outside, which would result in mis-colored images that may or may not be easily correctable in the digital darkroom if you are not shooting in RAW (which we strongly recommend!).

a more neutral color balance. Depending on the mood you want to establish, you might want to preserve that yellow light to convey a feeling of warmth and contentment (**Figure 5.36**).

**Figure 5.36** *Not all color casts are undesirable. In this image, the light is coming from two lamps and the fire in the fireplace. The strong yellow cast conveys a sense of warmth and nostalgia, which works for this particular image.*

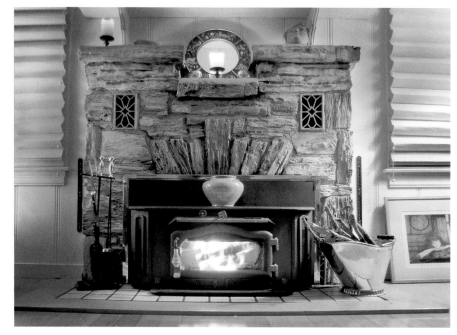

## Creating a Custom White Balance

Most DSLRs, and many deluxe point-and-shoots, offer the ability to create a custom white balance by reading the light that is reflected from a white or neutral gray object. The camera then uses that as the basis to calculate the custom White Balance setting. Essentially, what you are doing is telling the camera that the object should be white or neutral gray, and the camera is compensating for the color characteristics of the light that is striking the object. With most cameras, any custom setting you create will be used for all custom white balance shots until you create a new setting. Measuring a new value will delete the previous setting from the memory. Choosing a custom white balance, though not something you'll do every day, can come in handy, particularly in situations where the light sources are mixed or when you need to compensate for any artificial light source that has a strong color cast (**Figure 5.37**).

A    B

**Figure 5.37** *The lighting for this diner scene was a mixture of fluorescent and tungsten. In image A, Auto White Balance was used. In image B, a custom White Balance setting was used, resulting in an image with a more neutral color balance.*

If you're shooting RAW files (see the sidebar "White Balance and the RAW Image"), the subtle changes in overall color balance resulting from using a custom White Balance setting in the camera will make all files shot with a specific custom color balance setting more consistent. Therefore, the post-processing will be easier and faster. For those photographers who work in locations where the lighting is a blend of different sources, such as office fluorescents combined with large areas of window light, using a custom White Balance setting can provide an excellent way to match the exposure to the color temperature of the available light.

## White Balance Bracketing

If you find you are shooting in tricky lighting and are unsure as to which setting will work best, White Balance Bracketing may provide an elegant solution to the problem. This feature, which is usually found only on DSLR cameras, will automatically shoot a single image, create two additional copies of the shot, and apply a different white balance to each one. The primary white balance is based on the current setting, or if Auto White Balance is in use, on what the camera determines to be the best setting. The bracketed settings are derived from the main color temperature and range from a cooler, bluish tone to a warmer reddish tone. Like exposure bracketing, the differences in the white balance can be fine-tuned, usually ranging from +3 to –3 in whole-stop increments; some cameras may offer adjustments in fractions of a stop (**Figure 5.38**).

**Figure 5.38** *These images were taken using a White Balance Bracketing sequence.*

It should be noted that the use of the term *stop* for adjustment in white balance is just a convenience, since it is a means of expressing exposure modifications that most photographers are familiar with. In exposure terms, a full stop means that the image is receiving half as much or twice as much exposure—and this has no real correlation when applied to white balance. Cameras that offer White Balance Bracketing usually apply the modifications in units of *mireds* (pronounced "my-reds"). Since the calculation of mireds is far more complicated than thinking in terms of simple exposure stops (see the sidebar "Once Upon a Mired"), the latter method is generally how the changes in color temperature are expressed for bracketing white balance. The conversion factor from mireds to stops that a camera uses will vary by manufacturer and also according to whether an exact preset color temperature or Auto White Balance is being used.

White Balance Auto Bracketing is best used when you are unsure if the camera's color temperature setting is the same as the light source. You might

choose a fluorescent setting when photographing inside a warehouse, for example. But you may be faced with a situation of mixed lighting consisting of different brands and ages of fluorescent tubes, tungsten or halogen desk lamps, and perhaps even some daylight coming from large, open areas on a loading dock. In such a location, using the camera's custom White Balance setting would also be another option. One thing to remember about White Balance Bracketing is that it will drastically decrease the number of shots you can fit on a memory card (it writes three files for each shot you take).

## White Balance and the RAW Image

White Balance settings are only applied to the image if you are using the JPEG format. If you shoot in a RAW format, the White Balance setting at the camera level is not a "permanent" setting since the RAW data from the image sensor is not altered in any way before it's saved to the memory card. With a RAW file, White Balance is just another setting that you can apply when the image is converted into a more standard format using RAW conversion software. You can still measure the light at a location and use a custom setting while shooting RAW if you want to be able to apply the white balance "as shot" and then further customize the setting in the conversion software. You can also apply a custom white balance after the fact by using a color target in a control image, using that to determine the correct white balance for a scene, and then applying that setting to other images photographed in the same light (**Figure 5.39**). We cover techniques for adjusting white balance and neutralizing color casts in more detail in Chapter 8, "Working in the Digital Darkroom."

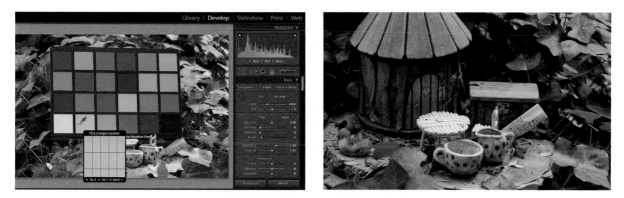

**Figure 5.39** *Creating a custom white balance after the image has been captured using an X-Rite Color Checker and the White Balance tool in Lightroom. The corrected White Balance settings are then applied to all the images taken in that sequence.*

Shooting RAW also eliminates the need to reset the white balance if you change locations and find yourself outdoors after shooting inside in artificial light. Along with additional latitude in exposure, we feel that this is another compelling reason to shoot in the RAW format.

## Once Upon a Mired

As discussed in Chapter 4, color temperature is measured in degrees Kelvin. Another unit of measure that is used when talking about color temperature is the *micro reciprocal degree*, more commonly known by the term *mired*. A mired is an approximate unit that represents the smallest change in color temperature that is perceptible by the human eye.

Mireds are used to express the differences between color temperatures to convert from one to another using photographic filters, such as when shooting under a tungsten light source (3200K) with daylight-balanced film (5500K). Digital cameras use the term to specify how differences in color temperature translate into the exposure stop system that most photographers are familiar with.

The mired value for a given color temperature is obtained by dividing 1 million by the color temperature. Using this formula, the mired value for standard tungsten light is 312 (1,000,000 / 3200 = 312). The reason for this complicated method of conversion is that changes in color temperature will produce a more noticeable color difference at low-color temperatures than at high-color temperatures. A 1000K difference between 2200K and 3200K, for instance, is 142 mired, but the same difference between 5000K and 6000K is only 34 mired. The mired is a way of measuring color temperature that takes this into account; because of this, it is the unit that is used for calculating differences in color temperature compensation filters.

To return to the earlier example of using daylight-balanced film (5500K = 182 mired) under a tungsten light source (3200K = 312 mired), the difference between the two is approximately 130 mired. A standard filter that would be used in this situation is an 80A, a light blue filter that is designed to increase the color temperature of the light from 3200K to 5500K. For film photography where actual filters are used, the downside is that the filters decrease the amount of light that enters the lens and must be compensated for by an additional 2⁄3 to 1 stop of exposure. With digital photography, you can adjust for differences in the color temperature of the light source with no impact on exposure settings.

# Breaking the Rules: White Balance as a Creative Tool

Just because certain White Balance settings exist for specific lighting situations, there's no reason you can't depart from those guidelines and employ them for artistic effect. When used this way, the White Balance settings are similar to warming or cooling filters that have long been used in traditional photography. If you use a tungsten or incandescent setting outside, for example, the scene will be rendered in cool, blue tones. This can be useful for suggesting the cold light of winter or using color to enhance images taken at certain times of day, such as early dawn or evening (**Figure 5.40**). Although using the white balance presets as digital "filters" is very convenient and easy to do, we prefer to capture the image without any creative interpretation applied in the camera. Just as a film negative does not necessarily contain all the interpretations that may be inspired by it, we like to keep our digital original unaltered in terms of color filtration and use Lightroom or Photoshop to apply such effects because we have more flexibility and control.

**Figure 5.40** *This image was photographed outdoors at night using a tungsten White Balance setting for creative effect to enhance the night atmosphere with a cool, bluish tone.*

# Adding Light with Flash

In a perfect world we would always have all the light we needed. It would be beautiful and exquisitely suited to the scene we were trying to capture with appropriate amounts of drama, subtlety, and color depending how we wanted the image to look. Sometimes, if we're lucky, it does seem to work out that way. But more often than not, we are confronted with situations where the available illumination is less than ideal, and we are faced with having to add a little extra light. This is especially true with low-light environments, such as interiors that are lit with artificial light sources. But it can also be the case outdoors with plenty of natural light all around. In this section we'll discuss some simple methods for using flash to supplement the available light in a scene.

## Fill Flash

**NOTE** In the previous chapter we mentioned that some compact cameras and DSLRs may offer a Night Portrait mode that can be used to automatically balance the flash output with the existing ambient light in a low-light or night scene. The one potential drawback to this is that on some cameras, such modes are only available when shooting in JPEG format.

As the name of the technique suggests, the goal of fill flash is to provide a little extra light to fill in areas that aren't receiving enough illumination from the existing light sources to balance the exposure. In most cases, fill flash is used to counter strong backlighting and also to add a hint of light in high-contrast scenes, such as when you're forced to photograph a portrait in midday. A hint of fill flash (emphasis on hint) will fill in harsh shadows. In many cases, if your camera has a built-in flash, all you need to do is simply turn it on. For compact cameras there is usually a mode button that accomplishes this, and for DSLRs you just need to pop up the built-in flash. When used with Program, Aperture-priority, or Shutter-priority modes, the camera will typically figure out how much flash to add (**Figure 5.41**). Cameras do differ, of course, so rather than take our word for it, you should refer to the manual that came with your camera, and if necessary, make some test shots before relying on the camera to calculate a good flash exposure for an important shot.

Fill flash can also be thought of as balancing the light from the flash with the existing ambient light. It can be accomplished in a variety of ways, and we'll cover some of the variations on this theme in the following sections. It's important to note that although the built-in flash on your camera may be a convenient way to add a little fill flash, because it creates a frontal illumination of the subject, it is also the least flexible. To truly extend your capabilities in bringing your own light to the scene, an external flash unit that has a

fully adjustable head(s) and power settings will offer the best combination of reasonably compact size and many features for modifying the type of light you can produce.

"No Flash"

"Fill Flash"

**Figure 5.41** *While climbing a peak overlooking Machu Picchu, this young hawk landed close enough to Seán that he was able to use the built-in pop-up flash on a DSLR to provide some auto-matic fill flash. This not only filled in the shadows, but also created a pleasing catch light in the bird's eye.*

## Bounced, Diffused, and External Flash

With a flash head that can be rotated and swiveled, one of the best ways to change the character of the light it creates is by directing it so that it comes from a different direction than the full frontal approach offered by a built-in flash. There are several ways you can redirect light from an external source:

- **Bounce.** By adjusting the head of the flash so the light bounces off a nearby reflective surface, such as a ceiling, wall, or reflector panel, you can increase the size of the light source as well as its direction. A larger light source created by a bounced flash creates a softer, more natural and more flattering light than the light from a standard on-camera flash (**Figure 5.42**).

A B

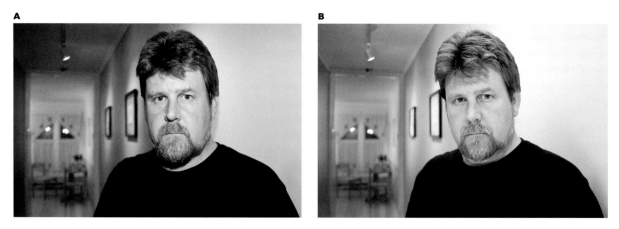

**Figure 5.42** *Image A was taken using an on-camera flash directed at the subject. For image B, the flash was bounced off a white ceiling and a gold reflector was placed at waist level to create additional bounced fill light to remove the hard shadows under the nose and chin.*

- **Diffused.** The light from the flash can be softened and diffused by directing it through a translucent material (**Figure 5.43**). Many bounce reflectors also feature a panel that can serve as a diffusion panel. As with bounce flash, directing the light through a fabric or plastic panel creates a larger and softer light source. Flash modifiers such as the Lightsphere by Gary Fong provide a small compact means of creating a larger and more diffuse light source (**Figure 5.44**).

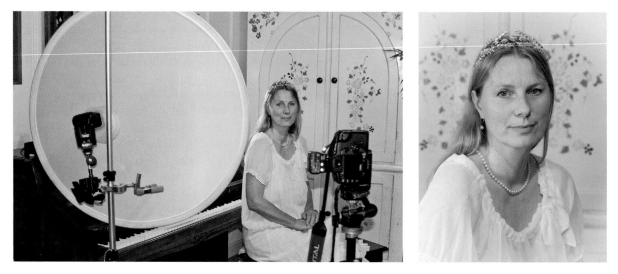

**Figure 5.43** *Diffusion panels also create a softer form of lighting from flash units.*

A                          B                            C

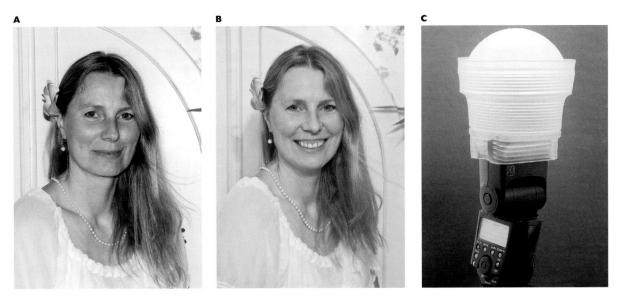

**Figure 5.44** *Image A was taken using a pop-up flash on a DSLR. In Image B, the light from a larger flash unit was modified with a Lightsphere Collapsible (image C) by Gary Fong, Inc. (garyfonginc.com) to create a softer, more diffuse light.*

- **External flash.** Although a flash with an articulated head that swivels and can be directed at different angles is a must for exploring creative flash techniques, removing the flash from the camera really opens up new worlds in terms of the light you can create with small flashes (**Figure 5.45**).

A                                         B

**Figure 5.45** *In image A, the frontal on-camera flash creates a bright reflection in the glass of the museum display case. For image B, the flash was removed from the camera and held off to the side at an angle to the glass case.*

# Controlling Flash Power Output

The goals you have for the quality of light created by the flash will vary for different shots. For some you'll want the flash output to make a visible difference in the image in terms of filling in the shadows but still be subtle and not obviously created with a flash. For other images, the light from the flash will be hard and dramatic, overpowering the surrounding light in the scene.

Although the metering systems on many flashes and cameras do a very good job of automatically calculating a flash level that creates a balanced fill light to compliment the ambient light, many external flash units also offer the ability to vary the power output of the flash. This provides you with the option to fine-tune the light levels emitted by the flash to arrive at the perfect mixture of flash and ambient light. Typically, power can be adjusted in 1/3 to 1/2 stop increments, either plus or minus to increase or decrease the strength of the flash (**Figure 5.46**).

**Figure 5.46**  *In the first image the flash was set to TTL mode and bounced off the ceiling at full power. In the second image the power was decreased by 2/3rds of a stop.*

# Balancing Flash with Ambient Light

The key to using flash creatively is to realize that you always have at least two light sources to work with: the existing ambient light, which can be anything from sunlit exteriors to interior lighting, and the flash. Instead of simply overpowering the existing lighting with the flash, you can create a balance between the two. As mentioned earlier, the basic concept of fill flash is in reality just another way of balancing the flash with the ambient lighting. Many of the tools that were previously discussed, such as varying the output power of the flash and using bounce, diffused, and most certainly off-camera flash, all play a part in creating an effective balance between existing light and flash.

## TTL or Manual?

You can handle balancing flash with ambient light in two ways: using the TTL (through the lens) metering capabilities of your flash and DSLR or running the flash on manual mode. Both have their advantages.

**TTL.** With TTL, you rely on the camera and flash to determine the proper flash power output and camera exposure. The TTL mode is a setting on your flash, and depending on the particular model of flash, it may have a different name. The camera can be set to whatever exposure mode you are most comfortable working with (though keep in mind that the fastest shutter speed for flash synchronization for most cameras is 1/200th of a second). When used on TTL mode, most dedicated flashes (especially those made by the camera manufacturer) do an excellent job at creating a pleasing balance between the flash and the existing light (**Figure 5.47**). So if you'd rather let the camera and flash take care of the settings, this is certainly a viable option. As with any reliance on the equipment to do things right, however, you should read through the flash instruction manual to ensure that you have all the settings correct. Also, do a round of test images before relying on this method for an important shot.

**Figure 5.47** *The flash was positioned on a light stand to the photographer's left, set to TTL mode, and bounced off the ceiling. The TTL metering provided an excellent automatic balancing of the flash with the ambient light. A small lamp on the piano created a nice highlight on the girl's head.*

**Manual.** Setting the flash on manual mode provides consistency between shots; you always know that the light output will be the same, even if you change the composition (with TTL, the exposure and flash output may change if the areas of brightness within the frame change). In manual mode you make test shots and refer to the image on the camera's LCD, as well as the histogram display, to judge whether or not the output from the flash is sufficient. With the flash set to manual, you can vary the intensity of the light in two ways: by decreasing or increasing the power output of the flash, or by simply moving the flash farther away or closer to the subject (this assumes, of course, that your flash is not on the camera but is mounted on a light stand). Although using the flash on manual mode may seem intimidating at first, once you experiment with this method a bit, it quickly becomes a very familiar way of working (**Figure 5.48**).

**Figure 5.48** *In this shot the flash was placed to the left on a light stand, and both the flash and the camera were set to manual to create the hard side light. By making a few test shots, the output power on the flash was adjusted until the desired quality of light was achieved.*

## Working with Flash Ratios

When working with multiple light sources, which is what you are doing when creating a balance between ambient light and flash, you need to consider the ratio between to two light sources. A lighting ratio is the brightness difference between light sources and typically refers to this difference in f-stops. A 1:1 ratio is what you get with balanced fill flash; the fill is the same brightness as the main light. In a setup with a 2:1 ratio, the main light is twice as bright, or in exposure terms, one stop brighter than the fill light. A 4:1 ratio means the light is four times as bright, or two stops brighter than the fill. Deciding on a ratio will determine whether the existing light source, be it the sun or an interior light, is the main light with the flash as fill light, or whether the flash is the main light with the ambient as fill.

The type of existing light that you are working with, as well as the kind of image you want to make, will have a big influence on the nature of lighting

ratios you choose for a particular shot. Balancing flash with interior light, bright outdoor sunlight, or the dimmer glow of twilight will require different approaches, but the essential underlying concept is the same: You are establishing a ratio between the different light sources that will determine how the two light sources work together.

## Determine the base exposure for the ambient

The first step to creating an effective balance between the flash and the existing lighting in the scene is to determine what the correct exposure is for the scene with no flash. This will give you a foundation exposure that you can build on once you add in the light from the flash.

**TIP** In a nutshell, the shutter speed determines the ambient light exposure, and the aperture controls the flash exposure.

Let's consider an interior portrait example: a clock smith in his shop. The main ambient light is a mix of daylight coming from the windows at the far side of the room and interior store lighting. For this example we'll assume that a basic exposure without flash is ISO 800, 1/60th at f/4. If you needed more depth of field, you could also change it to be 1/30th at f 5.6, or 1/15th at f 8 (**Figure 5.49**). A shutter speed of 1/15th is getting a bit slow for a handheld shot but careful camera bracing or a vibration-reduction lens should make it possible. When in doubt, use a tripod and make sure your subject holds still!

**Figure 5.49**  *The base exposure for the scene. The shadow areas are too dark, but the illuminated side of the image looks good.*

Keep in mind that the exposure in this example is good for the background, which we want to be darker than the subject. Areas that are in shadow will probably be much too dark, but that's where the light from the flash will come in.

The easy way to handle this shot would be to set your flash to TTL mode, bounce it off the ceiling (assuming the ceiling is a relatively neutral color), and let the camera and dedicated flash perform their light balancing magic. And that's perfectly OK! The technology is there after all, so you might as well take advantage of it (**Figure 5.50**). But what if you wanted to change the ratio between the existing light and the flash so that the flash was the brighter light? In that case, setting the flash and the camera to manual will give you a bit more control over your two light sources.

**Figure 5.50** *The magic of TTL flash does an excellent job of balancing the ambient light with the flash (which in this case was bounced off the ceiling).*

## Change the ambient exposure

To create a shot where the flash is the main light and the ambient is the fill, you need to darken the scene by underexposing it. So, if your initial base exposure was 1/60th at $f$4, you can darken it down one stop by changing the settings to 1/125th at f 5.6. To keep the camera exposure consistent, it is set to manual. A straight shot with no flash using these settings would result in a photo that was underexposed by one stop (**Figure 5.51**).

**Figure 5.51** *The scene with no flash, which is underexposed by one stop.*

Now it's time to bring in the flash. To keep the setup simple, position it a bit to your left or right, whichever is best for illuminating the shadowed side of the subject, and bounce it off the ceiling. You could also use a flash modifier to increase the size of the light and soften it. Set the flash to manual at normal power and make a test exposure. This will almost certainly be much too bright. Decrease the power output of the flash, and make more test shots until the exposure looks good. To make this determination, refer to not only the image on the camera's LCD screen, but also the histogram (and remember to expose to the right for an exposure that captures the best shadow detail with minimal noise). You can also change the power of the flash by moving it farther away from the subject.

The lighting ratio for this setup is 2:1, with the flash exposure for the main subject being one stop brighter than the ambient light used for the fill and the background. By leaving the camera exposure at the same settings, the exposure for the ambient remains consistent, even if you change the composition, and adjusting the power output of the flash gives you full control over both "lights" in your scene (**Figure 5.52**).

**Figure 5.52** *The final photo was made with a 2:1 lighting ratio with the flash as the main light and the ambient as the fill and background light. The flash was bounced off the ceiling and both the flash and the camera were set to manual.*

## Overpowering the sun

The sun is the brightest light source there is, but even with that intensity, it is possible to overpower the sun through creative camera exposure and flash. This technique allows you to use the sun as a backlit or rim light behind or to the side of the subject, and position the flash as the main light, illuminating the side of the subject that would normally be shaded.

In the example shown in **Figure 5.53** an initial test shot was made to determine an exposure that would create a deep blue sky. The sun was above and behind the scene, creating a subtle backlighting on the Joshua trees. The settings were ISO 100, 1/200th at f16. This resulted in an underexposed image that created the deep blue sky, but the sign and foreground tree were too dark.

**Figure 5.53** *A test shot to determine the base exposure for the scene without flash. The image is underexposed to create a deep blue sky.*

For the final image with flash, the aperture and shutter speed were the same (f16 at 1/200), but a flash was added to light the foreground. The flash was placed on a light stand to the photographer's left and was set to manual, and power output was set to +3 to provide as much light as possible to overpower the sun. A Lightsphere Collapsible was used on the flash to create a larger, more diffuse light surface. The flash was triggered via an infrared transmitter attached to the camera's hot shoe. With this setup, the flash became the main light, and the sun was used as background fill (**Figure 5.54**).

Since 1/200th of a second is the fastest shutter speed available to sync with a flash on the camera used for this shot, that aspect of exposure cannot be changed if you wanted to darken the background even more. But you still have three variables at your command: aperture, flash power output, and flash distance to the subject. By using a smaller aperture, you can cut back on the exposure for the background. If the main subject gets too dark, you can either increase the flash power output or move the flash closer to the subject.

**Figure 5.54** *In this shot the flash is the main light and the sun is the fill, creating a nice backlight effect.*

## Make Your Own Light

Getting the hang of using off-camera flash, especially on manual mode, may seem intimidating at first, but like anything, the more you play around with it, the more familiar it becomes. And "play" is the key word and concept here. The best way to learn this is to play, to experiment with test shots of cooperative (and patient!) family and friends. Fortunately, digital photography makes experimenting with off-camera flash very easy because you get immediate feedback by seeing the images on the camera's LCD screen.

In a sense the camera acts like a flash meter giving you feedback, not in exposure values but by showing you the photo you just took. And from that you can adjust your settings as needed. It is too bright and washed out? Then cut back the power of the flash or move the flash farther away from the subject. Not bright enough? Increase the flash power or move it closer to the subject. The more you experiment, the more you will develop an accurate sense for just how much to modify the flash power or how many feet to move the flash light stand. The ability to make your own light means that you can handle many photographic situations that you might have passed by if you had to rely solely on the existing light.

# Evaluating Images on the LCD Screen

After making sure that you are metering the light properly, using exposure compensation when appropriate, and checking the histogram to verify that you have captured a good exposure containing all the tonal information necessary to make a fine print, you need to review the image to check for various aspects of image quality. There is another aspect of seeing the light, which is learning how to interpret what the camera's LCD screen can tell you about the image. The LCD screen is a window onto the images you have already made, and as such, it is a valuable tool for evaluating exposure, checking how the light in the scene has been translated into the digital image, and examining how flattening the 3D world we live in into a 2D surface is working. Seeing the image within seconds of pressing the shutter button gives you the opportunity to retake the shot with a different exposure setting, explore a new angle of view, or move on to a different scene. Of course, a small screen on the back of your camera is no match for a good desktop monitor or even a laptop screen, but you should be able to look at the image thumbnail on the camera and get a good sense of the overall exposure and colors in the image.

Although the LCD certainly represents a wonderful development for photographers, enumerating all the great things it can do is pointless unless you also remove the rose-tinted glasses and take a hard look at all the things it can't do. As with any other feature on a digital camera, the LCD monitor has its limitations, especially when it comes to evaluating subtle exposure and focus differences, and knowing these limitations can give you a better understanding of what the little images on the screen are showing you.

Keep in mind that the angle at which you view the LCD can drastically affect the quality of the display. You can try this out by tilting the camera up and down or left to right to see this effect in action. In this respect the monitors on digital cameras have the same problems as LCD screens on laptop computers. The ambient light level also factors in to how well you can evaluate the image, with brightly lit, outdoor conditions making it very difficult to get a good view of the image.

# Configuring LCD Settings

Many cameras offer controls that affect the behavior of the LCD screen. Some are more significant than others, but all the controls influence how you interact with the LCD as a photographic tool for evaluating image quality:

- **Brightness control.** For reviewing images, one of the most useful of the LCD settings is a brightness control. Most DSLRs feature an LCD brightness control, and some even display a gray step bar so you can see how changes to the brightness are affecting a standard tonal reference. For most situations, we've found that the default brightness level is adequate for reviewing the thumbnails, but in outdoor situations where there is a lot a bright light, increasing the brightness of the display may make it easier for you to see the image. Just remember that increasing the brightness of the display has no effect on the actual image, so you shouldn't rely on this for reviewing the tonal characteristics of a photo. Evaluations of tonal levels, especially highlights and shadows, should be made using the histogram.

- **Image review.** With an image review feature turned on, the camera will automatically display a thumbnail of the photo immediately after it has been captured and as it is being recorded to the memory card. This is a great way to quickly check the image before moving on to the next shot. The duration of the display can often be changed, usually ranging from two to eight seconds. Once the display time ends, the LCD will turn off if the camera is a DSLR; if the camera is a non-SLR, it will switch back to a live-feed image of what is being seen through the lens. You may also be able to leave the display on until the next shot is taken, although we don't recommend this because it drains precious battery power.

- **Image review with histogram.** Cameras that provide a histogram display may also have the capability to display an immediate image review that includes a histogram for the photo. If the photography you do requires fast reactions, you can use this feature to take a shot: Quickly glance down to check for highlight overexposure, return the camera to your eye, dial in an exposure compensation setting, and be ready for the next shot. Cameras that display a flashing overlay on overexposed areas make these kinds of quick evaluations even easier.

- **Display off.** Any decent camera should also have the ability to turn off the image display, either through a dedicated button on the camera or with a timed setting that can be selected in the camera's menu options. The LCD display is one of the main drains on the camera's battery, so using it only when you need to will give you more mileage from a single battery charge.

## Checking Focus and Sharpness

The LCD screen can be used to check overall focus in an image, including how depth of field appears, but it is typically not ideal for determining fine levels of sharpness, particularly on areas in the image where details should be crisp. Many cameras provide the capability to zoom in on the thumbnail image and even scroll around to check on different areas of the magnified view. Even with this feature, however, we have found that it is difficult to truly judge the sharpness of a shot based solely on the LCD, because the zoomed view is not the actual high-res photo, but a scaled-down rendering for the LCD display. In most cases the view on the LCD will look less sharp than on a large monitor. Turning off the camera's built-in sharpening feature (a move we recommend) is another reason that zoomed-in views of the image may look slightly soft. If you are shooting in RAW format, the image is not sharpened by default, no matter what the sharpening options in the camera's menu may be set at.

Although not extreme, this slight visual disconnect between the sharpness you see on the LCD and what you see on a large monitor can be an issue, especially if you find yourself at a location where sharp focus is critical, and you can't easily return to retake shots where the sharpness is less than satisfactory (**Figure 5.55**). Sometimes, you just have to take for granted that the shots are sharp and use time-tested photographic practices (use a tripod, an adequate shutter speed, etc.) to do all you can to capture an image that has sharp focus where you need it. Knowing how your lenses perform, especially at different focal lengths and at various apertures, is critical to ensuring that you come home with images that have good focus. Shutter speed affects sharpness—more so with longer, telephoto lenses—so try to use a shutter speed that is appropriate for the focal length you're using. The common

rule of thumb for handheld photography is to use a shutter speed at least as fast as the focal length of the lens. For a 250mm lens, for instance, you would not want to use a shutter speed of less than 1/250 of a second. Remember to factor in any focal length magnification that may be taking place. For example, if you have a 28mm to 135mm zoom lens on a camera with a 1.6x focal length magnification factor, at 135mm the focal length is really 216mm. If the need for greater depth of field forces you to use a slower shutter speed, use a tripod or some other form of stabilization to ensure that the camera is steady. An electronic cable release will prevent movement from your hand from affecting the camera as you press the shutter button. In some situations, especially with longer exposures and telephoto lenses, using the mirror lockup feature will further reduce the possibility of focus-killing vibrations from resonating through the camera body.

**Figure 5.55** *At the time this photograph was made, the preview on the LCD seemed to be in focus. However, when seen in an enlarged view on a computer monitor, the fine details lack critical sharpness.*

# Working with Live View

If your camera offers Live View, the LCD has enhanced functionality that could be very useful depending on the type of photography you do. Although there are certainly limitations to Live View, especially when working outdoors in bright light, here are a few of the potential benefits:

- **Macro.** If you shoot close-up subjects with a macro lens, Live View allows you to see the scene without having your eye up to the viewfinder. This can be very handy in situations where you are shooting in cramped quarters. By using a remote release, you can view the image on the Live View screen and trigger the shutter at the precise moment you want to take the shot.

- **Checking critical focus.** In some shots where you are focusing on far-off elements, such as mountains in a landscape, the autofocus may not be quite as exact as you would hope. By placing the camera on a tripod and using Live View, you can zoom the preview until you are seeing a small section of the distant scene, use manual focus to fine-tune the focus until it is perfect, and then take the shot. Live View can also be useful for establishing focus when shooting at night where the autofocus may not function well with lower-light levels.

- **Monitoring camera vibration.** If you are working on a tripod (and most uses of Live View work best on a tripod) under conditions where motion might be transmitted to the camera through vibration, such as when shooting on a bridge or on a very windy day, you can compose your shot and then zoom in on the preview to see how much the camera is actually moving. When you see the motion diminish, you can take the shot.

- **Alignment issues.** If you are composing a shot with straight lines that need to be aligned precisely with the edge of the frame, Live View can give you a preview that is often easier to evaluate than what you see when looking through the optical viewfinder.

# Making Selects in Camera

After taking a series of photos, one of the primary uses of the LCD screen is the ability to select and delete images in the camera, and share them with your companions. Your editing practices at the camera level will vary depending on how well you can rely on what the LCD is showing you, the availability of extra memory cards or other portable storage solutions, and how comfortable you feel deleting something that you haven't had a chance to view on a large monitor. Katrin doesn't trust herself or recommend making selects based on the camera LCD. She finds it better to carry an extra card and take more photos rather than spending time reviewing images and possibly missing the shot. Here are some factors to keep in mind when editing images in the camera:

- **Reviewing thumbnails.** On some cameras, you have to turn a switch to enter a separate review mode to see the thumbnails; on others a quick press of a button will show you the most recent photo. Most SLRs are shooting-priority cameras, which means that as soon as you lightly press the shutter release button, the camera is returned to capture mode and is ready to take the next photo.

  In addition to letting you review each of the images you have taken as a full-screen thumbnail, most cameras offer an index view, which lets you see four to nine shots on one screen and quickly scroll through them.

- **Scrolling and zooming.** While in thumbnail review mode, you should be able to press the lens zoom control, or other buttons, to magnify the thumbnail view and zoom in for close inspection. The zoom factor will vary among different cameras, but a 6x to 12x magnification is common. DSLRs typically allow for greater thumbnail magnification than their more compact cousins. The camera's control wheel or multi-selector switch is used for scrolling left to right or top to bottom on the magnified image. The thumbnail scroll and zoom feature is essential for photographs where you need to check on details that are hard to see in normal view. A good example of this is a group portrait where you want to verify that everyone has his or her eyes open before calling an end to the session.

- **Flagging/protecting images.** Another feature we like is the ability to flag certain images as keepers. In many cameras this also serves double-duty to protect a photo from accidental deletion. This can be quite helpful, because no matter how careful you are, on some cameras there's a very fine and dangerous line between deleting a single image and erasing all the images on the card.

- **Deleting images.** Whether you choose to delete photos using the camera controls or to save that decision for later when you can view them on your computer will depend on a number of factors. One approach you can use to maximize space on the memory card is to delete any clearly bad shots as you go. Sooner or later, however, we all face the unpleasant reality of a full memory card. If you find you are running out of room and you have no spare cards in your camera bag, you may have no choice but to cull and delete right on the spot. In this case we suggest reviewing all images on the card and then deleting the ones that are obvious candidates for the trash bin. This may buy you some extra shooting time, but the shrinking number of shots remaining is sure to cramp the normal feelings of spontaneity and freedom to experiment that are usually part of the digital photography experience.

Some people prefer to do significant editing in camera. If the purpose for your images is clear and you know exactly what you need, editing in the camera can be an efficient way to save only the shots you need while preserving space on the card for new photos. Although this is certainly a viable option if you have faith in what the LCD shows you and your ability to understand it, we usually like to save major editing decisions for later when we can review our shots on the larger monitors in our digital darkrooms. Katrin is especially reluctant to edit out even questionable images while they are still in the camera, because she never knows if there might be a group of pixels or an interesting abstraction that she might find useful later. If your work includes collages or more abstract visual interpretations, even shots that other people might consider bad can be grist for the creative mill. Interesting blurs, exposure flaws, subject movement, unexpected expressions, or relationships between foreground and background elements that you didn't notice when you pressed the shutter button are all legitimate reasons to postpone deleting images until you've had the chance to see them displayed on a larger monitor (**Figure 5.56**).

**Figure 5.56** *Don't be so quick to delete less-than-perfect shots from your memory card! This handheld 2.5 second exposure is totally out of focus, but the silky blur and the deep blue of the sky give it a dreamlike quality that made it one of the most interesting shots Seán took that night.*

# The Range of Light

Good photographs are a mixture of many elements all coming together in a perfect instant at the time of exposure. Composition, viewpoint, timing, subject matter, technical control, and creative interpretation all play important roles in the final image. But the one element that can transform a scene like no other is light. By making changes to how the camera's image sensor is exposed to the light, you can exercise a great deal of control over your digital exposures. The key to this creative control lies in understanding how the camera's view of the world differs from your own view and knowing how to use the camera's settings to create the image you want. Once you develop this understanding and mastery of the technical controls on your camera, you'll never again have to settle for the default exposure that your camera gives you. Instead, you can evaluate the range of light in a scene, know how

the camera's meter will react to it, and make the necessary adjustments to craft the image you see in your mind's eye. Your images will improve and your enjoyment of digital photography will increase. Every photograph you take will teach you more about making photographs and working with the light to create the best image possible.

# Multiple Exposures and Extending the Frame

# 6

Throughout the long history of still photography, photographs have traditionally been bound by their rectangular or square frames, and most have been the result of a single exposure. This does not apply to all photographs from the pre-digital era, of course. The use of multiple frames to show a sequence of action has been around since the days of Eadweard Muybridge, who in the nineteenth century used high-speed photography to show how animals and people moved. Multiple exposures have long been part of the texture of photographic history, occurring accidentally at first and then later used for creative effect by many artists, including Man Ray and David Hockney.

Digital photography offers new possibilities for blending exposures together to break and extend the traditional rectangular frame. The creation of multi-image panoramas has never been easier to achieve, and the ability to photograph several exposures of a scene to capture a range of brightness values that could never be recorded in a single exposure has changed the very nature of what a photograph is and what we expect it to show us. The latest development in the technical evolution of the still camera is the ability to use them for stop motion animation, time-lapse photography, and high-definition (HD) video capture, extending the static frame of the still image into the realm of time, motion, and sound.

# Extending the Frame with Panoramas

We live in a big, beautiful world, and sometimes the stunning views that we want to record with our cameras are much too expansive to fit into a single photo. This problem is nothing new, of course, and ever since the early days of the medium, photographers have looked for ways to more accurately record the dramatic vistas of the natural landscape as well as the urban landscape of the great cities (**Figure 6.1**). Approaches have varied over the years and have included mammoth 20x24-inch glass plate cameras that intrepid landscape photographers of the late nineteenth century packed into the wild places of the American West, multi-panel displays of landscape photos, wide-angle lenses, and special large-format panoramic cameras that rotated during the exposure to capture an ultrawide view.

**Figure 6.1** *Panoramas have been popular in photography for a long time. This image shows the ocean liner Lusitania docked in New York c1907 after a record-setting voyage. Courtesy of the Library of Congress, Prints & Photographs Division [reproduction numbers, LC-USZ62-64956, LC-USZ62-64957]*

There is no way that a two-dimensional rectangular image, no matter how large it is printed, can ever approximate the view that we see when we are actually experiencing a landscape firsthand. As photography has moved into the digital era, however, it has brought with it techniques that can easily be used to extend the field of view of your lenses and overcome the limitations of the single image, and create a view that more closely encompasses the wide-open spaces of big skies and endless horizons.

# Photographing Panoramas

As you can see from the historical photo in Figure 6.1, it is actually two separate images that are arranged side by side with an obvious seam running through the middle of the image. Fortunately, you don't have to be concerned with such seams because of the quality of digital imaging software that seamlessly blends images from multiple source photos. The basic camera approach to making a panorama hasn't really changed much since the early days; it still involves photographing multiple, side-by-side or overlapping views of the same scene.

## Camera orientation: horizontal or vertical?

When you want to create a multi-shot panorama, the first decision you need to make is whether to orient the camera horizontally or vertically. We are not referring to the orientation of the finished image, but to the orientation of the individual shots that will make up the panorama. If you will be creating a horizontal panorama, it may seem natural to use the same camera orientation. For scenes where you will only be using two shots, horizontal shots certainly make the most sense. If you will be covering a wider range of scenery, you should consider using a vertical camera orientation for each "panel" of the panorama.

Shooting the source images vertically allows you to use more pixels for the final blended image, which means that you can make larger prints from the file. It also lets you include more of the height of the scene, giving the viewer more "head room" to enjoy the scene (**Figure 6.2**). Another potential pitfall of shooting horizontal source images is that you are likely to end up with a very long and narrow panorama. If you will be printing your masterpiece on a large format printer that can accept roll paper, this is not a problem. But on a standard-size desktop inkjet printer (13x19) imagine printing on 19-inch-wide paper only to have the height be a few inches (**Figure 6.3**).

**Figure 6.2** *By shooting panorama panels in a vertical orientation, you generate more pixels for the final image and capture more of the height of the scene.*

**Figure 6.3** *Using too many horizontal shots to cover a wide expanse of a scene will result in a panorama that has great length but the same height as the average bookmark.*

## Image overlap

One of the key aspects of successful panoramas is creating source images with enough but not too much overlap between each shot. The overlapping areas are crucial for the imaging software to detect matching areas and patterns in the photos that it uses to create a seamless blend between the photos. An overlap of 20–25 percent between each image is the minimum that you want to have, with 30–50 percent being a more conservative amount that will give the stitching software plenty of information to merge the different photos together. Seán usually likes to shoot panoramas with an approximate 50 percent overlap between the images. He uses the center autofocus point in the middle of the viewfinder as a reference point when determining the overlap area as he composes each shot (**Figure 6.4**). Because wider lenses may add distortion to an image, Katrin shoots with 40–50 percent overlap when working with wide-angle lenses (16-35mm) and with a 20 percent overlap when using longer lenses.

## Exposure

When you use your camera on any of the automatic or semiautomatic modes (Shutter or Aperture Priority), the light meter evaluates the brightness levels in the scene and comes up with an appropriate exposure for the shot. When making the source shots for a panorama, you move the camera from one side to the other to record different sections or panels of the entire scene. As the camera encounters varying reflectance values in the scene, the exposure may change and will be slightly different for each shot. This is especially true for the sky, where brightness levels can be quite different from side to side, depending on the angle of the sun. This is not as much of an issue as it was in the past due to improvements in panorama stitching software that now do a very good job of blending shots together, even if they have different exposures. But it is still important to understand how

**Figure 6.4** *Include a 25–50 percent overlap between each shot so that the panorama software has enough information to blend the images together.*

exposure differences can affect the final result, which depends on how well the merging software can even out these differences.

To ensure that you are creating photos that will be good source material for the panorama process, here are a few tips to keep in mind:

- **Keep the aperture consistent.** Aperture affects depth of field in photographs. If your source images have different apertures, this could cause noticeable focus or alignment issues. Use Aperture Priority or Manual mode to ensure that the aperture is the same across all the shots.

- **Use the same exposure for all shots.** Determine a good overall exposure for the entire scene. Set your camera to Manual and take all the source shots using this one exposure. Although the brightness of the sky may vary from one side of the image to the other, this ensures that there will be matching brightness levels in the critical overlap areas of the panorama.

- **Use the same white balance for all shots.** White balance is a stealth exposure variable that you might not be thinking of when making a panorama. But if the camera is set to Auto White Balance, it can change across the different source shots. An easy way around this is to simply use a White Balance preset that matches the lighting in the scene. For most panorama shots, which are typically outdoor scenes, set the White Balance to Daylight or Cloudy, depending on the lighting conditions. If you are creating an indoor panorama, choose a preset that most closely fits the lighting or use a custom White Balance setting.

- **Overlap the images by 20–50 percent.** A good overlap between images will result in a seamless and smoother blend between each source file.

- **Use a consistent focal length.** If you are using a zoom lens, make sure that the focal length stays the same for all shots.

- **Keep the camera as level as possible.** As you pan from left to right to take the different shots, try to keep the camera level and at a consistent angle in relation to the horizon. Using a tripod with a bubble-level and a panoramic head is the recommended method to maintain consistency, but even when working handheld, pressing your elbows tightly against your torso can help to create a much more stable handheld camera platform for shooting panoramas.

- **Test the software with exposure differences.** A finished panorama is only as good as the software that stitches it together. As stated earlier, some programs, including the Photomerge feature in Photoshop (version CS4 and later), do a very good job at evening out differences in exposure. Others may not do as well in this area. Test your program using panorama images with noticeable exposure differences between the shots. You can create such shots by leaving the camera on Auto and doing a wide sweep of a scene containing a good amount of sky. If your program does not blend the shots together well, you'll need to adopt a manual exposure approach.

- **Keep it interesting.** Just because an image is wide, tall, large, or small doesn't make it interesting. Before shooting the source images, take a moment to pan the entire scene while looking through the viewfinder. Look for dead zones, or boring areas, or areas that may cause stitching problems, such as areas with a lot of movement or exposure differences. Each area of the scene should be interesting. Apply the same rules of good composition as you would with any single-exposure image.

- **Embrace experimentation.** Panoramic photography is most commonly used for landscapes, but other subjects may work well in this format, too. Experiment and think creatively. Panoramas can be made from vertical subjects, interiors, still lifes, infrareds, black and whites, portraits, abstracts, and so on (**Figures 6.5** and **6.6**). Don't impose limits; just try it and see what happens.

**Figure 6.5** *A New York lunch isn't a standard panoramic subject. Image by John McIntosh*

**Figure 6.6** *Merging duplicate files—one of which has been flipped and saved as a separate file—creates Escher-like impossible stairs. Image by John McIntosh*

## Handheld panoramas

In the early days of digital panoramas, a tripod, sometimes with a special panorama tripod head, was almost always a necessity. But that is no longer the case for all types of panorama shots since modern stitching software does an excellent job of aligning and blending the images together. Certainly there are advantages to using a tripod for many types of photography, and for some specialized panoramic work that requires a high degree of accuracy, using a tripod is still a critical part of the process—we'll cover that shortly. For many panorama scenes, however, you can get excellent results by carefully holding the camera.

Before actually taking the shots for a handheld panorama, double-check your exposure and White Balance settings. You might also want to go through the motions in a test run, just to see where the approximate divisions between each frame will be. Depending on the markings in your camera's viewfinder, you may be able to uses these to help with alignment and calculating the overlap areas. When you're ready to start, take the first shot and then pan the camera from one side to the other, taking a new shot for each section of the scene. Be sure to factor in an appropriate amount of overlap between each image, and try to keep the camera as level as possible while maintaining a consistent vertical angle.

**TIP** To mark the beginning and end of panorama sequences, hold up your hand or an X-Rite Color Checker and take a "divider shot" before and after each sequence (you could also do a black shot by covering the lens). This will clearly delineate the pano shots from your regular images when viewing the thumbnails in an image workflow program such as Lightroom, Aperture, or Bridge (**Figure 6.7**).

**Figure 6.7** *Placing a hand at the start or end of a series of source images reduces confusion when sorting and stitching images.*

# Tripod-mounted panoramas

Using a tripod when shooting panoramas will give you the maximum level of precision and control. A tripod can ensure that the camera is perfectly level, and special heads and accessories can also help to eliminate parallax, which occurs when near and far objects don't align correctly in overlapping images.

## Leveling the tripod

Proper leveling of the tripod will help to maintain the alignment of vertical and horizontal elements in the scene when the shots are stitched together. If you think that this is an area you'd like to explore in depth, investing in a tripod with a level at the base of the head is essential, because this will ensure that the tripod legs are level (**Figure 6.8**). If your tripod has a ball head, you'll need to level the tripod in two places: at the legs and at the quick release clamp. Really Right Stuff (reallyrightstuff.com) makes a variety of tripod and clamp accessories for panoramic photography, including the PCL-1 Panning Clamp (**Figure 6.9**). This includes a level on the clamp, precision markings, and the ability to use it with other pano accessories that are designed to eliminate parallax.

**Figure 6.8** *A bubble level at the base of the tripod head is essential for leveling the tripod.*

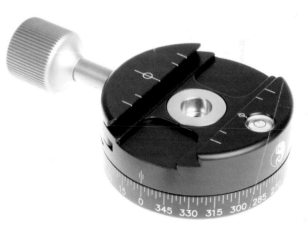

**Figure 6.9** *The PCL-1 Panning Clamp by Really Right Stuff is designed to work with ball heads. © 2010 Really Right Stuff. Image used with permission.*

### The importance of the nodal point

One side effect of some panoramas is parallax, which occurs when near and far objects are not properly aligned in overlapping frames. If you are shooting where most of the scene is at the same approximate distance from the camera, parallax is not likely to be an issue. It is most noticeable in interior scenes that contain objects that are close to and far away from the camera.

The key to eliminating parallax lies with the alignment of the nodal point of the lens. We first mentioned the nodal point back in Chapter 2, "How a Digital Camera Works," when we discussed lens focal length, which is defined as the distance, typically in millimeters, from the rear nodal point of the lens to the point where the light rays are focused onto the film or digital sensor. One way to reduce the chance of image parallax is to align the nodal point, or optical center, of the lens over the rotation point on the tripod. Normally, the camera body is aligned over the rotational center of the tripod. To align the rotational center with the lens nodal point requires an additional accessory called a nodal slide to offset the camera so that the optical center point of the lens can be properly positioned directly over the rotational center point of the tripod (**Figure 6.10**).

**Figure 6.10** *A nodal slide, such as this one from Really Right Stuff allows you to align the optical center of the lens with the rotational pivot point of the tripod. © 2010 Really Right Stuff. Image used with permission.*

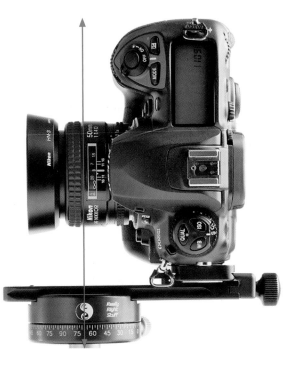

# Nodal Point or Entrance Pupil?

When referring to aligning the lens nodal point over the tripod's rotational center in panoramic photography, the underlying concept is the most important detail to keep in mind. Depending on whom you consult, you may encounter another term that refers to the optical center of the lens: the *entrance pupil*.

In a conventional lens, the entrance pupil is the image of the lens aperture when seen through the front of the lens. Due to the magnifying properties of lens elements, the size and location of the image of the aperture may not be the same as the size and location of the actual aperture inside the lens. The corresponding aperture image when seen through the rear of the lens is referred to as the *exit pupil*.

The exact definitions of nodal point and entrance pupil as they relate to making panoramic images are a topic of some debate among optical scientists, photographers, and the manufacturers of panoramic gear. But whatever name you use to refer to it, the critical concept as it relates to eliminating parallax is that when the camera is rotated around the optical center of the lens (i.e., the nodal point or entrance pupil), there is no change to the perspective geometry of the image.

## Finding the nodal point

The location of the nodal point varies depending on the type of lens you are using. In a fixed or prime lens it will always be in the same location for that lens. In a zoom lens, the location will change as you zoom the lens to a different focal length. Finding the nodal point for the lens involves mounting the camera on a nodal slide rail. Both the tripod and the tripod head should be level. Start out by positioning the approximate center of the lens over the center rotation point of the tripod.

Locate two vertical elements in the scene, one near and one far, such as the edge of a park bench and a distant tree. Position the camera and tripod so that both vertical elements are aligned in the viewfinder. The goal is to be able to pan the camera while maintaining the relative position of both the near and far objects.

Pan the camera to the left. If the rear vertical object appears to move to the left, the tripod rotation point is positioned in front of the lens nodal point. Slide the camera forward using the nodal slide and repeat the procedure. If the rear object appears to move to the right, the tripod rotation point is positioned behind the nodal point. Slide the camera backward and repeat the procedure.

When you can pan the camera and the rear vertical object does not appear to move in relation to the front vertical object, you have correctly positioned the nodal point over the rotational axis of the tripod. Refer to the markings on the nodal slide and make a note of the position so you can easily repeat the setup for future shots.

## Thinking Outside the Panorama Box

Landscapes, which are probably the most common subject for panoramas, are horizontal by nature, as is the way we see the world. So it follows that most panoramas are horizontal images. But that doesn't mean you have to photograph every panorama horizontally. Try to think outside the panorama box and see how you can use this technique in different ways.

### Vertical panoramas

Vertical subjects are naturals for a vertically oriented panorama (some people now refer to such images as "vertoramas" but we prefer simply "vertical panorama"). The technique is the same for a vertical panorama as it is for a horizontal one, but with some scenes you may notice more obvious perspective distortion when panning vertically, especially if there are vertical subjects such as trees or buildings that are relatively close to the camera. Still, you may find such distortion to be an interesting visual effect. There's no law that mandates that perspectives always have to be perfect and undistorted (**Figure 6.11**)!

**Figure 6.11** *Some subjects are well suited for a vertical panorama.*

## Increasing the pixel count in an image

You can also use the basic panorama approach for capturing an image with more megapixels so it can be reproduced at a larger size. It doesn't even have to be an obvious panoramic subject or format. By taking two or more shots of a scene, each one capturing a segment of the overall scene and overlapping slightly as mentioned previously, the images can be combined into a single file with a larger pixel dimension than is available from your camera with a single exposure (**Figure 6.12**).

**Figure 6.12** *Two shots were taken of this scene to capture an image with more pixels than could be captured with a single exposure.*

## Breaking the boundaries of the rectangular frame

As photographers we are used to seeing our images represented in a rectangular or square format. It is the common frame through which our images are seen in the viewfinder, viewed on the computer, printed on paper, or framed and hanging on the wall. The boundaries of the rectangle or square are familiar, and they serve the purpose of providing a visual canvas upon which we can compose our photographs, imposing a sense of form and structure to the image. But there is also a bit of tyranny to the rectangle, and many photographers look for ways to present their images in a format that breaks through the rigid rectangular frame. Panoramas are one way to explore this approach.

Instead of consciously trying to keep the camera level for each shot, what would happen if you purposely tilted it in a different direction as you made multiple photographs of a scene? The only way to know for sure is to give it a try! Long before the advent of digital cameras Seán worked on a series

of such images that were made with individual 35mm exposures that were custom printed as 8x10-inch prints in a traditional darkroom. Each matched the adjoining image and all were then mounted together to form a single large image with deliberate irregular edges (**Figure 6.13**).

**Figure 6.13** *Seán made this multi-shot image of a building in what was then East Berlin in his pre-digital days with a 35mm film camera. Each frame was printed and then physically collaged together to create the final image.*

Fortunately, creating this look with digital cameras and panorama software is much easier and less expensive than with 35mm negatives and traditional darkroom techniques! The irregular shapes created by purposely deviating from the straight and level approach can sometimes be quite interesting, and by turning off any auto blending options in the stitching software, you can create a collage that looks like several individual prints have been assembled together (**Figure 6.14**). In addition to the uneven edges that you may consciously create for panoramic images, the stitching process sometimes also creates its own irregular and often surprising shapes. You can choose to crop these shapes to a more conventional rectangle or not, depending on how the creative spirit moves you (**Figure 6.15**).

**Figure 6.14** *Channeling David Hockney: This panorama was made from ten images and assembled with no blending of colors or edges. A slight drop shadow was added to each layer in Photoshop to emphasize the look of different photos assembled together.*

**Figure 6.15** *Irregular shapes created by the panorama stitching process provide another way of venturing beyond the rectangular frame.*

## Assembling Panoramas

After you've photographed the different source images for a panorama, the fun part is putting them all together in the digital darkroom and seeing the final result. Several panorama-stitching programs are on the market, but for this discussion, we'll focus on using Photomerge in Adobe Photoshop CS5 and accessing that feature from within Lightroom or Adobe Bridge.

### Pre-panorama adjustments

Before diving into assembling the panorama, you should first take care of any image cleanup and overall adjustments. This is especially critical when it comes to removing any sensor dust spots that may be dotting the image. If your sensor has dust spots and they are visible in the sky areas of the image (or elsewhere), those spots will be repeated for every shot in the

sequence. It's much easier to remove them before making the panorama than after. Chromatic aberration, which typically shows up as cyan-red color fringing along contrast edges at the sides of the image, should also be addressed at this stage (**Figure 6.16**).

**Figure 6.16** *This instance of chromatic aberration was fixed in Adobe Camera Raw before assembling the panorama.*

The same goes for any overall adjustments to tone, contrast, and color. Get your images looking as good as possible before beginning the panorama assembly. To save time, you can apply adjustments to only one of the frames in the series and then synchronize those exact settings to all the other images in the sequence. If the different shots were made using the same exposure, the overall adjustments made to one will apply to all of them (**Figure 6.17**). The same holds true for the dust spotting in most cases, but you should still inspect the spotting up close to ensure that the spot removal matrix from the source image works well for the other images. We cover dust spot removal, global and local area image adjustments, and synchronizing Develop settings across multiple files in Lightroom in Chapter 8, "Working in the Digital Darkroom."

A

**Figure 6.17** *The same Lightroom Develop settings applied to the first image in the sequence (A) are applied to all the files for the panorama (B).*

B

## Photomerge

**NOTE** Lightroom will bring your files into Photoshop at the full pixel resolution of your camera. When using Bridge, RAW files will be imported into Photoshop at whatever size was last used in the Camera Raw dialog.

After you've cleaned up the dust spots and applied any overall adjustments to the files, you're ready to bring them into Photomerge. In Lightroom, select all the thumbnails in the pano sequence and choose Photo > Edit In > Merge to Panorama in Photoshop. The downside to using Lightroom to access Photomerge is that the full-resolution files will be used. We suggest creating an Export preset to create lower-resolution files (for example, 1000 pixels on the long end) to use as a Photomerge test. If you are using Adobe Bridge, a similar command can be found by choosing Tools > Photoshop > Photomerge. If Photoshop is not already running, it will launch and the Photomerge dialog will appear.

## Choosing a layout method

In the Photomerge dialog you are presented with a number of different layout options (**Figure 6.18**). When in doubt, choose Auto and the software will determine whether to use Perspective or Cylindrical, which are the most commonly used methods. Each layout option has its strengths for different types of panoramas:

**Figure 6.18**

*The Photomerge dialog in Photoshop CS5.*

- **Perspective.** This method works best for panoramas where there is obvious perspective within the image, such as a shot in which there are clear foreground elements that are close to the camera combined with background elements that are farther away. Interior panoramas are

good subjects for the perspective option. This layout will often result in the final merge having a "bow tie" shape (**Figure 6.19**). If you use the Auto layout method and the image has the obvious bow tie shape, it means that Perspective was used. If this does not work well for the image, close the file, don't save it, and run the Photomerge process again using Cylindrical.

**Figure 6.19** *The Perspective layout on the Makapu Point panorama creates too much distortion on the left side and doesn't work very well for this image.*

- **Cylindrical.** This method works best for classic landscape panoramas where the scene is essentially the same distance from the camera and the composition is a side-to-side pan of the scene (**Figure 6.20**).

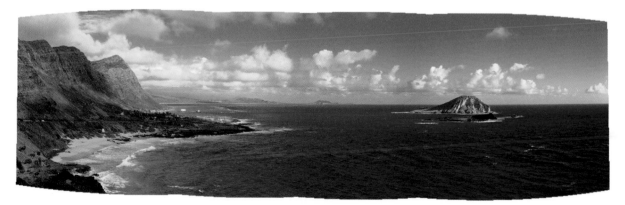

**Figure 6.20** *The Cylindrical layout method works best for classic landscape panoramas and works very well for the Makapu Point image.*

- **Spherical.** This method aligns and transforms the images as if they were for mapping the inside of a sphere. If you have taken a set of images that cover 360 degrees, use this for 360-degree panoramas.

- **Collage.** This method aligns the layers and matches overlapping content, and may transform (either by rotation or scaling) some of the source layers.

- **Reposition.** This method aligns the images in the basic position as layers with layer masks to create the panorama but does not apply any of the blending or transformations that are used in the other layout methods. The Reposition method is useful if you want Photomerge to arrange the images for you to work with in a manual collage.

At the bottom of the dialog are three check boxes for Blend Images Together, Vignette Removal, and Geometric Distortion Correction. The first is definitely recommended, because it ensures the smoothest blends between the source files, especially if they were made using different exposures. Vignette Removal corrects the slightly darkened corners that are sometimes caused by lens shades or when using zoom lenses. Geometric Distortion Correction is useful for panoramas where there are straight lines and angles, such as you might find in an interior scene or an image of buildings. Many times, if Katrin doesn't like the initial stitch she redoes it with Geometric Distortion Correction selected, and although slower, the results are more accurate and pleasing.

# Extending Exposure with HDR

Just as shooting multiple exposures to blend into a panorama can help to extend the frame, High Dynamic Range (HDR) imaging techniques allow you to extend the limits of camera exposure and create images that contain a range of contrast and brightness values that better reflect how you see the play of lights to darks, which would be impossible to capture in a single shot. The ability to easily create and combine multiple exposures of a scene into an HDR image has been one of the most groundbreaking aspects of digital photography, freeing photographers from the technical limitations of the image sensor in their cameras.

# When to Shoot HDR

In many scenes, the dynamic range of contrast from the deep shadows to the bright highlights exceeds the capabilities of image sensors to capture all the tonal detail present in the scene in a single exposure. High-contrast outdoor scenes on bright, sunny days; sunsets (**Figure 6.21**); twilight photography; and interior locations that combine darker areas with artificial illumination or views through windows to brightly lit exteriors are all situations in which you can use HDR techniques to capture a full range of tonal values.

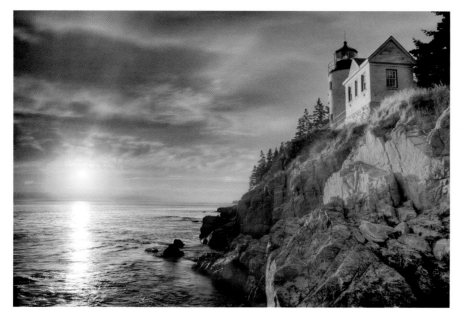

**Figure 6.21**  *This HDR image of Bass Harbor Head lighthouse in Maine was created from six exposures.*

Because HDR involves taking multiple shots of the same scene, each at a different exposure optimized to record a different level of brightness in the scene, it is not suited for all types of photography, especially where fast motion in the main subject is an integral part of the story, such as with sports photos. It is an excellent match, however, for landscapes, cityscapes, architecture, nature, travel, and still lifes, and can even be used to create an intriguing look for highly stylized portraits. For longer exposure times, a tripod is necessary, but for scenes where the shutter speeds are fast enough for handheld photography or where you can artfully brace the camera to reduce camera shake, your camera's Auto Exposure Bracketing feature will let you create HDR images of many different subjects.

# Photographing for HDR

To make a great HDR image, the first step is recognizing situations in which this technique will work well for the scene. As noted previously, any high-contrast scene with a wide range of brightness values is perfect for HDR. But even scenes with tamer contrast ratios can be enhanced in interesting ways when rendered in HDR.

## Exposure considerations

Recording a scene in HDR involves taking a series of shots so that all levels of the brightness range are recorded with a good exposure. The number of shots you create will vary depending on the range of contrast present in the scene. Three to seven are a typical number that work for many situations, but more may be necessary in extreme situations, especially when the light source, usually the sun, is in the frame. The number of shots you use will be determined by the lighting conditions and also by how much detail in the deepest shadows you want to reveal. To get the most benefit from HDR, shoot in RAW to capture as much tonal information as possible.

Here are some additional exposure considerations to keep in mind:

- **Aperture.** In terms of camera exposure, the main thing to remember is that, as with panoramas, the aperture needs to be the same for all the shots in the sequence so that the depth of field is consistent. Differences in depth of field will cause alignment issues when the images are blended together.

- **Shutter speed.** Because the aperture will not change, adjusting the shutter speed will create the range of different exposures. If you will be using an Auto Exposure Bracketing feature and holding the camera, keep an eye on what the shutter speeds are for the different shots. If the shutter speed gets too slow, it may not be feasible to hold the camera for the shot without some trace of camera shake being recorded. Vibration reduction lenses can help you get by when holding the camera, even at lower shutter speeds like 1/15th and 1/8th of a second. But you should test the camera's ability to record a sharp handheld shot at those slower speeds before relying on it for a photograph that really matters. When in doubt, try to steady the camera as best you can, and for best results, use a tripod.

- **Exposure range.** The classic approach to HDR exposure is to bracket the shots so that they are one stop apart in exposure (**Figure 6.22**), although some photographers use a 2-stop difference between images. In a shot where the "normal" exposure would be f/8 at 1/125, a 1-stop range would result in shutter speeds of 1/30 and 1/60 on the overexposed end, which will record more detail in the darkest shadows, and 1/250 and 1/500 on the underexposed side, which will record detail in the brightest highlights. This would produce a sequence of five images with an exposure difference of one stop each.

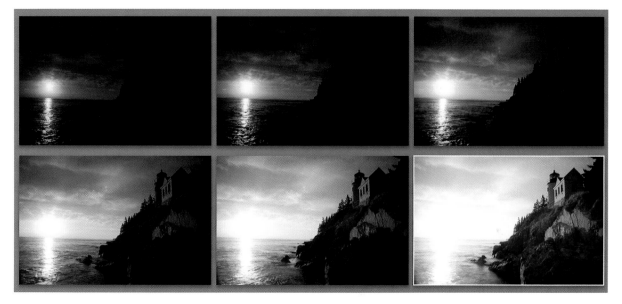

**Figure 6.22**  *The six source exposures for the lighthouse HDR image in Figure 6.21. These are exposed at 1 stop apart at f/20 and range from 1/15th of a second to 2 seconds.*

- **ISO.** If the camera is not on a tripod, the ISO should be set to a number that produces exposures with shutter speeds than can be adequately handheld. Onsite testing will determine the best ISO for handheld shooting. If you do have the luxury of using a tripod, choose a lower ISO, such as 100 or 200, to minimize noise.

**TIP** For tripod-mounted HDR work, consider using an electronic remote release or the camera's self timer. When longer exposures are necessary, this will reduce the chance that motion or vibration from pressing the shutter button is transmitted to the camera body.

# Auto Exposure Bracketing for HDR

Many DSLR cameras feature some form of Auto Exposure Bracketing (AEB). When you set your camera to high-speed, continuous shooting mode, it allows you to take a range of shots bracketed to different exposure settings. The amount by which the exposures are bracketed will vary depending on the camera, but typically you can change the exposure in 1/3 to 1/2-stop increments (**Figure 6.23**). Likewise, the camera determines the number of frames that can be exposed. Three auto bracketed shots are the norm for most cameras that offer this feature, but some high-end pro cameras let you take seven to nine shots.

**Figure 6.23** *The Auto Exposure Bracketing screen on a Canon 5D. The camera has been set to take three shots at one stop apart.*

To use Auto Exposure Bracketing for HDR, set the shooting mode to Aperture Priority and choose an aperture that will yield the right amount of depth of field for the shot (remember that you can use the depth of field preview button to see the actual depth of field through the viewfinder). The use of Aperture Priority mode ensures that the aperture remains consistent across all the shots. Brace the camera so that it is steady, and take the bracketed shots. When you're done shooting HDR sequences, be sure to remember to go back into the menu system and turn off AEB; otherwise, your next non-HDR shot will be bracketed.

## HDR styles

Once you have made the actual exposures and have downloaded them to your computer, you can begin the process of using HDR software to blend the different source files together into a single, high dynamic range image. It is in the processing of the files that creative and aesthetic concerns arise in how the image will look when the HDR merge is complete.

There is a range of different stylistic approaches to HDR imaging, and having an idea of where you want to go with the image will help you once you begin working with the software. Some HDR results are very exaggerated with intense color saturation, implausible shadow details, and over the top glowing edges. This style of HDR often looks more like an illustration than an actual photograph (**Figure 6.24**). Many photographers like this punchy, cartoon style of HDR, whereas just as many view it with disdain and feel that it is too much of a departure from what a photograph should be.

**Figure 6.24**  *This style of HDR looks more like an illustration than a photograph, with overly saturated colors, hyperdefined details, and obvious glowing edges.*

At the opposite end of the style spectrum are images that use HDR technology only to create an extended tonal range. This method results in images that have excellent (though not implausible) detail in both the highlights and the shadows, and a full, rich range of tones (**Figure 6.25**). They look like photographs, not candy-colored illustrations, and many times you wouldn't even know they were HDR images.

**Figure 6.25** *An HDR process was used to create this image of New York City, but the result looks much more like a well-exposed photograph instead of an exaggerated HDR shot. Image by Robert Anthony DeRosa*

Of course, like any creative medium, photography is very personal, and only you can say what the best approach is for your images. Knowing the styles that you like will help you chart a course through the myriad controls for fine-tuning and seasoning your image in HDR software.

## Processing the HDR Image

The source files are the first step in the HDR process. The second step takes place in the digital darkroom. The most widely used HDR program and the one that has set the standard for HDR processing is arguably Photomatix Pro by HDRSoft (www.hdrsoft.com). This is a stand-alone program that is also available as a plug-in for Photoshop, Lightroom, and Aperture.

HDR capabilities have been available in Photoshop for a number of years, but they have been pretty lackluster and not really usable. Many photographers

would simply use the Merge to HDR feature in Photoshop CS3 and CS4 to create an initial 32-bit file that they would then import into Photomatix for most of the HDR processing. With the release of Photoshop CS5, however, Adobe greatly enhanced the HDR features with the introduction of Merge to HDR Pro, a much needed improvement over what was available in previous versions. Adobe also created an HDR Toning feature that lets you apply HDR styling to single images.

We'll take a look at both programs in the following section. Our coverage of HDR processing techniques is not meant to be the definitive exploration of this topic. The goal here is to introduce you to the basic workflow and processing concepts, and provide an overview on techniques that can help you get started with your own explorations of HDR.

## Merge to HDR Pro

We'll begin our look at HDR processing with Merge to HDR Pro in Photoshop CS5. Just as with images that you will merge into a panorama, apply any overall adjustments and image cleanup, such as dust spotting and fixing chromatic aberration, before you launch the HDR process. Adjustments can be applied to one image and then synchronized with the other files in the sequence (see "Pre-panorama adjustments" earlier in this chapter).

When you're ready to start the HDR process, select all the thumbnails for the source images in Lightroom or Bridge. Merge to HDR Pro can be accessed from within Lightroom by choosing Photo > Edit In, from Adobe Bridge CS5 by choosing Tools > Photoshop, or from the Tools icon in the Mini-Bridge panel in Photoshop CS5.

When the Merge to HDR Pro dialog appears, you will see the source image thumbnails arranged below an initial preview of the merged image (**Figure 6.26**). If you feel you do not need to use all the source files for the HDR, you can click in the check boxes to remove them from the merged result.

> **TIP** Lightroom will always import images into Photoshop at the full camera resolution. If you just want to do a quick proof to see how an image will work in HDR, you can process smaller size files by starting in Bridge, opening one of the files in Camera Raw, and setting the image size to something smaller than the native camera resolution. Then click the Done button and return to Bridge. When you launch Merge to HDR Pro from Bridge, it will use the previous image size setting specified in Camera Raw. This will make the entire process go much faster because there is less pixel data to process. Just remember to set the Camera Raw image size back to native camera resolution when you are done.

**Figure 6.26** *The Merge to HDR Pro dialog in Photoshop CS5.*

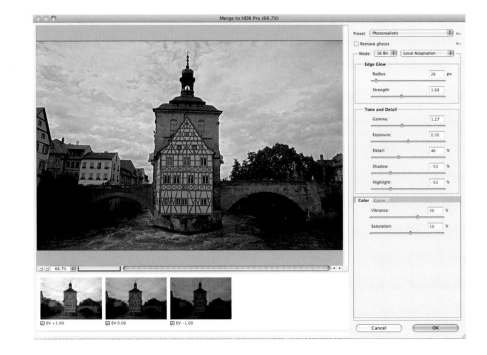

## Presets

A preset menu is located at the top of the dialog. Test-driving a few of these presets will give you an idea of some of the different ways you can style the HDR effect. To be honest, we find that most of these are pretty useless without additional intervention and should only be considered as a starting point for further explorations. But they are good for seeing how the sliders are configured to achieve a certain type of look. This is information you can use to help you find the look you want. For photographic-looking results, the Default or Photorealistic presets are a good place to start.

## Bit Depth and Mode

Under the Mode section, use 16 Bit to ensure that you have a file with high-bit tonal information to work with once the HDR process is complete. When 32 Bit is selected, the dialog reverts to the functionality of earlier versions of Merge to HDR; you don't have all the cool new creative controls, but it is useful if you want to create a 32-bit merged file to import into other HDR applications like

Photomatix. Local Adaptation should be selected, because this will give you the full set of tone mapping controls as well as access to a tone curve.

## Edge Glow

One of the hallmarks of a certain type of HDR style is a noticeable glow around contrast edges in an image, and this is where you can control this effect. A good way to see what different sliders do in a software program is to move them drastically back and forth and pay attention to the results. Radius and Strength work in tandem, and adjusting one will affect the results of the other (**Figure 6.27**):

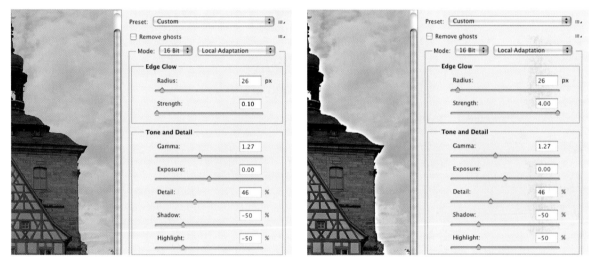

**Figure 6.27**  *The Radius and Strength sliders control the characteristics of the edge glow.*

- **Radius.** Controls the size of the glow effect. Smaller amounts create a thinner edge halo that hugs a contrast edge, whereas higher amounts not only increase the size of the glow but also soften it by spreading it into other areas of the image.

- **Strength.** Controls the intensity of contrast in the glow effect. Just as these sliders influence each other, the sliders in the Tone and Detail section can also affect them, so you may need to revisit them after configuring those controls.

## Tone and Detail

The Tone and Detail section contains five sliders that affect the overall tonal balance of the image (**Figure 6.28**):

**Figure 6.28** *The sliders in the Tone and Detail section create the overall balance between brightness and contrast in the image.*

- **Gamma and Exposure.** The Gamma slider adjusts the brightness difference between highlights and shadows, but it can initially be a bit confusing because it is reversed in terms of how sliders normally work; moving it to the left results in higher values and moving it to the right results in lower values. With a low setting there will be a pronounced difference between the highlights and shadows, with the former being very bright and the latter quite dark. Moving the slider to the right gradually removes the differences between the two tonal regions until the image takes on a flatter appearance, with highlights and shadows having a similar level of brightness.

  Exposure affects the overall tone and brightness of the image. It is fairly sensitive, and small movements can create very noticeable shifts in brightness. Just as with the Radius and Strength sliders, think of Gamma and Exposure as a tandem adjustment.

- **Detail, Shadow, and Highlight.** Detail sets the amount of contrast in the details of the image. Low values create a dreamy, diffuse look, whereas high values render a stark, high-contrast effect. Shadow and Highlight adjust the luminance (brightness) of those regions. Lower values darken and higher values lighten.

Working with all the sliders in the Edge Glow and Tone and Detail sections involves a lot of back and forth because they are interdependent; changes to one may prompt you to make further refinements to sliders you have already set. That's why developing a sense of exactly what each slider does is so important.

## Color and Curve

The Color sliders can be thought of as a way to fine-tune the color saturation, and the Curve offers you a great deal of control over contrast and brightness that can have a big impact on how the image looks.

- **Color settings.** These settings are similar to how Vibrance and Saturation are implemented in Camera Raw or Lightroom. Saturation affects all colors equally, whereas Vibrance has a more refined approach, affecting lower-saturation colors more and higher-saturation colors less.

- **Curve.** If you know how Curves works in Photoshop, this feature will be familiar to you. The lower-left corner controls the black point, whereas the upper-right corner controls the white point. You can click on the curve line to manually place a point and drag to adjust it. Think of the Curve as a way to fine-tune the overall contrast in the image after you've set all the sliders in the section above it. Keep in mind that you may need to revisit some of the previous settings to compensate for changes created by the Curve adjustments (**Figure 6.29**).

**TIP** If you have created an HDR look you like and you feel it might work well on other images that are similar in overall tone and contrast (such as landscape images), it's a good idea to save your settings as a preset so you don't have to start from scratch every time. Click the menu icon just to the right of the Presets menu and choose Save Preset.

**Figure 6.29** *The Curve allows you to fine-tune the contrast of the merged HDR image.*

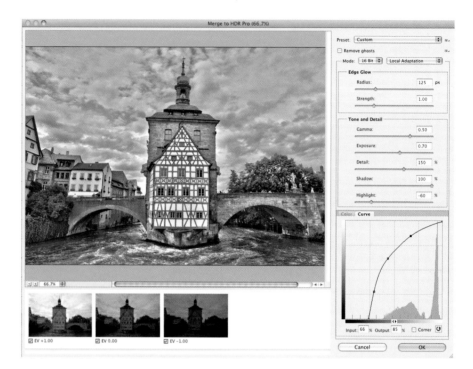

## Remove ghosts

If your image contains elements that might have traces of motion in them, such as moving water or tree branches, select the Remove Ghosts check box near the top of the dialog. Merge to HDR Pro will select the source file that is best for the motion-affected areas in the image (the thumbnail will be highlighted in green). You can also make your own choice by clicking on a thumbnail (**Figure 6.30**).

**Figure 6.30** *Ghosting is obvious in the surf in image A. Image B is a result of using the Remove Ghosts option in Merge to HDR Pro.*

Although the entire interface is a great improvement over the previous HDR functionality in Photoshop, this simple feature is a great addition that addresses one of the classic problem areas in HDR photography: moving elements within the image. Keep in mind that for some images, ghosted motion in the scene, such as movement caused by cars or people, may look interesting and might create an effect that works well with a particular photo (**Figure 6.31**).

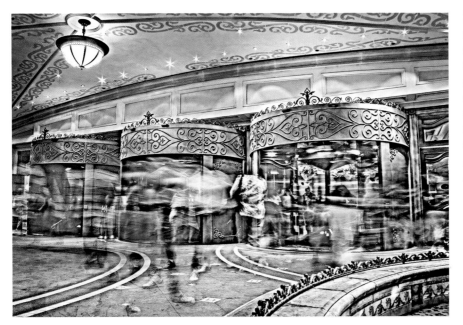

**Figure 6.31** *This HDR image was made from three exposures with long shutter speeds ranging from a half second to two seconds. The movement of the people entering the revolving doors resulted in motion blur that works well to illustrate the hustle and bustle of a busy Las Vegas casino.*

## Edge inspection at 100%

Before clicking OK to complete the HDR process, be sure to zoom in to 100% or more and scroll around the image to check the edges. A zoom menu is located in the lower-left corner of the dialog. You can move through the image by pressing the spacebar and dragging in the image.

Some combinations of settings can create hard and jagged pixilation along contrast edges (**Figure 6.32**). Low Strength settings are often to blame for hard "crackly" edges, so if you see any, try increasing the value of this setting. And keep in mind that changes to Strength may require slight modifications to Radius, Detail, and other settings. After clicking OK, inspect the edges again because Photoshop provides a much better view than the low-res preview in Merge to HDR Pro.

**Figure 6.32** *Inspecting the preview at 100% is a good way to check for problems with the edges.*

## Photomatix Pro

As mentioned earlier, Photomatix Pro is the application that set the standard for HDR software and is still the program that many HDR photographers prefer. The Tone Mapping settings offer many more controls for fine-tuning the image than Photoshop's Merge to HDR Pro, and the initial results without changing any of the sliders are likely to be more pleasing and have a more "finished" look.

Photomatix Pro's HDR features are divided into two sections. In the first you select the images from which an HDR image will be made. In the second you apply HDR Tone mapping. The tone mapping features are also available as a Photoshop plug-in that can be used with 32-bit HDR or 16-bit stand-alone images (**Figure 6.33**).

### Generate HDR

If you're using Photomatix to create the initial HDR, you'll use the Generate HDR feature to specify the files you want to use. In the Generate HDR Options dialog you can choose to have the software automatically align the source images and reduce noise and chromatic aberrations. There is also an option for reducing ghosting artifacts that lets you specify whether the ghosting is due to background movement such as water or foliage, or moving subjects like people or cars.

**Figure 6.33**
*The Photomatix Tone Mapping plug-in for Photoshop.*

# HDR Tone Mapping on a Single Image

Photoshop CS5 has an HDR Toning feature that lets you create an HDR look for a single exposure. This is very useful for those shots where you either don't have multiple exposures, or making them does not work for the subject (such as people or action scenes). To access this feature, choose Image > Adjustments > HDR Toning. The controls are exactly the same as those in Merge to HDR Pro, and you can even use saved HDR Pro presets. It's not the same as creating a real HDR because the tonal range will be limited to what was captured in the single exposure you're using. But it is a handy way to apply HDR styling to a stand-alone image (**Figure 6.34**). Additionally, you can combine the bracketed exposures in HDR Pro, save the result as a 32-bit file, and open it in HDR Toning to take advantage of the ability to zoom to a true 1:1 or 100% pixel view of the file, which is not possible in HDR Pro.

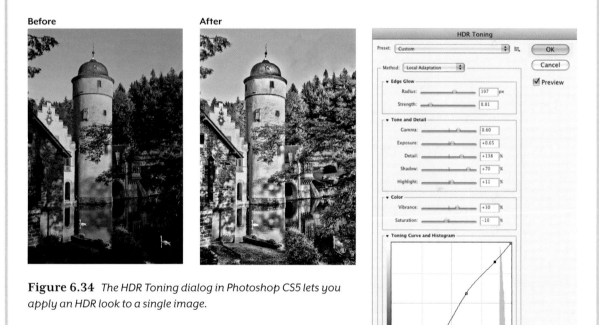

**Figure 6.34**  *The HDR Toning dialog in Photoshop CS5 lets you apply an HDR look to a single image.*

After clicking the Generate HDR button, the image is created from the source files and displayed onscreen. Initially, it looks pretty bad with excessive contrast, blown-out highlights, and totally black shadows. This is due to the fact that the HDR file is still unprocessed and also because standard monitors cannot display the wide range of tonal values available in an unprocessed HDR image. An HDR Viewer panel is supplied, which shows you the actual detail present in different areas of the image when you mouse over them (**Figure 6.35**). Once the HDR image is processed with Tone Mapping, the details in the highlights and shadows will be revealed.

**Figure 6.35**

*The Photomatix HDR Viewer shows the detail that is really present in the image.*

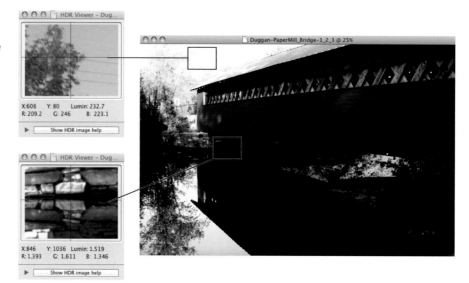

## Tone mapping

Tone mapping is the real heart of the Photomatix Pro software. The controls appear in a long panel and are divided between Details Enhancer and Tone Compressor. The Details Enhancer section is where all the HDR magic takes place and where crafting a classic "HDR look" is accomplished (**Figure 6.36**). There are no fewer than 15 sliders available for fine-tuning the many different qualities that create the look of the image, which is far too many to go into here. Check out the video tutorials for the latest version of Photomatix Pro at www.hdrsoft.com.

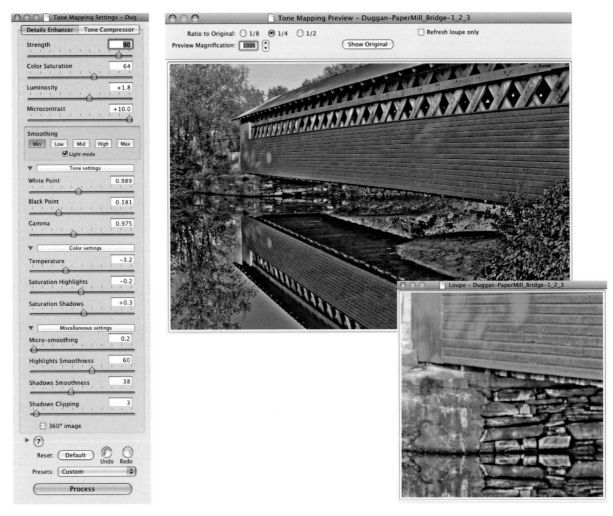

**Figure 6.36** *The Photomatix Tone Mapping interface is where most of the HDR styling action takes place.*

This increased level of control is the reason many photographers who specialize in HDR use this software (**Figure 6.37**). Until the revamped Merge to HDR Pro in Photoshop, Photomatix was the primary HDR program, and for many it is likely to retain that status. Although its interface is more complex (and likely more intimidating to those new to HDR), the initial results are much closer to the mark of what most people think an HDR photo should look like.

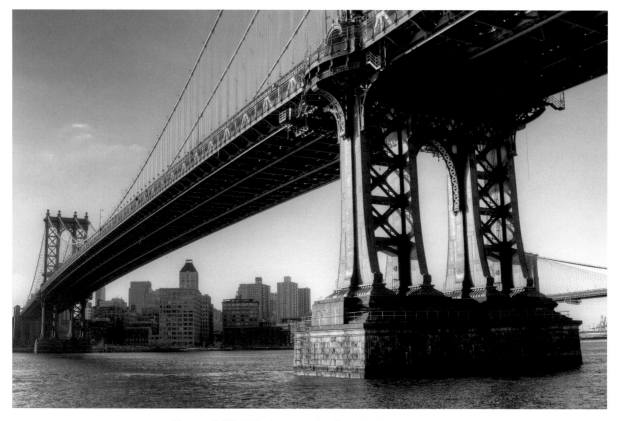

**Figure 6.37** *This photograph of New York's Manhattan Bridge was created from three source files that were combined into an HDR image using Photomatix Pro. Image by Robert Anthony DeRosa*

## Customize with Adjustment Layers

No matter what program you use for creating an HDR image and applying a tone mapping effect, one very important detail to remember is that simply running a series of files through HDR software does not necessarily make a finished image. At best you will have a really good combination of all the source exposures with a full range of tones as well as good color and detail that gives you a solid platform on which to continue enhancing the image. Nearly all HDR images can be improved with further enhancements and "seasoning" in Photoshop. The use of adjustment layers with layer masks

that affect specific areas in the photo can greatly improve the overall look of the final image. In the example shown in **Figure 6.38**, several adjustment layers have been added to apply separate modifications to the lower half of the photo, the sky, and just the river. A final Vibrance adjustment layer was added at the top of the layer stacks to fine-tune the color saturation.

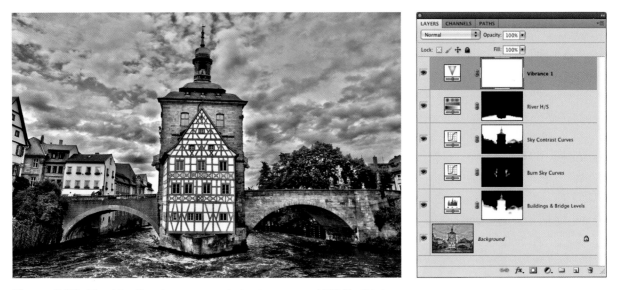

**Figure 6.38** *After blending three source photos to create an HDR file, this image was further customized with several adjustment layers in Photoshop CS5.*

# Night Photography

If you're looking for new territory to explore with your camera, then consider leaving the familiar world of daylight behind and venturing into the darkness to explore the magical landscape of night photography. In the deep shadows and mixed lighting of the nocturnal world even ordinary locations can become mysterious and beautiful. Long exposures, motion blur, the soft glow of the moon and stars, or the colorful wash of ambient street lighting all offer many interesting possibilities for creating intriguing images. The best thing about night photography is that it requires little or no extra equipment, and many cameras, even compact models, have the necessary

controls for capturing images in low light. Apart from some basic equipment, all you need is a willingness to explore and experiment, and stay out a bit later (or get up earlier) than usual (**Figure 6.39**).

**Figure 6.39** *Night photography lets you see the world in an entirely new way.*

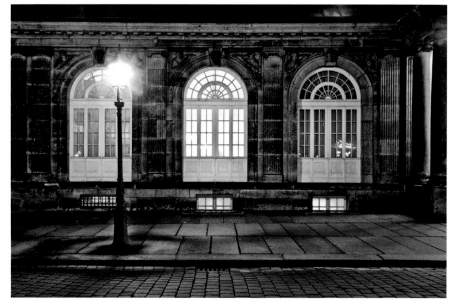

## Camera Controls

In basic principle, night photography is no different than photographing during the day: The shutter is opened to collect an adequate amount of light so that a proper exposure can be made. The primary difference is that the shutter must be opened for much longer than an exposure made in daytime or in bright, indoor lighting. If sharpness is desired, a tripod or some other means of stabilizing the camera must be used. Before venturing into the darkness, however, it's helpful to review some basic camera exposure information through the eyes of a nocturnal photographer.

## ISO

As we discussed earlier in the book, the ISO determines the light sensitivity of the image sensor. Higher ISO numbers indicate greater sensitivity in lower-light conditions, meaning that you may be able to take a handheld shot in very low light, or if you are using a tripod, that your exposure times will not be very long.

Modern digital cameras are pretty amazing in their ability to capture low-noise images at very high ISO ratings, but just keep in mind that there is a chance of more noticeable noise when working at higher ISOs. The amount of noise that you will see in your photos is primarily a factor of how the image sensor responds to low-light situations, since increasing the ISO is merely an amplification of the basic data that the sensor gathers. Some sensors perform better than others, and newer cameras are better in this regard than their older counterparts.

If you have the luxury of using a tripod, our recommendation would be to use the lowest ISO setting that results in exposure times of an acceptable duration. The primary factor here is a combination of your patience, how many shots you want to capture in a given time frame, and your own tolerance for noise. Seán generally uses 100 ISO when photographing at night with a tripod because this yields better image quality with no noise. The only times he increases the ISO is if the lower setting and existing light would result in overly long exposure times. While photographing at Machu Picchu on a very dark night with no moon, he opted for an ISO of 400 so that the exposure times would not get too long (this can also affect battery life). Even with an ISO of 400, his exposure times averaged about six minutes and that included added illumination from light painting using a small flashlight (**Figure 6.40**). In addition to lower noise levels, another advantage of a low ISO setting is that since it results in longer exposure times, it allows you more time to add supplemental creative lighting from a flashlight or multiple firings of an external flash.

**Figure 6.40** *The Temple of the Sun at Machu Picchu, Peru. This is a six-minute exposure with additional light painting on the walls of the ruins. The reddish glow is created by the lights from a dam a couple of miles downriver.*

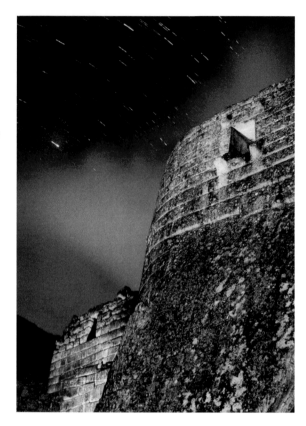

## Exposure modes

When it comes to which exposure mode to use for night photography, there are a few different approaches you can take:

- **Automatic mode.** You can leave the camera on Automatic mode and let it figure out how long the exposure should be. Although leaving the camera on Automatic mode does have its limitations, such as a wide-open aperture and a limit to the duration of the exposure time, with many cameras the results are surprisingly good. If you want to explore this route, the first item to check for is a way to turn off the flash. On most cameras, there is a flash off symbol that looks like a diagonal lightning bolt arrow overlaid with the international "No" symbol of a circle with a slash through it. Having a camera where you can override the flash is a must if you want to explore the world of night photography.

- **Aperture or Shutter Priority.** With a semi-Automatic mode such as Aperture or Shutter Priority, the camera calculates half of the aperture/shutter speed exposure combination. This can be useful if you need to be sure of a specific depth of field, or if a shutter speed of a certain duration is necessary to create a certain effect, such as when you want to create a motion blur effect.

- **Manual.** Manual mode is our favorite way of photographing at night because it allows us total control over the exposure. We typically use the same aperture for the entire session, which lets us vary the shutter speed in search of the perfect exposure. Since night photography is often a much slower, more contemplative process than daytime photography, operating the camera in Manual mode, even if you are not used to it, is very easy.

## White balance

In the past, photographing at night with film often meant unwanted color casts in the image since film is balanced for the color temperature of daylight, which is approximately 5500° Kelvin. The color temperature of night scenes can vary greatly depending on the types of illumination in the scene. Moonlight and starlight tend to produce cool lighting, whereas artificial lighting can result in color temperatures that are red, yellow, and green, or a combination of different color casts.

With digital photography, dealing with the white balance issue is easier than with film. When Auto White Balance (AWB) is used, the white balance can change on a per shot basis. For artificial light sources such as street lamps or illuminated signs, you could also try one of the White Balance presets such as Tungsten or Fluorescent. Many cameras also offer a custom White Balance feature that can be used to measure the illumination at the scene and adjust the white balance accordingly. If you shoot RAW (which is highly recommended for night photography), white balance is not as much of an issue since you can adjust the White Balance setting in Lightroom, Adobe Camera Raw, or in the RAW conversion software of your choice. This allows you to use White Balance as a creative setting to modify the look and feel of the image (**Figure 6.41**).

**Figure 6.41** *The white balance of this photo was modified in Lightroom to create a cooler and bluer color balance for the scene.*

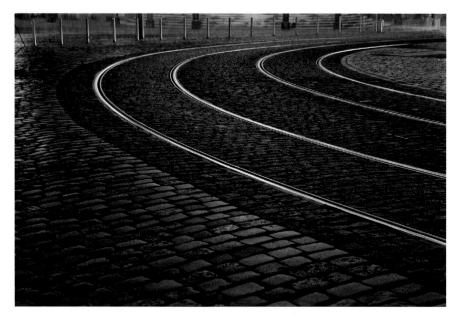

## Other Necessary Equipment

The only absolutely necessary piece of equipment for night photography is a camera that can do long exposures, and most cameras today have this capability. Timed shutter speeds generally go down to 30 seconds, and many cameras offer a Bulb setting for longer exposures. There are some other items that give you more control over your images.

### Tripod

Although handheld night photography is possible and blurry images are not always undesirable, a tripod is necessary if you want to make images where the scene is sharp and in focus (just be sure to turn off any image stabilization or vibration reduction features in the lens when the camera is mounted on a tripod). If you don't have a tripod with you, any stable surface, even the ground, will do for immobilizing the camera, although your choice of camera angle and compositions may be limited by the position and height of the impromptu stabilizing surface. Having a tripod makes it much easier to explore vantage points and control the framing.

## Exposure for Night Photography

As with camera exposure during daylight, the correct exposure for a night scene will be determined by a range of variables, including the ISO you are using, how bright the scene is, the level of artificial lighting, and how dark the sky is. Depending on all of these factors your exposure times could range anywhere from a few seconds to many minutes.

Try to use a consistent aperture for the entire session so that you can more easily make decisions about exposure times. If you are constantly changing the aperture, it's much harder to make an educated guess as to how much longer or shorter the exposure time needs to be. If the shot is too dark, increase the exposure time, and if it is too light, use a shorter exposure time.

If you are planning a night photo session at a specific location and you have time in your schedule, it pays to do some location scouting during daylight hours. Recognizing potentially strong compositions ahead of time can make your night session flow more smoothly.

For shots taken during or just after twilight, a clear sky will be a beautiful and mesmerizing deep blue (**Figure 6.42**). The later it gets, the darker and blacker the sky will become. Shooting when there is a full or nearly full moon will offer several benefits for your night photography, including the presence of the moon itself as a visual element, lighter skies, visible cloudscapes, and last but not least, much better light to help you see where you're going!

**Figure 6.42**
*The Frauenkirche in Dresden, Germany. A five-second exposure was taken in the early evening to capture the magic blue of the sky.*

## Locking shutter release cable

As mentioned earlier, most cameras offer timed shutter speeds down to 30 seconds, although some may have longer timed shutter speeds. After that you need to use the Bulb setting, which keeps the shutter open for as long as the shutter button is depressed. But this can be awkward and at times very uncomfortable. Seán had to do it once on a snowy night in subfreezing temperatures. Not long after that frigid experience, he added a locking remote release to his camera bag! The practice of holding your finger on the button can also transmit movement from your body to the camera, which increases the likelihood of a blurry image. A locking cable release allows you to open the shutter and lock it in the open position until the exposure is finished. For situations where your exposure times may be several minutes, this item is essential (**Figure 6.43**).

**Figure 6.43** *A locking remote shutter release is an important piece of equipment for night photography.*

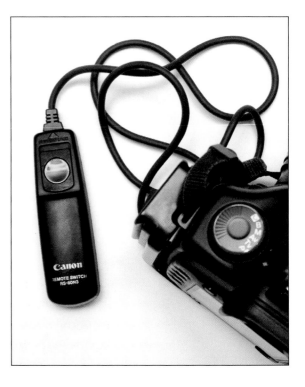

### Extra batteries

Long exposure photography can be a major drain on your camera's battery, which has to supply power to the image sensor for as long as the shutter is open. Temperature can also affect battery performance, and in very cold weather, your battery life may be much shorter than normal. You should plan on carrying extra, fully charged batteries with you for your nocturnal photo shoots. The longer the exposure times, the more likely you will need to use the extra batteries.

## Useful Accessories

Apart from a tripod, cable release, and extra batteries, there are also some additional, nonphotographic items that can be highly useful when taking pictures after dark:

- **Lens hood.** This will help to block extraneous light from entering the lens and causing lens flare.

- **Small flashlight.** Although this may seem obvious, it is important to note that in some areas it can be very dark at night. This is especially true if there is no moon or nearby city lights. Having a small flashlight is invaluable to help you see where you are going and also to see the controls on your camera. For subjects that are close to the camera, it can also be used as a focusing aid as well as for "light painting" (more on that later).

- **Large flashlight.** While a small flashlight is useful for the reasons mentioned above, a large and more powerful light can be used for light painting as well as to help the camera focus on scenes or subjects that are not close to the camera. Most autofocus systems rely on visible contrast in a scene to determine the focus, and when shooting in "available darkness," the lack of any significant illumination on a scene can make it impossible for the camera's autofocus system to work. By shining a powerful flashlight beam on a subject, you can create enough illumination so that the autofocus can work. See the section "Focusing in the Dark" later in this chapter for more on focusing at night.

- **External flash unit.** For night photography, external flashes can be handheld and used to "paint" the scene with light by firing the flash multiple times in different locations. Since this practice doesn't require any special synchronization with the camera, almost any flash unit will

do, even the old, battered, cheap one that is still cluttering up your camera closet or photo equipment drawer.

- **Colored gels.** These are useful if you want to paint with colored light by taping them over the front of a flashlight or external flash unit. A good photography or theatrical supply vendor should have these. If you want to explore using bright "pop" colors, even the transparent colored plastic sheets found at craft stores can work. Although it's true that colored effects could be added to flash-illuminated areas in Photoshop, it's not as fun as doing it during the exposure!

# Focusing in the Dark

One of the biggest problems when photographing in very dark conditions is focusing on the scene or subject. The autofocus systems in most cameras operate by detecting visible contrast in the scene. If no contrast is visible, the autofocus system will not work. It might seem logical to rely on manual focus in such a situation, but this can also be difficult if you have a hard time seeing the details of the subject through the camera viewfinder (and the lack of proper light doesn't make seeing any easier). Another factor to consider is that while all lenses have a focusing distance scale, relying on it does not always produce acceptable results with some lenses.

### Live View for night photography

If your camera has a Live View feature, you may find that this works well for manual focusing at night. The ability to zoom to 10x on the Live View display is very helpful for establishing and double-checking focus when working under conditions of available darkness.

### Flashlight focusing "assistants"

If Live View is not an option for you, using a large and powerful flashlight may help to throw some illumination on the subject and create enough contrast either for the autofocus sensors or for your eyes to detect. Another focusing trick that can work in some situations is to place the flashlight in the scene where you want the focus to be, and then target the flashlight beam with the autofocus sensor. Although this entails some walking back and forth on your part, the autofocus sensors easily detect the high contrast of the bright light against the dark background.

If your subject is beyond the reach of a powerful flashlight, such as with a distant landscape, you'll have to employ some other methods to help the camera find a focus.

If it is a clear night, try pointing the autofocus sensors at bright stars, or even better, the edge of the moon. If it is not too late, there is often a visible edge where the horizon meets the night sky that can be detected by autofocus sensors. The later it gets, however, the less visible this will be.

### Using flash for focus assist

Many flashes have an autofocus assist light to help the autofocus system. These AF assist features can range from a red pattern that is projected onto the subject, to a bright incandescent light, to a pulsing strobe from the main flash head that lasts for a second or two. Such a feature is useful in helping the lens focus in very dark conditions. After the focus has been set, you can turn off the flash (and the autofocus so it doesn't accidentally try to refocus) to take a photograph. Such AF assist lights have their limits, of course, and for distant subjects they may not be much help. And if you are trying to be discreet and not draw attention to yourself, then using a brightly pulsating strobe is probably not the best idea! The effective distance at which a flash-based focus assist works will vary depending on the camera and flash unit used, but the typical range is from 5–10 meters. The infrared sensor on an IR flash transmitter can also serve as a focusing aide and assist the lens in obtaining a focus, even under the very darkest conditions.

# Dealing with Contrast Extremes

Photographing at night offers the challenge of capturing a good exposure in situations that can often be described as available darkness. If artificial lighting is also a part of the shot, then extreme contrast can become an issue, especially if the source of the lighting, such as street lamps, theater marquees, or other illuminated signage, is visible.

There are two basic approaches for dealing with such contrast extremes: You can either "go with it" and let bright specular and reflective highlights caused by artificial lighting blow out to total white, or you can try a multiple exposure approach. With the latter method the multiple exposures can be combined, either manually in Photoshop or through an HDR process, to

create an image with the best exposure characteristics for different regions of the tonal range. This is probably the best way to ensure that you retain good shadow detail in important areas of the image without having bright highlights blasted totally out of control. Due to the longer exposure times in night photography, any multiple exposure approach will require a tripod to keep the camera steady (**Figure 6.44**).

**Figure 6.44** *Two exposures were made of this scene and combined in Photoshop using layers and layer masks.*

## Light Painting

One very intriguing way to augment the available light in a night shot is to add some of your own, either by using an external flash or a regular flashlight. During long exposure times of several minutes you can move through the shot and carefully "paint" certain areas of the scene with light. With the flashlight turned off, your movement through the shot will not be recorded. When you stop to paint a new section of the image, just make sure that you are not visible to the camera. You can do this by standing just out of the shot or by crouching behind a foreground object and using it to shield you from the view of the lens (**Figure 6.45**).

**Figure 6.45** *A flashlight was used to paint the three Joshua trees in the foreground with light over the course of a one-minute exposure.*

Light painting with a flashlight is really like painting in that you move the flashlight beam back and forth over an area to build up light. With an external flash you "pop" the flash to bathe different areas of the image with light. The use of small pieces of colored theatrical gels let you add color to the light painting, which can create some very interesting effects (**Figure 6.46**).

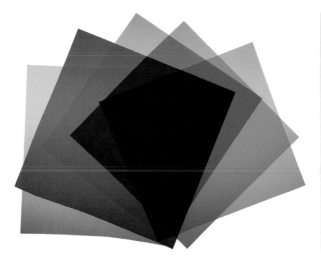

**Figure 6.46** *Colored gels were used with an external flash and a flashlight to illuminate different parts of the old mining structure in this photo.*

If you will be using an external flash, consider buying an auxiliary battery charger such as those made by Quantum (www.qtm.com). Repeated firings of a flash in dark conditions can drain conventional batteries very quickly. A Quantum power charger will cut down on the recycle times and greatly extend the battery life of the flash, which is an important consideration if you plan to be out all night painting with light.

## Night Motion

Even though you may be using a tripod for your night photography, keep your mind open to the idea of exploring the effects of motion within a photograph. The longer exposures that are typical with night photos, combined with the fact that many moving objects such as cars and trams are illuminated, merge to create the possibility of some very cool imagery.

### Motion in the scene

The river of tail lights on a busy street and the interior lighting of busses and trams as they pass through the frame during a long exposure can create delightful and unexpected effects that can be a good visual portrayal of the pulse of a city after dark (**Figure 6.47**), or a passing car breaking the solitude of a lonely desert highway (**Figure 6.48**).

**Figure 6.47**  *A four-second exposure taken in Honolulu, Hawaii.*

**Figure 6.48** *An exposure of three seconds captures a car speeding through the high desert of southern California.*

If you know that a specific motion will be repeated at regular intervals, you can set up the camera and make the shot several times, refining the length of the exposure until you get the effect you want. For the shot of the Dresden streetcar shown in **Figure 6.49**, Seán set up the camera on a bridge and waited for different streetcars to pass by him every five minutes as he tried out different approaches of capturing the motion of the illuminated interiors.

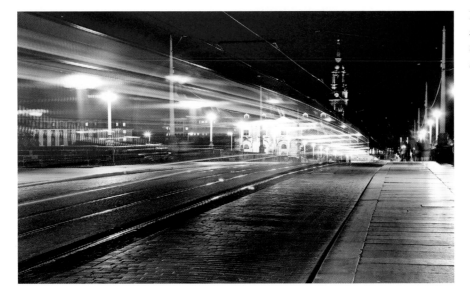

**Figure 6.49** *This ten-second exposure of a passing streetcar was taken in Dresden, Germany.*

## Camera motion

Movement within the scene is not the only type of motion you can add to your night photographs. For a side trip into the unexpected, take the camera off the tripod and carefully move it during the exposure to create surprising abstracts and light patterns. Rotate it back and forth, move it through the scene, turn it upside down. You might have a vague idea how such an image might turn out, but you're never completely sure until you see the image right after exposure. The results can be surprising and quite fun. Seán made the image in **Figure 6.50** during a night photography walkabout with Katrin through the old part of Las Vegas. The neon signs there were perfect for experimenting with camera motion. You can also zoom the lens over the course of a long exposure to create light streaks or repetitions of elements within the scene (**Figure 6.51**).

**Figure 6.50** *Twisting and rotating the camera during a 1.5 second exposure turned a neon sign into a beautiful abstract design of light and color.*

**Figure 6.51** *For this photo, the exposure began with the lens zoomed in close on the center of the tree. Over the course of the 17-second exposure, the lens was slowly zoomed out, creating the appearance of rays of light emanating from behind the tree.*

## Into the Night

Venturing into the half-light of twilight or the darkness of night is a very rewarding way to explore the world with your camera. The beauty of digital photography is that you can see the results immediately and make adjustments to camera angle, shutter speed, and aperture to fine-tune the shot. The nocturnal realm offers a different color and brightness palette, and long exposures punctuated by blurred motion and sparking lights create images with a sense of magic and mystery that are very different from photographs made during the light of day.

# Extending the Frame with Time

Photography is best known as capturing a specific moment in a spilt second to freeze time and reveal what the naked eye cannot see. Digital photography can also be used to explore the passage of time with time-lapse and stop motion photography, video, and sound.

# Time-lapse Photography

Photography is used for a variety of purposes: to record a dramatic sunset, chronicle the human condition, or focus on the personal. Additionally, still photography can also reveal what we simply cannot see—from the grandeur of outer space, to the incredible detail of macro photography, to the unseen passage of time that we are all a part of.

Time-lapse photography captures slices of time that you then render as a movie file to speed up the passage of time. Time-lapse photography has come a long way since we were in third grade when the teacher showed the class scratchy, flickering movies of crocuses breaking through the soil. It was fascinating to see how the plants twisted and turned, and pale stems were transformed into full blossoms. That is the magic of time-lapse photography in which a series of photographs of the same scene, taken at regular intervals over a period of time, are assembled together and then played back as a movie file.

By photographing a changing scene in regular intervals over an extended period of time, you are capturing the subtle changes of light, shadow, motion, and metamorphosis that the naked eye simply cannot see. Suitable subjects you can use to start learning about time-lapse photography include sunrises and sunsets, landscapes with moving cloudscapes passing through the sky, incoming and outgoing tides, urban scenes, construction projects, and of course blossoming flowers. **Figure 6.52** shows how Katrin photographed the opening of a daffodil with window light over the course of a day.

**Figure 6.52** *Source images for a time-lapse study of a daffodil blossom.*

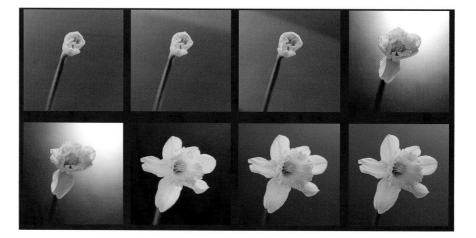

## The equipment

The equipment to do time-lapse photography ranges from point and shoot cameras to (as we recommend) a DSLR with a sturdy tripod and an intervalometer (**Figure 6.53**), which is a sophisticated cable release that controls the intervals between frames, the number of frames, and even when the camera should start to take pictures. Some cameras include an intervalometer function. To shoot for extended periods of time or longer than your camera battery can last, you'll also need an external power supply for the camera. After shooting the source images you'll need (for the budget-minded) QuickTime Pro, Photoshop CS4, or Photoshop CS5 Extended, or (for the sophisticated high-end) Adobe After Effects or Apple Final Cut Pro to create the image sequence.

**Figure 6.53** *Some cameras offer a built-in intervalometer function; others require an external intervalometer cable release.*

## How many frames?

For a normal representation of motion, movies are shown at either 24 or 30 (really 29.97) frames per second. To create slow-motion effects, you need to play back more frames per second; for example, 60 fps will result in smooth slow motion. To create a more compressed version of time—for example, an entire sunset elapsing in a very short amount of time—you need to play back fewer frames per second.

**NOTE** Shooting time-lapse source images with a slow shutter speed that is less than the interval time will result in very creamy and smooth time-lapse movies. For example, if you are shooting at one-second intervals, set the exposure to be ¾ of a second. The shutter speed must be faster than the interval.

Start by deciding how long the movie should be and then decide on a play-back rate based on whether you want slow motion or a faster, compressed representation of time and motion in the scene. Let's say you want a one-minute movie; use this formula, 60 seconds x 24 frames = 1440 frames. Now you need to figure out the duration of the event. For example, when photographing sunsets, start photographing an hour before sunset and shoot until one hour after sunset. So the actual event in this case is 120 minutes or 7200 seconds. To calculate what interval to shoot at, divide the number of seconds by the number of frames. In this example, 7200 seconds/1440 frames = 5 second intervals. If you want a smoother playback, shoot more frames. For the smoothest transitions, shoot one frame per second. Keep in mind that you can always decide to not use frames that you've shot versus needing frames you never captured.

## Take these tips to the bank!

Shooting source images for time-lapse photography can be time-consuming and tedious, so it is best to practice shooting before traveling to an exotic location to photograph a once-in-a-lifetime event or scene. Consider the following tips we've already learned. We've made the mistakes so you don't have to:

- Clean the camera sensor before a shoot, especially when shooting skies!
- Turn off the LCD preview to extend battery life.
- Use the largest camera card media possible.
- Prefocus the camera in manual focus.
- Shoot RAW to have more control over color balance and exposure adjustments.
- Shoot JPEG files when learning and to speed up post-shoot workflow.

- If you're shooting in daytime exteriors or interior scenes with fixed lighting, use manual exposure. However, if you're shooting from dawn into daylight or day into dusk, select an automatic or program exposure mode.

- When shooting late afternoon into nighttime, be sure to use a medium ISO and a fairly wide-open lens aperture. Otherwise, you could wind up with exposure times that are slower than the duration between each shot.

- Beware of shooting into the sun for extended periods of time during sunrise or sunset because the lens can focus the sun's rays into the body of the camera and burn pinpoints into the shutter curtain.

## Make the movie

After the shoot, the real fun begins!

1. Download the files and group the imported files in Adobe Bridge as a stack to evaluate a rough preview of the time-lapse motion before you begin the edit (**Figure 6.54**).

2. Delete any shots that are out of place, such as exposure errors or people walking in front of the camera.

3. Rename the remaining files with a simple four-number sequential naming system.

4. If needed, open images in Adobe Camera RAW to tweak color and exposure, and crop for final target use. For video and motion graphics, you don't need to be concerned with DPI but rather with the final resolution. High definition (HD) is 1920x1080 pixels, and standard definition (SD) is 720x480 pixels or 640x480 pixels.

5. Export the files as TIFFs or high-quality JPEGs.

6. Choose File > Open in Photoshop CS4 or Photoshop CS5 Extended, navigate to the folder of processed images, and select the first file. Because they are sequentially numbered, a check box option becomes available that enables you to open the files as an image sequence. Select this check box, and then click Open. In the next dialog, specify the frame rate, and the new video file is created (**Figure 6.55**).

Note that if you don't have Photoshop Extended, you can use QuickTime Pro to open the same folder as an image sequence video. The procedure is essentially the same as with Photoshop CS5 Extended: Choose File >

**Figure 6.54** *Five frames from a time-lapse sequence of sunset and twilight in Manhattan, viewed as a stack in Adobe Bridge.*

Open Image Sequence, navigate to the folder containing the sequence files, choose the first one, and then click Open. Next, choose a frame rate, and then click OK to create the image sequence.

**Figure 6.55** *Opening a folder of files as an image sequence and specifying a frame rate in Photoshop CS5 Extended.*

7. Once you have the image sequence video as a layer in Photoshop, you can add adjustment layers to further control contrast, color, and localized dodging and burning.

   It is critical to understand that when you save this image sequence file, it is a reference file to your TIFF or JPEG sequential images. If you move those images to a different location from where the working file is, Photoshop will need to reinterpret the footage. So, don't delete, move, or rename the folder of source images until you're done!

8. Choose File > Export > Render Video, name your target file, and then specify the location to save it and the format of the video (**Figure 6.56**).

**Figure 6.56** *The Render Video dialog in Photoshop CS5 Extended.*

All in all, time-lapse animation is a fascinating way to portray the passage of time. After you've gained some experience with it, you'll be making and sharing magical movies.

## Stop Motion Animation

In addition to time-lapse animation, DSLRs work quite well for creating stop motion animated stories. Stop motion animation is a slow and deliberate process that refers to carefully moving elements in a scene, stopping to record a frame, moving the elements slightly again, stopping to record another frame, and repeating the process over and over until you have a sequence of motion created by many photos. This very old animation method has been around almost as long as movies.

Many classic monster and fantasy films, such as the original *King Kong* (1933) and Ray Harryhausen's *Jason and the Argonauts* (1963) were filmed this way using motion picture film. Today, DSLRs have been used to create stop motion animation for such films as *The Corpse Bride* (2005), *The Fantastic Mr. Fox* (2010), and the *Wallace and Gromit* and *Shaun the Sheep* series of animated shorts from director Nick Park.

## Start with a story

All you need to get started is an idea for a story. It can be simple or involved, but just remember that stop motion animation is a slow and often tedious process that will take quite a while and thousands of frames to create just a few minutes of actual animation. Seán and his daughter made a short animated film together with his Canon 5D using some of her toys as the characters. It was a grand and epic story with detailed sets, painted backdrops, and a semipermanent "sound stage" set up in his office (**Figure 6.57**). The slow nature of the process, however, combined with working around his work and her school schedules, caused the project to last for weeks longer than they had anticipated.

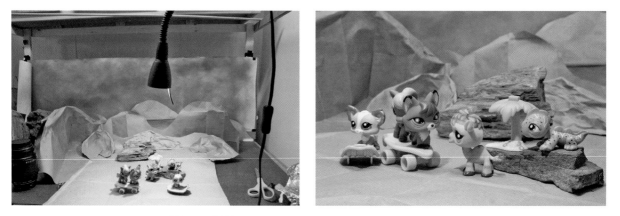

**Figure 6.57** *One of the sets for a short animated movie that Seán made with his daughter and a still from the finished movie.*

## Equipment and process

Just as with time-lapse photography, the camera will need to be on a tripod. If a scene will take a while to record, mark the position of the tripod legs with tape on the floor and try not to bump into it. A remote shutter release is a must to avoid having to use the shutter button on the camera. Use the camera's Custom White Balance function to set a white balance for the type of illumination you are using to light the set. For animation purposes, JPEG is preferable to RAW simply because the file size is so much smaller, and because you have the time to dial in a correct exposure, shooting RAW is not necessary.

Plan out each scene before you begin so you know what the action will be and how the characters have to be moved. Actually rehearsing some of the movements might be a good idea until you get the hang of it. Begin making small movements and recording a single frame for each movement. Repeat this cycle over and over until you have recorded all the movements for a given scene.

## Camera angles and point of view

Try to make a conscious effort to come up with different camera angles that help tell the story. Think about how camera angles and point of view are used in regular live-action films. A long shot can be used as an establishing shot to set the scene, but then move in closer to focus on the action. Another classic example of camera angles and point of view is the alternating over-the-shoulder technique for showing a conversation between two characters (**Figure 6.58**).

**Figure 6.58** *Alternating over-the-shoulder camera angles for filming a "conversation" between two characters.*

## Assembling pictures into scenes

After you've shot all the frames for a given scene, it's time to put them all together into a sequence and bring them to life (**Figure 6.59**). The basic steps are the same as those detailed in the earlier time-lapse section "Make the movie." Repeat the process for each scene in the story, and then edit the scenes together in video editing software such as iMovie, Adobe After Effects, Adobe Premiere, or Final Cut Pro to make the movie.

**Figure 6.59** *The lizard turns to deliver his big speech. A total of 88 frames were used to create approximately four seconds of this movement.*

## DSLR Video

The primary choice between making a movie versus a still image is determined by the action. Imagine a photograph of a beautiful landscape. Now imagine that same scene shot with video. Hold it—hold it—hold it; if nothing happens in about 20 seconds, you'll click onto a different Web site or flip the channel. But if a character walks into the frame or if the frame pans as industrial sounds increase, the viewer will be intrigued and will continue watching. Of course, the photographer could shoot a series of images with captions that address the environmental or social issues that this scene shows, but the videographer will engage the viewer by using a much different set of tools and skills to extend the story beyond the static frame of the still image.

Generally speaking, photographers have been primarily concerned with a single frame leading to a final print of the moment that uniquely captures and freezes the light, scene, and subject in a fraction of a second. Videographers and filmmakers concentrate on telling a story through the passage

of time. A photographer is trained to respond and capture "the decisive moment," whereas a filmmaker uses time, motion, and sound to set the scene, introduce the characters, and develop the story with a beginning, middle, and end.

The design, nomenclature, and ergonomics of a DSLR remain rooted in the photographic experience of the past. Until most recently, people used a DSLR for photography and a camcorder for video. Today, photographers are intrigued with the ability to shoot video, and videographers are enamored with the ability to capture quality still images—both with the same camera and lenses.

The capabilities of a DSLR as a video camera are so impressive that filmmakers are exploring their use in feature films and in HD broadcasts. The earliest results are very impressive because the fast and sharp DSLR optics allow for working in low light and with a shallow depth of field. The relative compact design and the high quality of the DSLRs allow for unusual camera perspectives that working with cumbersome video equipment simply does not.

DSLR cameras have every component and are often better than those included in a modern, professional video camera. In fact, the image sensor on many DSLRs is substantially bigger than those used in most digital camcorders. Speaking naively, all the camera makers had to do to make a still camera into a video camera was add high frame-rate capture; build in the suitable frame buffer and codec support for video file compression; and take advantage of larger and faster storage.

## Technical considerations

Working in video is more than changing the camera from single frame to video capture. The technical requirements of a video production are based on the fact that in a movie, either the subject is moving through the frame or the camera is moving, or in some cases as the director Spike Lee loves to do, both are moving. In every instance, stabilizing the camera so the image does not jump and jitter improves the effectiveness and viewer's enjoyment of the movie. To capture a stabile video, a video tripod with a fluid head that allows you to smoothly pan or tilt the camera without shakiness is an essential piece of equipment. Fluid heads use hydraulic dampeners to make all camera movements as smooth as possible. To move through a scene, skilled

videographers use a SteadyCam support, which looks like a medieval torture harness that the camera is attached to and the videographer wears, allowing the camera to glide through a scene. Interesting to us is that much of the technology that went into the development of image stabilization for video has been miniaturized and adapted into the image stabilization lens that still photographers now rely on to get a steady shot.

Sound quality is a critical issue to consider. In fact, viewers are more likely to watch a video with poor image quality but will have zero patience for poor sound. Currently, the microphones built into DSLRs are unsuitable for high-quality sound capture, because they pick up general ambient noise, including your breathing. To capture quality sound, specialized off-camera microphones that can be placed and focused are essential. Using a directional off-camera microphone immediately improves sound quality by being isolated from the ambient noise of the scene, camera, and crew. This is an issue that is solved in feature-film productions by using an entirely separate audio system and a highly trained team of audio technicians. Even with the expertise and staff, location sound is usually augmented or replaced by audio recorded in sound studios. For the occasional moviemaker, we recommend shooting the scene without sound (or removing the sound in post) and adding effective music or narration as the audio track.

Working in New York City has allowed Katrin to stumble upon numerous television and movie productions, and she can attest to the fact that nothing is as it appears in the movies or the TV series *Law & Order*. The red-blue flicker of police cars are created with rotating gelled lights positioned far away from the action; interior shots are lit with three-story high cranes, scrims, flood lights, and full-on generator trucks; and daylight rarely is, well, just daylight. There are a number of challenges in lighting for action. For a scene to be lit effectively, it must allow the actor to move through the scene with the expected exposure throughout the entire scene without changing camera exposure. Simply put, video requires using more lights with more planning. The more complex the story, the more you have to prepare. The inherent cost of shooting a film prohibits spontaneity. The scene is staged, the interior is set with props, and the actors are rehearsed. The magic is in the hard work; the devil is in the details.

## Preproduction and post

Planning, research, understanding roles and responsibilities are essential for a successful video production. Videographers rarely wander around shooting random video clips in the same way that people on vacation go out to take pictures or groups of photographers do on photo walks. Video production is a collaborative process, which requires planning, specialization, and communication.

Editing video can be done with the software that comes with the camera or your computer, such as iMovie or even QuickTime Pro. Professionals use Apple Final Cut Pro or Adobe Premiere Pro to edit and Adobe After Effects to add title sequences and special effects. Whenever photographers complain about file size or the time they put into finessing an image, Katrin tells them about video files, which are huge, hefty, and abstract because you aren't editing an image you are editing a sequence of images over time. To appreciate video editing on the simplest terms, mute the sound on the TV for a few minutes and count the edits (the cuts from scene to scene) in a standard 30-second commercial. You'll easily count 10–20 cuts in a 30-second commercial! Each scene, each camera angle, each A and B shot, with A-roll being the primary shot and B-roll the supporting shot, must be planned, lit, and shot.

With online options such as YouTube and Vimeo, distributing video has become much easier. But just as with photography, concentrate on quality over quantity. No one wants to watch endless hours of your family get together, but most people will watch a succinctly edited version that tells a story and develops a character.

As more and more media is viewed, shared, and consumed online, and with the demise of the printed news media, adding video functions to digital cameras and shooting video makes complete sense. As manufacturers race up the video hill with photographers and clients in close pursuit, it is essential to appreciate that shooting and processing video files simply isn't as straightforward as changing a dial on your camera to go from a single image to video. In all honesty, addressing the technical, aesthetic, and production considerations of a video production falls outside the scope of this book. But we do feel that video is and will be an increasingly important field for photographers to appreciate and work with.

# The Digital Darkroom

# Building a Digital Darkroom

With digital photography, the time you spend in front of your computer is arguably just as important as the time you spend behind the camera. The digital darkroom is where the photographic image is transformed from an exposure into a masterpiece, where an increasingly large library of photographic images is organized and managed, and where you prepare to share your images with clients, colleagues, friends, and family.

The tools of the digital darkroom aren't always inexpensive, but they are readily available and they provide much more flexibility and utility than the traditional darkroom tools. In this chapter we'll guide you through the process of selecting the right tools and configuring your digital darkroom so you can get the best results with your images.

## The Darkroom

We've often been asked why we refer to the *digital darkroom*, since you don't need to work in a darkened room with digital photography. It's not just because we're borrowing the term from film photography. We like to use *digital darkroom* because it reinforces the importance of the environment in which we work on our images (**Figure 7.1**).

**Figure 7.1** *The digital dark-room provides a comfortable working environment for the photographer, offering considerable control and flexibility.*

## Lighting

Digital darkroom lighting is an important factor when you're evaluating images on your monitor as you optimize them. Your monitor emits light to produce the image you see, and other light sources can influence your image as well. *Ambient* light—the light that fills the room from a variety of sources both artificial and natural—interferes with the brightness and color of the monitor's display (see the sidebar "Going Gray"). Too much ambient light causes the display to appear fainter. This distortion tends to cause you to adjust your images to make them too dark. The color of the ambient light can also influence your monitor's display. For example, early morning or late afternoon light can impart a warm cast to the image on your monitor, causing you to overcompensate by adjusting the color balance of images too far toward the cooler hues of blue and green.

Ideally, your digital darkroom should allow you to dim both ambient and artificial lighting. By using blinds or curtains on your windows and a dimmer switch on your lights, you can minimize the amount of light in the room. Even

better, just keep the lights off. To meet ISO standards for proper room lighting when viewing a computer display, the light level should ideally be below 32 lux. When you consider a typical office tends to be illuminated to around 350 lux or more, you can probably appreciate that meeting this standard explains why we still refer to the digital darkroom as a "darkroom."

Sometimes, you just may not be able to adequately darken your digital darkroom. In that case, we highly recommend using a *monitor hood* to block excess light so it won't reduce the contrast of your monitor and distort your perception of the images (**Figure 7.2**). You can buy one from any source that sells monitor accessories, or you can make your own by cutting black foam core to fit and then attaching it to your monitor with some sort of adhesive material.

**Figure 7.2** *A monitor hood helps block ambient light that would otherwise interfere with the image displayed on your monitor.*

When it comes to evaluating your prints, these rules change completely. Because prints depend on reflected light to be seen, you don't want to evaluate them in a darkened room. If you want to use your existing overhead lights, replace the bulbs with daylight-balanced 5000 Kelvin bulbs. We recommend those from SoLux (www.solux.net) because they have a high *color-rendering index*, which is a measure of how accurately colors are rendered under the illumination of a light source.

In addition to replacement bulbs, you can purchase stand-alone lights for the evaluation of prints, and simply leave your other light sources turned off. For this purpose we recommend the lamps available from Ott-Lite (www.ottlite.com) (**Figure 7.3**). We'll discuss the evaluation of prints in more detail in Chapter 9, "From Capture to Monitor to Print."

**Figure 7.3** *A lamp with a 5000-kilowatt illumination source, such as this Ott-Lite lamp, ensures the most accurate evaluation of your prints.*

## Going Gray

In addition to dimming the lighting as you optimize your images, it's helpful to avoid brightly colored walls. We also recommend not wearing clothing that is too bright or colorful, because this will reflect back onto the monitor. Having said that, you needn't take this to an extreme. As much as Tim loves the color gray, he's not about to paint the walls in his digital darkroom with 18 percent gray paint. And as much as Katrin is not enamored with gray—she did. The ideal mixture is two gallons of Photo White paint with one gallon of Munsell Gray #8. Order the Munsell Paint at B&H or a good paint store that works with museums and photo professionals. Make sure that the white is true white and doesn't have any brighteners in it. Although you don't need to change your clothes or put on a neutral smock before working on your images, be aware that that chartreuse sweater your aunt gave you isn't the best item to wear while doing critical color correction. Most important, understand that your working environment influences your visual decisions and therefore influences the quality of your images.

# The Computer

Your digital camera may be the cornerstone of your photography, but when it comes to perfecting your images, your computer is the foundation. Besides serving as the primary (or at least initial) repository for your digital photos, a computer also makes it possible to apply sophisticated adjustments to make your images look their best.

## Platform Considerations

We've all heard the advice to avoid discussing religion or politics in mixed company. We'd like to add to that list of forbidden topics: Avoid the debate over Windows versus Mac OS.

Frankly, we're tired of hearing the often-venomous debates about which computer platform is better. The simple fact is that you can produce excellent images using either platform. Regardless of which platform you choose, you can count on having the tools you need to produce the best-quality prints. In fact, Adobe has—in our opinion—done an excellent job of minimizing the differences between platforms in its software. When you're working in Adobe Lightroom or Adobe Photoshop, with a casual glance it isn't clear which platform you're using.

If you're buying a new computer and need help deciding between Windows and Apple, there are a few key things to consider. It probably makes sense to continue using a particular platform if you have been using that platform for years. While proponents of either platform will tell you their preferred operating system is easier to use, the reality is that ease of use is largely defined by what you already have experience with. Another consideration is the platform used by the person (or people) you'll go to when you need help. It is generally a good idea to use the same platform as those who will provide help when you need it, or those who you'll be sharing files with. It is also worthwhile to consider which software applications are available on each platform. Although there are tools available (such as Parallels Desktop for Mac, www.parallels.com) that allow you to run applications on a platform other than the one they were built for, doing so represents a compromise in terms of overall system performance.

So what do we use? Katrin is a longtime Apple user but can work with a Windows computer when necessary. Tim and Seán both straddle the fence, working with both platforms.

## Other Considerations

The key issues to consider when buying a new computer or upgrading an existing system all revolve around performance. Digital images contain a lot of information, especially if they're sized for large output. It takes a lot of horsepower to process those images with reasonable speed.

Still, no matter how much money you spend on your computer, you're going to be left waiting when you apply a complicated adjustment to a big image. Far too many photographers compound this problem by worrying more about their budget than about the capabilities of the computer. You certainly need to consider your budget, but whenever possible, buy more computing power than you think you need, because—believe us—you'll need that power before you know it.

### RAM

The key word when it comes to RAM (random access memory) is *more*. The official Adobe-released system requirements for both Photoshop and Lightroom call for at least 1 gigabyte (GB) of RAM, and for us that recommendation is not tenable—especially if you are processing large RAW files or actually want to enjoy working with your images. If you're working with large images, composites, or panoramas, you should really consider 4 GB as an absolute minimum instead. If your images are giving new meaning to the word *huge*, you may want to opt for 8 GB or more of RAM. Adding more RAM to your computer is the easiest and most effective way to increase computer performance (**Figure 7.4**). With the release of Photoshop CS5 and Lightroom 3, which both run as 64-bit applications, you can address much more RAM than in earlier versions. The general rule of thumb is to have twice as much RAM as processors. For example, if you work on an Apple MacPro Quadcore, which has four processors—8 GB of RAM is optimal—more than 8 GB of RAM will improve performance incrementally. The more RAM you have, the less memory swapping the operating system needs to do and the faster you'll be able to work. Fortunately, the prices of RAM have dropped and more is always better!

**Figure 7.4** *Adding more RAM is an easy upgrade that significantly boosts your computer's performance.*

## Processor speed

The processor is the "brain" of the computer, handling the number crunching involved in all tasks the computer performs. When you apply a filter, crop an image, or adjust contrast, the processor is doing the intense math behind the scenes. A faster processor means everything gets done faster. Of course, a faster processor also means a higher price.

Processor speeds are measured in gigahertz (GHz), which is a measure of the billions of cycles per second the processor undergoes. The speed at which a processor operates is referred to as its *clock speed*. Keep in mind that clock speed is only a relative measurement and must be understood in the context of the overall system architecture. For example, Macintosh computers achieve better performance than their clock speed indicates, because the architecture includes a larger cache, faster bus speeds, and other factors that improve overall system performance. Clock speed is useful only for comparing systems that use the same architecture and within the same family of processors. For example, you can't accurately compare system performance between systems running Intel versus AMD processors, because the

clock speed does not adequately take into account the other architectural differences between the processors that also affect overall performance.

One good way to compare system performance is to research results of third-party tests on various other Web sites. MacSpeedZone (www.macspeedzone.com) and Mac Performance Guide (www.macperformanceguide.com) provide performance comparisons for a variety of Apple computers. For Windows-based computers, *PC Magazine* frequently performs benchmark tests on new computers and publishes the results in the magazine and/or on its Web site at www.pcmag.com.

Besides the raw speed of the processor, another important factor is the number of *cores*, or individual processing engines, within the actual processor. These multiple cores actually appear as individual processors to the operating system, meaning that instead of one engine doing all the work, you have multiple engines working at the same time. This can greatly improve performance for applications that support *multithreading*, which is the ability to divide work into individual processes so a separate processor or a separate core within the processor can handle each of those processes.

We recommend buying the fastest multicore processor available for your computer. Most computers utilize a dual-core processor, but four- and eight-core processors are also common. Current processors operate from around 2 GHz to over 3 GHz, although these numbers will certainly increase in short order.

You can save hundreds of dollars by opting for a slower processor, but consider the time lost during the life of the computer. Staying under budget may require that you compromise on processor speed, but the fastest processor your budget will allow makes the most sense for digital photography.

## Hard drive

Tim likes to compare hard drive capacity with money: You can never have too much. If you've owned more than one computer, at some point you've probably had a hard drive you thought you'd never be able to fill. Then you filled it. Digital photography provides countless opportunities to fill all available storage space with your images.

Fortunately, hard drive prices have continued to plummet, so you can get significant storage space for a modest sum. We recommend having more hard drive space than you think you need. Among other reasons, your hard

drive is likely to fill faster than expected, because you'll probably end up taking more pictures than you think.

Hard drive space is currently measured in gigabytes and terabytes. We still remember when 100 MB was a lot of storage space; now, several hundred gigabytes is easy to fill. We recommend getting the largest hard drive available when you buy your computer, even if you plan to store your digital photos exclusively on external hard drives or other storage not permanently attached to the computer. You might even consider adding more than one hard drive to your computer for additional storage capacity.

Besides capacity, you need to consider the speed of the drive. The performance metric you're most likely to see is the rotation speed of the hard drive platters that store data. Drives typically spin at 5400 rpm, 7200 rpm, or 10,000 rpm, with some drives now spinning at 15,000 rpm. If you're considering working with video files, you really need to pay attention to RPMs, because video work is best done on the fastest hard drives possible. We recommend looking for a drive that operates at 7200 rpm or faster.

The other factor you're likely to see referenced when shopping for a hard drive is the speed of the interface. For example, the SATA (serial advanced technology attachment) interface can offer speeds of 300 MB per second (SATA 300) and 600 MB per second (SATA 600). However, this is actually the theoretical maximum speed of the interface, not the actual rate at which the hard drive is able to read or write information.

The most important factor to consider in terms of hard drive performance is the sustained transfer rate, which is a measure of how fast the hard drive is able to read and write over a sustained period of time (not just in a short burst). Unfortunately, this information can be very difficult to obtain. In some cases it can be found in the specifications for the hard drive on the manufacturer's Web site, or reviews online or in print.

Many photographers dismiss hard drive performance as an unimportant consideration, focusing instead on RAM and processor performance. Hard drive speed certainly doesn't deserve to be the most important issue in terms of overall system performance, but with ever-increasing digital camera resolution and the ability to produce large multilayered image files, your digital image files are likely to be quite large and can therefore take considerable time to open or save. Paying a little more for a faster hard drive can save a considerable amount of time down the road.

**TIP**  Some users prefer to split their hard drives into more than one partition, so they have a logical division between program files and image files, for example. This also provides potential benefits in capacity because the packets of data are smaller when you split a large drive into multiple partitions. However, we prefer to keep the drive as one cohesive block of storage, even if we're giving up some space in the process, so that our images aren't spread across multiple drive letters. We're willing to give up some capacity in exchange for a cleaner organizational system.

Another relatively new option you might consider is the use of a solid-state drive (SSD) to store data (such as your Lightroom catalog or images you're actively working on) where performance is the primary concern. While this technology is relatively new and quickly evolving, SSD drives have the potential to offer significantly better performance compared to traditional hard drives. However, because performance can vary significantly, we encourage you to read reviews and compare specifications for SSD drives before making a purchase decision.

## Display adapter/Video card

It wasn't that long ago that photographers could pretty much ignore the specifications of their display adapter (also referred to as a video card), which generates the signal shown on a display. Even with a very high-resolution display, there simply isn't a tremendous amount of information being shown at a given time, so even a modest display adapter would be up to the tasks required of it despite the raw horsepower required by Photoshop and other imaging applications.

Things have changed. The primary difference today is that Photoshop and Lightroom take advantage of the graphics processing unit (GPU) on the display adapter or video cards (Mac). By leveraging the display adapter in this way, overall performance can be improved and special interface effects can be enabled.

Fortunately, while a relatively high-end display adapter will provide you with a variety of benefits in the digital darkroom, it is easy to find a display adapter that will meet your needs without breaking the bank. Any display adapter targeted at a gaming audience will likely provide more than enough processing power for your digital imaging work.

We have been happy with display adapters utilizing the nVidia chipset, which actually includes adapters from a wide range of manufacturers. Because this is an area that sees considerable change over a very short period of time, we highly recommend seeking information from reviews found in *PC Magazine* (www.pcmag.com) and other sources. In particular, look for a display adapter with at least 1 GB of video RAM (VRAM). Adobe also maintains a list of compatible display adapters in the Support section of its Web site (www.adobe.com). If you're working on the Apple platform, the built-in video cards are all compatible with Adobe tools.

# Display

As much as the core components of a computer are important elements of a digital darkroom, the display is especially important for photographers. You'll spend a lot of time looking at your monitor while working on your images, and having an accurate, high-quality display is crucial.

## The Value of a Second Monitor

When you're optimizing your images in the digital darkroom, the monitor is your viewfinder into the image. We are firmly of the opinion that if one monitor is good, two must be better. In fact, we're confident that once you've worked with multiple monitors, you'll never go back to working with just one again.

A second monitor enables you to double your working area on the computer, although you'll sacrifice working area on your real desktop. To us, the advantages are well worth the lost space. With more room on your display, you can work more efficiently. For instance, you can display your image full screen on your primary monitor, and then move all your toolbars, panels, and other controls to the second monitor so they don't get in the way of the image (**Figure 7.5**).

Adding a second monitor is pretty straightforward. You'll need a second monitor, of course, plus an available video output on your computer (you can add another video card to provide that additional output). With Windows systems, you can replace your existing video card with one that supports dual monitors.

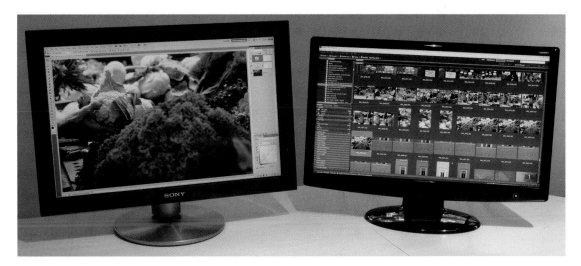

**Figure 7.5** *Setting up multiple monitors on your computer allows you to work much more efficiently.*

## Display size

It would be easy for us to simply tell you to get the biggest monitor available, but that may not necessarily be the best solution, considering your budget and the amount of space you have available on your desk. We will say that the more space available on your monitor, the better. We consider 17- to 19-inch displays to be a bare minimum, with a 23-inch monitor being an ideal starting point. If the size of your desk and wallet will allow, you can also opt for a 30-inch or larger display.

Of course, bigger isn't always better when it comes to your display. You need to consider how close to the display you'll be sitting based on your desk configuration. If you can't be a comfortable distance away from a particularly large display, you may be better off with something a little smaller.

## LCD specifications

Although LCD (liquid crystal display) displays have improved significantly over the years and have rendered CRT monitors obsolete, there are still some limitations to keep in mind when looking for an LCD display.

*Viewing angle* is a measure of the range in front of the monitor from which you can still see the image clearly. A 180-degree viewing angle would be impossible, because it would allow you to see the display on the monitor when viewing it from the side. A 90-degree viewing angle would mean you could see an accurate picture when viewed from 45 degrees on either side of center (**Figure 7.6**). Once you look outside the viewing angle range, the display gets darker and colors may shift. You should look for a display with a viewing angle of 120 degrees or more.

*Contrast ratio* measures the range of tones the monitor can display, from the brightest white to the darkest black. A lower contrast ratio means the monitor can't display some tonal values, and this generally translates into a loss of detail in shadowed areas of your images. Typical LCD displays offer a contrast ratio of around 700:1 to 1000:1, which we recommend as a minimum range of values to look for.

**Figure 7.6** *Many LCD displays have a limited viewing angle, making the image appear dark when not viewed from directly in front.*

Because of the way an LCD monitor's internal elements are designed, these monitors produce the highest quality display when operating at their "native" resolution. To ensure the best quality, look for an LCD that offers a native resolution you intend to use. We recommend looking for a display with a high native resolution. For smaller displays, this will often be in the range of around 1600x1200 pixels, but for larger displays this can be 2560x1600 or more. Just keep in mind that with higher resolutions the relative size of objects on the screen will be smaller, which can be a disadvantage for some users. Personal preference plays a role here, so if possible, visit a retail location that has a wide range of LCD monitors on display, so you can see which produces the most pleasing image to your eye.

## Calibration

Just buying a great monitor doesn't guarantee that the images displayed on that monitor will be accurate. If the display isn't accurate, the image adjustments you make in response will also be inaccurate. To ensure that the image you're seeing is accurate, you need to calibrate your display.

The calibration process consists of two parts. One is the actual calibration in which you adjust the display to get it as close as possible to established standards for luminance and color temperature. The second part is creating a custom profile for the monitor, which provides a formula for determining the adjustments necessary to produce an accurate display (**Figure 7.7**).

**Figure 7.7** *Calibrating your monitor on a regular basis ensures that the images you're seeing are as accurate as possible.*

Over a period of time (generally measured in months for an LCD), the monitor's color and tone will shift due to the gradual deterioration of the monitor's internal components. The most common issue for LCD displays is a change in brightness as the illumination source fades over time. Therefore, you should recalibrate your display regularly. It is often recommended that you calibrate your display every two weeks, but we feel this is more frequent than necessary for a relatively new display. For new monitors, once a month is more than adequate. As your monitor ages, you may need to calibrate it more frequently. We'll talk about the available tools and the actual process of calibrating and profiling your display in Chapter 9, but keep in mind this is a critical tool for your digital darkroom.

# Backup

Computers are incredibly reliable, and it's relatively rare for a hard drive to fail—but when it does, you'll want to have backed up your images redundantly to ensure those images are safe. With hard drive capacities constantly increasing and prices constantly decreasing, we tend to replace hard drives (or the computer containing them) long before they get anywhere near the end of their useful life. The fact that our image files continue to accumulate only accelerates the upgrade cycle.

Because of the high reliability of our computers and storage media, it is easy to become complacent and ignore the need to back up. Don't! Backing up is a critical aspect of working with your images in the digital darkroom. Every time you add new images or perform significant work with your images (such as adjustments or keywording), you should perform a backup of your important image files. Also, make a plan to back up your data on a regular basis regardless of how much work you've performed in the meantime. Most backup software even allows you to schedule automatic backups so you don't have to remember to initiate them. This is a convenient feature, but if you implement an automatic system, be sure to confirm on a regular basis that the backups are being performed successfully as scheduled.

And redundancy is a good strategy: One backup is good, but multiple backups provide additional security. For example, if you are using an external hard drive for backing up, get two of them and alternate them between backups. There are a number of methods you can use for backing up your data, and you may want to use more than one method to provide greater redundancy.

## External Hard Drives

External hard drives (**Figure 7.8**) provide an excellent way to back up your data or supplement the storage capacity of the hard drive inside your computer. They are convenient to use because once they are connected to your computer through either a USB or FireWire connection (and in some cases an eSATA connection), they appear as just another hard drive on your computer. They also offer high storage capacity—hundreds of gigabytes to several terabytes—in one package.

**Figure 7.8** *External hard drives offer a flexible and high-capacity storage solution.*

There are several ways you can use an external hard drive:

- **Primary storage.** Use the internal hard drive in your computer for the operating system and applications, and store your photos and other data on an external hard drive.

- **Auxiliary storage.** When your internal hard drive fills up, an external hard drive is easy to add to gain additional storage capacity.

- **Backup of internal drives.** Because of their high capacity and convenience, external hard drives are an excellent way to back up your internal hard drives, including your system folder and applications.

- **Redundant storage.** If you're using an external hard drive for primary or auxiliary storage, you'll need to back up that data as well.

When using an external hard drive for backup purposes, you can simply copy files from your internal hard drive to the external drive using the file-management capabilities offered by your operating system. In this case, any time you update your images files on your internal drive, you'll want to make a duplicate copy on the external hard drive designated for use as a backup.

# Software

A more convenient solution than a manual backup would be to use software such as EMC Retrospect (www.retrospect.com) to perform a backup to your external drive, which would automatically compress the data. The disadvantage to this approach is that the backup isn't an exact copy of the original files but rather a backup volume that can only be accessed by using the Restore function in the backup software.

Another excellent option if you're using an external drive for backing up an internal drive, or if you are using it for redundant storage, is to use drive mirroring software that allows you to maintain two identical copies of all data on a hard drive automatically. For example, Techsoft's Mirror-Folder (Windows only, www.techsoftpl.com) and SoftRAID (Macintosh only, www.softraid.com) allow you to configure automatic hard drive mirroring, where the contents of one drive are automatically duplicated in real time to a second drive. The only disadvantage to real-time mirroring is that if you are using full-time drive mirroring, you can't really store the backup copy in a different physical location, which is something we strongly recommend. Fortunately, these and other drive mirroring solutions also allow you to synchronize on command, which is effectively the same as performing a backup except that the files are duplicated from one drive to another. This is a perfect solution for most photographers using external hard drives to back up their images. On a Mac, straightforward synching applications include CarbonCopyCloner and SuperDuper, and on a Windows machine, you can use SmartSync Pro or GoodSync.

# Offsite Storage

To ensure the safety of your images, we strongly recommend making multiple copies of your backup and storing at least one of those copies at a separate physical location. That may mean storing it at a safe deposit box at the local bank, at your home or office, or at a friend's house. If a fire destroys your computer, you don't want the backup to be on the desk above the computer that is also consumed by the fire. The more cautious you are about backing up your critical data, the less chance that you'll suffer the permanent loss of important images.

## Online Backup

The ability to perform a backup of your critical data that is stored on a remote server is—at least in concept—a perfect solution. Not only can you configure such a service to perform an automatic backup of your system in the background, but by its nature the backup is offsite, which provides additional peace of mind with minimal effort.

As much as online backup is an ideal solution in theory, in practice it isn't really a good fit for photographers—at least not yet. The problem is that photographers generate a tremendous amount of data, and even high-speed Internet access isn't exactly fast when it comes to transferring a large number of relatively large image files.

That being said, you may want to consider an online backup solution for your most important image files as a supplement to your normal backup process. There are a large number of online backup services, such as Mozy (www.mozy.com) and Carbonite (www.carbonite.com). These services will continue to improve as upload (and download) speeds increase.

# Long-term Maintenance Issues

Unfortunately, your backup efforts don't end when you implement a system for creating frequent and redundant backup copies of your data. You also need to consider the long-term maintenance of your backup solution.

Most external hard drives use USB or FireWire connections. These are certainly commonplace on today's computers, but before long new technology will replace existing connections, and you may find that in the future you won't have the port required on your computer to connect to today's external hard drives.

Digital photography includes a wide range of advantages, and we absolutely love it. However, we also need to keep in mind that there are issues that come with these advantages. One of them is the need to maintain our digital image file storage over time. If you give some thought to planning an archival storage strategy for your images that includes redundant backup and maintenance over time, you'll ensure that your images will be available for enjoyment by many future generations.

In particular, periodically evaluate whether the file formats and storage media you are using for your images face any risk of becoming obsolete. If so, start transferring your images to new media sooner rather than later, or convert files to different file formats if necessary (although the chances of commonly used file formats no longer being supported are not too high).

# Printers

If you're using a digital darkroom to work on your images, you likely want to produce the final prints yourself as well. This allows you to produce prints to your specifications on media that best expresses the character of your work, and to fine-tune the output to perfection. Printing images yourself also gives you the satisfaction of personally taking your image through the full process from the time you composed the picture all the way to displaying the final print.

Once you've made a decision about which printer represents the best solution for you, you'll be ready to produce prints of the highest quality, which we'll discuss in Chapters 9 and 10.

## Inkjet Printers

Although there are still a variety of other printer types available for producing photographic prints, a variety of factors have caused photo inkjet printers (**Figure 7.9**) to achieve near exclusive use by photographers, and for good reason. These printers offer output of exceptional quality with inks that will ensure a long life for the image with relatively fast output and quite reasonable prices.

Inkjet printers spray ink in microscopic droplets with precise positioning onto the paper. There are two basic techniques for spraying the ink onto the paper. Printers from Canon, Hewlett-Packard, and others use thermal technology, where the ink is heated until enough pressure builds up to splatter an ink droplet onto the paper. Epson, on the other hand, uses a patented technique where an electrical charge is used to create a vibration that effectively "shakes" the ink droplet onto the paper. Neither way sounds like a very accurate way to put ink to paper, but they actually function with incredible precision. Both methods are perfectly capable of producing excellent images.

**Figure 7.9** *Photo inkjet printers are the only type of printer photographers need to seriously consider for producing photographic prints.*

Because of all the marketing efforts to promote inkjet printers, choosing the best model can be daunting. Most of today's photo inkjet printers produce exceptional-quality prints, so you need to consider additional factors when making a decision.

Be sure to purchase an inkjet printer specifically designed for photographic output. That means it will use at least six inks to produce images of photographic quality or possibly more to extend the tonal range and color gamut. We also highly recommend that you visit a store that can provide print samples from each of the printers you're considering.

## Inkjet inks

Two types of inks are available for inkjet printers: dye based and pigment based. Most printers can only use a single type of ink, so the type of printer you choose will usually determine the type of ink you'll be printing with. More to the point, the types of inks that meet your needs will determine

which printers to consider. Dye-based inks provide the most vibrant colors at the cost of reduced print longevity. Some dye-based inks will last only a couple of years under typical display conditions, whereas others can last as many as a couple of decades when paired with particular types of paper. Pigment-based inks offer extended longevity but with colors that aren't quite as vibrant as dye-based inks (though the difference is quite minimal with the latest inks).

If you are selling prints of your images, print longevity is a critical factor. When someone buys a print, they expect it to last when they hang it on the wall. At the very least the print should last as long as the best "traditional" print from a wet darkroom. Quite simply, that means you'll need to use pigment-based inks. The latest pigmented inks, such as the UltraChrome inkset from Epson, provide vibrant colors that come very close to matching what is possible with dye-based inks. According to tests conducted by Wilhelm Imaging Research (www.wilhelm-research.com), the recognized leader in image permanence testing, prints using UltraChrome inks will last up to 200 years (or more) under normal display conditions, depending on the paper type used.

If you need prints to look as good as possible but you don't need them to last (say you're printing the images as proofs or for short-term display), then dye-based inks are a good option because they offer the most vibrant colors at a lower price than pigment inks.

Those caveats aside, our general recommendation is to use pigmented inks for all inkjet prints. The color vibrancy of the latest pigment inks is very good, and you'll have longevity on your side.

## Specialized inks

Certain specialized inks provide potential benefits in quality and cost. These products are of particular interest when it comes to printing black and white images. Available solutions are generally referred to as *quadtone* inks, because they include several shades of black ink to produce a full tonal range with no color cast. The original ink sets included four tones of black ink; but the quadtone name has stuck even though recent ink sets feature even more shades of black.

Similar options enable you to produce black and white prints that include a particular color tint, such as a warm appearance. If you're interested in

using third-party inks, review the options available from Cone Editions (www.inkjetmall.com), Lyson (www.lyson.com), and MIS Associates (www.inksupply.com), among others.

---

### Third-party Inks

You can use a variety of third-party inks in place of the manufacturer's inks in many inkjet printers. Third-party inks tend to be less expensive than those from manufacturers. We prefer not to use third-party inks, however, since they typically have a greater tendency to clog the printer nozzles, and in most cases they don't offer the same longevity as the manufacturer's inks. We feel it's best to use the inks specifically designed for your printer.

Another way to save money is by using a continuous inking system (CIS). These systems replace the ink cartridges in your printer with special connections to large ink tanks that you can refill at any time. So you can continuously operate the printer without ever having to change cartridges, and you save money by buying inks in bulk. If you produce a large volume of prints, a CIS solution might be worth considering.

In either case, be aware that using third-party inks may void your printer warranty.

---

## Print Longevity

After print quality, we consider print longevity to be the most important issue to consider when buying a printer. Unfortunately, it can be difficult to get accurate information about the longevity of the inks used in a particular printer. Printer manufacturers will make their own claims, but we prefer to trust an impartial third party that uses consistent criteria and conditions to test print longevity for a range of printers. As mentioned earlier, the most respected lab for image permanence testing is Wilhelm Imaging Research. Its testing is the most precise in the industry.

On the Wilhelm Imaging Research Web site (www.wilhelm-research.com) you can view archived longevity data for a variety of printers, and new testing is being conducted constantly. As the results of new tests emerge, they are

posted to the Web site. This is an excellent reference to use when determining which printer will best meet your needs if longevity is a primary concern.

## Print Size

A particular printer can only produce prints up to a maximum output size, so you'll want to be sure to anticipate your future needs when buying a printer. At the lower end are printers that can print up to a maximum of 8.5 by 11 inches. A step above that are the larger desktop printers capable of producing prints up to around 13 by 19 inches. Many photographers start out with a printer that can print up to 8.5 by 11 inches but quickly decide they'd like to be able to print larger. A 13-by-19-inch print may seem huge when you're just getting started making your own prints, but in time you'll probably start wanting to produce large prints of your best images (**Figure 7.10**). Keep in mind that you can always make small prints on a large printer, but you can't make prints larger than the printer will allow.

**Figure 7.10** *As your skills improve in the digital darkroom, you'll likely find yourself wanting to produce larger prints of your photos.*

If even a 13-by-19-inch print doesn't seem big enough for your needs, you may want a wide-format inkjet printer. These printers will commonly support paper widths of typically 24, 44, and 60 inches. They will accept both cut-sheet and roll paper, providing tremendous flexibility. Note that many printers, including most wide-format printers, also allow you to produce panoramic prints that are as wide as the printer will allow and as long as the software will allow.

If you won't be producing large prints very often, it might make sense to buy a desktop printer that will handle the largest prints you anticipate producing on a regular basis and then to send your image files to a print lab when you need a larger print.

## Print Media

Print media is what we'd otherwise call paper, but of course the material you print on isn't necessarily paper. When buying a new printer, you'll want to consider the types of media it can print on. You may expect to print only on standard glossy or matte papers, but having the flexibility to print on different surfaces will let you get creative with a variety of materials later if you wish.

Glossy papers provide higher contrast and saturation, giving more "snap" to your images. Matte-surface papers mute the colors and reduce contrast, providing a softer final image. Semigloss papers fall somewhere in between, although they behave more like glossy papers than matte papers. Specialty print materials can add an artistic touch to your image. These include textured papers, silk, canvas, or other materials.

Several issues affect a printer's ability to print on a particular type of media. One is the ability of the printer to feed the media type through in the first place, since each printer has a minimum and maximum thickness it can handle. Another factor is the texture of the media. For example, some canvas material lacks traction, leaving the printer's rollers unable to properly feed the media into the printer.

Even if a printer can feed a particular media type, that doesn't necessarily mean it can successfully print on it. To produce a good print, the inks must properly bond with the paper. Some inks simply won't bond properly with certain papers or other materials, causing them to puddle up or migrate on the media.

To play it safe, use media specifically designed to work with your printer. Many papers will work with virtually all inkjet inks, but some will work only with dye-based or pigment-based inks. Most third-party paper manufacturers indicate which types of printers their papers are best suited for. To play it absolutely safe, stick to print media from the same manufacturer as your printer, being sure to confirm the specific media you're interested in is compatible with your specific printer and ink set. However, we also feel completely comfortable using print media from a variety of third-party companies, because most of them conduct extensive testing to ensure broad compatibility with most photo inkjet printers.

## Cost of media

Printer manufacturers make most of their profits not by selling printers (which in many cases they practically give away) but by selling the paper and ink. Since these costs can be considerable, you'll want to factor them into your printer purchasing decision.

For example, consider the cost of replacement ink cartridges for your printer, taking into account the (sometimes incredibly optimistic) estimates provided by the manufacturer of how many pages per cartridge you can expect to print. These estimates are generally based on printed text, even for photo printers. Photographic prints require much more ink than a typical text document, so you'll only want to use the estimates as an approximate indication of the relative cost of inks among printers.

Many photographers seem to fixate on the price per print with inkjet printers. Keep in mind that an inkjet print is in most cases less expensive than a traditional chemical print. Still, you'll want to have some idea of what your prints are costing you. You can calculate your own ink and media costs by keeping track of how many square feet of prints you are able to produce before replacing the ink cartridges. A typical sheet of 8.5-by-11-inch paper costs about $1, so making a series of test prints can certainly add up.

You may be tempted to produce test prints on less expensive paper and then produce the final image on your favorite paper. However, proper proofing is best done on the media you'll use for the final print. Therefore, we encourage you to get the image perfected on the monitor before attempting to make the final print. Appropriate color management can also help avoid wasted paper, which we'll cover in Chapter 9.

# Essential Accessories

In addition to the computer components, there are additional accessories we consider essential equipment for an efficient digital darkroom.

## Card Reader

You can connect your digital camera directly to your computer and transfer your images using that connection, but that's an inconvenient approach because it turns the camera into an oversized card reader that isn't as easy to work with. It also creates a risk that you'll accidentally snag the cable, sending your digital camera crashing to the floor. Instead, we recommend getting a card reader that allows you to connect your digital media cards directly to the computer (**Figure 7.11**). This way you can keep your camera in the bag safe and sound.

**Figure 7.11** *We recommend that you use a card reader to transfer your images to the computer, leaving your camera safely in the camera bag.*

We'll talk about how to actually transfer your images in Chapter 8, "Working in the Digital Darkroom." But while you're setting up your digital darkroom, a card reader is an excellent accessory to add.

When choosing a card reader, the two issues to consider are the type of media the reader supports and the speed of the reader. Many card readers support only one type of digital media card, and since most cameras also only accept one type, you can just buy a reader whose card type matches your camera's. If you want to play it safe, there are some card readers that read multiple digital media card formats.

The speed of the card reader is determined by the connection it uses to the computer (as well as the capability of the digital media card). Most card readers use either a USB or a FireWire connection. For USB, we recommend getting a card that supports the USB 2.0 standard (assuming your computer has a USB 2.0 port), because this provides considerably faster transfers than the previous USB 1.1 standard. To achieve the speeds USB 2.0 offers, both the card reader and the port it plugs into must be USB 2.0 compatible. USB 2.0 sends data at up to 480 Mbps. There are two versions of FireWire as well, generally referred to as FireWire 400 (offering 400 Mbps data transfer) and FireWire 800 (with an 800 Mbps speed).

## Wacom Tablet

When you think of editing images, you probably don't think of drawing, so you may not think you need a drawing device. Think again. A tablet and stylus allow you to perform the same tasks as a mouse, and then some. The major advantage is that you use a stylus much like a pen, holding it in your fingers to draw on the tablet (**Figure 7.12**). This allows much more precise control compared with using a mouse that you hold with your whole hand. In addition, a stylus is pressure sensitive, so it will respond differently depending on how hard you press down when drawing.

**Figure 7.12** *A Wacom tablet is an invaluable tool for working with your images in the digital darkroom.*

We all use a stylus extensively when performing image adjustments such as dodging and burning, when applying targeted adjustments, and for other tasks where finesse is important. Although this tool can require some getting used to for those who have grown accustomed to using a mouse, we think that after you've worked with it for a few days you'll agree that a tablet is a must-have accessory.

We strongly recommend the Wacom (pronounced "WOK-um") brand because its tablets give you significant control over your adjustments. These tablets are available in several sizes. We consider the smallest size too small for photo editing and the largest size to be unwieldy. The "medium" size is ideal for fine digital darkroom work.

# Software

The most powerful computer in the world isn't much good without software, and when it comes to optimizing your photos, you'll need specialized software. There is no shortage of options, but you'll want to make sure the software you choose meets your needs before you spend the time learning to use it.

## Adobe Photoshop Lightroom

Adobe Photoshop Lightroom (**Figure 7.13**) is an image-management software tool built on the photographer workflow. It is organized into modules that allow you to organize, optimize, and share your images. Although it is best suited to photographers who need to manage a large number of images and share images with clients, it is also powerful enough and includes plenty of features to make it an appropriate choice for most photographers. As a result, it has become our digital imaging tool of choice. We discuss the use of Lightroom in extensive detail in Chapter 8.

**Figure 7.13** *Adobe Photoshop Lightroom serves as a workflow tool to help you manage, optimize, and share your images.*

# Adobe Photoshop

If you run into limits in what you can do to your images in Lightroom or if you want to create composite images or perform other advanced tasks, you'll want to use Photoshop (**Figure 7.14**).

Photoshop provides incredible power and flexibility. You can exercise full control over the process of optimizing your images with advanced selection tools, adjustment tools, and other options that provide virtually unlimited possibilities.

**Figure 7.14** *Photoshop is the photo-enhancement tool of choice for the serious photographer.*

Besides the features built into Photoshop, there are other reasons to choose it as your photo-editing software. For one thing, it has become the industry standard for advanced image optimization, which means you'll find many sources of information on how to use it. If you have a problem, you can consult books, magazines, online forums, workshops, seminars, conferences, and other resources to answer your questions and learn the best techniques.

Of course, Photoshop's immense power doesn't come cheap, either in price or in the time investment required to learn it. Be prepared for a steep learning curve, but recognize that your efforts will pay off in terms of the quality of your results and the power and flexibility of the tools available.

## Plug-ins

As if the software available didn't offer enough options for working with your images, there are also a number of plug-ins that extend the capabilities of your software. Most of these plug-ins are designed for Photoshop and Lightroom, but they can often be used with other software as well or even operate as stand-alone tools.

We really don't use too many plug-ins, preferring to find a way to achieve the same results with the tools available in Photoshop. Our reasons are many: We like the challenge; we have enough knowledge of Photoshop and Lightroom that we can do it ourselves; we prefer not having to purchase the plug-ins; and we can exercise more control over the processes. However, plug-ins can often simplify otherwise difficult tasks, and they provide features not found explicitly in Photoshop, so we want to direct you to some that we consider most useful.

- **nik Dfine.** Digital cameras often produce images with some degree of noise, particularly when you're using higher ISO values or longer exposure times. The process of optimizing the image can often exaggerate this noise, resulting in an image of less-than-ideal quality. Dfine from nik Multimedia (www.nikmultimedia.com) provides a solution to this problem. Dfine provides automated tools to quickly fix your images, as well as more advanced tools to help you analyze and optimize your images.

- **Image Doctor.** As its name implies, Image Doctor from Alien Skin Software (www.alienskin.com) provides a variety of tools for fixing problems in your images. It allows you to remove blemishes and defects, repair artifacts caused by JPEG compression, and replace unwanted elements of your images without leaving a trace. Image Doctor provides all of these options within an easy-to-use interface.

- **PhotoKit.** There is a series of plug-ins for Photoshop available under the PhotoKit banner from a group of industry experts who formed Pixel Genius (www.pixelgenius.com). They provide dozens of effects for digital images that replicate film effects, apply sharpening, and optimize creative color. The wide range of tools provides automated ways to create effects that would otherwise be time-consuming to produce with Photoshop. The input and output sharpening features of PhotoKit Sharpener have been incorporated into Adobe Lightroom and Adobe Camera Raw.

- **PhotoFrame.** PhotoFrame is a plug-in from onOne Software (www.ononesoftware.com) that lets you put an artistic edge around the outside of your image (**Figure 7.15**). The plug-in comes with a library that includes thousands of edge shapes, enabling you to quickly and easily add a creative look to your image's edge.

**Figure 7.15** *PhotoFrame allows you to put creative edges on your photos that are sure to grab the viewer's attention.*

- **Color Efex.** Color Efex is a collection of plug-ins from nik Multimedia that offers a comprehensive set of filters for image enhancement, optimization, special effects, and replication of traditional darkroom techniques. The plug-ins provide powerful options for adjusting the lighting and color of digital images. Besides the photographic filters, another set of filters in the Color Efex collection simulates effects from the traditional "wet" darkroom. These include sepia toning and solarization, among others.

- **Viveza and Topaz Adjust.** For creative effects, also consider nik Multimedia Viveza and Topaz Adjust, both of which allow you to create stylized image looks very quickly. As with all plug-ins and gratuitous effects, we recommend using them in moderation!

### But wait, there's more!

What we've presented is a mere handful of the most popular plug-ins for Photoshop (or for other software supporting Photoshop plug-ins). In addition to these products, there are dozens—if not hundreds—of actions and filters available offering workflow enhancements, advanced editing capabilities, and creative ways to change your images. If you're looking for new ways to work with or interpret your images, take a look at the many plug-ins available to extend the capabilities of your photo-editing software. As a start, visit www.thepluginsite.com, which maintains a list of plug-ins for Photoshop in its Resources section, and www.actionfx.com for an overwhelming number of actions to automate image enhancement.

## Adobe Photoshop Elements

Photoshop Elements (Windows and Macintosh) is offered as a feature-limited version of industry-standard Photoshop. Unlike previous "LE" (Limited Edition) versions of Photoshop, Elements has an excellent set of features and provides a great solution for those just getting started with digital imaging (**Figure 7.16**).

Elements includes the most important features of Photoshop, such as advanced selection tools, the ability to work with multiple image layers in a single document, and a variety of filters. Although the program is missing some of the most advanced features, it adds usability enhancements to make learning the program easier. It features an enhanced help system, including "recipes" that guide you through complex tasks step by step.

The tools that Elements is missing can be found in the full version of Photoshop, but they are tools only advanced users would miss. These include CMYK support, HDR imaging, access to channels, ability to record actions, and other features. We consider Elements an excellent stepping stone in terms of starting out. Once you've gained confidence, you can move up to Photoshop.

**Figure 7.16** *Photoshop Elements provides most of the functionality of the full version of Photoshop at a lower price and with more detailed guidance for the novice user.*

# Lightroom Settings

Before you get ahead of yourself working with your images in Lightroom or Photoshop, it is a good idea to review the various settings available. In many cases the default settings will work well, but you may want to make some changes to suit your preferences and your particular workflow.

All the key settings for Lightroom are accessed from the Preferences dialog by choosing Edit > Preferences in Windows or Lightroom > Preferences on Macintosh. The Preferences dialog is divided into pages that are accessible using buttons found at the top of the dialog.

# Preferences

The General page (**Figure 7.17**) of the Preferences dialog contains settings that are for the most part self-explanatory and are really a matter of personal preference.

**Figure 7.17** *The General section of the Lightroom Preferences dialog.*

The following settings on the General page are important to consider:

- **Automatically check for updates.** Adobe provides updates to Lightroom on a relatively regular basis, and we strongly recommend always working with the latest version to ensure you have recent bug fixes and the latest features. With this check box selected, Lightroom periodically checks the Adobe Web site for updates to Lightroom and will notify you if there is an update ready to install. You can also choose Help > Check for Updates to manually check for updates at any time.

- **Default Catalog.** Lightroom automatically opens the most recently used catalog upon starting, but if you work with multiple catalogs, that might not be your preference. You can use this option to have Lightroom prompt you to choose a catalog at startup, or you can select a previously used catalog to always be opened. You can, of course, change the catalog you're working with at any time by choosing File > Open Catalog.

- **Automatic Import.** If you select the "Show import dialog when a memory card is detected" check box, whenever you insert a digital media card into a the card reader (or attach a camera to the computer) the Import dialog appears so you can import the images contained on the media card. We recommend you leave this option selected so you can take advantage of the ability to copy images from the digital media card as part of the import process, as well as to help remind you that whenever you download images you should also import them into Lightroom so you don't forget.

- **Reset Warnings.** Lightroom presents a variety of warning messages that also include a check box you can select so a particular warning message will not display in the future. If you deselect warnings you would actually like to receive alerts for, you can click "Reset all warning dialogs." This causes all warning messages to once again appear as applicable, because you cannot reenable specific messages.

- **Catalog Settings.** The Go to Catalog Settings button, as its name implies, brings up the Catalog Settings dialog, which can also be accessed by choosing Edit > Catalog Settings on Windows or Lightroom > Catalog Settings on Macintosh. The settings in this dialog are discussed later in this chapter.

The Presets page (**Figure 7.18**) of the Preferences dialog contains settings related to the presets used in all of Lightroom's modules.

**Figure 7.18**  *The Presets section of the Preferences dialog.*

The following options are available:

- **Auto Tone Adjustments.** If you select the "Apply auto tone adjustments" check box, Lightroom applies automatic adjustments for tonality to all images you import. We prefer to leave this option deselected. Although the automatic tone adjustments generally improve contrast and thus produce a more pleasing preview in Lightroom, we prefer to tailor the adjustments to each image. Having said that, if you need to maximize the speed with which you process your images to share with clients, you may want to select this option. Note that you can apply the automatic tonal adjustment to individual images at any time using the controls found in the Library and Develop modules.

- **Auto Black and White.** Although we prefer not to use automatic tonal adjustments, we do prefer to leave the "Apply auto mix when first converting to black and white" check box selected. The default settings for this automatic adjustment tend to work reasonably well with most images and represent a good starting point from which to fine-tune the settings.

- **Specific Defaults.** There are two check boxes related to applying default settings to specific camera settings. The first causes the default settings established in Lightroom to apply to a specific camera serial number. This is helpful for situations where you want to apply specific settings (for example, camera calibration or a black and white version of the image) to a specific camera. Such an option is often used by wedding photographers who identify a particular style of image to a particular camera body, so different interpretations of the images can be applied for each camera. The second check box relates to specific ISO settings. This option is most useful for assigning unique noise reduction settings based on the degree of amplification applied by the camera.

- **Preset Location.** The presets you create or install go into a folder based on the type of preset in the Lightroom installation folder. If you prefer, you can also store these presets in the same folder as the Lightroom catalog. This is most helpful if you have stored the catalog in a remote location, such as on an external hard drive you want to be able to transport to different computers.

- **Restore Presets.** From time to time you may find it necessary to restore the default presets and defaults in Lightroom. For example, if you have made modifications to the default export presets, you can click the Restore Export Presets button to restore the defaults that are included with Lightroom. Note that the set of restore buttons will only affect the default presets and templates that are included with Lightroom, not third-party or user-defined settings.

The External Editing page (**Figure 7.19**) of the Preferences dialog contains options for the use of a separate application (such as Photoshop) for optimizing your images.

**Figure 7.19**  *The External Editing section of the Preferences dialog.*

The following settings are available:

- **Photoshop settings.** The first section of the External Editing page allows you to specify the settings to be used for images that will be opened in Photoshop from Lightroom. The particular settings used depend on your workflow, but based on the assumption that you want to maximize the quality and amount of information contained in your images, we recommend using the TIFF file format, the ProPhoto RGB color space, a bit depth of 16 bits/component, a resolution based on your intended output (but probably 360 ppi for most applications), and no compression.

- **Additional External Editor.** The second section of the External Editing page provides settings for an additional image-editing application

besides Photoshop. The general settings are the same as those found in the settings for Photoshop (see the previous bullet item). Clicking the Choose button will bring up a dialog where you can select the additional application you'd like to use for adjusting your images. In addition, after establishing the desired settings, you can save those settings as a preset that can be used as a shortcut you can select later. The ability to create a preset is obviously most helpful to photographers who need to work with more than one application in addition to Photoshop.

- **File Naming.** The final section of the External Editing page allows you to specify filenaming to be used for images you open with another application. Keep in mind that whenever you open an image from Lightroom in another application, a new derivative image is created. In effect, Lightroom is automatically exporting an image, opening that image in another application, and then saving the image as a separate file that is managed along with the original. You can choose a template from the menu (or choose Edit to create your own template) that will specify the filename to be used for the derivative image. Note that the Custom Text and Start Number fields are only enabled if they are used as part of the template you choose.

The File Handling page (**Figure 7.20**) contains settings related to files and the metadata contained within those files.

**Figure 7.20** *The File Handling section of the Preferences dialog.*

The settings include:

- **DNG settings.** The Import DNG Creation section includes settings related to creating DNG (digital negative) files if you opt to create DNG versions of your images upon import. The first setting allows you to determine whether the filename extension should be uppercase or lowercase, which is purely a matter of preference. The Compatibility option allows you to designate that a DNG file should be compatible with earlier versions of Adobe Camera Raw and should only be set to an earlier version if you need to maintain backward compatibility with other users who are not working with the latest version of the software. The JPEG Preview setting determines how large the embedded JPEG should be, which affects overall file size (we opt for the Medium Size setting here). A check box allows you to embed the original RAW capture within the DNG file, which Tim recommends doing to ensure maximum flexibility down the road, whereas Katrin prefers to leave this option off to save on file size.

- **Metadata handling.** Lightroom supports hierarchical keywords in metadata, allowing you to create "categories" for individual keywords. For example, when defining a location, you could have Canada, the United States, and Mexico as keywords contained within the North America hierarchy. The vertical bar symbol (|) is used as a separator for hierarchical keywords by default. If you'll be importing images that have had keywords assigned by a different application, you can have Lightroom recognize the period (.) and slash (/) characters as hierarchical keyword separators as well by selecting the applicable check boxes here. You can also specify if you want to replace spaces in filenames with a different character to help ensure maximum compatibility with other applications or operating systems.

- **Raw Cache.** The Camera Raw Cache Settings section contains a few options related to the cache for RAW images managed by Lightroom. The location of this cache can be changed by clicking the Choose button. You can also specify the maximum size for this cache (we generally increase this from the default of 1 GB, based on how much total hard drive space is available). If you are experiencing problems in Lightroom, such as inaccurate or missing preview images, you can also click the Purge Cache button to force Lightroom to clear the existing cache and rebuild the cache for images being managed by Lightroom.

The Interface page (**Figure 7.21**) contains settings that are almost purely a matter of personal preference and aesthetics.

**Figure 7.21** *The Interface section of the Preferences dialog.*

These include:

- **Panels.** The Panels section contains an option for which mark should indicate the bottom of each panel and a setting for the font size within Lightroom.

- **Lights Out.** The Lights Out section allows you to determine the color (a shade of gray, actually) that should be used when the "lights out" view is enabled, as well as the degree to which the display should be dimmed for this view.

- **Background.** The Background section allows you to choose a color (again, really a shade of gray) and texture (we recommend against this) for the background of the main window as well as the secondary window you can create for use with multiple displays.

- **Keyword Entry.** The first setting in the Keyword Entry section allows you to determine whether keywords should be separated by commas or spaces. If you choose commas (which is the default), you are allowed to use spaces within keywords. If you choose to use spaces to separate

keywords, you must enclose keywords in quotation marks if the keyword should contain a space.

- **Filmstrip display.** The Filmstrip section contains a series of check boxes that are all self-explanatory and relate to what information you would like displayed along with thumbnail images on the Filmstrip panel.

- **Tweaks.** The word "tweaks" is a somewhat casual word for use in a professional software application, but in this case it seems fitting because the settings in this section allow you to apply minor "tweaks" to the Lightroom interface. The first check box allows you to adjust the behavior of the Zoom tool in Lightroom. The default is for the zoom to center on the position you click within the image, but if you deselect this check box, the image will simply be zoomed when you click with the center remaining unchanged. The second check box allows you to specify whether you want fractions to be displayed as a single character or as numbers separated by a slash.

## Catalog Settings

As mentioned in the prior section, the Catalog Settings dialog can be accessed by clicking the Go to Catalog Settings button in the General section of the Preferences dialog, or by choosing Edit > Catalog Settings in Windows or Lightroom > Catalog Settings on Macintosh.

The General page (**Figure 7.22**) of the Catalog Settings dialog contains only one real setting, as well as some general information:

**Figure 7.22** *The General section of the Catalog Settings dialog.*

- **Information.** The Information section contains specific information about the catalog, including the location, filename, dates of creation, backup, and optimization, as well as the current size of the catalog. Clicking the Show button opens the folder containing your catalog files.

- **Backup.** The Backup section contains a single menu allowing you to specify the frequency of backups for the catalog. As much as the reminders and the actual act of backing up your catalog can be annoying, it is important to ensure the safety of your valuable information. At the very least we recommend using the option to back up your catalog weekly.

The File Handing section (**Figure 7.23**) primarily relates to the handling of images upon import, particularly to the previews created for those images. Its options include:

Figure 7.23 *The File Handling section of the Catalog Settings dialog.*

- **Preview Cache.** The first two settings in the Preview Cache section relate to the size and quality of the previews generated for your images by Lightroom. The default size of 1440 pixels (on the long side) is adequate for most users, although you may want to opt for a larger setting if you are running your display at a particularly large resolution. The Preview Quality option has a direct impact on the size of the preview images generated and therefore the size of the overall image cache. We find the Medium setting to be a good balance between image quality and catalog size. The final menu in this section allows you to specify when the large 1:1 preview images should be discarded. We recommend the After 30 Days option, which ensures that the full-resolution previews are available for most images during the time you're most likely to access them while providing a path for older previews to be discarded to help reduce the size of your catalog.

- **Import Sequence Numbers.** The two settings in the Import Sequence Numbers section allow you to adjust the count for the number of import tasks that have been performed and the current sequence number for imported images. These numbers only come into play when you use the value as part of a template for filenaming, so they are not critical for most users.

The Metadata section (**Figure 7.24**) includes metadata-related settings you might expect to find in the Preferences dialog rather than the Catalog Settings dialog. These include:

**Figure 7.24** *The Metadata section of the Catalog Settings dialog.*

- **Metadata Editing.** The Editing section of the Metadata page includes only three check boxes (and one button). The first check box allows you to determine whether you want Lightroom to suggest keywords as you type based on recently entered keywords. This is generally helpful (and is selected by default), but some users find it mildly annoying and prefer to leave the option off. A button to the right of this check box allows you to clear all existing suggestion lists. The second check box allows you to determine whether Develop module settings should be written into the metadata for the source image file rather than only being stored within the Lightroom catalog, which helps ensure portability of the adjustments you've applied to your images. The final check box allows you to have changes written into the XMP "sidecar" file for RAW captures in addition to being stored within the Lightroom catalog. Selecting this may seem perfectly reasonable, but it will slow Lightroom down because every change you make will be saved to the XMP file. What we suggest and practice is after selecting, editing, and devolving images, you return to the Library module and choose Edit > Select All followed by Metadata > Save Metadata to Files.

- **EXIF.** The EXIF section includes a single check box that determines whether changes made to date and time metadata fields (such as the capture date) should be written to the metadata contained within the original image. We generally consider this a good thing, so that the date and time information contained within your source images will be accurate based on changes you've applied. But some photographers prefer that their original image file not be altered in any way, and thus prefer to deselect this option.

# Ready for Images

Getting your digital darkroom set up correctly from the start ensures that you're able to work more efficiently and with better results. Now that we've guided you through the process of selecting the appropriate equipment and setting up your digital darkroom, you're ready to start working with your images. In the next chapter we'll show you how to get all your digital photos into the computer so you can sort and edit them before moving on to optimizing those images.

# Working in the Digital Darkroom

Photography has changed dramatically over the years—from cumbersome wet plates to black and white roll film to convenient color, and now in the digital world a transformation seems to be happening faster than ever. Every now and then there are changes that deeply impact how photographers practice their craft. To state the apparent, digital cameras have made one of the most dramatic differences in the entire history of photography. The software world has also undergone significant change. Until most recently, Adobe Photoshop was the one and only cornerstone of the professional digital photographer's workflow. However, today Adobe Photoshop Lightroom has begun a significant shift in how photographers organize and process their images. In fact, all three of us view Lightroom as the primary digital-imaging application for photographers, with Photoshop playing an essential yet supporting role. In this chapter we'll explore the complete Lightroom workflow for photographers.

## Workflow Overview

Before delving into the details of working with your photography in Lightroom, you need to understand how Lightroom is designed and how that design affects your workflow. Lightroom is divided into individual task-based modules that relate to the key portions of a photographic workflow,

and the interface has been designed in a consistent way so that once you feel comfortable with one module, you'll be perfectly comfortable working in all the modules.

The primary module is the Library module, which is where you'll import, sort, organize, manage, and export your images. You can then move on to the Develop module, which you'll use to adjust (and perfect) the appearance of your images. Other modules include Slideshow, Print, and Web, which you can use for sharing and presenting your images.

**Figure 8.1** *Lightroom is organized into five modules that enable a logical workflow for managing, optimizing, and sharing your images.*

Each module is made up of four panels that remain relatively consistent regardless of which module you're currently working with (**Figure 8.1**). The top panel contains the module picker, which allows you to switch

between the individual modules. The bottom panel contains the Filmstrip, which provides a perpetual view of the currently available images as well as tools for filtering your images. The left panel contains the relatively broad settings, such as choosing which set of images you want to work with or which preset or template you want to use to adjust or share your images. The right panel contains the more detailed settings, such as specific controls for changing the appearance of an image or altering the layout for the output you're creating to share your images. The large center area of each module is dedicated to your image(s).

Generally speaking, you'll work through the modules from left to right on the module picker, starting with the Library module to organize your images, then the Develop module to optimize your images, and finally the Slideshow, Print, and Web modules to present and share your images. Within any given module you'll typically start with the left panel to set general criteria, and then use the controls on the right panel for fine-tuning.

# Download and Import

Lightroom is built on catalogs (we addressed settings for catalogs in the previous chapter), which are database files containing information about the images you're managing. So, it is necessary to import your images before you can work with those images in Lightroom.

**NOTE** Importing images does not place them into the image catalog; rather, the catalog keeps track of where your images are located on your hard drive.

## Using the Import Dialog

You can import images into Lightroom from your hard drive and your camera cards by using the Import command. To get started, make sure the card reader is attached and camera card is inserted or the hard drive is mounted, and then navigate to the Library module and click the Import button at the bottom of the left panel, or choose File > Import Photos (**Figure 8.2**). The Import dialog appears.

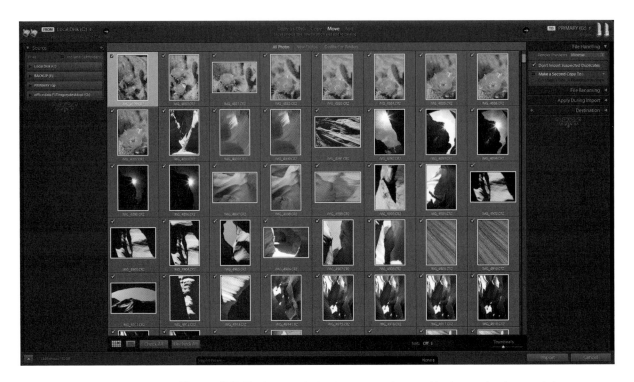

**Figure 8.2** *The Import dialog is command central for importing images into your Lightroom catalog.*

## Image sources

On the left panel of the Import dialog, select the source of images to import. If you're downloading and importing images from a digital media card, you would select the card reader, but you can also navigate to any other folder available on your computer that contains images you'd like to import. Note that you can select the Include Subfolders option on the Select a Source menu at the top left of the Import dialog if you'd like to import images in folders inside the currently selected folder. This is generally necessary when importing directly from your digital media cards, because many cameras create multiple folders for the images as they are captured.

After you've selected a source of images to be imported, thumbnails appear in the central area of the Import dialog. By default, all photos in the selected location will be selected for import, as indicated by the check mark at the top left of each thumbnail. Images that already exist in the Lightroom catalog

are dimmed out, which is a helpful reminder not to import the same images more than once. If there are specific images (such as bad exposures or blurry pictures of your feet) that you'd like to exclude from import, click to clear the check mark for those bloopers.

## Import options

At the top center of the Import dialog, choose the appropriate import option. When downloading from a camera digital media card, choose the Copy option. For photographers who prefer to use the Adobe DNG file format for efficient storage of their images, choose the Copy as DNG option. This is effectively the same as the Copy option except that the copies created will be in the Adobe DNG format rather than the original file format of the photos you're importing. Converting to DNG slows down the import process, so it is best done after you've applied basic image metadata and processing improvements using the Convert Photos to DNG controls (Library > Convert Photos to DNG). If the images you are importing are already stored where you want them, select the Add option. We don't recommend the Move option, which is really move and delete (cue scary music), because it can lead to a loss of images if you don't have the images backed up.

Above the thumbnail display you can choose All Photos to view all the images that will be imported. Choose New Photos to exclude images that have previously been imported into the current catalog, or choose Destination Folders to sort the images into sections based on their source folder (which is useful when you're importing a folder with multiple subfolders in it). Below the thumbnail display you'll find additional controls. The first set of buttons allows you to switch between grid (thumbnails) and preview (single image) display, which can also be accessed by pressing G for grid display or E for loupe/single image display. The Check All and Uncheck All buttons allow you to quickly select all or none of the images for import. You can also select the sort order and adjust the size of thumbnails with a slider.

## Import destination

At the top-right corner of the Import dialog you can select the destination for the images you're importing if you're using the Copy (or Move) option for the import operation. Click the menu to select a specific source. Choose Other Destination if you need to choose (or create) a folder that is not listed in the menu.

**NOTE** Lightroom 3 also manages video clips in addition to still images, so thumbnails of any video files contained in the source folder will be displayed during import, and any selected videos will be imported into the Lightroom catalog along with your still photos.

## File Handling

The right panel contains a variety of options related to the import of your photos. The File Handling section contains three settings. The first determines the size of the previews to be rendered during import. We use the Minimal option so that the import and related processing will be performed as quickly as possible. This does mean there will be a slight delay when zooming into a particular photo, but it also helps keep the Lightroom preview cache relatively small and can help improve overall performance. If you prefer to avoid the slight delay as Lightroom creates 1:1 previews, after importing, select Photos > Previews > Render 1:1 and either continue with other tasks or grab a beverage as Lightroom processes the previews.

Selecting the Don't Import Suspected Duplicates check box excludes images that are already contained within the catalog from the import operation, so duplicates will not exist in the catalog.

You can create a backup of your images during the import process by selecting the Make a Second Copy To check box and then clicking the menu to select a location for this additional copy. This can be a convenient method to create a backup copy of the images from your camera cards onto a separate external hard drive, helping to ensure you never lose an important image. Backing up on import is useful and recommended on a busy location or studio shoot, but the backed-up files are basic copies of the original files. These second copy files do not have the same previews or receive the same metadata treatment as described in the following pages. Therefore, we suggest using Lightroom's backup option as a convenient backup on busy shoots, but highly recommend backing up your image files and Lightroom catalog onto separate media with a scheduled backup using software such as CopyCarbonCloner or Retrospect Remote to back up and verify your files.

## File Renaming

The File Renaming section allows you to change the filenames of the imported images but is only available if you are moving or copying the images. When the Add option is selected, the File Renaming section will not be visible. If you want to rename your photos during import, select the Rename Files check box, and then choose an option from the Template menu. You can also choose Edit to bring up the Filename Template Editor dialog (**Figure 8.3**) where you can define a file naming structure. If you do define your own structure, you

should choose Save Current Settings as New Preset from the Preset menu so you can save those settings for future use. When you're finished defining your filename template, click the Done button.

**Figure 8.3** *The Filename Template Editor dialog allows you to structure a template to be used for renaming your images during import.*

## Apply During Import

The Apply During Import section allows you to apply Develop presets or Metadata presets (both discussed later in this chapter) to your images. This can be helpful if you want to apply a similar appearance (such as a black and white interpretation) to all the images being imported, or if you want to add specific metadata values (such as your copyright information) to all the images. In addition to these options, a Keywords field allows you to assign keywords to every image upon import.

## Destination

The Destination section provides an additional method for choosing the destination folder for the images being imported, which again does not apply to the Add option for importing. Use the folder tree display to navigate to and select the folder to which you'd like to copy your images. Note that the Into

**TIP** Be careful to only assign keywords during import that will apply equally to all the images you are importing. For example, if you are importing photos from a trip that took you through several European countries, you don't want to list all those countries in the Keywords field of the Import dialog because then every image will include keywords for multiple countries, even though each image was captured in a particular country. In this example, you could, however, include "Europe" as a keyword for all the images.

Subfolder check box allows you to select a master folder first and then enter text for the name of a new folder to be placed within that master folder. The imported images will then be stored in the subfolder rather than the master folder.

### Import Presets

At the bottom center of the Import dialog is an option to choose a preset or save the current settings as a preset via the Import Preset menu. This can be a helpful shortcut to configure your basic settings in the future. But you should try to keep the settings as "generic" as possible to minimize the number of changes you need to make during future imports. For example, when creating a preset, it's a good idea to select a top-level folder where you store all your photos (for example, a "Photos" folder on an external hard drive) and select the Into Subfolder option in the Destination section on the right panel. Then, for future imports, you can select your source, choose the desired preset, and enter a folder name and any keywords you'd like to use for the import.

It's worth noting that the Import dialog can be collapsed to a small size (by clicking the white triangle in the lower-left corner) that includes only the key settings you need to perform an import. This option is especially helpful if you use a preset to define the basic parameters for your import. To expand the Import dialog, click the small white triangle again.

Once you've established all your preferred settings, click the Import button to begin the process of importing and cataloging your images so you can work with them in Lightroom.

# Sorting and Organizing

One of the challenges of digital photography is that it removes many of the barriers that would limit the number of images a photographer would capture. For example, just the notion of "wasting film" or being limited to only 36 exposures per roll would motivate many photographers to be relatively judicious in their photography. As a result of larger and faster camera cards, photographers today tend to capture more images than they did when using film, which means they usually have a particularly large number of images to manage. Fortunately, Lightroom provides a variety of features that will help you manage even a large collection of images efficiently.

# Catalog, Folders, and Collections

The left panel of the Library module contains options primarily aimed at allowing you to select the group of images you want to work with at any given time in Lightroom (**Figure 8.4**).

## Catalog

The Catalog provides a few ways of filtering the entire set of images contained in the current catalog:

- **All Photographs.** The All Photographs option, as the name implies, displays all images contained in the current catalog. Note that to the right of this option and many of the other options you'll see a number indicating how many images are represented by the option.

- **Quick Collection.** The Quick Collection option relates to a special category of images that have been added to the Quick Collection. The Quick Collection is designed as a method of temporarily identifying images you're working on for a particular project or quick task, such as making an impromptu slide show to show clients the edit of a shoot. You can add images to the Quick Collection by clicking the circular icon at the top right of the thumbnail for any image, or by selecting an image and pressing B, or by right-clicking (Control-clicking) and choosing Add to Quick Collection. Clicking on the Quick Collection option in the Catalog section on the left panel displays only images that are included in the Quick Collection. Keep in mind that the Quick Collection simply represents a status for your images. Including an image in the Quick Collection will not in any way affect an image's inclusion in another collection.

- **Previous Import.** The Previous Import option allows you to quickly gain access to the images that were most recently imported into the current Lightroom catalog. Click this option and you'll be viewing only the images that were included in the most recent import operation.

## Folders

The Folders section on the left panel is relatively straightforward, especially for photographers who have already defined a folder structure for managing their collection of photographic images. In this section you'll see a "tree" view of all folders that contain images in the current catalog. Expand (or

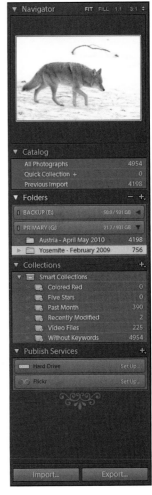

**Figure 8.4**  *The left panel of the Library module contains options for determining which images you'll be working with.*

collapse) the view as needed using the triangles to the left of folder names to navigate to the desired folder. Click on a folder name to display only the images contained within that folder.

## Organize with Folders

Regardless of which software you're using to help manage your digital photographs, it is essential to start with a baseline organizational system. That means organizing the images you store on your hard drives and other storage media in logical groups—each contained within folders.

The key here is to determine what structure makes the most sense for those folders. It is generally best to keep all of those folders in one place if at all possible, such as on a single (and large) external hard drive. However, as your library of images continues to grow you may need to divide your images among more than one hard drive. In that case, you'll also want to come up with a systematic approach for dividing images among different storage devices. This could be as simple as choosing a cutoff date for each storage device or separating the images into chronological or logical topics (for example, personal work versus commercial work).

It is also important to have a clear plan for the folder structure you'll use for organizing your images where they are stored. For most photographers, this is a relatively easy concept to put into practice, because they already think of their images as being divided into specific groups. For nature photographers, the folders might identify each of the trips they've taken to capture beautiful images in remarkable locations. For wedding and portrait photographers, this may be as simple as using the names of the people they were photographing. For commercial photographers, the images might be organized based on the client name and/or job number. Some photographers, including Katrin, organize their images by date, creating a folder for each year, within which they have folders for each shoot that are named year, month, and date_signifier (for example, the folder 20100615_Michigan contains all the photos that Katrin took on June 15, 2010 in Michigan).

Regardless of how you tend to think of your images, you'll maximize the efficiency of your image management workflow by starting with at least a basic organizational structure at the folder level. That folder structure will be reflected in Lightroom for the images you manage with Lightroom, and of course you can then use Lightroom to further organize your images in a variety of ways.

## Collections

Although the Catalog and (especially) Folders sections on the left panel provide adequate options for many photographers, the Collections section offers incredible flexibility for managing images based on virtually any criteria, including but not limited to camera settings, ranking and rating, keywords, and metadata.

A collection is a virtual folder that allows you to add images to a collection you define to group together images that share particular criteria. For example, if you are working on a project to publish your images, such as a calendar, you could create a collection for that project and then add the appropriate images to the collection. Those same images could also reside in a "Portfolio" or "Exhibition" collection—without doubling or tripling the number of physical copies on your hard drive. You can define a collection based on any criteria you like and include images in that catalog that are contained in a wide variety of folders.

To create a (standard versus smart) collection, click the plus button to the right of the Collections label on the left panel and choose Create Collection from the menu. Type a name for the new collection and click Create. You can then drag images into this collection, and they will be referenced there. It is important to keep in mind that when you add an image to a collection in this way, that image is neither copied nor moved into the collection. Rather, a reference to the original image is created, so you can filter your images based on their inclusion in a particular collection.

As mentioned, collections are virtual folders, and much like the folders on your hard drive they can contain subfolders. In the context of collections, this structure is referred to as a collection set. To create a set, click the plus button to the right of the Collections label and choose Create Collection Set from the menu. Type a name for this collection set in the Create Collection Set dialog, such as "Client Projects," and click Create. With a collection set created, when you create a new collection, you can add it to an existing collection set by choosing the desired option from the Set menu in the Create Collection dialog. Creating collection sets allows you to further organize your collections of images and reduce clutter in the Collections section by collapsing sets you aren't currently working with.

After you've created a collection, you can add images to that collection by dragging and dropping the images onto the collection. You can remove an image from the current collection by right-clicking (Control-clicking) and choosing Remove from Collection.

The types of collections you can choose from include:

- **Smart Collections.** Another great option is the ability to create Smart Collections. A Smart Collection is a collection that is populated with images automatically based on particular criteria. The criteria are based on metadata values available within the images. Click the plus button to the right of the Collections label and choose Create Smart Collection. You can then build the criteria that defines the Smart Collection. Select an option from the first menu (for example, Rating), and then choose how you want that criteria evaluated from the second menu. For example, if you're creating a Smart Collection based on the star rating, you could choose the "is greater than or equal to" option and then specify four stars as the value to the right of the second menu. If you'd like to include additional criteria, click the plus button to the right of the first criteria definition. Then configure the options and add additional criteria as needed. Once you've defined the values that will determine which images are included in this Smart Collection, click Create. All images that meet the criteria you specified will be included in this collection automatically, and if you change the attributes for an image so it no longer meets the criteria for the Smart Collection, that image will automatically be removed from the Smart Collection. Use Smart Collections to organize portfolios, client projects, or types of photography such as panoramic or HDR source images.

- **Module specific collection.** In Lightroom 3, collections can be accessed in all the modules and also be module specific. To create a module-specific collection, navigate to the desired module, for example, Slideshow; click the plus button to the right of the Collections label; choose Create Slideshow; and decide whether to include the selected photos or create new virtual copies (referenced versions of the original files). This is a fabulous refinement of the Collection feature and allows you quick and easy access to groups of images you want to print or present as a slide show or on the Web. In fact, Katrin keeps track of which images she wants to print with a dedicated Print collection.

# View Options

Just as Lightroom provides many options for managing your images, it also provides a variety of methods for viewing and evaluating your images.

## Panel display

In many cases it can be helpful to hide one or more of the panels to focus your attention either on other panels or on the image you're working with. To hide the left and right panels, press the Tab key. To hide all the panels (left, right, top, and bottom), press Shift-Tab (**Figure 8.5**). You can also hide individual panels by clicking the arrow at the outside center of a particular panel. To reveal the panel again, either hover your mouse over the "stub" for the panel to reveal it temporarily (when you move your mouse away from the panel, it will disappear again), or click the arrow again to bring the panel back permanently (or at least until you decide to hide it again).

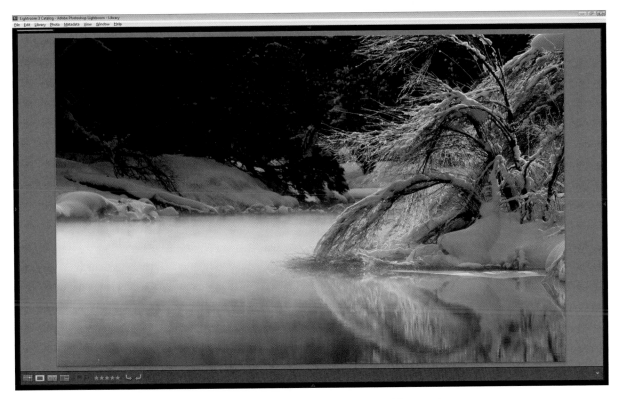

**Figure 8.5** *There are a variety of options for controlling the appearance of the panels in Lightroom, including the ability to completely hide all the panels.*

Of course, this behavior assumes you've left the panels set to the default option of Auto Hide & Show. You can also have panels hide automatically and only display again when you click on the stub for the panel by right-clicking (Control-clicking) on the outside edge of the panel and choosing Auto Hide. Or, if you'd prefer the panels to only hide or show when you actually click the arrow associated with a given panel, right-click (Control-click) and choose Manual.

You can also synchronize panels that are opposite each other (left and right or top and bottom). To do so, right-click (Control-click) on the desired panel and choose Sync with Opposite Panel.

## Navigator

**Figure 8.6** *The Navigator panel allows you to zoom and pan around the image to get a closer look at specific areas.*

The Navigator section on the left panel provides a preview of the current image or of a different image when you move your mouse over a thumbnail image, but it also allows you to zoom into and pan around the current image (**Figure 8.6**). To the right of the Navigator label are four options that adjust the zoom setting for the currently selected image. Fit resizes the image so it fits within the currently available space. Fill enlarges the image so it completely fills the available space, causing most images to be cropped at least slightly since the aspect ratio of the image may not match the aspect ratio of the display area. The 1:1 option enlarges the image so one pixel on your monitor represents one pixel in the actual image. The fourth option is a "higher" zoom setting. The default is a 3:1 zoom, so the image is displayed at 300% of the 1:1 size. However, there is also a menu that allows you to choose from a variety of zoom settings up to 11:1, which is reserved for very serious pixel peeping.

You can also pan around the image with the Navigator. A box overlaid on the preview image in the Navigator indicates which portion of the image is currently being displayed. If you click outside this box, the image will be panned to view the area you click. If you click and drag inside this box, you can move the box to a new location, and thus pan the image display. Clicking inside the box in the Fit or Fill display zooms the image to the maximum setting defined by the fourth option at the top right of the Navigator.

## Grid view

Grid view is often referred to as the thumbnail display, but we tend to think of it more as a light table for the digital age (**Figure 8.7**). You can access Grid view by clicking the leftmost button on the toolbar below the preview area in the Library module or by choosing View > Grid. In fact, the menu command as well as the keyboard shortcut (G) can be used regardless of which module you're currently working in. With either of these options you'll be immediately switched to the Library module in Grid view, looking at thumbnails of images based on the current settings in terms of the source of images and any filters you've applied.

**Figure 8.7** *Grid view allows you to view thumbnails of the images that are currently available to you in Lightroom.*

While in Grid view you can also use the Sort menu on the toolbar below the grid display to choose the order in which you want the images displayed, and then use the "a/z" button to toggle the sort order between ascending or descending order. To the extreme right of the toolbar is a Thumbnails slider, which allows you to adjust the size of the thumbnail display. This obviously represents a compromise between how many images are displayed at once and how easily you can evaluate the thumbnail images.

We use Grid view primarily for doing the initial sorting of our images and for applying keywords and other metadata values to multiple images at once, as we'll address later in this chapter.

## Loupe view

Loupe view allows you to view a single image and potentially to zoom in on that image for an even closer look (**Figure 8.8**). You can switch to Loupe view by clicking the second button on the toolbar when you're in the Library module. You can also switch to Loupe view in the Library module regardless of which module you're currently working in by choosing View > Loupe or pressing E (to recall the keyboard shortcut, just remember there's an "e" at the end of "loupe"). Also, as you may have realized from the discussion of the Navigator, if you choose a zoom setting while in Grid view, you'll automatically be switched to Loupe view for the current image at that magnification setting. When in Loupe view, clicking on the image will also toggle you between the current maximum zoom setting on the Navigator and the Fit or Fill option, depending on which you had been using most recently.

We use Loupe view whenever we are working on a single image in the Develop module (it is the default view there), when we need to evaluate sharpness or other fine details in the image, or when we need a closer look while assigning keywords or other metadata to the image.

**Figure 8.8** *The Loupe view allows you to view a single image for closer examination.*

## Compare view

No matter how decisive you are, there will be times when you have difficultly deciding on which in a series of images you want to use for a particular need. Whether you're comparing multiple photos of the same subject or several completely different images, the Compare view provides a great solution for evaluating images to identify the best of a group.

To get started, you'll first need to select the images you want to compare. From our perspective, the easiest way to do this is to select the images using the Filmstrip. Click on the first image you want to compare, press the Shift key, and click the last image in the series. If the images aren't contiguous on the Filmstrip, press Ctrl (Command) and click on individual images to toggle them as selected or deselected. Once you have the images selected, click the Compare View button (the third from the left) on the toolbar, or choose View > Compare, or press C (**Figure 8.9**).

**Figure 8.9** *Compare view allows you to compare multiple images to help make a decision about which image you want to work with.*

Although the concept of the Compare view is easy to understand, the mechanics of using it can be a bit confusing to get the hang of. The idea is that at any given time there is one image that is the current Select image. In other words, this is the image that at least for now is your favorite (even if only in theory). That image is being compared to a single Candidate image. If you decide the Candidate image is better, you can replace the Select image with the Candidate image (by clicking the Make Select button on the toolbar). If you're not entirely sure about that decision, you can swap the Select and Candidate images (by clicking the Swap button) while you continue to decide. If you determine the current Candidate image isn't as good as the

Select image, you can keep your current Select image and move on to the next Candidate image. To navigate among the Candidate images, click the left or right arrow to move to the previous or next image, as desired. Continuing in this manner, you'll eventually cycle through all your Candidate images (perhaps multiple times) and settle on a final Select image. When you've decided that the current Select image is the top pick, you can click the Done button on the toolbar and the current Select image will become the only selected image. That image will be displayed in Loupe view.

You can zoom in on your images by using the Zoom slider on the toolbar. With the lock option selected, both images will zoom and pan in concert with each other, so you can evaluate the same area of both images at the same zoom setting. You can click the lock icon to toggle the locked display on or off. If you have adjusted both images to different zoom settings or panned to different positions within each image, you can quickly set them both to match the current settings of the Select image by clicking the Sync button on the toolbar.

## Survey view

Another option for comparing multiple images is the Survey view. In this view you evaluate a group of images simultaneously, gradually removing images from the mix as you zero in on a single image. To get started, as with Compare view, you'll need to select several images. Then click the Survey View button on the toolbar, choose View > Survey, or press N to enter Survey View mode.

Once in Survey view (**Figure 8.10**) you'll see all the images you selected in the preview area. This is certainly a situation in which it is beneficial to hide the panels, so you may want to press Shift-Tab at this point. In fact, you may also want to take advantage of the Lights Out display by pressing L to dim back the interface, as discussed in the next section.

When you hover your mouse over an image, an X appears in the bottom-right corner of the image. Click the X to remove the image from the current selection. In this manner you can methodically narrow down your selection to a single image or a smaller group of images. Using Survey View mode is an excellent way to see which images work well with one another or which image is weaker than the rest.

**Figure 8.10** *Survey view makes it easy to narrow down a selection from multiple images to a single image.*

## Lights Out display

Although hiding the panels can be very helpful for focusing your attention on only the controls you really need at the moment or perhaps just a single image, there are still other interface elements that may distract you from the task at hand. When you really need to focus on the image and nothing else, the Lights Out display is your solution. Lights Out has two settings: the first is referred to as a "dimmed" display and the other is the true "lights out" option. Press the L key to toggle through the dimmed and lights out displays, and then to return to the normal display (**Figure 8.11**). In the dimmed

display the images remain in their normal display, but the remaining controls are dimmed by a percentage you can adjust in the Preferences dialog (discussed in Chapter 7, "Building a Digital Darkroom"). In the full lights out display everything other than the image (or images) is completely black, allowing you to view the images without any interface distractions.

**Figure 8.11** *The dim (top) and lights out (bottom) displays allow you to focus more attention on the image rather than the Lightroom interface.*

# Flags, Ratings, and Labels

The ability to apply flags, ratings, and labels to your images helps narrow down a large shoot or group of images to the very best images that you really want to work with. Each of these options is similar in terms of helping you categorize your images, but each is useful in a slightly different context. Any of these attributes can then be used for sorting or filtering your images, so it can be helpful to assign these attributes to images to make finding the right image later that much easier.

## Flags

Flags are designed to identify images as being selected, not selected, or rejected. You can choose these options by selecting Photo > Set Flag (or by right-clicking or Control-clicking and choosing Set Flag) and then selecting Flagged, Unflagged, or Rejected. However, it is much easier to use keyboard shortcuts to assign these flags. Select one or more images and press P to assign a "pick" flag, U to assign an "unflagged" or "unpick" flag, or X to flag the image as rejected. The flags are obviously most useful for identifying those images you want to work with (the picks) and those images you'll likely never work with (the rejected images). Flagging is a binary "yes" or "no" judgment that is often based on focus, exposure, and composition criteria. A white flag means the image is worth a second look, whereas a black flag signifies that the image does not meet the criteria and/or you never want anyone to see it. Assigning a black flag to an image does not delete or remove it from the Library or your hard drive; it simply dims it out. To easily remove all black flagged images, choose Photo > Delete Rejected Photos, and then choose Delete from Disk (the preferred option) to move the files into the trash; or click Remove to remove them from the image Library.

**Figure 8.12** *Ratings allow you to assign a relative quality value to your images, helping to sort and filter images later.*

## Ratings

Ratings are perhaps the most straightforward of the options for labeling your images (**Figure 8.12**). They represent a quality judgement, and in most cases photographers think of the five-star images as their most successful and the one-star images as their least successful. To assign a star rating, you can use the menu options by choosing Photo > Set Rating (or by right-clicking or Control-clicking on an image and choosing Set Rating), but again it is

easiest in most cases to use keyboard shortcuts. Use the numbers 1 through 5 to set that number of stars as the rating for the selected image or images, or press 0 (zero) to remove a star rating from the selected images.

## Color labels

Color labels (**Figure 8.13**) are a bit more arbitrary and thus open to interpretation by each photographer. The original intent of the color label metadata value was to assign a priority ranking for individual images. However, because of their arbitrary nature, you can use color labels for just about any purpose. For example, many photographers use color labels to identify images for particular projects or as being in a particular stage of their overall workflow. The available color labels are red, yellow, green, blue, and purple. To assign a color label from the menu choose Photo > Set Color Label, or right-click (Control-click) and choose Set Color Label. You can also press 6 for red, 7 for yellow, 8 or green, and 9 for blue. The purple and "none" options do not have shortcut keys associated with them.

**Figure 8.13** *Color labels are an additional (though somewhat arbitrary) method of organizing your images.*

As you can probably appreciate, a color label by itself doesn't necessarily have an inherent meaning. If you'd like to assign a particular meaning to the colors, you can change the names associated with each color label. While in the Library module, choose Metadata > Color Label Set > Edit to bring up the Edit Color Label Set dialog. Enter values for each color label, and then choose Save Current Settings as New Preset from the menu at the top of the dialog. Type a name for this set in the New Preset dialog and click Create. Then click Change in the Edit Color Label Set dialog to set the current preset as the definition for color labels you assign. For example, assigning a color to all your HDR or panoramic source images makes them very easy to identify.

**TIP** If you change the names for color labels in Lightroom and also use Adobe Bridge to browse your images, be sure to change the color label definitions in Bridge to match. Otherwise, the color labels will not be recognized in the opposite application.

# Keywords

Imagine being able to search your huge library of images and find exactly what you were looking for because you had applied meaningful text information to all your images. Unfortunately, reality tends to be different for many photographers. To begin with, applying keywords can involve a tremendous amount of time. Also, just because you've applied keywords doesn't mean you'll be able to find just the image you need when you need it. That requires a thoughtful approach to keywording that helps ensure you are specifying

keywords that are most useful for a particular image, and also that a later keyword search won't return an inordinately large number of images, defeating the whole purpose of assigning keywords in the first place.

What it comes down to is that keywording is a task that some photographers should pursue diligently, whereas other photographers shouldn't spend more time on keywording than the return is worth. If you work with stock photography or otherwise find you're frequently searching for a specific image, investing the time and effort to keyword your images makes sense. If you shoot less or tend to navigate to a particular folder to find the image you need, or your situation is such that you need to find an image that meets a variety of criteria and any image meeting that criteria will be fine, you may not want to invest too much time applying keywords.

If you do decide that keywording will prove beneficial for your particular workflow, it is also important to take the time to create a keywording strategy that will make the most sense for you. Think carefully about how you tend to search for images and what attributes you think about when attempting to find a particular image. For example, we think about the more obvious attributes for our images and often neglect qualities like the emotion evoked by an image. When someone asks you for an image, chances are they'll be thinking more about what the image represents than about the specific content of the image. Thinking of keywords in terms of place, person, subject, description, and attribute is helpful. Photos have to be of something or someone and taken somewhere!

## Applying keywords

Once you've spent some time determining how you want to approach keywording, you'll need to understand the mechanics of applying keywords. There are several ways you can do this in Lightroom, and all of them are accomplished in the Library module.

**Figure 8.14** *The Keywording section in the Library module's right panel allows you to enter and review keywords for the currently selected image(s).*

**Keywording section.** The first method of applying keywords is to enter keywords manually in the Keywording section in the Library module's right panel (**Figure 8.14**). If you want to assign the same keywords to multiple images, switch to Grid view and select multiple images (if you are in Loupe view, only the image currently displayed in the preview area will be updated). Make sure the Keyword Tags option is set to Enter Keywords, and then enter keywords separated by commas in the text field below. If you

choose the Keywords and Containing Keywords option, keywords will be displayed but not edited (and the list will include hierarchical keywords). If you choose Will Export, you'll only see the keywords that have actually been assigned to the current image, which does not include the "automatic" hierarchical keywords.

If you want to work with hierarchical keywords, which means having keywords that are contained within a hierarchical structure, you can separate keywords with the > symbol. Type the parent category keyword first, then the > symbol, followed by the subcategory keyword. For example, a bear is an animal, so you could enter "animal > bear" to create keywords for the category animal and subcategory bear.

**Keyword Suggestions.** Besides entering keywords manually, you can also assign keywords using shortcut buttons in the Keywording section on the right panel. In the Keyword Suggestions subsection (**Figure 8.15**) you'll see suggestions for keywords based on recently added keywords. If you'd like to add one of these keywords to a currently selected image (or images), click the button for that keyword. Any keywords you click will be added to the keyword list for the currently selected images.

**Figure 8.15** *The Keyword Suggestions controls allow you to click a suggested keyword to apply it to the currently selected images.*

**Keyword List.** You can also apply keywords by dragging and dropping a keyword from the Keyword List onto your images. You can drag a keyword to an individual image to add that keyword to the image or select multiple images and drag a keyword to one of the selected images; the keyword will be added to all selected images. You can even add multiple keywords to one or more images at once by first selecting multiple keywords on the Keyword List and then dragging the group of selected keywords to an image.

**Keyword sets.** In addition, you can utilize keyword sets to assign keywords to your images. These are similar to the Keyword Suggestions except that you can modify this list as you deem appropriate. There are a few sets of Keyword Suggestions (outdoor, wedding, and portrait) included with Lightroom, which you can select from the menu in the Keyword Set subsection. By choosing Edit Set from this menu, you can also define your own custom set of keywords (**Figure 8.16**). Enter keywords in each of the available fields (you can leave some blank if you'd like), and then choose Save Current Settings as New Preset from the menu in the Edit Keyword Set dialog. Type a meaningful name for this new set of keywords, and click the Create button. Then click Change in the Edit Keyword Set dialog, and the new set will be

available. You can then choose that set (or any other available set) from the menu in the Keyword Set subsection.

**Figure 8.16** *You can customize keyword sets for quick access to commonly used and relevant keywords.*

**Keyword List section.** The Keyword List section on the right panel provides yet another way to apply keywords to your images. This list represents all the keywords that have been added to any image in the current Lightroom catalog. To add a keyword from this list to the currently selected images, click to the left of the keyword to add a check mark. If you want to remove any keywords from the currently selected images just click the check mark to remove it. Using this list helps to ensure that you are using the same spelling and formatting for the keywords you add to your images. You can also add new keywords to the Keyword List by clicking the plus button at the top left of the Keyword List subsection. Type a new keyword in the Create Keyword Tag dialog, adjust the other settings as desired, and click the Create button. Note that you can select the "Add to selected photos" check box to add the new keyword tag to the currently selected images.

**Painter tool.** An additional option for assigning keywords (or a variety of other metadata values) to your images is the Painter tool, which is available in the Library module's Grid view (**Figure 8.17**). To enable this tool, first switch to Grid view in the Library module, and then click the spray paint can icon in the toolbar below the grid display. From the Paint menu choose the attribute (in this case Keywords) and type a keyword in the field to the right of the menu. Then click on images to add the keywords you entered to those images, or drag across multiple images to apply the keywords to multiple images. When you're finished, either click on the circle where the spray paint can icon had been located, or click the Done button on the toolbar. To remove a keyword with the Painter tool, press Alt (Option) to remove an applied keyword. The Painter tool can be used to apply a variety of metadata attributes including labels, flags, ratings, metadata, settings, rotation, and setting a Target Collection (a collection you want to add an image to) to your images.

**Figure 8.17** *The Painter tool can be used to quickly apply keywords (or other metadata) to your images.*

# Metadata

At the bottom of the right panel in the Library module you'll find the Metadata section. This section allows you to view and modify (for editable fields) the information about your images that is stored within those images (**Figure 8.18**).

To the left of the Metadata label is a menu that allows you to choose which fields you'd like to view. The Default option includes the most commonly used metadata fields, but for more options you'll probably want to choose the EXIF and IPTC option.

Regardless of the set of metadata fields you've chosen to display, some will be read-only and others can be modified. To change a particular value, click on the field and enter a new value. For many of the fields, you can also click a right-pointing arrow to the right of the field to take a particular action. For example, if you click this button for the Website field, the Web site address entered in this metadata field will be opened automatically in your default Web browser.

You can also assign metadata presets using the menu at the top of the Metadata section. If you've not yet defined a preset, click the Preset menu and choose Edit Presets. In the Edit Metadata Presets dialog enter the values desired for any available fields, and then choose Save Current Settings as New Preset from the Preset menu at the top of the dialog. Enter a new descriptive name for the preset and click Create. Click Done in the Edit Metadata Presets dialog, and the new preset will then be available from the Preset menu at the top of the Metadata section on the right panel. Choose the desired preset after selecting one or more images, and the values you defined will be added to the metadata for the selected images.

It is important to keep in mind that metadata is not automatically written out to the original image files (or sidecar files for RAW captures), but rather is stored within the Lightroom database. If you'll be browsing images or metadata with applications other than Lightroom, it is important that you write that information out to the original file. To do so, choose Metadata >

**Figure 8.18** *The Metadata section allows you to view and (in most cases) update the metadata values associated with the current image.*

Save Metadata to File from the menu, or more easily press Ctrl-A to select all images followed by Ctrl-S (Command-A/Command-S). In fact, using these shortcut keys to write the metadata changes to your files before quitting Lightroom at the end of the day is a good habit to develop.

# Filtering

A large part of assigning keywords and metadata to your images is the benefit of quickly and easily being able to find specific images based on those values. Lightroom provides a variety of methods for filtering images based on virtually any metadata value, making it relatively easy to find a particular image.

The first step is to narrow down the currently available images to the smallest set that contains the image you're looking for. In some cases that might mean choosing All Photographs in the Catalog section on the left panel. However, whenever possible, you should start by selecting the folder or collection that contains as few images as possible but also contains the image you're looking for.

### Using the Filter options on the Filmstrip

Once you've selected the appropriate folder or collection, the fastest way to filter those images is to use the Filter options on the Filmstrip panel (**Figure 8.19**). To put these options to use, you'll first need to turn on the filter by clicking the switch button located at the top right of the Filmstrip. Next, select the criteria you'd like to use to filter the images. You can choose (or create) a preset from the menu to the left of the switch, or select specific settings for the flag, rating, and color label for the images to the left of the menu.

**Figure 8.19** *The controls at the top-right of the Filmstrip provide quick access to filtering options for your images.*

### Using the Filter Bar

If the settings available for filtering on the Filmstrip aren't adequate, the next step is to use the Filter Bar at the top of the Library module. If the Filter Bar isn't currently visible, choose View > Filter Bar, or press the \ key to toggle its display (**Figure 8.20**).

**Figure 8.20** *The Filter Bar provides a variety of methods for filtering your images to find just the photo you're looking for.*

The Filter Bar includes four basic options:

- **Text.** The Text option is the broadest, allowing you to search for any text in any available field for any image. When you stop and think about the wealth of information contained within each image, you can appreciate just how powerful this simple search feature can be. For example, you can search for text that appears in the filename, the folder name containing an image, keywords that have been added to the image, details about the exposure (such as shutter speed, the lens used, or the camera model), or any other field contained in metadata. Think of the Text option as having a catch-all search capability that can often be quicker than other options (for example, it is faster to type 500 than it is to choose the 500mm lens from the Lens category in the Metadata filter option).

  The first pop-up menu allows you to designate which fields you'd like to search in, and the second pop-up menu allows you to determine how the value you enter will be evaluated for the selected fields. You can then enter any text in the search box and press Enter (Return) to search for that value. The text you enter can be searched across any value entered (or automatically added) to any metadata field, including keywords, EXIF metadata added by your camera, or any other image attribute.

- **Attribute.** The Attribute option provides search criteria similar to those found on the Filmstrip. This includes the flag, rating, and color label fields, but also allows you to filter based on the file type. The available options are master photos (your original images), virtual copies (copies of the original created so you can apply different interpretations to the image), or videos (video clips you are managing in Lightroom along with your still images). Click on the desired attribute and your images will be filtered accordingly.

- **Metadata.** The Metadata option is certainly the most flexible and powerful option on the Filter Bar. The basic idea is that you can identify a column representing a particular attribute for your images, and then choose from the available options within that attribute. By adding multiple columns, you can narrow down the images matching your criteria to a manageable number.

  To set the metadata value associated with a particular column (you should work from left to right, however), click the header for that column and choose the desired field from the menu. Next, click the desired value within that column to filter the images to only those that include that value. Then set the field and value for the next column. If you want to remove a column, click the menu button at the top right of the column and choose Remove this Column from the menu. If you need to add an additional column, click the menu button and choose Add Column from the menu. The columns are additive, so you should start from the left and work your way right to apply additional filters to narrow down the images that match the criteria you've defined. Do this until you have filtered down to a manageable number that enables you to locate the specific image you're looking for.

- **None.** The None option does not apply a filter, so you'll use this option to clear the filtering you've applied with the other options.

# Quick Develop

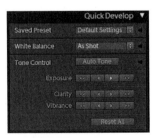

**Figure 8.21** *The Quick Develop section in the Library module's right panel allows you to apply quick (and relative) adjustments to one or more images.*

The Quick Develop panel contains the fundamental adjustment controls to improve image exposure, contrast, and presence. Quick Develop is often dismissed as being only a subset of the controls found in the Develop module. And to add insult to injury, it doesn't have the fine control that is available in the Develop module. However, there is an important reason you'll want to utilize the Quick Develop controls: These controls allow you to apply relative rather than absolute adjustments. That isn't really meaningful when working on a single image, but it does mean you can apply the same relative adjustment to multiple images at once. For example, if you applied an Exposure adjustment to multiple images in the Develop module, all the images would be adjusted to the same Exposure setting, which likely would not produce a good result for all the selected images. In the Quick Develop section (**Figure 8.21**), when you apply an adjustment, you're increasing or

decreasing in increments for all the images to the same degree. For example, you would be increasing Exposure by a set amount for all the selected images, with each being adjusted relative to the existing settings for that image. So, you could use Quick Develop to easily open up an exposure on an image to see if the image deserves a star ranking or if it's a keeper or not.

At the top of the Quick Develop section you'll find preset options that allow you to apply presets for develop settings, crop ratios, and treatment (color versus black & white) for the images. Note that to see all the controls in this subsection (or the other subsections in Quick Develop), you'll need to click the triangle to the right of the heading of the subsection to expand and collapse the subsection.

The additional controls are a subset of those found in the Develop module. The difference is that instead of using sliders to change a value, you use left and right arrow buttons. The left and right arrow buttons decrease or increase the value of the adjustment. The double-left and double-right arrows decrease and increase by a more significant amount. Obviously, the Quick Develop controls are primarily useful for adjusting multiple images to the same degree, but they are also handy as a quick way to apply basic adjustments to your images to allow you to stay in the Library module as you rank and rate your images. For details on what each control actually does, refer to the details in the sections that follow.

# Processing Your Images

The Develop module includes a wide variety of controls that allow you to correct problems and perfect the aesthetics of your images. The various controls for adjusting your images are found on the right panel in the Develop module. We recommend making the overall image look its very best before applying selective specific adjustments. The only exception to that advice is improving the image with the desired crop before dedicating a lot of time adjusting the image.

# Basic Adjustments

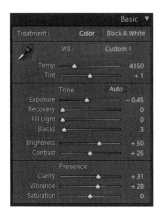

**Figure 8.22** *The Basic section on the right panel in the Develop module contains controls for the basic image adjustments.*

The Basic section (**Figure 8.22**) on the right panel in the Develop module contains the fundamental tone, contrast, and presence adjustments, and is where you should start all your image processing. The available adjustments are as follows:

- **Treatment**. This adjustment determines whether the image will be represented in color or black and white. Besides the obvious change to the image, this also changes the controls that will be presented in the HSL/Color/B&W section. You can think of this control as a shortcut to switching between the HSL or Color option (for a color image) and the B&W option (for a black and white image). We'll address all of these adjustments later in this chapter.

- **White Balance Selector tool.** The White Balance Selector tool is the eyedropper to the left of the White Balance controls. It provides an automated tool for establishing a white balance correction. Click this tool and then click on an area of the image that should be neutral gray. The Temp and Tint sliders will be adjusted automatically so that the area you clicked on will be neutral. You can refine the Temp (blue to yellow) and Tint (green to magenta) sliders to fine-tune the color balance. In all honesty, neutral is often overrated. Many images are more appealing and successful due to intentional warmth or cooling that shooting in candlelight, at sunset, or on a cold winter's day imparts to an image.

  When using the White Balance Selector tool, resist clicking all over the image. Rather, drag the eyedropper onto a neutral area and watch the Navigator panel. It will show what the image will look like if you clicked on a certain area, even before you click.

- **WB (White Balance).** The options on the WB menu are (for RAW captures) primarily related to the White Balance settings you could otherwise choose from on your camera. This can provide a good starting point for fine-tuning the color in your images. The As Shot option sets the Temp and Tint sliders based on the White Balance setting that was used in the initial capture. The Auto option causes Lightroom to evaluate the image and attempt to apply an automatic adjustment. Custom returns the Temp and Tint sliders to the values you most recently established by adjusting the sliders, or the As Shot settings if you haven't yet applied any adjustment.

- **Temp.** The Temp slider adjusts the color temperature compensation of the image. This shifts the overall color balance of the image between blue and yellow, allowing you to cool or warm the overall appearance of the image, respectively. Think of the Temp slider as being corrective (attempting to establish an accurate color appearance) as well as creative (allowing you to apply a cool or warm interpretation to the image). As a photographer you already know you make an effort to photograph during the "golden hour" of early morning and late afternoon to achieve beautiful color. Although shifting the Temp slider won't make up for missing the optimal time, it can still greatly improve an image. Whether you're warming up a scene that was captured in cool shady light or pushing an already warm scene just a little more to enrich the colors, the Temp slider can help you achieve significant improvements and interpretations.

- **Tint.** The Tint slider provides a shift between green and magenta, and as such is relatively corrective (rather than creative) in nature. That also means any adjustment you apply to the Tint slider will generally be relatively modest. Start with Temp to get the color looking its best, and then fine-tune with Tint, mostly paying attention to any indications of a slightly green or magenta cast in the image, both of which are generally undesirable.

- **Auto.** The Auto button in the Tone section causes Lightroom to apply an automatic tonal adjustment to the image, which can affect all the adjustments available in the Tone section (Exposure, Recovery, Fill Light, Blacks, Brightness, and Contrast).

- **Exposure.** The Exposure slider controls the overall luminosity of the image, but it should be thought of as a white point adjustment. In other words, it allows you to specify how bright the brightest pixels in the image should appear. In most cases it is beneficial to press Alt (Option) while adjusting the Exposure to see a clipping preview. Generally speaking, you'll want to adjust the Exposure value to a point just before pixels begin to appear in the clipping preview display to maximize the tonal range of the image. This will also help ensure that the light areas of the image are adequately bright. Granted, this isn't necessary for all images, but we think it is fair to say that most images will benefit from setting an accurate highlight value, which Exposure enables.

- **Recovery.** The Recovery slider restores detail (within reason!) that has been lost due to an excessively bright exposure. Naturally, there are limits to what it is able to accomplish. In cases where the image still contains some detail but that detail is not clearly visible because the highlights are too bright, increasing the Recovery value can help retain visible detail in those bright areas. To us, the most common use of Recovery is not so much for recovering lost detail as much as helping to ensure that the detail already present in some of the brightest highlights is actually visible. In some cases, highlight detail can have very subtle tonal variations, such as in bright white clouds or wedding dresses, and Recovery helps to differentiate these subtle highlight variations.

- **Fill Light.** The Fill Light adjustment is very similar to the concept of fill flash, helping to reveal detail in the darkest shadow areas of the image. Increase this value to expose more detail in the dark shadows. Think of it this way: If you wish you had used fill flash or even a fill card in the original capture, the Fill Light adjustment can help achieve a similar result. It won't be exactly the same as if you had used fill flash, but it can help considerably to make subtle shadow details more visible. Use the adjustment with caution: Overzealous use of Fill Light may reveal digital noise and make the shadow values look muddy gray.

- **Blacks.** The Blacks slider allows you to set the black point for the image. Moving the slider to the right causes more of the shadows to be interpreted as black, whereas moving the slider to the left tends to open up the shadows. Pressing the Alt (Option) key enables the clipping preview so you can evaluate which areas of the image will experience clipped shadow values based on the current setting. Although it is best to avoid clipping any highlight detail, sometimes clipping shadow detail can improve the image (think of a silhouette, for example). Increasing the Blacks value can also provide some density to the image, which not only helps avoid a washed out appearance, but also improves the perceived saturation of colors.

- **Brightness.** The Brightness slider affects the midtone brightness of the image. Move the slider to the left to darken and to the right to brighten the overall image. This is a very simple control, but it can have a significant impact on the image. Adjusting Brightness applies an adjustment that will not adversely affect the Exposure and Blacks adjustments, so you are able to brighten and darken midtone values in the image without affecting contrast.

**NOTE** Lightroom Brightness and Contrast should not to be confused with the destructive Brightness slider in pre CS4 versions of Photoshop. They may share the same names, but that is where any similarity ends.

- **Contrast.** The Contrast slider allows you to increase or decrease the overall contrast of the image. Moving the slider to the right steepens an internal S-curve and moving it to the left flattens out the curve.

- **Clarity.** The Clarity control is a haze reducer for the image. It is very similar to sharpening but affects broader midtone areas of the image rather than fine details. This can be tremendously helpful for reducing the appearance of haze in an image or to simply enhance textures that are important to the final image. You can also apply something of a blur effect (which can be particularly nice for portraits) by setting a negative Clarity value.

- **Vibrance.** The Vibrance adjustment allows you to adjust the saturation of colors within the image. However, it operates with much more sophistication than a simple saturation adjustment. When you increase Vibrance, the colors that have relatively low saturation are boosted more than the colors with relatively high saturation. When you reduce Vibrance, the colors with relatively high saturation are reduced before those with relatively low saturation. In both cases the result is generally a much more pleasing adjustment to the image. We find ourselves singing the praises of Vibrance just about every time we use it on an image, but we also try to use it reasonably and avoid values above 30.

- **Saturation.** The Saturation adjustment increases or decreases the intensity of colors in a relatively uniform way regardless of the relative saturation of the existing colors. In most cases the Vibrance adjustment is more appropriate, but the Saturation slider can provide a bit of a boost in either direction when you're not getting quite the intended effect with Vibrance. Be careful not to push Saturation too high; as you increase image saturation you can lose image details.

> **TIP** There are so many tonal adjustment sliders—so where should you start? The three most important image controls in the Basic section are Exposure, Blacks, and Brightness, and they should be applied in that order. Set the white point with Exposure, set the black point with the Black slider, and adjust the midtones with Brightness.

## Tone Curve

The Tone Curve section (**Figure 8.23**) on the right panel in the Develop module allows you to apply tonal adjustments to general tonal areas. Instead of affecting brightness of the overall image, you are able to brighten or darken based on tonal values. For example, you can darken the dark tones while brightening the lighter tones to increase contrast without causing a loss of detail in the extreme dark or highlight areas.

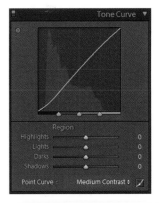

**Figure 8.23** *The Tone Curve controls allow you to refine the tonality for specific tonal ranges within the image.*

 **TIP** When evaluating overall adjustments, toggling between before and after views of your image can be incredibly helpful. While working in the Develop module, press the Backslash key (\) to toggle between a view of the image without any adjustments and the image with all adjustments applied.

**NOTE** All of the sections on the right panel in the Develop module with the exception of the Basic section include a "switch" control at the top left of the section that allows you to disable the effect of all controls in each section.

The tonal ranges you are able to adjust individually include Highlights (the brightest areas), Lights (the relatively bright but not brightest values), Darks (the relatively dark but not darkest values), and Shadows (the darkest values).

Each of these regions can be adjusted by moving the actual tone curve up or down, by adjusting the four parametric sliders below the curve display, and by using the TAT (Targeted Adjustment tool, addressed in the following section).

Directly beneath the Tone Curve are three sliders that divide the curve into four regions. Move these sliders left or right to refine the distribution of tonal values for the shadow, midtone, and highlight regions. For example, if you want to darken only the absolute darkest areas of the image, you can shift the leftmost slider to the left to reduce the tonal range affected by the Shadows slider, and then apply the desired adjustment with the Shadows slider.

Another option for using the Tone Curve adjustment is to work directly on the image. Click the "target" icon at the top left of the Tone Curve section to enable this adjustment option. You can then click on an area of the image representing a tonal value you want to adjust, and drag upward to brighten or downward to darken that tonal range.

In addition, you can establish a basic adjustment by choosing an option from the Point Curve menu. The Linear option applies no tonal adjustment to the image, Medium Contrast applies a slight increase in contrast, and Strong Contrast applies a relatively significant contrast increase to the image. All of these modifications can be adjusted and refined at will.

## HSL / Color / B&W

The HSL / Color / B&W section allows you to apply fine-tuned adjustments to the color in your images, including the ability to produce a black and white interpretation of the image. To get started, click on the HSL (hue, saturation, luminance), Color, or B&W (black and white) text label at the top of the section to determine how you want to adjust the image.

The HSL option (**Figure 8.24**) allows you to adjust the individual hue, saturation, and luminosity for each of the color ranges for the image. This provides a tremendous degree of control over the overall color of the image, although it does mean there are a total of 24 sliders to work with (8 color ranges for each of the three color attributes).

The Color option (**Figure 8.25**) actually provides you with the same controls as the HSL option but organized in a different way. Rather than seeing all the Hue sliders together, all the Saturation sliders together, and all the Lightness sliders together, you'll see the Hue, Saturation, and Lightness sliders for each color range individually. The default display includes color swatches you can click on to specify which color range you're currently working on. You can also click All to enable all the color controls, which again are divided based on the color range you're affecting.

If you click on the B&W option (**Figure 8.26**), the image will be converted to a black and white appearance. In this mode the Color sliders allow you to adjust the relative luminosity of each of the color ranges to produce a customized interpretation of the color image in a black and white version. For example, darkening blues will darken skies or lightening greens will cause grasses and trees to glow. Avoid extreme use of the Luminance sliders, because aggressive lighting and darkening can create undesirable (read ugly) halos where color and tonal values jut up against one another.

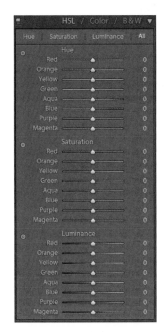

**Figure 8.24** *The HSL option provides individual controls for hue, saturation, and luminosity that can be applied to each color range within the image.*

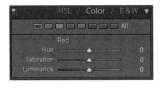

**Figure 8.25** *The Color option provides the same controls as the HSL option but with a slightly different organization.*

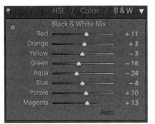

**Figure 8.26** *The B&W adjustment allows you to adjust the individual luminosities for each range of color values within the image.*

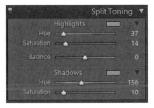

**Figure 8.27** *The Split Toning controls allow you to apply one color to the highlights and another color to the shadows in your image.*

# Split Toning

The Split Toning controls allow you to apply a separate color effect to the highlights and shadows, producing an image that can be thought of as black and white with a separate color tint for the highlights versus shadows.

There are individual Hue and Saturation sliders for the Highlights and Shadows (**Figure 8.27**). To see an effect, you need to increase the Saturation

for one or both of these values. Then adjust the Hue slider to determine the color to be applied to the highlights and shadows. The Balance slider then determines the tonal value at which the two colors will be divided. In other words, do you want the highlight color to apply to more tonal values or the shadow color to apply to more tonal values?

You can also adjust the color for either Highlights or Shadows by clicking the color swatch contained within each section and then choosing the desired color from the menu. Working in opposites creates the most effective changes: Try warming the highlights and cooling the shadows to create a subtle color depth.

# Detail

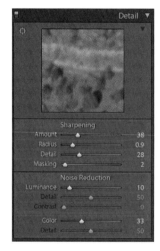

**Figure 8.28** *The Detail section on the right panel provides controls for sharpening and noise reduction.*

The Detail section (**Figure 8.28**) allows you to apply sharpening and noise reduction to the current image.

The sharpening controls available in Lightroom are designed as input sharpening, which means they are intended to compensate for the softness that can occur in the original capture due to such factors as the conversion from analog light to digital values, the anti-aliasing filter on most image sensors, and lens softness. This is very different from sharpening you might apply for creative or output purposes. Therefore, you should be very judicious with the sharpening you apply at this stage of your image-optimization workflow.

The Sharpening controls include the following:

- **Amount.** The Amount slider controls the intensity of the sharpening effect. Move it to the right to increase the amount of sharpening and to the left to reduce the amount of sharpening.

- **Radius.** The Radius setting determines how far outward from the contrast edges the sharpening effect will be visible. In other words, this determines the size of the contrast halos that will be added to enhance perceived sharpness.

- **Detail.** The Detail slider determines the degree to which fine details will be enhanced by sharpening contrast. Move the slider to the right to extract fine detail from the image and to the left to suppress sharpening except in areas of the finest detail.

- **Masking.** The Masking slider allows you to specify how much contrast must exist before a sharpening effect is applied. Moving the slider to the left causes virtually all areas of contrast, no matter how minor, to be enhanced by the sharpening effect. Moving the slider to the right causes only the areas of relatively high contrast to be enhanced. The mask should be white on the edges of detail and black or very dark on smooth surfaces. For example, a person's skin should not be sharpened, but the eyelashes and eyebrows should be. Therefore, the mask would be dark to black on the skin and light to white on the details of the face.

For all the sharpening controls, press Alt (Option) while adjusting the slider to view a grayscale preview of the effect of the adjustment. This is especially useful when using the Masking slider to see the mask that is controlling where the sharpening is being applied.

For Noise Reduction, the following adjustments are available:

- **Luminance.** The Luminance adjustment applies a reduction of textural noise, which is exhibited by variations in tonality at the pixel level. At a value of "0" no noise reduction is applied, and increasing this value increases the amount of luminance noise reduction applied.

- **Detail.** Whenever you increase the Luminance setting to apply noise reduction, the details will be softened. The Detail slider assists in recovering this detail with subtle sharpening, hopefully without allowing the noise to return. Increase this value as needed to compensate for the loss of detail caused by your Luminance adjustment.

- **Contrast.** The Contrast slider allows you to increase contrast to compensate for the loss of contrast that can occur from the softening attributes of applying noise reduction.

- **Color.** The Color slider is similar to the Luminance slider in that it allows you to reduce the appearance of the color speckle noise in the image. The difference is that the Color slider compensates for noise exhibited as color variations between pixels. A higher value applies a stronger noise reduction adjustment but will also tend to reduce overall saturation of colors within the image.

- **Detail.** The Detail slider associated with the Color slider is similar to the control by the same name associated with the Luminance slider. The only difference is that this slider operates to enhance color detail lost by the application of color noise reduction.

Applying noise reduction is always an exercise of controlling softening details to remove the noise and maintaining details by not over softening. The noise reduction in Lightroom 3 is much improved over earlier versions and is a professional-level tool.

# Lens Corrections

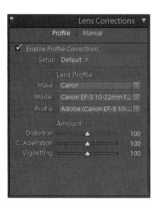

**Figure 8.29** *The Lens Corrections adjustments allow you to compensate for image issues caused by the lens during capture.*

The Lens Corrections section (**Figure 8.29**) on the right panel in the Develop module allows you to apply automatic and manual corrections for inaccuracies and distortions caused by your particular lens and camera combination. The fact that these adjustments are applied to the RAW captures versus the rendered pixel files is a huge step forward in RAW processing, and we highly recommend applying lens corrections at the time of RAW conversion.

If you choose the Profile mode, you can enable automatic adjustments for the image. To apply those adjustments, you need to select the Enable Profile Corrections check box. You can then choose the appropriate equipment options from the Make, Model, and Profile menus. These profiles include the information necessary to automatically compensate for the behavior of a specific lens and image sensor combination, which is at the heart of the power of Lens Corrections feature. If the specific camera and lens options you've used for a particular capture aren't available, you can either choose a similar make, model, and profile or use the Adobe Lens Profiler to create your own custom profiles. You can get more information online at http://labs.adobe.com/technologies/lensprofile_creator/.

After applying the appropriate equipment options to establish the baseline lens correction for the image, you can fine-tune the additional options. The Distortion slider allows you to compensate for pincushion or barrel distortion, pushing the corners inward or outward to correct for this distortion. The C. Aberration slider allows you to adjust for chromatic aberration, removing color fringing from high-contrast areas of the image. The Vignetting slider allows you to darken or lighten the corners of the image to introduce vignetting or compensate for vignetting caused by the lens.

If you switch to Manual mode, you'll need to adjust the various settings yourself, but you also have access to a wider range of controls. The Manual controls are divided into several sections, the first being Transform. The controls in this section display a grid over the image when adjusting them to assist with alignment. They include the following:

- **Distortion.** The Distortion slider allows you to correct for pincushion or barrel distortion. Moving the slider to the right pinches the image inward, and moving it to the left bulges the image outward.

- **Vertical.** The Vertical slider corrects for perspective distortion, which occurs when you need to tilt the camera upward to view a subject (such as a building) that is too tall and too close to include in the frame without doing so. Moving the slider to the left tilts the image away from you, and moving the slider to the right tilts the image toward you.

- **Horizontal.** The Horizontal slider produces an effect much like the Vertical slider except that the image is tilted in a horizontal plane rather than vertical. This helps to correct for situations where the subject was not photographed directly head-on. Moving the slider to the left tilts the left side of the image forward, and moving the slider to the right tilts the right side of the image forward.

- **Rotate.** The Rotate slider, of course, rotates the image around its center. Moving the slider to the right rotates the image clockwise, and moving it to the left rotates the image counterclockwise. This allows you to correct for issues such as a horizon line that isn't perfectly horizontal.

- **Scale.** Scale allows you to adjust the relative size of the image and can be thought of primarily as a cropping tool. As you manipulate the various other Transform controls, the outer edges of the image may move inward or outward in various areas relative to the original image canvas size. This can cause pixels to move outside the canvas area, in which case you would want to reduce the Scale value to bring those pixels back into the canvas area. Or the adjustments might cause pixels to move inward, leaving empty areas in their place; in this case, you would want to increase Scale to compensate.

The Lens Vignetting section (only available when working in Manual mode), which as the name suggests, allows you to compensate for darkening of the edges of the frame caused by light falloff with certain lenses (particularly wide-angle lenses). It also allows you to apply a darkening effect if desired for aesthetic reasons. The controls for Lens Vignetting include:

- **Amount.** Moving the Amount slider to the left darkens the edges of the image, and moving it to the right lightens the edges.

- **Midpoint.** The Midpoint slider allows you to apply the effect toward the center of the image (by moving it to the left) or away from the center (by moving it to the right).

The final set of controls for Lens Correction (also only in Manual mode) is Chromatic Aberration, which allows you to compensate for color fringing caused by a lens that doesn't focus light of all color values on the same plane. The controls include:

- **Red/Cyan.** This slider compensates for red and cyan fringing. Move it to the left or right to apply a correction, finding the position that eliminates (or minimizes) that color fringing. It is helpful to zoom in on an area that exhibits chromatic aberration before adjusting this slider. Press Alt (Option) while adjusting the sliders to see the chromatic aberration against a grayscale image.

- **Blue/Yellow.** The Blue/Yellow slider utilizes the same concept as the Red/Cyan slider, with the obvious difference being that it applies to blue and yellow color fringing rather than red and cyan.

- **Defringe.** The Defringe menu allows you to select from a couple of options that will apply automatic correction for chromatic aberration. When the Off option is selected, no automatic correction is applied and only the sliders are in play. However, you can also choose Highlight Edges to apply an automatic adjustment to only the high-contrast edges within the image, or All Edges to apply that automatic adjustment to all contrast edges within the image. It is generally best to test the settings to evaluate the results before deciding on the best choice. We typically use the sliders first and then apply the Defringe option only if the sliders weren't completely successful. In particular, be careful when using the All Edges option, because it can cause muted colors in the image.

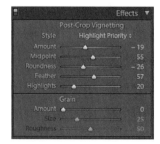

**Figure 8.30** *The Post-Crop Vignetting controls allow you to apply a creative vignetting effect to the image.*

## Effects

The Effects section on the right panel contains settings for vignetting to be applied after the crop, as well as settings for applying a film grain effect to the image.

The Post-Crop Vignetting controls are an extension of those found in the Lens Correction section. The difference is that the controls in the Lens Correction section are aimed at correcting for vignetting caused by the lens, whereas the Post-Crop Vignetting controls are designed for a creative effect (**Figure 8.30**). As a result, they affect only the image that is visible after any cropping has been applied. The following controls are available for Post-Crop Vignetting:

- **Style.** The Style control determines how the vignetting effect impacts the edges of the image. The Highlight Priority setting causes highlight details to be retained, so they don't get flat or blocked by the vignette effect. Color Priority retains the appearance of colors, ensuring that they are only darkened or lightened while helping to retain their hue and saturation. The Paint Overlay (our least favorite!) option causes the effect to behave as though black or white paint (that is partially translucent) is applied to the outer edges of the image.

- **Amount.** The Amount slider determines the strength of the vignetting effect. A positive value lightens the edges of the image, whereas a negative value darkens the edges.

- **Midpoint.** The Midpoint slider determines how far toward the center of the image the vignette effect will extend. A low value causes the effect to extend far into the center of the image, and a high value keeps the effect limited to only the outer edges.

- **Roundness.** Roundness determines if the vignette effect will produce a somewhat circular shape (with a positive value) or a more rectangular shape (with a negative value).

- **Feather.** The Feather control allows you to determine how much the vignette will blend along the transition from adjusting the relative brightness at the edge of the image to the interior of the image that is unaffected. A higher value will cause a larger (and thus smoother) transition.

- **Highlights.** You can brighten highlights that have been darkened by a vignette with a negative Amount value by increasing the Highlights slider. This adjustment is only available if the Amount is negative. A higher value applies a stronger brightening value to the highlights.

Film grain is somewhat akin to digital noise. However, although digital noise is almost always avoided by photographers, sometimes film grain is actually desired from an aesthetic perspective. Lightroom allows you to add a film grain effect to your images with the following controls:

- **Amount.** The Amount slider controls the amount of visible grain texture in the image. A higher value produces more grain.

- **Size.** Size determines how large the scale of the grain structure you're adding is. A larger value produces grain with a larger structure. If you think of grain as appearing somewhat like a sand texture, the size relates to the size of the grains of sand.

- **Roughness.** The Roughness slider allows you to control how much the grain structure appears to clump together. A low value results in a grain structure that is relatively uniform, whereas a high value results in a more random or "scattered" grain structure.

## Camera Calibration

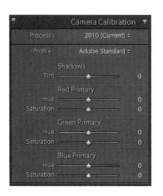

**Figure 8.31** *The Camera Calibration controls provide options for how the image is processed by Lightroom in terms of overall appearance.*

The Camera Calibration section (**Figure 8.31**) on the right panel includes controls for compensating for the color behavior of the camera, but also includes controls affecting the way the image is processed. The following controls are included in the Camera Calibration section:

- **Process.** The Process menu allows you to determine which processing engine should be used to interpret the adjustments you've applied to the image. This option is included primarily for legacy purposes. In general, you should leave this set to the 2010 (Current) option, but if you had previously processed an image with an older version of Lightroom or Adobe Camera Raw and want to retain the original appearance based on those adjustments, you can choose 2003 from the menu.

- **Profile.** The Profile menu relates not to the profiles you might be familiar with in a color management context, but rather to how the image is treated relative to settings you can apply in-camera. Adobe Standard applies the standard Lightroom interpretation to the image. The remaining options relate to profile settings that are available in your camera, such as Landscape or Portrait.

- **Shadows.** The Shadows slider allows you to shift the color of shadows in the image between green (to the left) and magenta (to the right). Keep in mind that this setting (as well as Hue and Saturation below) is intended to compensate for the behavior of the camera, not to apply a color correction to the image.

- **Hue.** There is a Hue slider for each of the primary colors (red, green, and blue). Moving the slider applies a shift in the primary color value associated with the slider, effectively altering the color of that primary. For example, if you feel your camera is consistently producing reds that look too magenta, you can correct for this by shifting the Hue slider for Red Primary.

- **Saturation.** There is also a Saturation slider for each of the primary colors, and adjusting any of these sliders allows you to reduce (by sliding left) or increase (by sliding right) the saturation of the applicable primary color.

# Selective Adjustments

It always amazes us how effective the Develop controls are and how well they improve our images. The Selective Adjustment tools are the frosting on the cake because they allow you to refine and improve localized areas of an image. Always start by improving the overall image appearance (also referred to as global changes), and then move to the selective (also called localized adjustments) to add the final polish to your images.

## Crop

Under the Histogram panel are a series of icons that provide access to various tools for adjusting your images. The first of these icons is the Crop tool. To enable cropping, click the Crop icon at the top of the right panel. You can then adjust the crop by dragging the edges of the crop box overlaid on the image (**Figure 8.32**), or by clicking and dragging outside that crop box to rotate the image within the crop area. You can also use the controls that are displayed on the right panel when you enable cropping (**Figure 8.33**).

If you click the crop icon to the left of the Aspect label, you can then click and drag on the image to define a specific crop. Below that is an Angle tool that allows you to drag on the image to define a line that should be perfectly horizontal or vertical to straighten the image. The Aspect menu allows you to constrain the crop to a particular aspect ratio, and the Angle slider is an alternative method for adjusting the angle of rotation for the image.

You can click Reset at the bottom of these crop controls on the right panel to reset all the settings to their defaults. Clicking Done below the preview image or Close on the right panel hides the crop controls.

**Figure 8.32** *When working with the Crop tool, you'll see an overlay on your preview image that you can manipulate directly to refine the crop.*

**Figure 8.33** *The Crop tool can be controlled using the options found on the right panel.*

## Spot Removal

The Spot Removal tool allows you to conceal dust spots or apply the most basic blemish removal with a circular correction brush. Note that Lightroom is *not* the application in which to do high-end or very involved retouching or cleanup. That is Photoshop's revered purpose. To enable the controls, click the Spot Removal icon (the second icon) near the top of the right panel.

**Figure 8.34** *Controls on the right panel allow you to adjust the brush attributes for the Spot Removal tool.*

The Spot Removal tool can be used in a Clone mode that copies pixels from one area of the image to another, or in a Heal mode where the pixels you copy are blended into the destination area. The options are set with the Brush setting (**Figure 8.34**). Below this option you'll find settings for Size, which affects the size of the area to be cleaned, and Opacity, which affects the degree of opacity or transparency that will be applied to the copied pixels.

After adjusting the settings as desired, click on an area of the image that needs to be corrected, for example, a dust spot that needs to be removed. Circles indicate the source and destination areas with an arrow between the two pointing toward the destination area (**Figure 8.35**). You can drag either of these circles to change the position of the source or destination, and drag on an edge of either circle to adjust the size of the area being affected.

**NOTE** Lightroom's Spot Removal brush is akin to traditional print spotting or dabbing to cancel dust spots. It is not a restoration or retouching tool like Photoshop's Clone or Healing brush.

**Figure 8.35** *When you apply a correction using the Spot Removal tool, the source and destination areas are displayed on the image.*

You can then click in another area of the image to fix that area, and then change the settings if desired for this additional correction. After applying multiple corrections, you can also click on one of the circles associated with any particular correction to apply changes to the settings for that specific correction area.

The Reset button at the bottom of the Spot Removal adjustment section removes all spot corrections, and the Close button hides the Spot Removal controls.

## Sync Settings

The Sync Settings button found at the bottom of the Library module's right panel is used to apply identical settings to multiple images. This is especially helpful when performing image cleanup work to remove spots caused by dust on the camera sensor, because those spots will appear in the same position on multiple images.

To get started, clean up one representative image (usually one with large flat surfaces such as sky) in the Develop module. In the Filmstrip panel, the image you cleaned up will be selected (so it is the primary selection). Press the Ctrl (Command) key and click on additional images to select them as well. When you've selected all the images you want to clean up in the same way, click the Sync Settings button.

In the Synchronize Settings dialog that appears, you can choose which settings from the primary image you want applied to the other images you selected. In this example, you would choose the Spot Removal option, but you can also use this feature to apply a variety of other adjustments to a group of images to match those from a single image. After selecting the check box for each adjustment option you'd like to synchronize, click the Synchronize button to apply the changes to all the selected images.

# Red Eye Correction

**Figure 8.36** *The Red Eye Correction tool provides controls to fine-tune the effect in the image.*

The Red Eye correction tool allows you to fix the red color that can appear in the pupils of people when a flash is used too close to the centerline of the lens. To apply a correction, click the Red Eye Correction tool (the third icon) near the top of the right panel. Then click at the center of the eye you want to correct and drag outward to define a shape that covers the entire eye. Lightroom will identify and apply an automatic correction to the red eye appearance in the eye. You can then adjust the Pupil Size slider to alter the size of the area being corrected and the Darken slider to adjust the degree to which the pupil is darkened (**Figure 8.36**). You can then drag in another eye to apply an additional correction, or click in a circle for an existing correction to adjust the settings for that adjustment.

Click Reset to clear all prior red eye corrections, or Close to hide the Red Eye Correction tool controls.

# Graduated Filter

The Graduated Filter tool allows you to apply a linear, stronger to weaker correction with the effect tapering off from one side of the image to another (**Figure 8.37**). This is a great tool to use to darken skies, lighten landscapes, or apply creative clarity or color wash effects to, for example, water. After clicking the Graduated Filter icon (the fourth icon) near the top of the right panel, you can drag on the image from the area you want to affect to the area you do not want affected. Short pulls of the tool apply very steep gradients, and longer pulls apply a more gradual transition. After dragging, you can click the center icon of the gradient to drag it around to a different position in the image, drag one of the bounding lines to adjust the size of the gradient transition, or click and drag on the centerline to adjust the angle of rotation for the gradient effect.

**Figure 8.37** *You can use the Graduated Filter tool to apply an adjustment that gradually tapers off from one side of the image to another.*

You can then choose what type of effect you want to apply to the image using the Effect menu, or adjust the individual sliders for Exposure, Brightness, Contrast, Saturation, Clarity, Sharpness, or Color. In all honesty, we usually guestimate the amount of the changes to be applied, and after pulling the gradient, readjust the sliders to refine the effect while watching the image. The slider controls found here were explained in detail earlier in this chapter when we addressed the Develop module's Basic panel. The Color option allows you to apply a color overlay to the image. Click the color swatch and choose the desired color from the color picker.

If you'd like to add an additional graduated adjustment, click the New option at the top of the Graduated Filter tool's controls. To revise an existing adjustment, click the Edit option. You can clear all gradient adjustments by clicking the Clear button at the bottom of the Graduated Filter controls, and hide the controls by clicking Close.

## Adjustment Brush

The Adjustment Brush (press K to activate it) allows you to apply targeted adjustments by painting those adjustments directly into the image (**Figure 8.38**). This actually represents what we consider to be one of the more powerful adjustment capabilities in Lightroom, and one that enables you to exercise a tremendous amount of creative control over your images. We frequently use this feature to apply a dodging and burning (lightening and darkening) adjustment to selective areas of an image, effectively painting with light. It also allows you to emphasize a particular subject or area of an image by enhancing certain attributes (such as contrast and saturation) in specific areas. You can even use this tool to completely desaturate most of the image, resulting in a black and white image where a key element (such as only the model's eyes) is still in color.

To get started, click the Adjustment Brush icon (the rightmost of the set of tool icons near the top of the right panel). Then adjust the settings for the brush using the controls near the bottom of the set of controls for the Adjustment Brush.

**Figure 8.38**  *Use the Adjustment Brush to paint a specific adjustment into targeted areas of the image.*

The A and B buttons allow you to switch between two brush configurations. For example, they allow you to switch quickly between a relatively hard-edged brush and a soft-edged brush. Size (drum roll please) affects the size of the brush, the Feather control adjusts how soft the edge of the brush is (and thus how much the effect blends into the surrounding area), and Flow determines how much the effect builds on itself if you drag over the same area repeatedly. Selecting the Auto Mask option causes the brush to evaluate the area you paint over and attempts to automatically follow the edges of the object you're adjusting. Density allows you to reduce the strength of the affect that is being painted, but also build up an adjustment if you paint over the same area multiple times. If you select the Erase option instead of A or B, you can alter the Size, Feather, and Flow settings, and the brush will erase an existing effect from the image.

You can then paint on the image to define the area you want to affect with your targeted adjustment. After painting this area, you can adjust the Exposure, Brightness, Contrast, Saturation, Clarity, Sharpness, and Color controls, just as you can with the Graduated Filter tool.

To add an additional targeted adjustment, click the New button and create an additional adjustment. To revise an existing adjustment, make sure the Show Edit Pins option is set to Always on the toolbar below the preview image, and then click the icon associated with the adjustment you want to refine. The currently active adjustment is shown as an icon with a dark center, whereas other adjustments are shown as a white icon without a dark center.

To clear all targeted adjustments, click the Reset button at the bottom of the Adjustment Brush controls. To hide the controls, click the Close button.

# Develop Presets

The longer you work with Lightroom, the more opportunities you'll learn to take advantage of to save and apply presets (Metadata, Develop, output templates, etc.). As mentioned in the section "Download and Import," you can apply Develop presets to add a certain look to your images. You can also apply these presets via the Quick Develop controls in the Develop module. The Develop module presets are useful to quickly apply a particular look to one or more images (**Figure 8.39**). In addition, you can create your own presets to apply the same effect to images later. When working in the Develop module, move the mouse over the name of a preset, and the Navigator will show a preview of what the currently selected image will look like if you apply the preset. To actually apply the preset to the image, click the name of the desired preset.

Presets really just store the adjustment values you've applied to the image, so you can fine-tune the result to perfection after applying the preset as a starting point. And if that refinement (or any adjustment) results in an effect you like and might want to apply to other images later, you can save those settings as a new preset. Click the plus icon to the right of the Presets label, and enter a descriptive name for the preset in the New Develop Preset dialog. By default, any new preset you create will be saved in the User Presets folder (presets that are included with Lightroom are found in the Lightroom Presets folder), but you can also choose a different folder from the Folder menu.

**Figure 8.39** *Develop presets allow you to easily apply a set appearance to one or more images.*

To create a new folder, choose the New Folder option from the Folder menu, type a folder name, and then click Create.

In the New Develop Preset dialog you can also determine which adjustments should be saved as part of the preset. In general, you probably only want to include adjustments that will be generic to images you'll apply the preset to in the future. For example, color and tonal adjustments are probably best included, but adjustments that relate to a specific image such as Graduated Filters or creative dodging and burning are best excluded from a preset. Once you've defined which adjustments should be included in your new preset, click the Create button. The preset will then appear in the designated folder and be ready to apply to any image in the future.

> **TIP** Keep in mind that presets can be applied to your images at a variety of points in your workflow. For example, you can apply a preset to all images upon import, to all images being exported, to a set of selected images, or in a variety of other situations.

## Previous and Reset

At the bottom of the Develop module's right panel are two additional buttons that relate to the adjustments you apply. The Previous button applies the same settings to the current image as you applied to the previously adjusted image. The Reset button causes all the adjustments for the current image to be reset to their default values.

# Leveraging Photoshop

For an increasing number of photographers, Lightroom is the only tool needed for optimizing (and managing) images. However, in some cases Photoshop can be used to produce results that are not possible in Lightroom. For example, you can send multiple images to Photoshop to create a high dynamic range (HDR) image or a composite panorama.

To utilize either of these options, select the images, and then choose Photo > Edit In from the menu. For an HDR image, choose the Merge to HDR Pro in Photoshop option. For a composite panorama, choose the Merge to Panorama in Photoshop option. In either case Photoshop will be launched if it isn't already running, and the appropriate dialog will be presented to enable you to create your composite image using the automated tools in Photoshop. For additional information on panoramic and HDR photography, see Chapter 6, "Multiple Exposures and Extending the Frame."

When Photoshop is finished assembling the image, choose File > Save (do not choose Save as), and then choose File > Close. When you return to Lightroom, the newly created composite image will be included in the catalog with the original images. You can then continue to manage and optimize this image with the tools in Lightroom.

# The Optimized Image

The best part of working with Lightroom is that you are never changing the actual image data and can always reset or back up via the History panel. So rather than concentrating on the exact amount a slider is moved, you can concentrate on your images—experiment, go too far, make mistakes, learn, and start over. Who knows what fabulous effects you'll discover that are perfect for your images and vision.

Once you've utilized Lightroom to manage and optimize your images, you're ready to share those images with clients, colleagues, family, friends, and others. Before delving into sharing images, you'll want to gain an understanding of color management, which we'll cover in Chapter 9, "From Capture to Monitor to Print." Then you'll be ready to share those images, as we'll demonstrate in Chapter 10, "The Digital Portfolio."

# IV

# Output, Manage, and Present

# From Capture to Monitor to Print

Once you've photographed and optimized your image, the moment of truth arrives. It's time to put ink onto paper to produce a print. For many photographers, the look and feel of the final print is in their mind's eye as they press the shutter release button, and the final print completes the experience of the image. If it isn't just right, the photographer won't be happy and won't be enthusiastic about sharing the image with others. What defines that perfect print? If you've optimized the image, a perfect print matches what you see on your monitor and conveys what you envisioned when you took the picture.

Many photographers get frustrated when they can't produce prints that match the image on their monitor. Fortunately, there are tools to help you achieve a close match between the monitor image and the final print. Even with the variations your choice of print media imparts—such as changes in contrast, saturation, and texture—you want the colors in your prints to be consistent, predictable, and accurate. These issues all fall under the category of color management.

# The Importance of Color Management

Color management is a critical aspect of digital imaging because it provides the tools to produce predictable, accurate, consistent, and repeatable output, whether on a monitor, on the printed page, or in a gallery exhibit. When you spend time and effort getting your image just right, you want the final display to present exactly what you intend the viewer to see. Color management provides a way to achieve this goal while cutting down on test prints, wasted media, and frustration.

Each device that deals with your image has unique characteristics. Every monitor and printer display color differently. Color management enables you to bridge the differences between these devices through the use of *profiles*, which describe the color behavior of a device so that color can be reproduced accurately. (See the "Profiles" section later in this chapter.)

Keep in mind that an effective color management system includes an appropriate working environment and methods for evaluating your results. We discuss the working environment in Chapter 7, "Building a Digital Darkroom," and we discuss the evaluation of prints in a later section in this chapter.

# Understanding Limitations

The most important detail to understand about color management is the inherent limitations of monitors, inks, paper, viewing conditions—even your mood as you work on an image. We're all looking for prints that perfectly match our monitor display, but that goal is unattainable. Monitors and the printed page use very different methods of displaying an image. Monitors use a transmissive light source, producing an incredibly luminous image that literally glows with light. Prints, on the other hand, depend on reflected light for their illumination, and they will never have the same colors and luminosity as a monitor.

You also need to consider how the specific ink and print media you're using will affect the final appearance of the print. For example, glossy materials allow the inks to sit on the surface, enhancing color saturation, contrast,

and sharpness. The images simply have more "snap" to them. Matte papers, on the other hand, generally absorb the inks more, resulting in reduced color vibrancy and contrast. Color management helps you get consistent and accurate output, but prints of the same image on different materials will still look different.

Comparing a print to the image on your monitor also involves a certain amount of interpretation. You need to be able to look past the differences between the two mediums and evaluate how closely they match in terms of tone and color. While proper use of color management helps to ensure the most accurate display for any output method, an image will appear differently depending on the specific output you produce.

# Profiles

A *profile* describes the color behavior of a particular device, so that the behavior can be translated into a known standard. Once the behavior is standardized, another device profile can translate that information again to reproduce the image to match the original. Katrin likes to use the analogy of the United Nations to describe profiles. The printer speaks German, the monitor speaks French, and the digital camera speaks English. The profile is the universal translator that allows all the "languages"—color behavior—spoken by each device to be understood and interpreted in a way that ensures universal results.

Later in this chapter we discuss how to create or obtain profiles for digital cameras, monitors, and printers. First, let's look at some of the issues related to the actual profile files that you will save on your computer.

## Where Do Profiles Go?

When you create your own profiles, they will in most cases be saved automatically to the correct location by the software you use to build them. When you create, purchase, or download a profile for your digital camera, scanner, monitor, or printer, you may need to save the profile in the correct location yourself, so that applications that need to use it can find it.

# Digital Camera Profiling

Until recently, profiling a digital camera was a task we left to studio photographers who worked under strictly controlled lighting situations. For the many photographers like us who shoot under a variety of lighting scenarios, the expense and ineffectiveness of building profiles for digital cameras as the light source changed simply wasn't worth the effort. With the introduction of the X-Rite Color Passport and the ColorChecker Passport software you can profile your camera quickly and easily. The X-Rite Color Passport is a passport-sized (go figure!) hardcover case that holds three color cards–a white balance, the ColorChecker, and a Creative Enhancement Target (**Figure 9.1**). The free ColorChecker Passport (download at www.xritephoto.com) also works with the ColorChecker Classic card, which is often referred to as the Macbeth ColorChecker (**Figure 9.2**).

**Figure 9.1** *The X-Rite ColorPassport is a useful reference chart designed specifically for digital photography and digital camera profiling.*

**Figure 9.2** *The ColorChecker Classic card also allows you to build camera profiles.*

To profile your camera follows these steps:

1. Place the Color Passport into the scene and make sure it is evenly lit.

2. Set your camera to the type of light you're shooting in (daylight, tungsten, etc.) and take a picture, ideally in the RAW capture mode. The ColorChecker should take up at least 10 percent of the image, but we usually try to fill the frame with the ColorChecker.

3. Download the file to your computer and either convert it to DNG with the Adobe DNG Converter or open it in Adobe Camera Raw or Adobe Photoshop Lightroom and export the file as a DNG.

4. Open the DNG file with the ColorChecker Passport software, which will locate the ColorChecker. Click Create Profile; the software prompts you to name the profile so it can be saved.

To apply the camera profile follow these steps:

1.  Relaunch Photoshop or Lightroom and open files taken under the same lighting conditions.

2.  In both Adobe Camera Raw and Lightroom the profile is located under the Camera Calibration tab on the Camera Profile menu.

3.  Select the appropriate profile (**Figure 9.3**) and review the results. If you prefer the rendering of the standard profiles that ship with Adobe Camera Raw or Lightroom, that is completely fine because rendering is subjective.

Building camera profiles with the X-Rite Color Passport allows you to produce the most accurate results possible to maximize the capabilities of your camera. Knowing that you've captured a known color reference is a fabulous starting point for more accurate color from start to finish.

**Figure 9.3** *Applying the custom camera profile via the Lightroom Calibration tab.*

For Windows Vista and Windows 7, profiles should be saved to Windows\System32\Spool\Drivers\Color. For Mac OS X, profiles should be saved in the System/Library/ColorSync/Profiles folder.

Also, keep in mind that some software will load the available profiles at startup, so after installing new profiles, you may need to restart the software application or simply restart your computer.

## Can You Share Profiles?

Before you consider whether you can share a profile, you need to consider whether you'd actually want to. The only situation where you would possibly want to share a profile is for a printer. Monitor profiles are specific to the individual monitor. Each monitor's display will gradually *drift* (meaning the color will shift) over time. Therefore, even if a friend has the same model of monitor as you, you wouldn't want to share your profile. Instead, your friend would want to create a custom profile for his or her own monitor.

While the same issues theoretically apply to photo inkjet printers, in reality printers of the same model are usually very consistent in their output. Similarly, paper and ink are manufactured within very strict tolerances so that a custom printer profile will remain accurate even with different batches of the same type of ink and paper. Therefore, sharing printer profiles is of much more interest to photographers.

Whether you can share profiles depends on how the profiles were created. If you build a profile with the commercial software tools designed for that purpose, you'll need to refer to the license agreement that came with the software you're using to determine whether you are allowed to share the profiles you create with others. It used to be rare that you could legally share profiles created with such tools, but over the past few years the license agreements have become more lenient, and in most cases you are allowed to share the profiles.

If you obtain a profile from a third party, you'll need to check with that third party to see if you can share the profiles with others. If you obtained the profile for free from a paper manufacturer, for example, you can probably distribute the profile freely. If you obtained the profile from a service provider who builds custom profiles, the agreement you have with that provider may prevent you from legally sharing profiles.

We address some of the sources for building or purchasing custom printer profiles in the "Printer Profiling" section later in this chapter.

# Monitor Profiling

We can't stress enough how important it is that you have an accurate display on your monitor, and we highly recommend that you calibrate and profile your monitor about once a month. The monitor is the focal point of the digital darkroom. The final product may be a print from your inkjet printer, but the monitor is what you use to evaluate the accuracy of the print, and that same display is how you decide which adjustments are necessary to optimize the image. If your monitor display is inaccurate, every image-editing decision you make will simply be a blind roll of the dice.

Profiling your monitor is a two-step process. First, the display must be calibrated by adjusting the settings on the monitor to get it as close as possible to established standards. Second, you then generate a profile that describes the color characteristics of the monitor, so that the operating system can compensate for that color behavior to help ensure the most accurate display possible. The process of building a monitor profile is sometimes referred to as *characterizing* the display.

## Profiling Package

The best way to calibrate and profile your monitor is with a package that includes software to guide you through the calibration process and a sensor (called a *colorimeter*) to read the actual values produced by the monitor to create an accurate profile. The profile is then specific to your monitor, ensuring as consistent and accurate a display as possible (**Figure 9.4**).

**Figure 9.4** *A monitor sensor (colorimeter) reads the values displayed by the monitor during the profiling stage of monitor calibration, ensuring the most accurate profile possible.*

Several software-and-sensor packages allow you to calibrate your monitor. These include the ColorMunki and i1Display packages from X-Rite (www.x-rite.com) and the Datacolor Spyder 3 (www.datacolor.com). All of these packages include the hardware and software that enable you to produce a profile for your monitor. Some of the newer LED-illuminated LCD displays don't work well with standard colorimeters, because of the difference in their gamut and RGB primaries. To help enable color management of these displays, some manufacturers (such as NEC) have commissioned the manufacturing of custom colorimeters with optimized filter sets for the RGB primaries on these displays. Additionally, some higher-end displays come with their own software, such as Eizo's Color Navigator and NEC's Spectra-View II. The benefit is that the display is integrated with the software and makes the needed adjustments automatically.

## Calibration

Monitor profiling software will guide you through the process of optimizing the display settings to get your monitor as close as possible to the established calibration standards. This includes adjusting brightness and contrast to achieve optimal black and white points for the display, as well as configuring the color settings for the monitor.

For some LCD monitors you actually won't be able to make adjustments to the display, and thus can't perform the calibration step. This is less than ideal, especially from the standpoint of overall display luminance (most LCD displays are too bright by default). The luminance or brightness of LCD displays can be too bright to match to a printed output; so you'll want to limit the white luminance of the display to approximately 80-120 cd/m2 (candelas per meter squared, a measurement of emitted light), depending on the overall level of illumination in the room. It is best to purchase a display that provides controls for brightness, contrast, and color balance to help ensure the highest quality results. Without proper calibration, the profile will need to apply significant adjustments to the display output, which can result in posterization and other quality loss issues with the displayed image.

Once black (more important for CRT monitors) and white (more important for LCD monitors) points are established, you'll need to configure the color settings for the display. The best monitors allow you to adjust the red, green, and blue channels independently, so you can fine-tune the exact color

temperature of the display. Other monitors only allow you to select preset color settings that define the color temperature of the display. Lower-end monitors don't offer any adjustment for color temperature, but these are not monitors we would recommend for imaging work to begin with.

Once you've adjusted the physical settings of your monitor, it is very important *not* to adjust them again until the next time you calibrate your monitor.

## Target values

When you calibrate and profile your monitor, you must specify the target color temperature and gamma values for the process. The color temperature is a measure of the color of neutrals on your display. Obviously, you would normally expect neutrals to lack any color cast, but reality is a bit different.

Typically, the native white point (the color of the light emitted without any adjustment) for CRT displays is approximately 9300 degrees Kelvin (K), which is much too blue. The native white point of LCDs can be somewhere between 6500K and 7500K. The white point should be set somewhere between 5000K and 6500K. A target value of 5000K has typically been the white point for the graphic arts industry in the United States, where this has been a standard color temperature for controlled viewing stations. A 6500K target value has been the standard for video and Web applications, and has become a somewhat standard white point, but as with many of the other choices in color management, there are good arguments for both color temperature target value options.

Since a setting of 5000K can result in a white point that is too yellow, 5500K is often used as a good intermediate white point. (The choice will depend on the situation and artist involved.) To add more confusion to this decision (in the case of laptops and projectors), it's best to select the "Native" white point, if this option is given. This will not force the display—which is already limited in bit depth—to adjust and possibly create "banding" or other undesirable artifacts.

The target gamma setting defines the relative lightness or darkness of the middle tones in the display. Historically, a gamma setting of 1.8 was generally considered the standard for Macintosh systems, with 2.2 used for Windows. However, we recommend targeting a gamma setting of 2.2 for both operating systems. This will produce an image with slightly higher contrast, which reflects the typical output more accurately than a gamma setting of 1.8 would.

## Profile building

After you've calibrated the monitor and set target values, the software and the sensor do the rest of the work. You place the sensor against the front of the monitor to read a series of values displayed on the monitor. By measuring the difference between what the software actually displayed and the values measured by the sensor, the software generates a table that defines the color behavior of the monitor. This is the monitor profile. The software then saves the profile in the appropriate folder on your system and sets it as the default monitor profile so it will be used as the basis for an accurate display.

If you have a number of monitors in a studio or office, it is important to calibrate and create profiles for each one. An accurate monitor display is critical, particularly if you'll be sharing images across multiple computers. All monitors should be calibrated to the same standards, preferably by the same person, to help ensure consistency. Regardless of the operating system, the default display profile is then used by ICC-compliant applications (such as Adobe Photoshop or Lightroom) to display colors accurately. You don't need to tell the application about the display profile; it automatically finds it. Also, as we describe in the next section, you should calibrate and profile your monitors on a regular basis.

## Frequency

Profiling your monitor isn't a one-time task. Over time the components of your monitor deteriorate, causing a change in the appearance of the display. For LCD monitors this generally translates into a display that gets less bright over time, but color shifts can also occur. Therefore, it's important to build a new profile regularly. How frequently you need to profile depends in part on your monitor's age. As it gets older, the display will drift more significantly. We recommend profiling your monitor once a month to ensure the most accurate display. Additionally, we also profile our monitors before large important jobs or if the viewing conditions have changed.

# Printer Profiling

Much like the profile for your monitor, a printer profile describes the color behavior of your printer, so that the output will render accurately.

But while a monitor profile is specific to a particular monitor, a printer profile is specific to not only the printer, but also to the paper, ink, and print resolution (usually 1440 or 2880) you use for a particular print job. That means you'll need a separate profile for each printer-paper-ink combination you use. Fortunately, since you'll typically use a single printer and ink combination, the only real variable for most photographers is the type of paper you use. For the most accurate output, you'll need a custom profile for each type of paper you'll print to.

Fortunately, printers include profiles that are generic for the printer model. These provide reasonable output provided you use the type of paper the profiles are built for. If the paper you're using doesn't have a profile, you can often use a profile for a paper with a similar surface type and still get good results.

When the generic profiles included with your printer aren't accurate enough to provide the best results (see the "Evaluating Prints" section later in this chapter), either you can use the printer settings to fine-tune the output through (frustrating) trial and error, or you can obtain or build a custom profile that will improve the accuracy of your output.

## Generic Paper Profiles

Each type of paper has specific absorption and reflection properties that cause variations in the appearance of colors in the print. Therefore, if you get excellent results with a particular paper from let's say Epson, but then switch to a similar looking third-party paper, you'll likely get inaccurate output.

To remedy this problem, many third-party paper manufacturers provide generic paper profiles for a variety of printers. These profiles are reasonably accurate, so if you're using a third-party paper, we recommend that you check the manufacturer's Web site to see if profiles are available for your printer. Then produce a test print of an image that is known to contain accurate colors to determine whether it provides accurate colors in your prints. A good image to use for this purpose is the PhotoDisc target image discussed in the "Memory colors" section later in this chapter.

## Profiling Services

If profiles are unavailable or inaccurate for the papers you are using, a custom profile can do the job. For example, Cathy's Profiles (www.cathysprofiles.com) will generate a custom profile specific to your printer, ink, and paper combination for $35 each and Chromix ColorValet builds profiles for a wide variety of print technologies for $99 (www2.chromix.com).

To obtain a profile, you simply download a target image and print it using specific settings as instructed by the company you're using to generate the custom profile. You then mail the printed target to the company so it can be scanned using a spectrophotometer to accurately read the color output. The resulting profile is then delivered to you so you can install it and begin using it for printing.

Purchasing profiles from an outside service is certainly convenient, and the results can be very good. If you need profiles for a few paper types for a single printer, this is an excellent way to go. In fact, the cost of the profile should quickly offset the cost of wasted ink, paper, time, and frustration.

## Build Your Own

If you print on a wide variety of materials, particularly with several different printers, you may want to invest in a solution that allows you to generate accurate profiles whenever you need them (**Figure 9.5**). These solutions are more expensive than buying a few custom profiles from an outside service, but they allow you to produce an unlimited number of custom profiles on-demand.

**Figure 9.5** *Building your own printer profiles with special tools designed for the purpose allows you to create accurate prints with a wide variety of papers and printers with relative ease.*

Building a custom profile involves printing a test target that includes patches of a variety of colors. These color patches are then read using a spectrophotometer so the values of the printed color patches can be compared to what was expected.

When printing the print target that is the basis of building the profile, it's critical that you do not apply a profile or any printer adjustments to the output. Carefully follow the specific instructions included with the tool you're using to produce the custom printer profile to ensure accurate results. We also recommended that you allow the print target to dry for 24 hours to allow the inks to fully cure before reading the patches and building a profile.

One of the more popular solutions for creating custom printer profiles is the relatively new ColorMunki Photo from X-Rite (www.xrite.com). This package allows you to create profiles for monitors and printers, and is one of the more affordable options at under $400. Another affordable option is the Spyder3Print package from Datacolor (www.datacolor.com). This solution is priced below $350, but only allows you to produce printer profiles (you'll need a separate tool for monitor profiling). The Spyder3Studio package from Datacolor includes both monitor and printer profiling capabilities for about $600. One of the more advanced (and expensive) solutions is the i1XTreme bundle from X-Rite. This package sells for about $1,500, but it includes high-quality tools for generating profiles for digital cameras, monitors, digital projectors, and both RGB and CMYK printers.

# Evaluating Prints

Regardless of the tools you're using to ensure the most accurate prints possible, you need to be able to evaluate the accuracy of your prints to ensure the best results and to identify any changes that are necessary in your workflow. Several factors can impact that evaluation process.

## Lighting conditions

ICC printer/paper profiles are built with the assumption that the print is being viewed under a light source with a specific color temperature and intensity combination, 5000K and 2000 lux. These are the conditions that most standard viewing booths attempt to create and why they're excellent for print evaluation. However, there are some good arguments that the

light source you should evaluate your print under should be the same light source the print will be illuminated under when it's exhibited. This won't typically be the same as the viewing booth type of light. Of course, a limit to your ability to evaluate the print under the exhibition lighting is the fact that you might not know what this lighting will be; if the print is exhibited in a room with a window or mixed lighting, the viewing conditions could be continually changing and impossible to duplicate. One temptation is to view the print under the same lighting you're using for your computer display and compare the two. The problem with this is that the ISO standard viewing condition for a display is 5000K, with a subdued intensity or 32 lux. This is much too dim a lighting condition to evaluate print quality. So, you must keep the evaluation lighting in mind when you evaluate your prints and come up with some strategy.

Every light source has a particular color cast that influences the appearance of the print. Existing color-management solutions revolve around a standard illumination of 5000K, so using a 5000K illumination source allows for the most accurate evaluation of your prints. You can replace your existing lightbulbs with 5000K bulbs, such as those available from SoLux (www.solux.net) and other sources. Or you can use special lamps with 5000K bulbs, as well as special viewing booths that utilize 5000K light sources (**Figure 9.6**).

**Figure 9.6** *Special viewing booths that utilize a 5000K light source provide a perfect method for evaluating your prints more accurately while still doing so in close proximity to your monitor. Photo by Reid Elem*

Of course, just because color-management systems revolve around a 5000K illumination source doesn't mean that's the best solution for you. If you know what type of lighting your images will be displayed under, evaluate the prints under that lighting. The human visual system includes a capability referred to as *white-point adaptation* that generally does a very good job of compensating for the color of light used to illuminate an image. But it is still best to make decisions about the print based on how it will ultimately be presented. It's the final result that matters most.

## Memory colors

When testing the accuracy of your print workflow and output results, using the right image for testing can make all the difference. Without an image that serves as an accurate testing basis you won't know whether the monitor or printer is to blame when your results are unsatisfactory.

*Memory colors* are colors that you can easily identify as accurate based on your personal experience. For example, virtually everyone knows the yellow of a banana, the red of an apple, and the green of a watermelon. One of the more common test images that utilizes memory colors is the PhotoDisc International (PDI) target image (**Figure 9.7** on the next page). This image also includes areas of various tonal values that should be neutral, including white shelves and shadows of those shelves. If you open this image on your monitor, you'll know immediately if the display is accurate. When you print the image, you can also evaluate the accuracy of the print with no reference other than your own memory of what the included colors "should" look like. Because you know the original image file is accurate, you can determine whether your monitor or printer profiles are inaccurate based on how accurate the image appears on each. You can download the PhotoDisc target from a variety of online sources, including www.inkjetart.com/custom.

When evaluating a print of the PhotoDisc target or other sample image, look carefully at the neutral values. The PhotoDisc target includes a chart with neutral gray blocks of varying tonal values, as well as white areas and shadows that should likewise be neutral. It requires practice to develop an eye for detecting color casts in places where an image should be neutral and for analyzing the accuracy of memory-color objects within the image.

**Figure 9.7** *The PhotoDisc target image utilizes the concept of memory colors to allow you to evaluate the accuracy of the monitor and print visually.*

You can also build your own test target (**Figure 9.8**) image as explained by Tom Ashe, Associate Chair of MPS Digital Photography program at the School of Visual Arts, by incorporating the following elements:

- **Skin tones.** You're naturally critical of how skin tones are rendered and reproduced—partially because they are relatively close to neutral and partly because you look at others more thoroughly than you do at inanimate objects. Use a variety of skin tones and be careful to not add too much contrast in the transitions from highlight to shadow. This is often an area that can produce defects, such as posterization or oversaturation in the shadow areas.

- **Neutrals.** Neutrals are useful for seeing color balance and cross curves, differences in color cast in the shadows, three-quarter tones, midtones, quarter tones, and highlights.

**Figure 9.8** *Geoff Scott's target image utilizes all of the required elements.*

- **Memory colors.** You're sensitive to inaccuracies or shifts in hue of memory colors, such as blue sky, green foliage, or product colors, so use memory colors.

- **Saturated colors with detail.** You'll want to watch for the loss of detail in saturated colors, which may show up when you print your images.

- **Highlight and shadow details.** With the compression of tones that happens from scene to print in photography, the ability to maintain detail in the extremes is important.

- **Color references.** Be sure to provide patches of primary colors, such as red, green, blue, cyan, magenta, and yellow, and reference colors from the images. These color reference patches (as long as they are large enough) are especially useful for making measurements after the fact with either densitometers or spectrophotometers to evaluate color reproduction.

- **Grayscale and spectrum gradations.** The incorporation of a grayscale gradation (as opposed to grayscale steps, which are valuable for measurements) is very useful for watching for cross curves in printing or in monitor quality. The spectrum gradation, depending on the color space

of the image, can show significant differences in the color gamut of devices, profile quality, and rendering intents, with even more sensitivity than most images.

- **Space for labels.** Be sure to provide space at the bottom for labels reporting the color space of the image, the type of printer and paper used, and workflow information.

## Evaluating the print

Learning to evaluate or judge the technical attributes of a print takes practice but is a skill you can learn. Use the following criteria when looking at prints for technical merits:

- **Neutrality and color balance.** If a print has an overall unwanted color, the print has a color cast. If the print doesn't have a color cast, it's described as being neutral. Color casts or color balance shifts are typically described by the predominant hue that is seen.

- **Brightness and contrast.** The brightness of an image is a description of the overall tone of the print or image, or portion of the print or image. It's possible to describe a print (or elements of a print) as being too dark, heavy, having too much ink lay down, or too much density. Or, it's possible to describe the print (or portion of the print) as being too light or as having too little density.

  The contrast of the image is the transition of tones from dark to light or from the shadows to the highlights. An image or print described as being low in contrast has less of a tonal difference between the dark parts of the print and the lighter parts of the print. A low-contrast image is often described as having less snap or depth. With a high-contrast image, the tonal difference between the highlights and shadows of the print are more extreme and there are fewer middle tones, or midtones.

- **Highlight, shadow, and color detail.** When evaluating image or print quality, it's important to monitor the amount of detail that's been maintained in different portions and aspects of the image. If there is a loss of detail, edits may need to be made to the RAW file in Adobe Camera Raw or Lightroom, or to the image in Photoshop. On the other hand, the loss of details could be a sign of needing to build a new profile or changing rendering intents.

- **Posterization and smoothness of gradations.** Part of the tonal quality of a digital image or print is found in the ability to render smooth gradations or transitions in tones and colors without breaks in the transition. When you see breaks in transitions that should be smooth, this defect is called posterization, which is especially disturbing in skin tones.

- **Color rendering and reproduction.** The translation of colors from input through to the display and the print or color rendering can result in shifts in hue, tone, and saturation from what is expected. These shifts are especially important to watch for in memory and product colors when evaluating print quality.

### Fine-tuning profiles

After you've evaluated your print, you'll want to correct any inaccuracies. If you've built a custom profile, you may be able to fine-tune it with various software tools such as ProfileMaker from X-Rite. This process can be a challenging task, but it does give you excellent control over the final output. Alternatively, if testing reveals the profile is not entirely accurate, you may want to simply re-create a new profile, being particularly careful to perform all the steps correctly in order to yield a better result.

You can also use the generic profiles included with your printer and then use the options available in the Printer Properties dialog to fine-tune the output color. This process can be time-consuming, because you must produce a variety of prints, adjusting the color balance for each, to find compensation settings that produce accurate output. But once you find the right settings, you can reuse them whenever you use the same paper on that printer. We address the use of profiles in the printing process in the following section.

**TIP** An exercise that Katrin uses to illustrate printer profiles in the classes she teaches is to print an image first with an appropriate profile and then with no profile. She then compares these two prints to show what the colors should look like as well as what the printer thinks they look like when a profile isn't applied. This is a good way to get a better perspective on how the profile is affecting the final output, and it can give you a better sense of how accurate the profile is.

# Printing via Lightroom

With accurate printer profiles to help ensure the best results possible, you'll naturally want to put ink to paper to produce high-quality prints of your favorite images. Lightroom makes the process of printing your photographic images easy, whether you're printing a single image or an entire portfolio.

In this chapter we focus on the color-management aspects of printing from Lightroom, and in Chapter 10, "The Digital Portfolio," we'll go into more detail on the various print layout options.

# Print Setup

The first step in producing a print from Lightroom is to select the image (or images) you want to print. Let's assume at this point that we want to print a single image:

1. Go to the Library module, locate an image you'd like to print, and click on that image in the Filmstrip to select it.

2. Choose the Print module. The image you selected will be displayed in the preview area based on the current output settings.

3. Before you start configuring those settings, click Page Setup to bring up the Print Setup dialog (**Figure 9.9**). Make sure the printer you intend to use is selected in the Name menu, and set the Size to the appropriate value based on the paper size you'll be printing to.

4. Click OK to close the Print Setup dialog.

**Figure 9.9** *The Print Setup dialog allows you to select the general printer settings, such as which printer you'll be using and the paper size you'll print to.*

5. Choose a template that represents a good starting point from the left panel of the Print module (**Figure 9.10**). Again, we'll address the many options for fine-tuning your print layout in the next chapter

6. Scroll down to the Print Job section in the right panel.

**Figure 9.10** *After selecting the image(s) you want to print and choosing a template as a starting point in the Print module, you're ready to configure the final settings for printing.*

## Output Settings

The Print Job section at the bottom of the right panel in the Print module (**Figure 9.11**) provides the settings necessary to optimize the accuracy and quality of the final printed image. To start with, be sure the "Print to" option is set to Printer. Since the focus is on producing the best output quality possible, make sure the Draft Mode Printing option is deselected.

**Figure 9.11**   *The Print Job section of the right panel in the Print module provides the key settings for producing printed output.*

Lightroom uses an adaptive interpolation, and we recommend allowing Lightroom to calculate and if needed interpolate file size before the file is handed off to the print driver. For the technically inquisitive, Lightroom 2 maximum print resolution was 480 ppi, and Lightroom 3 can print up to 720 ppi, which takes advantage of information captured by the newer and larger digital camera sensors.

The Print Sharpening settings are intended primarily to compensate for the issue of *dot gain* in the print. Dot gain is the spreading of ink on paper, and it leads to a reduction in perceived sharpness. The Print Sharpening setting in the Print module is different from the Sharpening settings found in the Detail section of the right panel in the Develop module. The former is designed to optimize the print, whereas the latter is designed to optimize the aesthetic appearance of the image.

After selecting the Print Sharpening check box, you can set the strength to Low, Standard, or High. This is largely a matter of personal preference, and we encourage you to perform some testing to determine which setting is most pleasing to your eye based on your specific output process. Image subject, print size, and personal preference all influence print sharpening—with larger prints requiring less sharpening as you view them at a greater distance. In general we follow these guidelines:

- **Low.** For images of people where the sharpest detail is undesired (as much as we hate to say it this is usually woman and young children!). Moody, foggy, atmospheric photos will benefit form the low sharpening setting.

- **Standard.** Generally this is a very good setting and is a happy medium. It's a good choice for landscapes, groups of people, and flowers.

- **High.** Use this setting for gutsy images of architecture, landscapes with a lot of texture and detail, dramatic abstract images, and industrial scenes.

The Media Type setting also affects the sharpening effect. Quite simply, you should use the Matte setting for matte paper and the Glossy setting for glossy or semi-gloss papers. However, you may find that you get better results with coated matte papers by using the Glossy setting.

In terms of achieving a print with accurate color, the Color Management setting is among the most important in the Print module. The Profile option should be set to the profile applicable to the printer, ink, and paper combination you're using for output, such as a custom profile as discussed earlier in this chapter. Initially, Lightroom will not list any profiles here, so you'll need to choose the Other option to bring up the Choose Profiles dialog (**Figure 9.12**) containing a list of all installed printer profiles on your computer. Select the check box for all profiles you would like to have available when printing from Lightroom and click OK. Then choose the appropriate profile for the output you're producing from the Profile menu on the right panel.

**Figure 9.12** *The Choose Profiles dialog allows you to determine which printer profiles will appear on the list in the Print Job section of the right panel in Lightroom's Print module.*

With a profile selected, the Rendering Intent option will become available with two options: Perceptual and Relative. For most printed output we recommend the Relative option (which relates to the Relative Colorimetric rendering intent) because it preserves the accuracy of most colors while only shifting those colors that fall outside the color gamut of the specific printer, ink, and paper combination you're using. Perceptual differs in that it compresses the overall color gamut of the image (and thus reduces overall saturation) to fit the color gamut of the print profile. This does preserve the relationships between colors, but can also have a relatively significant impact on the saturation of the printed image.

## Printer Properties

When you've established the Print Job settings, you can click the Print button at the bottom of the right panel to bring up the Print dialog. Make sure the correct printer is selected from the Name menu and click the Properties button to bring up the Properties dialog for your printer (**Figure 9.13**). The correct settings in this dialog are essential for getting the best prints in terms of quality and color accuracy. The specific settings available and arrangement of the controls will vary among printer manufacturers and even among individual printer models from the same manufacturer, but the same general settings are critical to the most accurate and highest quality output:

- **Paper type.** One of the most important settings is the paper type. Each paper type has different absorption qualities and will produce a different color effect as a result. By selecting the correct paper type, the printer will adjust output to produce the most accurate results. If your paper type isn't listed in the options, select the type that is closest in terms of surface type.

- **Output quality setting.** The right output quality setting has a dramatic impact on the quality of the final print. For glossy papers a setting of 1440 dpi is best. For some matte papers a lower setting may be required, but we don't recommend using anything lower than 720 dpi output. With some printers these options are labeled with names such as Photo or Best. Check your printer manual for recommended settings. In many cases, the highest quality setting (such as 2880 dpi) will only use more ink, cost more money, and take longer to print but will not provide a visible improvement in print quality.

- **No Color Adjustment.** If you are using a custom printer profile, it is important to select the No Color Adjustment or equivalent option in your printer properties. Otherwise, the printer will adjust the output, which defeats the purpose of the custom profile.

- **Color adjustment.** If you've selected the generic profile for the printer, you may want to use the available color-adjustment options. Start with all settings at their neutral values and then produce a test print. Then print again, revising the settings to adjust the appearance of the print. Through trial and error you'll find the settings that give you the most accurate colors. Save those settings so they can be used whenever you use that particular paper. Keep in mind that using a custom profile will almost certainly yield better results than this process.

- **Paper size and adjustments.** Select the correct paper size as well as the other available options. For example, most photographers prefer to center the print on the page (even when it will be matted later). A variety of options allow you to adjust the way the image prints. The quality and color settings are the most important, but the other available options can be helpful as well.

**Figure 9.13** *The Properties dialog differs for different printer manufacturers and even different printer models, but the same general settings will be available for all. The dialog shown here is for the Epson Stylus Pro 7900 wide-format printer.*

## Black and White

While photo inkjet printers are designed for optimal color output, many of them can be used very effectively for black and white prints (**Figure 9.14**). The key thing to remember when printing black and white images is that in most cases you want to use the same settings as you do for color prints. Even though you don't want any color in the image, using only the black ink will severely limit the tonal range of the final print, producing images without smooth tonal gradations. Most important, you should set the option in the Properties dialog for your printer to print with all the ink colors, not just the black ink. Some printers also offer additional options to enhance black and white output. For example, many Epson photo inkjet printers support an Advanced B&W Photo print mode that ensures the best results.

For printers that don't offer an advanced option for generating black and white prints, a highly accurate custom profile should provide neutral prints. In the absence of an accurate profile (or if you aren't using a custom profile), you'll need to use the generic profile for your printer. When using a generic profile, you'll most certainly need to adjust the output settings to get a neutral print. Create a test print with the settings at their neutral values, and then make adjustments for the next print based on the accuracy of the test print. Through trial and error you should be able to produce a neutral print with most printers.

Besides working with your printer's existing Properties settings, you can also use other software to help improve the accuracy of your output. Software such as ImagePrint from ColorByte Software (www.colorbytesoftware.com) provides exceptional control over the output process, allowing you to exercise tremendous control over the printing process. This can help you to produce perfectly neutral black and white prints or to add color tints to those images when desired.

**Figure 9.14** *With a high-quality printer profile or some fine-tuning of the print settings, you can achieve perfectly neutral black and white prints.*

## Inkjet Archival Issues

We discussed the issue of print longevity as it related to the inks used in various inkjet printers in Chapter 7. The type of ink used—whether dye-based or pigment-based—is the most significant factor affecting the longevity of your print. All prints are sensitive to light, temperature, and humidity levels, and the way the images are stored and presented impacts how long they'll last before noticeable fading occurs.

Of course, you'll get the best print longevity if you put your print in dark storage in a temperature- and humidity-controlled environment. That may sound silly, but consider that you may have important family images that you want to pass along to other family members in print form. In that case, storing them carefully will help ensure that they last for many generations. For pigmented inks, prints in dark storage will generally last for over 200 years, based on accelerated testing conducted by Wilhelm Imaging Research (www. wilhelm-research.com).

We consider the testing conducted by Wilhelm Imaging to be the most accurate assessment of potential print life. While the company doesn't test all printers, it does test many of the most popular models. You can check its Web site for longevity estimates for many printers using a variety of papers.

For images that will be on display, one of the best things you can do to ensure long display life is have the image professionally matted and framed under glass (matting should prevent the image from contacting the glass). This will provide a sealed environment that will block most ultraviolet (UV) light. Hanging the picture where it won't receive direct sunlight also helps.

Fortunately, with digital images you can always open your master image file and produce another print. Still, when you display a print, you want it to last as long as possible, so use care in selecting the best environment for displaying your prints.

# Print to JPEG

Besides the ability to print your images to paper, Lightroom also enables you to produce a JPEG image that reflects what the print would otherwise look like. This can be used for creating a file to send for printing to an outside print service (though we recommend exporting TIFF files for this purpose) as well as to prepare print proofs that can be shared with clients and others.

The basic workflow for producing JPEG output in this fashion is exactly the same as preparing images for normal printing. Once you've configured the print layout, in the Print Job section of the right panel in the Print module of Lightroom choose JPEG File from the "Print to" menu. When you do so, some of the controls in the Print Job section change to reflect different considerations for a JPEG file versus printed output (**Figure 9.15**).

**Figure 9.15** *Choosing the JPEG File option for "Print to" in the Print Job section of the right panel causes the available controls to change.*

The File Resolution option (which will now be in the place of the Print Resolution setting) defaults to 300 ppi, but you can change this value if desired. Setting the resolution is only critical if you are using this JPEG as the basis of printed output, in which case you should use the setting recommended for the specific printer configuration or service provider parameters that will ultimately be used.

The Print Sharpening controls are exactly the same as those available for printing, which may seem odd considering the output will be a JPEG file rather than a printed image. However, if your intent is to print the JPEG, you should utilize sharpening settings (as discussed earlier in this chapter) based on the printing process to be used. If the sole purpose is to share the images via email or other means, you can deselect the Print Sharpening check box to disable sharpening.

As discussed in previous chapters, JPEG files always use some level of compression to reduce the file size, but that compression causes some loss of image quality. The JPEG Quality slider allows you to adjust the degree of compression to be applied, with a higher quality setting yielding less compression. If the JPEG file will be used for printing, the JPEG Quality slider should be left at the maximum value of 100. For sharing via email or other situations where you want to balance image quality with file size, a setting of around 75 generally provides good results.

By default the output dimensions of the JPEG file produced will match the paper size you established when you clicked the Page Setup button at the bottom of the left panel in the Print module. If you prefer to have the resulting files resized to different dimensions, you can select the Custom File

Dimensions check box and enter new values in the text boxes below. This is helpful for situations in which you want to print to one output size but then produce proof images that are smaller in size.

After adjusting the settings as desired in the Print Job section, click the Print to File button below to bring up the Save File dialog (**Figure 9.16**). You can then type a name for the JPEG output and also specify a location where the images should be saved. When you click the Save button, Lightroom processes the images and generates one or more JPEG files. If there is only one JPEG file (meaning there's only one page of printed output), the file will be placed alone in the folder you specified. If there are multiple pages, there will be multiple JPEG files, which will be saved to a new folder with the name you specified in the location you designated.

**Figure 9.16** *The Save File dialog allows you to specify the name and location for JPEG files to be generated.*

# Printing via Photoshop

Printing from Photoshop is more complicated than Lightroom in large part because the process is more "manual," requiring you to perform a variety of tasks that Lightroom would otherwise handle automatically.

# Sizing the Image

 **TIP** Another way to get a better idea of the change being applied to your image is to first change the resolution with the Resample Image check box deselected. This ensures that the number of pixels in the image doesn't change. You can then set the output Resolution to the setting you want to use, and the Width and Height values will automatically change to reflect the size of the image at that resolution with no interpolation applied. You can then select the Resample Image check box and adjust the output size as needed. By using this two-step approach, you learn what the output size would be with no interpolation, which tells you how significantly you are increasing (or decreasing) the image size.

To produce a print of a specific size with optimal quality, you need to set the output size and resolution before printing. To resize the image in Photoshop, choose Image > Image Size from the menu to bring up the Image Size dialog (**Figure 9.17**).

**Figure 9.17** *The Image Size dialog allows you to establish the output dimensions for your image.*

The top portion of the Image Size dialog provides the ability to resize your image to specific pixel dimensions. Since this is not helpful for printed output, you'll want to either change the unit of measurement to percentage or focus on the Document Size section of the dialog.

You can simply set the target Width and Height for the image, along with the desired Resolution. Keep the Constrain Proportions check box selected so that the height and width automatically maintain their proportional relationship. At the top of the dialog, the new size will be indicated by the Pixel Dimensions label, followed the image's size before resizing. This tells you how significantly you're changing the size of the image.

To actually change the size of the image at a given resolution value, you need to select the Resample Image check box. This allows Photoshop to change the number of pixels in the image according to the dimensions and resolution you entered. When you change the number, Photoshop uses interpolation to add or remove pixels as needed.

In addition to the Resample Image check box, a drop-down list provides options for the method of interpolation to be applied. For most photographic images we use the Bicubic option, which provides better image quality than Nearest Neighbor or Bilinear. The Bicubic Smoother option is a good choice if you are making a significant enlargement of your image, because it will help prevent jagged lines in the enlarged result. Bicubic Sharper is designed for reducing the size of your image, though our preference is to reduce the image size using Bicubic and then apply sharpening after resizing.

**NOTE** You should apply sharpening to an image after resizing it, as described in Chapter 10.

## Print Settings

To set the output options and ensure the most accurate output, you'll need to adjust a variety of settings in the Print dialog (**Figure 9.18**). To get started, choose File > Print.

**Figure 9.18** *The Print dialog allows you to configure and preview your printed output.*

The left side of the Print dialog shows a preview of the image to be printed. Once you have established the appropriate settings on the right side of the dialog, you'll be able to select the three check boxes below the preview image. Select the Match Print Colors check box to use your color management settings to adjust the preview image to simulate what the final output will look like. Keep in mind this is only an approximation of what the final output will be, but this option can be very helpful for confirming that the correct settings are being used and providing a sense of what the final output will look like. In fact, this is a good way of determining which paper types might be best for the specific image you're printing by simply choosing different printer profiles.

Selecting the Gamut Warning check box places a gray overlay on any areas of the preview image that contain colors your printer, ink, and paper combination (based on the settings in the Print dialog) will not be able to print. This is again helpful for determining which papers are ideal for a given image, and so you'll have more realistic expectations of what the print will look like. Selecting the Show Paper White check box causes the preview to reflect the color of the paper you're printing to. This can be particularly important when you are printing to papers that are not pure white, such as those with a creamy color.

At the top center of the Print dialog, be sure to select the printer you intend to send the image to. You can then click the Print Settings button to bring up a dialog that allows you to adjust the paper size and orientation.

If the image is in 16-bit-per-channel mode, be sure to select the Send 16-bit Data check box to maximize the potential of the printed image. Doing so will help ensure the smoothest gradations of tone and color possible. In many cases the difference won't be easily seen with the unaided eye, but if you have the high-bit information, it makes sense to send it to the printer.

You'll generally want to select the Center Image check box, which as the name makes abundantly clear causes the image to be centered on the printed page. You should leave the Scale to Fit Media check box deselected since you already resized the image as desired.

The most important settings in terms of producing an accurate print are the color-management options on the right side of the Print dialog. At the top right of the dialog, select Color Management from the menu. Then set the option below, which identifies the source color space for the image being printed, to Document.

Set the Color handling option to Photoshop Manages Colors. Then choose the appropriate profile for the specific printer, ink, and paper combination you're using from the Printer Profile menu.

The Rendering Intent option allows you to select a *rendering intent*, which defines how colors that are not available in the destination profile are dealt with. With the Relative Colorimetric rendering intent, colors that are within the color gamut of the destination profile will remain unchanged. Colors that are outside that gamut will be shifted to the closest matching color within the gamut. The Perceptual rendering intent causes all colors to be compressed to fit within the destination space. This can cause a slight shift in the image, but it maintains the relationships between colors. For most images, the Relative Colorimetric rendering intent is the best choice. If you have significant colors that are out of gamut (which you can determine using the Gamut Warning option), Perceptual may be a better choice. Of course, with Match Print Colors selected for the preview, you'll be able to get a sense of the best option for the particular image you're printing.

Select the Use Black Point Compensation check box to ensure that black is accurately mapped in the destination profile.

With the color-management settings established in the Print with Preview dialog, you can click the Print button to select your printer and set the appropriate properties based on the type of output you're producing.

## Printer Properties

After clicking the Print button in the Print dialog, you can select your printer from a drop-down list in the Print dialog that appears. You must then click the Properties button to select additional options for your printer, as discussed earlier in this chapter. The right settings in the Properties dialog are essential for getting the best prints in terms of quality and color accuracy.

# Printing Services

Having your prints produced by an outside service involves perfecting your image based on your monitor display and then sending the file to a service to print it for you. Taking this route is particularly useful when you need an image printed at a size larger than your printer allows, or in large quantities.

# Specialty Print Labs

When it comes to producing large prints with the highest possible quality, sometimes it makes sense to leave the work to someone with years of experience producing beautiful photographic prints. It often makes more sense to pay someone else to produce prints for you than to invest in a larger and more expensive printer, for example. A large number of such specialty print labs are capable of producing exceptional results with your images, such as FinePrint Imaging (www.fineprintimaging.com).

In the past, sending an image to a print lab generally meant it would produce the output with a high-end printer such as the LightJet or Chromira models (often costing hundreds of thousands of dollars). Laumont Studio in New York City does work closely with world-renowned artists, galleries, and museums, where the highly qualified staff works one on one with the artists to make the very best print possible. However, today, sending an image to a print lab generally means the print will be produced on a top-end photo inkjet printer using pigment-based inks.

It's important that you discuss the file preparation requirements for a direct photo print with the lab that will be producing the image. Most labs require an RGB image in the Adobe RGB 1998 color space, sized to the final output size at 300 ppi or higher. It should be a flattened image, saved in 16-bit-per-channel mode (though you'll want to confirm the print lab does indeed support high-bit images). In most cases you won't need to apply a custom profile for the print. It may be helpful to include a proof print along with your digital image file, although there will probably be an additional charge if your image needs to be adjusted to match the proof print in the final output.

You can produce files for third-party labs very easily by using the Export function in Lightroom:

1. Select the images in the Library module that you want to send for printing.

2. Click the Export button at the bottom of the left panel to open the Export dialog. Many of the settings are a matter of personal preference (for example, whether you'll rename the images upon export), but several are very important in terms of producing the best results.

3. In the File Settings section, set the Format menu to TIFF, Compression to None, Color Space to Adobe RGB 1998 (or as recommended by your print lab), and Bit Depth to 16 bits/channel.

4.  In the Image Sizing section, select the Resize to Fit check box and choose Long Edge from the associated menu.

5.  Choose the desired unit of measure (for example, "in" for inches) and enter a value representing how large you want the long side of the image to be (the short side of the image will be sized in proportion).

6.  Set the Resolution option to 360 pixels per inch, or as recommended by your print lab.

7.  For output sharpening, select the Sharpen For check box, set the associated menu to Matte Paper or Glossy Paper depending on the media your prints will be produced on, and set the Amount as desired or based on a recommendation from your print lab.

8.  Adjust any other settings as desired, and click Export.

The files will be processed and saved in the location you designated, ready for you to deliver to the print lab so it can produce high-quality prints to your specifications. Be sure to include a text file with your files that explains your settings, especially color space and print sharpening so that the lab, for example, doesn't sharpen the file again.

## Online Print Services

Digital photography and the Internet have enjoyed a similar rise in popularity at the same time. They seem a perfect match in many ways. Sure enough, there are no shortage of online companies offering photo-printing services, such as Shutterfly (www.shutterfly.com), Snapfish (www.snapfish.com), and even local drugstores such as CVS or Walgreens. These services are best suited for producing quick prints conveniently or for allowing far-flung family and friends to purchase copies of your images.

Most of the online print services use some form of direct photo printer to produce traditional photographic prints from your digital image files. Be sure to check with the service for the most appropriate settings to ensure the best image quality. For many of these services, converting your images to the sRGB color space will yield the best results.

Although you would typically want to size the image to the final output size at 300 dpi, in some cases the online services will require a small image file size than the final results would normally require. There will also be restrictions on the maximum file size you can upload for printing. In most

situations, the image will need to be saved as a JPEG rather than a higher-quality TIFF image.

Even with these restrictions, the prints produced are of excellent quality in most cases, and are particularly good for snapshot photos. Be sure to carefully review the image requirements for the service you're using before uploading images and ordering prints. Then use the Export function in Lightroom as outlined earlier in "Specialty Print Labs" to configure the image settings and produce the final images to upload to the service and order your prints.

# The Perfect Print to Share

You've expertly adjusted your images so they match the vision you had when you pressed the shutter release, and you've produced excellent prints from your images. Now it's time to share those images with others. That means creating a portfolio so that others can view your images, whether it's for pure enjoyment, for a potential purchase, or for any other reason. In the next chapter we show you how to prepare the perfect portfolio.

# The Digital Portfolio

10

As photographers, we create images to nurture and to satisfy our creative inspiration, as well as to share our photographs—our vision—with others. We don't create photographs to then hide them from the world—not our good ones, anyway. We want our pictures to be seen.

In previous chapters we showed you how to improve your photography, how to optimize your images in the digital darkroom, and how to produce the best prints possible. While a fine print represents the ultimate goal for many photographers, digital photography offers many other opportunities for creatively sharing images. These include digital slide shows, online photo sharing and social media sites, smart phones, and creating your own custom Web galleries. In this chapter we'll look at the purely digital ways of sharing your images with your family, friends, and the world.

## Presenting Photos Online

With potential viewers numbering in the billions, the Internet represents the widest possible audience for your images. It has become the primary platform for the viewing and sharing of photographs, and it makes sense to take full advantage of the many ways you can share your images with the online global community. Whether you just want to share a few personal images with family and friends or are more interested in creating an online portfolio, or finding a market to sell prints or license your images,

the Internet offers great potential and convenience. If a client needs to see and approve images from a photo shoot, if a designer needs to select just the right shot to use in an advertisement, or if distant family members want to see the latest pictures of the kids, the Internet allows you to quickly make your photos available to anyone with online access.

# Preparing Photos for Online Viewing

Images shared online will naturally be viewed on a monitor, which provides a very different experience than a printed image. Because of those differences, you need to optimize the image for display on a monitor.

Although some photo sharing sites allow you to upload larger images and will create downsized versions for display on a Web page, you are relinquishing a fair amount of creative control to an automated process. We feel that for the best-looking images online, it makes sense to handle the preparation yourself. Fortunately, even the most basic image-editing programs allow you to resize photos. The Export feature in Adobe Lightroom makes it very easy to quickly create Web-sized versions of several images at once, and this is our preferred method for prepping images for online display. In this section we'll cover preparing images for the Web using both Lightroom and Photoshop.

## Image size for online display

The size of an image online is determined by how many pixels are used to describe the photo, as well as the resolution of the monitor that is displaying the image. Although there are a variety of display resolutions in use, and you cannot accurately predict what every viewer may be using, you can make a few assumptions and do some simple research to determine what is the best size for your online images.

First, decide whether you are interested in strictly a display version of the image or if you also want to make a larger size available that can be printed. The latter scenario is what you would consider if you are uploading to a photo sharing site that also allows viewers to order prints of your images (see the sidebar "Sizing Files for Online Prints" later in this chapter).

For online display purposes, you'll want to consider the audience for your images. Most likely, the Web viewers who are interested in photography have

their monitors set to a display resolution of at least 1024 by 768 pixels and most likely higher. The standard 1024 by 768 pixels provides a good benchmark for how large you should size your images. Keep in mind that the Web browser's interface elements as well as the design of the Web page are using up some of those pixels, and this will make the available viewing area for the image smaller than the actual display resolution.

• Even assuming that the average viewers have their monitors set to at least 1024 by 768, you generally do not want to create images that will fill the screen. Doing so results in larger file sizes that take longer to download and display on slower Internet connections. Plus, you don't necessarily want to be providing bigger files for just anyone to access. The larger the file, the more that can be done with it should less than scrupulous individuals choose to download the file for their own purposes without your permission. (We'll cover this and other security issues later in this chapter in "Protecting Photos Online.")

• One way to determine the best size for online display is to look at the size of the images that other photographers have on their Web sites. Find a site where the images are sized similar to what you would like for your photos. Many Web browsers will show you what the exact pixel dimension is for an image. For example, in Firefox you can right-click on the image and choose View Image Info to display information about the image, including the size in pixels (**Figure 10.1**). In Internet Explorer, right-clicking on the image and selecting Properties will provide a variety of information, including the pixel dimension (**Figure 10.2**). In Safari you can right-click on an image and select Open Image in New Tab, and the pixel dimension for the photo will be displayed in the browser window title bar (**Figure 10.3**).

For most of the images that Seán posts to his blog or Web site, the maximum size is 650 to 750 pixels for the longest dimension. This works well for the average monitor resolution that most people will be using to view his sites, and the files are not large enough for anything but onscreen display, which limits what potential pixel thieves can do with them. If you are used to viewing Web sites on a very large monitor like a 30-inch Apple Cinema display with a resolution of 2560x1600, then an image size of 650 to 750 pixels wide may seem small. But keep in mind that not everyone will be viewing your Web site on such a roomy display.

**Figure 10.1** *The View Image Info display in the Firefox Web browser.*

**Figure 10.2** *The Properties display in Internet Explorer.*

**Figure 10.3** *Displaying image size in the browser window in Safari.*

# Exporting Web-sized Files in Lightroom

Lightroom offers two ways to create images for Web display: One is a very convenient export feature for basic resizing and saving in a different file format. The other is the Web module where you can create entire Web photo galleries complete with index pages of thumbnails and individual pages that display larger versions of the images, all linked together and ready to be uploaded to the Web. We'll cover using the Web module functionality to make Web galleries a bit later in this chapter.

## The Export dialog

In the Lightroom Library module, choose the images that you want to export to Web-sized versions. Then choose File > Export. The Export dialog provides three presets that ship with Lightroom, as well as the ability to create your own presets. Start by selecting the For E-mail preset because that will already contain several settings that are appropriate for a Web-sized image (**Figure 10.4**). You can save a new custom preset once you have modified some of the settings.

**Figure 10.4** *The Export dialog in Lightroom 3. The For E-mail preset is selected to serve as a starting point for creating a new preset.*

A range of different attributes can be configured for the exported files:

- **Export Location.** This determines where the exported files will be saved. You can either choose a specific folder or select "Choose folder later," which will prompt you to choose a folder location each time you use these settings. The "Choose folder later" setting is very useful if you will be saving the settings as a preset, because you may not want to export files to the same folder every time.

- **File Naming.** This lets you determine how the exported files will be named.

- **File Settings.** This refers to file Format, Color Space, and Quality settings. For Web images choose JPEG as the Format and sRGB as the Color Space. The Quality setting is specific to the JPEG format. Higher quality will result in a larger file size, whereas lower quality will yield smaller file sizes. The JPEG format is always a trade-off between image quality and file size. To really judge how JPEG compression affects image quality, you might consider doing a test and exporting several versions of the same photo at different quality levels and then evaluating them to see where your personal JPEG quality threshold is. We typically use a Quality setting of 75 because it creates a manageable file size without radically compromising image quality (**Figure 10.5**).

**Figure 10.5** *The File Settings in Lightroom 3's Export dialog.*

- **Image Sizing.** From the menu choose Long Edge and then enter the desired pixel dimension for the longest side of the image. The advantage of using this method, as opposed to specifying an exact dimension, is that the same preset can be used for both horizontal and vertical images. A vertical image will be 700 pixels tall and a horizontal image will be 700 pixels wide (**Figure 10.6**).

**Figure 10.6** *The Image Size settings in Lightroom 3's Export dialog.*

- **Output Sharpening.** Choose Sharpen for Screen and then Standard. As with JPEG quality, to really see how each sharpening level is affecting the file, testing and evaluation is in order.

- **Metadata.** Minimize Embedded Metadata will only include your copyright notice (assuming that you have already added this in Lightroom); it will not include any keywords, IPTC contact information, or camera and exposure information. Deselecting this option will include all metadata that is associated with the file. The ability to include keywords in the files you post on the Web can be very useful, especially if you want your images to show up in any image searches based on keywords that are already used with your photos. Selecting the Writing Keywords as a Lightroom Hierarchy option will include the hierarchical structure that Lightroom uses, including any keywords and their containing keywords, and will ignore any synonyms that are associated with a keyword (**Figure 10.7**).

**Figure 10.7** *The Output Sharpening, Metadata, and Watermarking settings in Lightroom 3's Export dialog.*

- **Watermarking.** With this option you can add a simple copyright watermark that will be based on any copyright notice already present in the metadata of the file. For more options, including the ability to specify a graphic image as a watermark, you can choose Edit Watermarks. We'll take a closer look at Lightroom's watermarking features in "Protecting Photos Online" later in this chapter.

- **Post-Processing.** This area determines what happens after the file has been exported. You can choose from simply showing the location of the files in the Mac Finder or Windows Explorer to opening your email program and automatically attaching the file to a new message, opening the images in Photoshop, or even applying a Photoshop action to the files for further processing that is beyond the functionality offered in Lightroom.

When you have changed all the settings to what they need to be for the new preset, click the Add button in the lower left to create a new preset based on the current settings (**Figure 10.8**). This preset will then be available from the main Lightroom interface by choosing File > Export with Preset.

**Figure 10.8** *Saving the current export settings as a new export preset.*

# Preparing Web Images in Photoshop

The export functionality in Lightroom is a one-stop shop for preparing files for the Web. By contrast, the same process in Photoshop is a bit more involved, simply because you have to apply a few different steps instead of handling it all in one place. The main steps for preparing an image for the Web in Photoshop are resizing the photo to the desired dimensions, converting the color profile to sRGB, sharpening the file, and saving as a JPEG file.

## Resizing images

You can size the images in Photoshop by selecting Image > Image Size. Then, with the Resample Image check box selected, choose pixels as the unit of measurement and enter a new height or width for the image. If you have the Constrain Proportions check box selected (which we recommend), the other dimension will be automatically adjusted to maintain the proportions of the image (**Figure 10.9**). Since you are making the image smaller, open the menu at the bottom and choose Bicubic Sharper (best for reduction). For Resolution, 72ppi or 96ppi are standard settings, but the truth of the matter is that the resolution doesn't really matter for Web images because Web browsers display an image based on the pixel dimensions. Two images saved at the same pixel dimensions but with different resolutions, 300ppi and 72ppi, would both appear the same size when viewed in a Web browser (**Figure 10.10**).

**Figure 10.9** *The Image Size dialog in Photoshop CS5.*

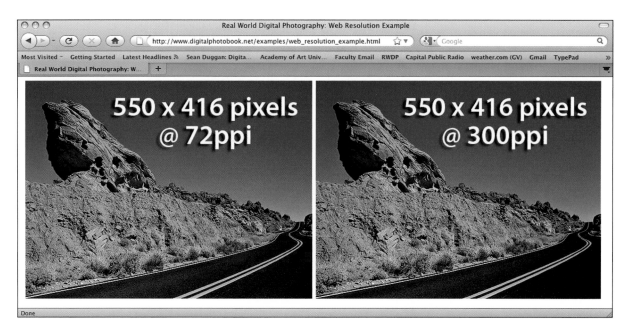

**Figure 10.10**  *Two files with the same pixel dimensions but different resolutions will be displayed at the same size when viewed in a Web browser.*

## Converting to sRGB

In Chapter 9, "From Capture to Monitor to Print," we discussed using color-management techniques to produce the best prints. Unfortunately, on the Internet color management is somewhat unreliable because Web browsers offer limited support at best for color management, and you have no idea if the viewer is looking at your images on a calibrated monitor in a controlled viewing environment or for example on a dimly lit train where the light is constantly changing. To get the best colors possible, we recommend converting images that will be displayed on the Web to the sRGB color space. This color space is designed to match the color display on a typical monitor, and using it for Web images is the best way to ensure that the image looks the way it is supposed to. In Photoshop there are two ways you can convert to the sRGB profile. Choose Image > Mode > Convert to Profile, select sRGB IEC61966-2.1 from the Profile menu, and click OK (**Figure 10.11**). You can also convert to sRGB when using the Save for Web & Devices dialog to export a Web version of the photo. We'll take a look at this option for saving for the Web a bit later.

**Figure 10.11**

*The Convert to Profile dialog in Photoshop CS5.*

## Sharpening

When images are reduced in size, they can lose some sharpness. To compensate for this, you can apply sharpening after resizing the file to improve its appearance. Lightroom's Export feature includes an option to sharpen the files, but with Photoshop, it is a separate step. Photoshop offers many sharpening filters and techniques to sharpen images, with the Unsharp Mask and Smart Sharpen filters being among the best. Before applying any sharpening, make sure that you are viewing the image at 100% (View > Actual Pixels) because this will provide the most accurate view for evaluating the effects of the filter. To sharpen for screen viewing with the Unsharp Mask filter, start with a low Radius setting (about 0.4 to 0.8) and a modest Amount (about 60% to 100%). For Smart Sharpen, start with an Amount of 60% to 100% and a Radius of 0.5 to 0.7. Set the Remove option to Lens Blur for a more subtle application of the sharpening. Because the monitor display accurately represents what the final image will look like, you can use the Preview to determine the best settings to use (**Figure 10.12**).

**Figure 10.12** *The Unsharp Mask and Smart Sharpen dialogs in Photoshop CS5.*

## Save as a JPEG

After resizing the image, converting it to sRGB, and sharpening as needed, you're ready to save the image as a JPEG file. Choose File > Save As, select the JPEG file format, and use a Quality setting of 8–10. To speed up your production, image resizing, sharpening, and saving as a JPEG can be recorded as a Photoshop Action that can also be applied as a batch process to an entire folder of images.

## Save for Web

Although you can use the Save As dialog to save a JPEG, as described earlier, we advise using the Save for Web & Devices dialog because it gives you more control over the various options that can affect the quality of the image as well as the size of the compressed file. It also provides a variety of ways to compare different Quality settings against the original, uncompressed image.

After downsizing your image and sharpening, choose File > Save for Web & Devices to display the Save for Web & Devices dialog. We prefer to use the 4-Up tab to preview the image, which will display the original image in the upper left, followed clockwise by three samples at varying Quality settings (**Figure 10.13**). Select the JPEG High option from the Preset menu to provide a good starting point for your images. You can fine-tune the Quality level for any of the three sample images, which allows you to preview how more or less compression will affect both the image quality and the file size. The content of the photo, image size, and target audience will affect how you balance image quality versus file size.

An Image Size option is located in the lower right of the Save for Web & Devices dialog, but we do not recommend sizing the image here. The reason is that after an image has been resized, it needs to be sharpened, and this dialog is the last stop before the JPEG file is saved. It is much better to resize the image prior to this step so you can apply custom sharpening before saving the file.

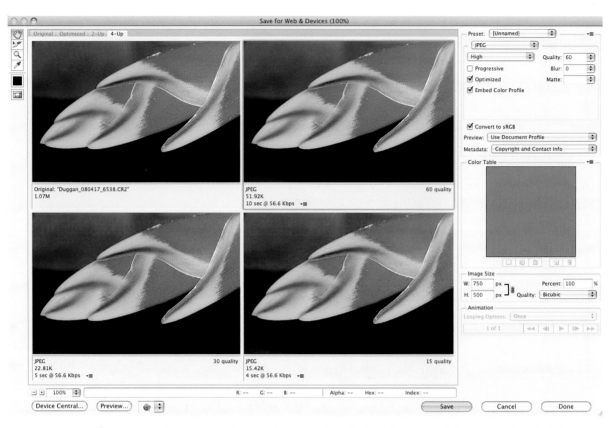

**Figure 10.13** *Photoshop CS5's Save for Web & Devices dialog, shown here in 4-Up view.*

Apart from the basic JPEG Quality settings, you should also make sure that the Embed Color Profile check box is selected. Although not all Web browsers are created equal in terms of how well they recognize and honor embedded ICC profiles, it's much better to select it for those browsers that do know what to do with it. If you have not yet converted the file to sRGB, you'll find another check box here that will handle the conversion as the JPEG file is created (**Figure 10.14**). There is also a Metadata menu that lets you decide how much metadata will be included in the saved JPEG file. You have a wider range of choices here than are available in the Lightroom Export dialog. They include None, Copyright, Copyright and Contact Info, All Except Camera Info, and All (**Figure 10.15**).

**Figure 10.14** *The Save for Web & Devices dialog provides options for converting the image to sRGB and embedding a color profile.*

**Figure 10.15** *The Metadata options control what types of metadata will be included in the saved file.*

Once you've adjusted the image to suit your needs, click the Save button, and enter a filename and location for your image. Clicking the Done button will not save the file but will remember the settings so they can be used on the next image.

**Figure 10.16**
*The Image Processor dialog in Photoshop CS5.*

**TIP** If you don't have Lightroom and you have several images to prepare for either Web or email, you can use the Image Processor in Adobe Bridge. In Bridge, select the thumbnails of the images you want to resize and choose Tools > Photoshop > Image Processor (**Figure 10.16**). This command will create JPEG versions of the selected files that are resized to a target size you specify. It will even convert them to sRGB and embed the color profile. The only thing it does not do is sharpen the files, although this can be added on by accessing a sharpening action that you can create in Photoshop.

## What About GIF and PNG?

The GIF (Graphics Interchange Format) file format is specifically designed for images with either solid colors or relatively few colors (such as logos, text graphics, or Web navigation elements) that will be displayed on a monitor rather than printed. GIF files support a maximum of only 256 colors. This limitation in the number of colors that can be reproduced means that it is not the best choice for photographic images. Although you can optimize those colors to the best 256 hues for a particular image, 256 colors isn't enough to produce a realistic photographic image. And in most cases, when compared to a 256-color GIF file, JPEG will do a much better job of yielding a smaller file size.

The PNG (Portable Networks Graphics) format was originally designed as a replacement for GIF, but it also has a version that supports more color depth. In Photoshop's Save for Web dialog, PNG comes in two flavors: PNG-8 and PNG-24. PNG-8 is similar to GIF in that it supports 8-bit color, which is the same 256-color maximum as that offered by GIF. As such, this disqualifies it from being a viable format for photographs. PNG-24 supports 24-bit color and can contain the same amount of color as can a JPEG file, but the file sizes are much larger than a JPEG saved at high quality. PNG files can also support transparency, which is certainly something of interest to Web developers but less so for photographers who just want their images to look good on the Web. For a good balance between image quality and small file size, and to be viewable in the widest range of programs, our recommendation is to use the JPEG format.

## Preparing Web Images in Other Programs

When it comes to the digital darkroom, this book is obviously very Lightroom and Photoshop-centric. But the relatively simple tasks required to prepare an image for Web display can be accomplished by most image-editing programs. The main point to remember is that whichever program you use, prepping a file for Web display requires the following steps:

1. Decide on the size, in pixels, that you want the image to be.

2. Resize the file to the target pixel dimension.

3. Sharpen the resized file.

4. Convert to the sRGB color profile (this step can come before or after sharpening).

5. Save in the JPEG format and embed the sRGB color profile.

Those are the essential steps. Depending on how the file will be displayed, there can also be additional steps related to adding a copyright watermark and making sure that your copyright notice is part of the file's metadata. We'll cover those steps a bit later in this chapter.

## Sending Photos via Email

Sharing images via email today is certainly easier than it used to be. In the "old days" of a few years ago you had to size your files so that they would be easily viewable within the body of the email; otherwise, the recipient would only be able to see a tiny portion of the image. Today's email programs, whether on your computer or their Web-based equivalents, are very good at scaling large files so that you can easily see them. Even if a Web email program shows only a thumbnail of the image, when you click on it to view a larger version, the Web browser that displays it will scale the image to fit the active browser window (**Figure 10.17**).

**Figure 10.17** *Most email programs, whether they are installed on your computer or based on the Web, will scale even very large images so they can be easily viewed.*

Even though email programs will scale large images, it's still a good idea to size your images to a smaller target size that works well for including them within an email. At the very least this is a common courtesy to the recipient; a smaller file will download much faster than a larger one. This is especially relevant if you plan on attaching several images to an email message. If your primary goal is sharing a cool photo, then sizing it smaller is the way to go. The only reason you would need to send a full-sized file would be if the trusted recipient needed to work with or print the full-resolution file.

The Export dialog in Lightroom offers a preset designed for preparing images for email. You can access this by choosing File > Export with Preset > For E-Mail. The preset will size images to be 640 pixels on the longest side, convert them to sRGB, minimize embedded metadata, and save them as a medium-quality JPEG. At the end of the process, the preset will show you where it has saved them. In the Post-Processing section of the Export dialog, you can also choose Open in Other Application and select your email program to automatically attach the image to a new email message. If you use Microsoft Entourage, a menu item lets you email the exported image via that program. Keep in mind that you can modify any of the settings for this preset by choosing File > Export, selecting the preset on the left, changing the settings, and then saving a new preset.

## Sharing Your Photos Online

If you don't have your own Web site, you can still share your images on the Internet by taking advantage of the countless Web sites that offer photo sharing services. These range from sites for sharing personal images with family and friends, to pages that can be viewed by anyone on the Web, to more professional photo portfolio sites and services that allow you to sell prints and other photo products based on your images.

### Personal photo sharing sites

Web sites that let you upload your personal photos into albums are some of the most popular types of sharing services available because they tap into the very fundamental need we have to share moments from our lives with the people we love. Typically, the photos you upload to this type of photo sharing web site are only available to your immediate circle of family and friends (you decide who gets to see the images by sending them an invitation

with a link to your online photo albums). Invited visitors to the site can view the images as a slide show and can even order a variety of photo products from the images, such as prints, photo books, calendars, cards, and coffee mugs (**Figure 10.18**).

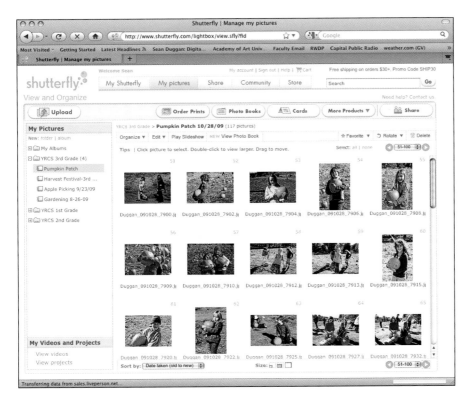

**Figure 10.18** *Photo sharing sites make it easy to share photos and order prints as well as other photo products.*

It would be impossible for us to list all the sites that offer some form of photo sharing service, but three of the most well established sites include shutterfly.com, snapfish.com, and kodakgallery.com.

These sites are generally free to use; the Web site makes its money from the prints, photo books, and other items that people order. If your goal is only to share screen-sized versions of your photos, it is best to prepare your images as described earlier in this chapter. If you also want visitors to be able to order prints and other photo products, you'll have to upload larger versions that are suitable for reproduction (see the sidebar "Sizing Files for Online Prints" later in this chapter).

With some services, such as Shutterfly.com, you can customize the look of your sharing site by choosing from a collection of design templates that are

provided free of charge (**Figure 10.19**). People who subscribe to your photo pages can receive automatic email updates whenever you add new images, making it easy for you to keep your personal photo community up to date. Most sharing sites can also be password protected if you are concerned about nonfamily members viewing the images.

**Figure 10.19** *Many sites let you customize the design of your photo sharing pages.*

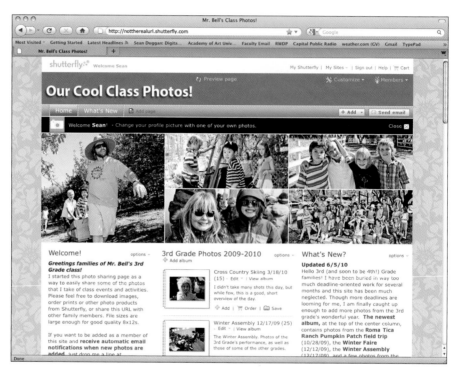

## Photo sharing/Social media sites

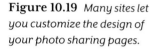

**NOTE** Join the *Real World Digital Photography* book Flickr group by pointing your Web browser to www.flickr.com/groups/ realworlddigitalphotography.

Another way to share photos is to post images to a site that is part photo sharing and part social media site. On these Web sites anyone can see your images (although there are usually ways to specify that certain images only be viewed by family and friends) as well as post comments about the photo. This direct interaction with other people from all over the world creates a community aspect that is a different sharing experience from the closed, invitation-only aspect of personal sharing sites.

Of these sites, the most well known is arguably Flickr (flickr.com). At the most basic level, Flickr is free, but for a modest yearly fee you can upgrade your account to access all the features the site offers, including the ability to

organize images into many different sets and collections, as well as add them to groups created by other Flickr members. Flickr also allows for the creation of prints, photo books, and other products. But unless you want others to be able to use your images for this purpose, we strongly recommend turning off this option (you receive no part of the sales price). You can upload larger files to Flickr, but if your goal is purely to share your images with the global online community and not to make them available for printing, we recommend resizing them to smaller files as discussed earlier in this chapter.

Located in the lower-left corner of the Lightroom 3 Library module, the Publish Services allow you to easily upload photos from your Lightroom catalog directly to your Flickr photostream. In a dialog that is very similar to the Export dialog, you can specify how large the uploaded files will be, apply sharpening for screen viewing, and even add a copyright watermark based on the copyright notice in the file's metadata (**Figure 10.20**). If you have a Flickr Pro Account, you can modify the image in Lightroom and then republish it to your Flickr photostream. Updates you make to the title of the image in the Metadata pane of the Library module will be also reflected on your Flickr page when you republish the image. A Flickr Pro Account also lets you monitor and respond to viewer comments directly from within Lightroom (**Figure 10.21**).

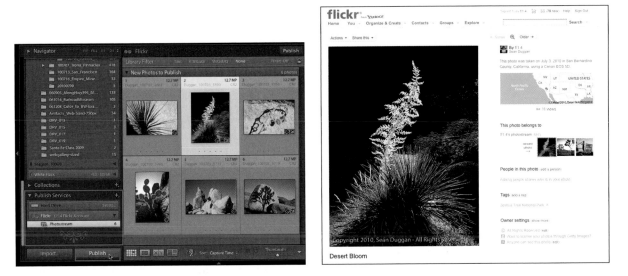

**Figure 10.20** *Using Lightroom 3's Publish Services, the photo of the desert bloom is selected and published to Seán's Flickr photostream. Lightroom sizes the image, sharpens it, and adds a copyright watermark.*

**Figure 10.21** *Lightroom 3 provides the ability to sync with your Flickr photostream where you can monitor and even respond to viewer comments.*

## Real World Digital Photography on Flickr

We have created a group on Flickr for readers of *Real World Digital Photography* to share your images, techniques, and experiences as you explore this book and the exciting world of digital photography. We invite you to post your images there and join the community. It's a great way to get to know other photographers and get feedback on your images. The three of us will be stopping by from time to time to add some of our own photos, as well as create discussion topics and join in on the conversation. You can find the Flickr group by pointing your Web browser to www.flickr.com/groups/realworlddigitalphotography.

## Photo portfolio/E-commerce sites

There are also a number of photo portfolio Web sites that will host a professional-looking online gallery of your work. Many also offer e-commerce functionality, allowing you to use the site to market prints of your photos, provide purchase links for electronic personal use downloads, and sell licenses for royalty-free or rights-managed stock (typically there is an additional fee on any sale based on a percentage of the price or licensing fee). Most sites that provide such high-end functionality are fee-based, such as PhotoShelter (photoshelter.com), which offers a range of different plans that you can subscribe to either monthly or annually. For this fee you do get a high degree of flexibility and customization, as well as the ability to integrate your own HTML and CSS coding to combine your unique Web site design

with all the features and functionality that Photoshelter offers. Although HTML customization is a possibility, you do not need to have any Web coding experience to use the service. Photoshelter provides a variety of portfolio templates that you can use (**Figure 10.22**), as well as an export module for Lightroom and Aperture.

**Figure 10.22**

*Idaho photographer Mike Shipman uses PhotoShelter to power the galleries, preview pop-ups, e-commerce functionality, and home page slide show on his Web site blueplanetphoto.com.*

Other sites, such as ImageKind (imagekind.com), are directed less at professionals and more at casual hobbyist photographers who are looking for an easy way to sell prints and other products generated from their images. These sites generally offer a basic service for free and then more customizable plans that can be purchased on a monthly or yearly basis. The Web site company handles all the product fulfillment and financial transaction aspects of the order. The cost for this service is covered in the wholesale price of an item, but there may also be an additional fee on any sales based on a percentage of the sales price.

## Sizing Files for Online Prints

Many photo sharing sites such as Shutterfly (shutterfly.com) or Snapfish (snapfish.com) allow viewers to order prints of your photos. This is a great way to share images that family members or friends may be interested in viewing or purchasing as prints for their own photo albums, frames, or refrigerators.

If you do want to sell prints through an online service, either for personal purposes or to market your work through professional photo portfolio sites such as Photoshelter.com, you will need to upload a file that has enough pixel information to make the largest print size that you will be offering. For example, an 11x14-inch print will need to be sized to 11x14 inches at a specific resolution (dots per inch, or dpi) so that it contains enough information to make a good print at that size. The exact resolution setting may vary from vendor to vendor depending on the type of printed output that is being made, but a print resolution between 240 and 300 dpi is usually a safe bet for most purposes. Those Web sites that also offer a printing component should have an FAQ or support page that addresses the ideal resolution requirements for the printing service they offer. In most cases, the largest print-sized version of the file will also be used to generate files for smaller print sizes, as well as thumbnails or larger display versions, but you may also be able to upload your own customized display versions.

## Automated Photo Web Galleries

Online photo sharing Web sites provide a simple and convenient way to provide access to your images, but they don't offer the degree of control you enjoy when you create your own Web site. With your own site you can design the pages exactly the way you want them, which means you can customize the presentation of your images.

Not every photographer, however, is well versed in the technical nuances of creating a Web site. Fortunately, there are automated Web gallery solutions available that make it easy to put together a great-looking gallery of your images. Besides automating the tasks of creating an index page of thumbnails, creating all the pages where the larger versions are displayed, and

linking all of them together, these software tools also automatically resize your images so you don't need to prepare them ahead of time. Once the Web gallery is completed, you can upload the pages and associated image files to your Web site, and make them available for all (or just a few, if you password protect the folder) to see.

## Lightroom Web photo galleries

Lightroom's Web module offers a range of tools that allow you to easily create a professional-looking Web gallery of your images. Several existing template designs for both HTML and Flash-based galleries are included, as well as the ability to modify the settings and create your Web gallery templates. And the best thing is that you do not need any Web coding experience to use these features to create efficient and attractive Web galleries (**Figure 10.23**).

**NOTE** The Web galleries that Lightroom creates need to be uploaded to existing Web server space that you have access to and control over. If you already have a Web site, the functionality offered by Lightroom is a convenient way to easily add new galleries of images to your site. It is important to note, however, that each gallery is a separate entity that is not linked to any of the other sections of your Web site. You will also need to create an index page listing the different galleries that you have created via Lightroom and update this as you add new galleries.

**Figure 10.23**
*A Flash-based Web gallery created in Lightroom 3.*

Using the Web module in Lightroom to create a gallery of your images can be broken down into four main steps: choosing the images; selecting a template and/or modifying the settings to create a new layout; previewing the finished gallery; and uploading the gallery files to your Web server. Let's take a closer look at this process:

1. **Create a collection for the images.** If your Web gallery will consist of photos from many different folders in your image Library, the easiest way to work with them in the Web module is to gather them together into a collection. The Collections pane is available to you when working in the Web module.

2. **Double-check metadata.** Before diving into choosing a template, stay in the Library module a bit longer and take some time to double-check the metadata for each of the images. Make sure that each file has the appropriate copyright notice associated with it. If you have Lightroom configured properly, the copyright notice should be added to your files as they are downloaded from the memory card, but it's good to verify this before publishing them on the Web. Additionally, some of the Web galleries can use other metadata, such as the title of the image. If you want Lightroom to automatically use the title in the metadata as the display title for the image in the Web gallery, make sure that each photo's title is correct (**Figure 10.24**).

**Figure 10.24** *Lightroom 3 can access the title that is stored in the metadata and use that to create a title on the page where the larger version of the photo is displayed.*

3. **Choose a template.** With your images chosen and the metadata double-checked, you can click on the Web module and browse through some of the templates that ship with Lightroom. The Template Browser is on the left side of the Web module. As you mouse over the name of a template, a small preview appears above. Clicking on a template will generate a preview in the main content area in the center of the interface. In the small preview above the list of templates, Flash-based templates are identified with an italicized *f* and HTML templates are labeled HTML (**Figure 10.25**). Even if your plan is to create your own look and feel for the Web gallery, it makes sense to let the program do most of the heavy lifting for you by choosing a template that is close to what you want. Once you have selected the template, you can then edit the individual settings to customize the settings to suit your needs.

4. **Input Site Info.** After you have chosen a basic style for the Web gallery, go to the Site Info section on the right side of the Web module and enter the pertinent information for your gallery. This includes the site title, collection title (if any), collection description, contact info, and a link for your email account or your main Web site. The Identity Plate option can be used if you have already specified a graphic, such as your logo, for Lightroom to use as an identity plate, or you have created a custom text identity plate (**Figure 10.26**).

**Figure 10.25** *Small thumbnail previews are generated to give you a rough idea of what each template will look like.*

**Figure 10.26** *The Site Info settings for this HTML gallery allow for the addition of a custom identity plate (top left), as well as a title for the collection and an email link for visitors to inquire about print sales or image licensing.*

**Figure 10.27** *The Color Palette settings.*

**5. Modify the Color Palette.** The Color Palette group of settings allows you to modify the color palette for the Web gallery (**Figure 10.27**). If you are satisfied with the colors in the existing template that you started with, there is no need to change these.

**NOTE** The settings that are available may be different than those shown here, depending on which template you are modifying. Not all aspects of the template may be able to be modified.

**6. Change the Appearance.** The options in the Appearance section will vary depending on the template you are working with. For a grid-based HTML template, you can change the number of rows and columns in the grid in addition to other settings such as drop shadows and borders for the photos, cell numbers (numbers that appear behind the thumbnails), and the size of the images for the individual photo pages (**Figure 10.28**). For a Flash template, you can only add an identity plate and control the size of the large images and thumbnails (**Figure 10.29**).

**Figure 10.29**
*The Appearance settings for a Flash template.*

**Figure 10.28**
*The Appearance settings for an HTML grid template.*

**7.** **Add Image Info.** The Image Info section is where you can access specific information in the metadata for each file (**Figure 10.30**). To use the example mentioned earlier, if you choose to show the image title, it will be displayed on the individual image page (**Figure 10.31**). You can choose from several items that can be displayed, including a caption, custom text, date, equipment, exposure, filename, and sequence. Using the filename would be useful if you were posting images for a client to review.

**Figure 10.30** *The Image Info settings with the Title option selected.*

**Figure 10.31** *The title in the image's metadata is used to add the title to the page that displays the larger version of the photo.*

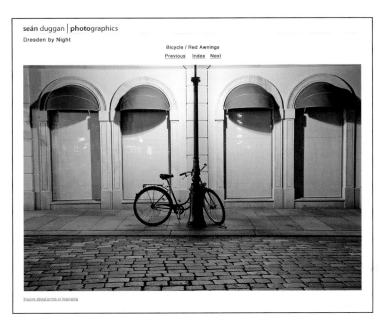

**8.** **Select Output Settings.** The exact options presented in the Output Settings panel will vary depending on the type of gallery you are creating (**Figure 10.32**). In the HTML gallery used in this example, this is the area where you specify the JPEG Quality settings for the larger images, the level of sharpening that is applied, as well as whether or not they will have a copyright watermark (**Figure 10.33**).

**Figure 10.32** *The Output Settings options.*

**Figure 10.33** *Copyright information from the file's metadata is added to the larger version of the photo.*

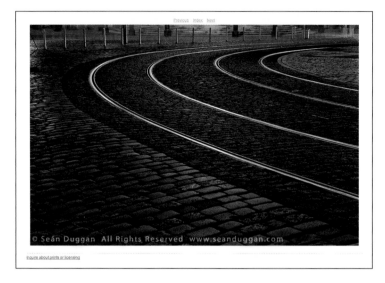

9. **Specify the Upload Settings.** The Upload Settings section is where you enter the FTP (File Transfer Protocol) information required for Lightroom to access your remote Web server (**Figure 10.34**). Different locations on your Web site can be saved as presets, making it easy for you to upload images to different areas of the site. You can also specify different subfolders for each new gallery, which makes it easier to send a client a link after the files have been uploaded. For example, if you have a saved FTP preset configured to upload photos to a folder called *yourwebsite.com/clients*, you could then create a subfolder with a specific client's name and the photos would be place in that subfolder within the clients folder (**Figure 10.35**). You could then email your client a link to access the photos, such as *www.yourwebsite.com/clients/smith*.

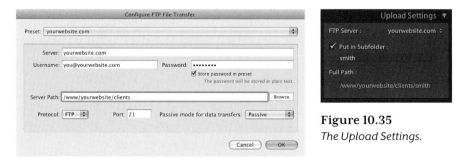

**Figure 10.35**
*The Upload Settings.*

**Figure 10.34** *The Configure FTP File Transfer dialog.*

### Testing the Web gallery

Although you can preview the photo gallery directly from within the Lightroom Web module, it's always a good idea to view it in a Web browser before you actually upload it to your site. To do this, click the Export button at the bottom-right corner of the Web module. Choose a location for the exported files, and Lightroom will process all the images and create the necessary Web pages and supporting files needed for the Web gallery. Keep an eye on the progress bar in the upper left of the Lightroom interface because this operation can take several minutes depending on how many files are involved.

When the export process is complete, locate the Web gallery folder on your computer (**Figure 10.36**), and open the index.html file into your favorite Web browser. Click through all the pages and make notes of anything you want to change (wrong titles, a slight adjustment to the size of the larger images, text color, etc.). With your change order in hand, return to Lightroom and make the necessary changes. Export another version of the gallery to proof once more in a browser before returning to Lightroom to upload the final gallery to your Web site.

**Figure 10.36** *The exported folders and files for the Web photo gallery created by Lightroom.*

### Saving a new Web gallery template

If you like the resulting template that you created, consider saving it as a custom template so you can easily access it in the future. To save the current settings as a new template, go to the top of the Template Browser on the left side of the Web module and click the plus button. Choose a name for the template and click Save (**Figure 10.37**). The new template will then be a choice in the User Templates section or in another folder if you have chosen to create one (**Figure 10.38**).

**Figure 10.37** *Saving a new Web gallery template.*

**Figure 10.38** *The new template in the Template Browser.*

# Airtight Gallery Options

In addition to the HTML and Flash designs that you can choose in the Template Browser, there are three other possibilities that can be found in the Layout Style choices in the upper-right corner of the interface. These are Flash-based plug-ins designed by Airtight Interactive that will create a specific style of Web gallery (**Figure 10.39**). You can't really change much about their appearance (and for some people that may be a plus!), but one of them may work well for the gallery you want to create.

- The **AutoViewer** displays the images in a linear sequence. You can click on the left or right side of an image for the next or previous image, or you can play all the photos as a slide show (**Figure 10.40**).

**Figure 10.39**
*Flash viewers from Airtight Interactive are also provided in the Lightroom Web module.*

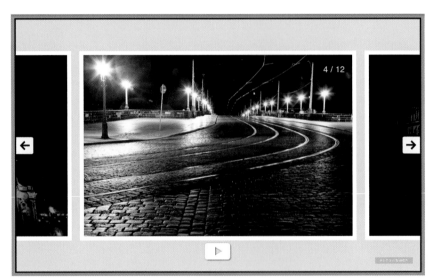

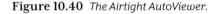
**Figure 10.40** *The Airtight AutoViewer.*

- The **PostcardViewer** displays the thumbnails as if they were postcards casually arranged in a slightly uneven grid. Clicking on a thumbnail zooms in to show you a large version of that image (**Figure 10.41**). The PostcardViewer can be fun the first few times you see it, but once the novelty wears off the effect can become a bit tiresome.

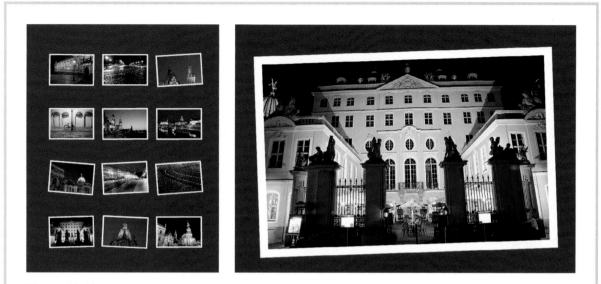

**Figure 10.41** *The Airtight PostcardViewer.*

• The **SimpleViewer** shows a grid of small thumbnails on the left with a larger version of the active image on the right (**Figure 10.42**). If you are interested in obtaining more customizable stand-alone versions of these Flash image galleries, check out simpleviewer.net.

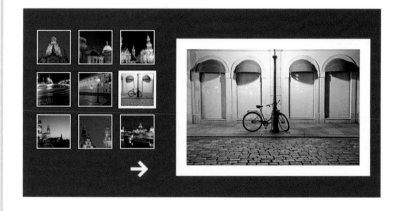

**Figure 10.42** *The Airtight SimpleViewer.*

## Adobe Bridge Web Photo Gallery

If you do not have Lightroom but instead have Photoshop CS4 or later, you can use the Output features in Adobe Bridge (which comes with Photoshop) to create Web photo galleries. The available templates and options in Bridge are not as extensive as those found in Lightroom, and the previewing is a bit clunky, but with a little patience you can generate very serviceable Web galleries using Adobe Bridge.

Start by either gathering the images for the gallery into the same folder or grouping them into a collection. Then choose Window > Workspace > Output. Select all the thumbnails that you want to use in the gallery. At the top of the Output pane on the right, click Web Photo Gallery, and then choose a Template and a Style. Click the Refresh Preview button to generate a preview of the Web gallery (**Figure 10.43**). You can also choose to view a preview in a Web browser.

**Figure 10.43** *The Output workspace in Adobe Bridge CS5 offers similar Web gallery features to those found in Lightroom.*

When the preview is displayed, work your way down through the scrolling panel on the right side and change the different options as needed. The available settings and controls are very similar to those found in Lightroom. You will not see any changes in the preview area unless you click the Refresh Preview button again (that's what we mean by the preview function being "clunky"). When you're satisfied with the way the gallery looks, you can

either click Save to export the folders containing the gallery, or click Upload to send the gallery directly to your Web server (just as in Lightroom, you need to enter the necessary FTP information to upload the gallery files).

### Other Web gallery software

Adobe Photoshop Elements 8 includes some highly stylized templates for online albums, many of which include detailed backgrounds and Flash-based animation. Start in the Elements 8 Organizer to select a collection of images you want to post, and click the Share button. Then click Change Template to choose from a variety of online album styles. Depending on the style you choose, there are many ways to customize the album. Although these interactive animated galleries are not what professional photographers would be interested in, there's no denying that they are quite fun for photos of the family vacation or your kids' birthday parties.

In addition to Photoshop Elements, many other image-management software tools include the capability to create online photo galleries. Some enable you to modify existing templates and define your own templates. A few of the programs that allow you to create your own Web photo galleries include Photo Mechanic (camerabits.com), ACDSee (acdsee.com), and iPhoto (apple.com/ilife/iphoto/).

# Protecting Photos Online

Protecting your photographs from unauthorized use is an important aspect of reinforcing the value of your images. For photographers to maintain the value of their images, they must control the use of those images. In the film-based past, the risks of unauthorized duplication of photographs weren't very high. If someone saw your image, it was likely as a print on the wall or in a magazine, and making a high-quality copy of that print wasn't very effective.

The digital world, and especially the Internet, provide new opportunities for your images to be duplicated without your permission, and those copies may be of identical quality to the original. Because online digital image files can easily be copied, they need to be protected. One way to do this is to make it as difficult as possible to copy the images and reuse them. You can also lay the groundwork for mounting a successful legal claim should your copyright be infringed upon.

**NOTE** If you remember the Web Photo Gallery feature from previous versions of Photoshop and wonder why you can't find it in Photoshop CS5, that's because the Web gallery functionality was removed from Photoshop in CS4 and added to Adobe Bridge.

# Copyright

Copyright is a legal form of protection for any original artwork expressed in a tangible form. This includes works such as books, poetry, paintings, movies, and of course, photography. Simply by virtue of the fact that you created your photographic images, you own the rights to those images. Owning the copyright means you own the exclusive rights to use and profit from your creation. Your work cannot be used by anyone else without your specific permission. Only you, the copyright holder, have the legal right to copy (in other words, sell and profit from) the image.

Any work—such as a photograph—that is eligible for copyright protection is considered protected as soon as it is created. As soon as you take a picture, it's protected by copyright law and belongs to you. To increase your chances of successful litigation against someone who uses one of your images without permission, it is absolutely essential to register your images with the United States Copyright Office. You don't have to register your images for them to be protected by copyright law, but in case your images are used without your authorization, your claim of image ownership is easier to establish, and damages and attorney fees are much easier to collect if the image has been registered.

## Copyright registration

**NOTE** Commercial photographer Seth Resnick tells us, "The best part of registering a copyright is that when there is a dispute, the potential for litigation leads to a settlement. When an opposing attorney knows that the images are registered, they will likely settle right away because resolving disputes is always better than fighting them."

Registering your images provides a number of benefits. It establishes a public record of your claim to copyright for the work. It also satisfies the requirement that your work be copyrighted *before* you file any infringement suit. In addition, when your copyright has been formally registered, if you are successful in pursuing legal action against an infringer, you are entitled to up to $150,000 per infringement plus attorney fees. If you haven't registered the images prior to an unauthorized publication or use, you can still sue (once you've registered the image after the fact), but only actual damages can be awarded, and that can be very difficult to assign a value to. To underscore the importance of copyright registration, it is nearly impossible to find an attorney who will take a case to court without the registration. Seán once spoke with a copyright attorney and was told that the first thing attorneys will ask you when you come to them with a possible case of infringement is, "Have you registered the copyright?"

Fortunately, registering your images with the U.S. Copyright Office online is easy. You must submit a copyright application form, a nonrefundable filing fee (currently $35 per application if you register online or $50 per application if you send in a hard copy of the registration), and a copy of your images. With electronic copyright registration, submitting copies of your image files is as simple as uploading a compressed ZIP archive of small (400x400 pixels) JPEG files (conventional filing requires submitting a CD or DVD of the digital files). A single application can contain literally thousands of images.

After you submit your registration application and the nonrefundable filing fee, and upload a copy of your images to the U.S. Copyright Office Web site (copyright.gov), the application will be processed. You will then receive a certificate confirming the registration of your images. It usually takes six months to receive a certificate for electronic filing, although you may receive it in less time. Conventional paper applications can take as long as 22 months to receive the certificate (all the more reason to file electronically!). Note that your images are considered registered/protected when you complete the application, not when you receive the certificate many months later.

We recommend filing for copyright registration for all new images as soon as you return from a photo trip. If this is not practical, create duplicate copies of your images for copyright registration, and set them aside for future registration. Then submit the images on a regular schedule (for example, many photographers file copyright at the end of the month or every 90 days). For maximum copyright protection, images should be registered as unpublished before they are posted anywhere. If images are published, they should be submitted for registration by the photographer or by any third party to whom the photographer has assigned rights (for example, stock agencies generally handle the registration in the photographer's name).

More details about registering your images with the U.S. Copyright Office, along with other valuable information about copyright protection, are available at the U.S. Copyright Office Web site (copyright.gov). Another great resource for photographers is The Copyright Zone (copyrightzone.com), a blog run by successful commercial photographer Jack Reznicki and leading copyright attorney Edward Greenberg.

**TIP** Lightroom's Export dialog, discussed earlier in this chapter, is an excellent way to batch process files for copyright submissions.

**TIP** Jack Reznicki and Edward Greenberg have authored an incredibly useful book titled *Photographer's Survival Manual: A Legal Guide for Artists in the Digital Age* (Lark Books, 2010). It covers all the important legal issues that photographers need to know (and all too frequently don't!).

## Size Restrictions

Keeping the size of your images small is probably the number one way to discourage unauthorized use of your images. This won't completely stop would-be thieves from taking them, but it will limit what they are able to do with them. An image size of 700 by 467 pixels for the Web translates into an image that would only print at approximately 3 by 2 inches with good quality. The image could be interpolated to a larger print, but large prints of excellent quality won't be possible. Saving images in the JPEG format will also leave compression artifacts in the image, further ensuring that large prints won't look good.

We recommend keeping your images sized to 700 pixels (or smaller) on the long side for Web site viewing. For a monitor set to 1024x768, a 700-pixel image will consume approximately one-half of the available space on the monitor. If you need to provide larger images, be aware that someone could print those larger images at larger sizes. For any images that you feel must be seen at a larger size, a visible watermark is a good idea.

## Visible Watermark

A watermark is a visible mark on the image that discourages viewers from using it by making it clear that the image is protected by copyright. The disadvantage is that a visible watermark adds a visible, and in many cases irritating, element to your image that most photographers would rather avoid. The picture was taken to show the scene depicted, not to emphasize who holds the copyright. For this reason, most photographers avoid using a visible watermark or limit themselves to using a smaller, understated watermark that appears along the lower edge of the photo.

However, if you decide that using one works for your purposes, you'll get the maximum deterrent effect by using a watermark that covers a significant portion of the image. A popular example is to place a partially transparent copyright symbol or your logo over a large area of the image (**Figure 10.44**). To soften the appearance of the watermark text, reduce the Opacity setting for the watermark options in Lightroom or the opacity on the type layer if you are using Photoshop to create the watermark. This will allow the

underlying image to show through partially, reducing the visual impact of the watermark while maintaining its deterrent effect. The viewing experience is less than ideal, of course, but the image is certainly not likely to be stolen.

**Figure 10.44** *There is no mistaking that this image is copyrighted! The super-sized copyright symbol was added in Photoshop and styled with transparency and layer effects.*

An alternative is to put more discreet text listing the copyright holder in a corner of the image, leaving most of the image clearly visible (**Figure 10.45**). Or, if you don't want a watermark to block any of the image, you can enlarge the canvas in Photoshop and put the watermark text outside the image area. This is a reasonable solution if you want to allow the viewer to see the whole image, but it's also easy for a talented image thief to crop your watermark out of the image or to retouch it with the Clone Stamp tool in Photoshop. If legal action is required at some point, it is easier to demonstrate that the image was willfully stolen as evidenced by the cropping or retouching of the watermark.

**NOTE** Downloading another photographer's images, whether they're water-marked or not, and cropping them or changing them in any way is against the Digital Millennium Copyright Act.

**Figure 10.45** *A more subtle copyright watermark.*

Copyright 2010 Seán Duggan - All Rights Reserved

## Customizing watermarks in Lightroom

As we discussed earlier in the section on exporting images from Lightroom, you can use that program to easily add a visible copyright watermark to your images. The options range from a simple watermark that is based on the copyright notice in the file's metadata to custom watermarks that you can create and save, or even graphic files such as your logo or the classic copyright symbol. Here's how to customize the copyright watermark in Lightroom 3:

1. In the Export dialog (File > Export), select the preset you want to use. Then go to the Watermarking section of the Export Settings, select the Watermark check box, and choose Edit Watermarks (**Figure 10.46**).

**Figure 10.46** *Preparing to edit a copyright watermark.*

| ▼ Watermarking | Basic Watermark–no date– web URL |
| ☑ Watermark: | ✓ Simple Copyright Watermark |
| ▼ Post-Processi | Edit Watermarks... |

2. In the Watermark Editor you can modify a variety of settings to control the placement and visibility of a text-based watermark. You can even type in new custom text and preview the effect for every image that is being exported (**Figure 10.47**). If you make changes that you want to keep, you can save the current settings as a new Watermark Preset.

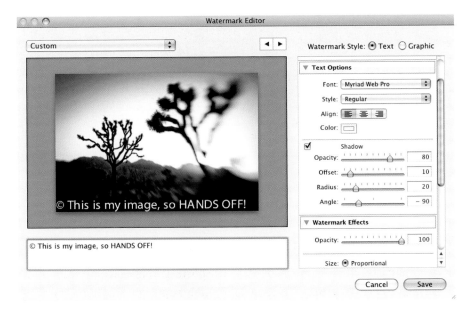

**Figure 10.47** *Creating custom copyright text in the Watermark Editor.*

3. If you want to use an image as a watermark, you first have to prepare a file that can be used for this purpose. Lightroom accepts two formats for watermark images: JPEG and PNG (this is where the PNG-24 format's ability to save transparency comes in handy). Use Photoshop or another image editor to prepare a watermark file and save it as either a JPEG or a PNG file. The size should be as wide as you expect your largest Web images to be. In the example shown in **Figure 10.48**, the watermark graphic is approximately 600 pixels wide.

4. Under Image Options at the top of the Watermark Editor, click choose or click the button for Graphic at the top of the dialog. Navigate to where you have saved your watermark file and select it. Click Choose to return to the Editor for further styling of the watermark. Scroll down to Watermark Effects for opacity, size, and positioning options.

**Figure 10.48** *A custom graphic placed as a copyright watermark.*

## Invisible Watermark

If you don't want a visible mark on your images, but you still want to mark them as yours, an invisible watermark provides a possible solution. The most popular option is the Digimarc plug-in from Digimarc Corporation (digimarc.com). This plug-in embeds in the image a watermark that holds key information about the copyright holder. This won't deter theft, but it will help you establish that an image is yours and was taken without permission.

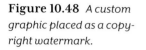

**NOTE** As of this writing the Digimarc plug-in is only available for Photoshop and Photoshop Elements.

The Digimarc plug-in actually changes the pixel values of your images slightly, so that information can be embedded into the image. You can use a plug-in that's included in Photoshop to read the watermark so you'll know who the owner is, and the copyright symbol will be included in the title bar of the image. Because pixel values are changed, the image can get a bit soft and grainy if too strong of a watermark is applied. The plug-in can vary the strength of the watermark. A more durable watermark causes a more visible loss of quality in the image, but it helps to ensure that even with adjustments to the image the watermark data will remain intact.

To apply an invisible watermark to your images using this plug-in, you must sign up for a subscription service from Digimarc. Prices range from $49 per year for the Basic subscription, which allows up to 1000 images; $99 per year

for a Professional account, which covers up to 2000 images; up to $499 for a Small Business account, which covers up to 5000 images. The Professional level and above also provide the Digimarc Search Service, which crawls the Internet, constantly searching for images with your watermark and actively seeking Web sites that have infringed on your copyright. If you appreciate the benefit of having your images tagged with your information so that those who save your images can view copyright data, then Digimarc provides a solution.

Of course, you can always add your copyright notice to the metadata for your images, but that won't help you ferret out any possible infringement that may be taking place elsewhere on the Web. For most photographers, the actual benefits are minimal. As the old saying goes, locks keep honest people honest. In reality, most people who have a mind to steal an image and use it without permission aren't going to bother checking for a Digimarc tag.

## Web Programming Protection

For more advanced users who want to provide the maximum protection possible for their online images, there are programming options for your Web site that can help protect your images. These methods include using mouse rollover images, disabling the right-click option that allows viewers to save images, and using plug-ins that limit the ability to view images without permission:

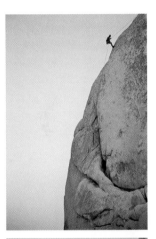

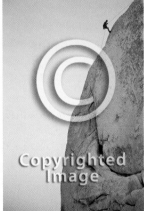

**Figure 10.49** *Image protection via a mouse rollover effect: The nonwatermarked photo is replaced with the watermarked version when the user's mouse moves over the image.*

- **Rollover.** Mouse rollovers display a different image when the mouse is moved over an existing image on a Web page. This is typically used to show that a button is active when the mouse moves over it, but it can also be used as a form of image protection. By replacing the regular image with a watermarked version when a mouse moves over the picture, it prevents the user from right-clicking to download the image (**Figure 10.49**). Rollovers are created by JavaScript, and they can be complicated to code directly into the HTML of a Web page. But most modern Web-authoring programs let you easily define rollover states for an image with a different image visible for that state. All you have to do is create the different versions of the image.

- **Disable right-click.** For users who don't mind doing a little custom programming for their Web pages, some JavaScript routines provide several ways to protect your images. The most common disables right-clicking of the mouse, which is a common way for viewers to access the

Save Image option of their Web browser. This can deter some users from stealing images but can also be frustrating for visitors who use the right-click option to navigate on a Web site. Another variation on this theme is a JavaScript pop-up message alerting the viewer that the image is copyrighted and prompting them to acknowledge this, such as the example from Seth Resnick's Web site in **Figure 10.50**. Of course, savvy users can quickly defeat this security measure by turning off JavaScript support in their browser preferences, but there are other reasons that Resnick displays his photographs this way: "Each of my images are actually in a frame. The frame is really there because it has my copyright notice and contact info. While it is true that anyone can still steal and while it is true that they could simply cut the image out of the frame, the important part is that the frame is viewed legally as encryption and any act to alter it is a willful violation of the Digital Millennium Copyright Act."

**Figure 10.50** *Commercial photographer Seth Resnick (sethresnick.com) uses a visible frame with his copyright notice and contact info combined with this JavaScript pop-up message when you right-click on an image.*

- **Flash galleries.** One advantage of a Flash Web site is that you cannot right-click on an image and save it to your hard drive. For this reason alone, many photographers prefer to use the Flash format for their Web galleries.

One detail to keep in mind is that all the methods just discussed are powerless against a very basic workaround: the screen capture. By using screen capture software to take a picture of the screen, anyone can capture your low-resolution images from your site, either by capturing the entire screen or defining a capture of just the currently displayed image. And that brings up the hard truth about posting your images online: There are limits to how much protection is possible, but as long as the image size is small there are also limits to what a thief can do with the file.

## Limits of Protection

It is important to keep in mind that you can only do so much to protect your images online.

As mentioned earlier, our recommendation is to keep images small enough so they can't be used for traditional publications or to produce prints of high quality, and to use a subtle watermark to indicate that the images are protected by copyright. Of course, that does not stop some people from using your images for onscreen use, such as on their own Web site or for multimedia use. Although more aggressive methods of protecting your images exist, they either require a significant investment of time and money, or they create an inconvenience and an annoyance for those who visit your Web site to see your images, or both.

Sharing your images on the Internet involves a certain amount of risk. But it also offers many benefits, including increased exposure for your work, the opportunity for meaningful social and professional connections, and the possibility of additional sales. Both Katrin and Seán have sold prints and image usage rights of photos that they have placed on their Web sites or blogs that they thought no one would be interested in!

**NOTE** Due to the current Apple position that Flash will not be supported on the iPhone or iPad, many photographers are faced with the dilemma of reworking their Web sites to HTML5 standards.

**NOTE** Katrin has received emails from complete strangers notifying her that her images were being used or posted without her permission. She followed up with the offending Web site owner and demanded that the images be removed—so far this has worked every time.

# Digital Slide Shows

Digital slide shows are a great way to share your images among groups of people, from small or intimate gatherings of family and close friends to a more formal presentation given to a roomful of many people. A slide show can take place on your laptop, be presented on your TV, or be projected onto a large screen.

Digital projectors allow you to take your images to any audience and share them with great flexibility. When the only projectors available were slide projectors, most photographers settled for showing one image at a time with no transitions between images. Those who wanted to invest the time and money in more advanced solutions created custom slide mounts and used multiple projectors with a dissolve unit to combine and transition between images.

Digital projectors provide the basic capability of a slide projector, namely projecting an image onto a screen. But since they are transmitting the signal from a computer, you also have all the possibilities of modern digital imaging and presentation software. You can include multiple images on each "slide," use remarkable transition effects between images, easily synchronize images with music, and even include video clips in your show.

## Preparing Photos for Projection

Getting your images ready for a projected slide show is identical to the process of preparing images to share on the Internet or via email except that the size of the images will be different. The reason is that a digital projector behaves essentially the same way as a computer monitor except that it's projecting an image to be displayed on a screen or wall rather than directly on a monitor.

The size of the images will depend on the resolution supported by the digital projector you'll be using. The computer running the slide show must also support that resolution, but that shouldn't be a problem. Most computers support much higher resolutions than today's digital projectors offer.

Most digital projectors currently offer WXGA (1280 by 600 pixels) or XGA resolution (1024 by 768 pixels) with some of the lower-end models topping out at SVGA (800 by 600). SVGA is fine for shows being presented to a small audience on a small screen, but WXGA or XGA will provide a higher-quality and a more detailed image that will translate better on a larger screen.

These higher-end projectors are also much more likely to be closer to the native resolution of the laptop you are using to present your slide show (although display resolutions on laptops can be easily changed to fit the requirements of a given projector). When you know the resolution of the final projected image, you know the maximum dimensions possible for your images. For example, if you're using an XGA digital projector, you'll want to size your images to fit within 1024 pixels wide by 768 pixels tall. If you will be including borders or backgrounds behind the images, the total area of the visible slide including borders or backgrounds would be 1024 by 768 pixels.

For projected display, the output resolution (dpi) doesn't make any difference. Only the pixel dimensions affect the size and detail of the image in the projected display. However, with some of the software used to build digital slide shows, the image will be sized properly only if it's set to an approximate display resolution. In those situations, you'll want to set the output resolution to 72 dpi for Macintosh and 96 dpi for Windows. We are in the habit of setting this output resolution just to be sure the images are sized properly before we place them in the slide show. You can always resize the image once you've placed it in the software with no loss of quality, since the wrong resolution just means the image will be scaled incorrectly. However, it's much more convenient to have it sized properly to begin with.

We still recommend converting the image to the sRGB color space and sharpening the image to optimize its appearance on your monitor, just as we explained earlier in this chapter for preparing your photos for online sharing.

To help achieve optimal performance for the slide show, the image pixel dimensions should be the same as the resolution of the projector. Large files require more processing and with some slide show software can cause problems such as delayed or slow transition effects. We therefore recommend saving the images as JPEGs with a Quality setting of about 8–10. This will provide excellent image quality with a reasonably sized file.

**NOTE** Not all slide show software requires that you resize your images. Some programs, such as Lightroom, may be able to resize the projected file on the fly from larger files.

## Slide Show Software

With your images chosen and prepared, you're ready to create the actual digital slide show. Many software tools do this job, and all provide the same general capability to create a basic slide show presentation. Where they differ is in the additional capabilities they offer. Some programs offer advanced features such as showing more than one image on the screen at a time,

applying various transition effects between images, synchronizing slides with music, and more. The right software depends in large part on the type of show you plan to present.

Each of the following software options discussed provides an excellent solution for creating slide shows; the best choice for you depends on the type of show you want to create, the software you may already have, and the features you need.

## Lightroom

Of the five modules in Lightroom, one is devoted entirely to creating slide shows, and this is the method we use for most of our image presentations. Although there are aspects of the process that are specific to slide shows, the basic steps have a lot in common with creating a Web photo gallery:

1. Choose the images and arrange them in a Collection (**Figure 10.51**).

2. Sequence the images for narrative and visual effect.

3. Choose a slide template to start with.

4. Customize the look and timing of the slides.

5. Add music (if desired).

6. Test-drive.

7. Present!

**Figure 10.51** *Arranging images into a Collection is the best way to create a staging area for a slide show.*

 **TIP** Ctrl-click (Command-click) on the small triangle next to one of the slide options to collapse the entire list (**Figure 10.52**). Then you can open them one at a time.

On the right side of the Slideshow module are the six different options for customizing the look of your slides: Options, Layout, Overlays, Backdrop, Titles, and Playback. Here's a rundown of how some of these settings can be used to customize the look of your slides:

- **Choose a template.** The slideshow templates that come with Lightroom are few compared to the extensive Web photo gallery templates it offers (**Figure 10.53**). The default template will give you a starting point that you can easily modify. Just as with the Web gallery templates, the preview above the list will change as you mouse over different templates.

- **Options.** These settings let you add a Stroke Border to the image as well as a Cast Shadow under the image (**Figure 10.54**). Available controls let you customize the color and width of the stroke and four different characteristics of the shadow. Keep in mind that if you are starting with the default template, which has a black background, you will not be able to see the shadow. Background color can be changed in the Backdrop panel. If you want the image to fill the entire slide area with no background, select the Zoom to Fill Frame check box, although this may crop the image.

**Figure 10.52** *Ctrl-click (Command-click) on a triangle button to collapse all the options.*

**Figure 10.53** *The Slideshow Template Browser.*

**Figure 10.54** *The options for adding a stroke or a cast shadow.*

- **Layout.** This is where you control the size of the image within the total area of the slide, as well as its placement (**Figure 10.55**). By default it is centered, and all the controls are linked, so that moving one slider affects all the sliders, keeping the image centered. Click on the small squares next to each control to adjust each one independently. This allows you to create slides with an off-centered placement of the image (**Figure 10.56**). Click the Link All button to restore to a centered placement.

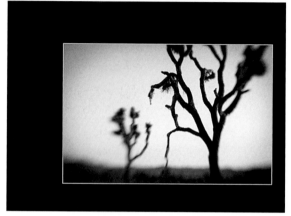

**Figure 10.55** *The Layout sliders control the size and placement of the image within the frame.*

**Figure 10.56** *Who says that images always have to be centered? Sometimes, an off-center approach may work well for a particular group of images.*

The Show Guides option in the Layout panel will display guidelines relative to the edges of the image that are the closest to the edges of the slide (**Figure 10.57**). This can be useful for fine-tuning the placement of the image in the frame. Guides, even if left on, are not displayed when you play the slide show.

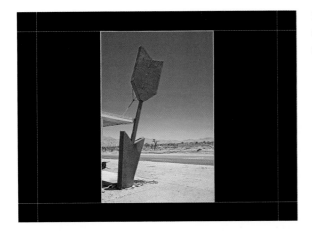

**Figure 10.57** *Guides can be useful for positioning the image within the frame.*

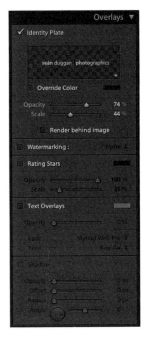

**Figure 10.58**
*The Overlays controls.*

- **Overlays.** This panel contains several settings; all of which let you add additional elements that can be placed as overlays on top of the slide (**Figure 10.58**). The first option lets you add your identity plate to the slides. Adjust the controls for Opacity and Scale to get the size and transparency just right, and then drag on the identity plate to position it (**Figure 10.59**). You may need to change the settings in the Layout panel to create a space for the identity plate.

**Figure 10.59** *Drag on the identity plate in the Slide Editor view to position it where you want it.*

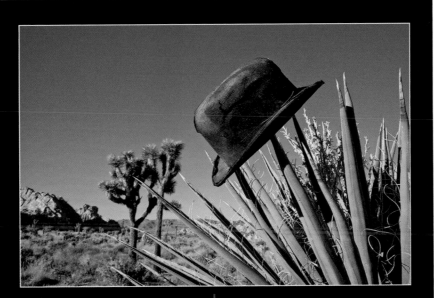

The remaining settings in the top half of the Overlays panel let you add a copyright watermark over the images, as well as display the star ratings associated with each file. This latter option can be useful if you are reviewing selects in a slide show format and want to see what the ratings are (**Figure 10.60**).

**Figure 10.60** *Star ratings displayed as an overlay.*

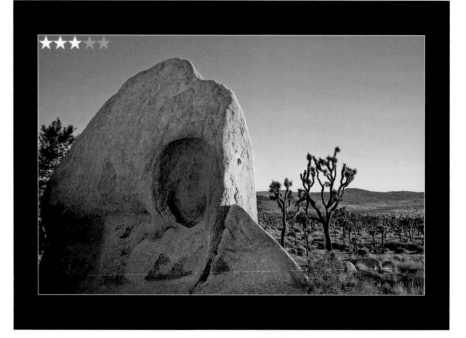

- **Text Overlays.** These settings are also found in the Overlays panel, but they merit their own discussion. Text overlays are very useful for displaying specific metadata that is associated with each photo, such as filenames, captions, and exposure info (**Figure 10.61**). If you are interested in adding a custom text overlay to the slides, however, you will undoubtedly experience some frustration with this feature. This is due to the fact that although you can add custom text, it is added in the *same position to every slide* in the presentation. We would love the ability to add custom text on a per slide basis, but unfortunately that functionality is not available in Lightroom 3.

195.0 sec at ƒ5.6

**Figure 10.61** *Exposure information displayed as a text overlay.*

If you want to use the Text Overlay feature to add information from a caption to the slide, it would seem logical that if only one image had a caption, then only one image would have an overlay based on the caption, right? Sadly, this is not the case. Even if none of the other images have a caption, they are defaced with the designation *<empty>* (**Figure 10.62**). Although there may be programming reasons that explain why this is not technically a bug, it is certainly something we'd like to see addressed in future versions of Lightroom. OK, we'll get off our soapbox now!

Once you accept its limitations, using the Text Overlay feature is fairly simple. At the bottom of the Slide Editor area, click the ABC button to show the Custom Text menu and the text box. This will automatically enable the Text Overlay button in the Overlays panel. To create custom text that will appear over all the slides, type in the text box and press Enter (Return). If you want to use specific metadata as the text overlay, open the Custom Text menu and select a metadata option. You can also choose Edit in this menu to display the Text Template Editor, which can be used to create a custom text string that can combine custom text with other metadata such as EXIF and IPTC data (**Figure 10.63**).

**Figure 10.62** *When using captions as a text overlay, images that do have a caption result in the expected overlay, but images with no caption are labeled <empty>.*

**Figure 10.63** *The Text Template Editor.*

Custom Text can be formatted in the Overlays pane and can be repositioned by clicking and dragging on it like you did earlier with the identity plate. Click and drag on a corner handle to scale the text larger or smaller. Multiple text boxes can be added to slides by clicking off of an active text box, then clicking ABC again, and choosing the new text options. To remove a text box, click on it to activate it and then press Delete.

- **Backdrop.** These options let you configure the background behind the image (**Figure 10.64**). Your choices include a Color Wash, which is a blend of

two colors (**Figure 10.65**), using a Background Image, or specifying a solid Background Color. To create an image background, select the Background Image check box and drag a photo from the Filmstrip into the Background Image area in the Backdrop panel. Customize it by modifying the Background Color and the Opacity for the Background Image (**Figure 10.66**).

**Figure 10.64**
*The Backdrop settings.*

**Figure 10.65**  *A color wash used as a background.*

**Figure 10.66**  *The Backdrop settings also let you specify an image for a slide background. In this example the Layout settings have also been changed to offset the main image against the background photo.*

**Figure 10.67** *The Title controls let you add a transition slide to the beginning and end of a slide show, but the name is a bit misleading.*

- **Titles.** The Titles panel is good evidence of misleading advertising. From such a name (dare we say "title"?) one would assume that you would be able to actually add a title to the beginning of your slide show. But such is not the case. All you can do is add a solid color slide to the beginning and end of your slide show to create a gradual transition into and out of the presentation (see the sidebar "Title Slide Workaround" for a sneaky way around this lapse in functionality). You can add your identity plate to the beginning and ending transition slides, but your only options for modifying this are scaling it larger or smaller and changing the color (**Figure 10.67**).

To activate this feature, select the check boxes for Intro Screen and Ending Screen in the Titles panel, and then choose a slide color by clicking in the color swatch. If you want to add your identity plate, select the check box for that. You can adjust the size of the identity plate with the Scale slider, and if you want to specify a new color for it, select Override Color and choose a new color.

> **TIP** For more control over title slides, create them in Photoshop or another image-editing program, and then import them into your Lightroom catalog so they can be added to the slide show.

- **Playback.** The final set of controls affects certain aspects related to the actual playback of the slide show (**Figure 10.68**). If you want to add music to the presentation, select Soundtrack and then navigate to your music folder to choose a song. Lightroom 3 only recognizes .mp3, .m4a, or .m4b audio files. The music will play when the slide show is viewed within Lightroom or when it is exported as a video file. Click Fit to Music to adjust the duration of the slide show to the length of the audio track.

If you have more than one monitor, you can specify which screen displays the slides and blank the other screen. Slide Duration controls the length of time each slide is displayed along with how long the transition is between each slide. Other options here will randomize the order of the slides, repeat the slide show on a continuous loop, and prepare previews in advance.

**Figure 10.68** *The Playback controls.*

# Title Slide Workaround

We do our best not to let software programming shortcomings or limitations stop us in our tracks. Where there's a will there's a way! Well, sometimes, at least. It didn't work for trying to add custom text to only one slide, but it did pay off for finding a way to create a custom title slide that really is a title. The trick is to create a custom identity plate that you can use as a title!

To do this, select the Add Identity Plate and Intro Screen check boxes in the Titles panel. Then click the small triangle button in the lower right of the identity plate preview area, and choose Edit from the menu (**Figure 10.69**). In the Identity Plate Editor, click Use a Styled Text Identity Plate, and then type the title of your slide show (**Figure 10.70**). Customize the font, weight, size, and color as desired (remember that the color can always be changed in the Titles panel). Click the menu in the lower left and choose Save As to save the title as a new identity plate. Click OK, and in the identity plate menu for the Intro Screen slide, select the title you just created (**Figure 10.71**).

**Figure 10.69** *Accessing the Identity Plate Editor in the Titles panel.*

**Figure 10.70** *Creating a custom identity plate that can be used as the title for a slide show.*

**Figure 10.71** *Applying the new slide show title identity plate to the intro screen title slide.*

**TIP** If you like the look of the slide show that you've created, save it as a new template so you can use it again without reapplying all the settings. Click the plus button at the top of the Template Browser to create a new template based on the current settings.

- **It's showtime!** Click the Preview button in the lower-right corner of the Slideshow module to preview the presentation in the center content area. You can use the pause button and left and right arrow buttons immediately under the preview area to interrupt the slides or move forward and backward. When you're ready to show it in full-screen mode, click on the first image in the Filmstrip and click the Play button. You can override the slide show playback settings by pressing the spacebar to pause and resume the presentation. The right arrow key will advance to the next slide, and the left arrow key will return to the previous slide. Pressing Esc ends the slide show and returns to the Slideshow module.

## Exporting a Lightroom Slide Show

Playing a slide show within Lightroom is probably the most convenient way to view it. But if you need to share it with someone else, run it on another computer that does not have Lightroom installed, or post it to your Facebook page, you'll have to take advantage of the slide show export options; all of which can be found in the Slideshow menu.

- **Export PDF Slideshow.** This option creates a PDF presentation that can be played back using the free Adobe Reader software. You can choose the size as well as the quality level of the slide show. PDF slide shows use a fixed duration for the slides, do not include fade transitions, and any soundtrack you have added in Lightroom is not supported.

- **Export JPEG Slideshow.** If you need to generate actual image files that incorporate any backgrounds or other styling you have created in the Slideshow module, you can export the slide show to a folder of JPEG files. This can be useful if you need to present the slides using other software applications, which often work by targeting a folder of images. Any intro and ending screen "title" slides are not exported as JPEGs because only actual image files are processed. You can import the rendered JPEG files back into your Lightroom catalog to have a streamlined version of the slide show that can be played back using a basic full-screen slide show template.

**TIP** At lower video resolutions, fade transitions between slides can appear slow and a bit blocky. If you know that you will be exporting a video version that requires a size of 480x320 or lower, set the fade duration to 0.0 seconds to remove the fade between images.

- **Export Video Slideshow.** Choose a video preset for the slide show and refer to the summary in the dialog to get a sense of which setting makes the most sense for what you want to do with the video (**Figure 10.72**). If you're viewing it on your own computer or burning it to a DVD, a larger

size is fine, but if you want to post it to a Web site, a smaller size is better. Slide shows are saved as H.264 MPEG-4 files and can be viewed on other computers using common media players such as Windows Media Player 12, Adobe Media Player, and Apple QuickTime Player. Exporting the slide show as a video will create a portable version of the slide show that has everything you see when it's played in Lightroom—music, fading transitions between slides, and intro and ending screens (**Figure 10.73**).

**Figure 10.72**  *The Export Slideshow to Video dialog.*

**Figure 10.73**  *The exported slide show as an MP4 video file viewed in the QuickTime Player.*

## Apple Keynote

At first glance, Apple Keynote (Macintosh only, apple.com/keynote/) may look like it was designed with only the corporate presenter in mind. However, it offers an excellent method for creating photo slide shows. It includes a number of predesigned themes to get you started, and lets you edit those themes or even build your own. You can combine multiple images into one slide and use its excellent dissolve and 3D transitions to produce an impressive slide show.

Katrin uses both Lightroom and Keynote for her image presentations. She has received many positive comments on the quality of the fades and dissolves in the Keynote presentations.

## Microsoft PowerPoint

Although Apple Keynote looks like it was designed for the corporate presenter, Microsoft PowerPoint (microsoft.com/office/powerpoint/) is indeed designed for corporate presentations. However, it can also be used to produce excellent digital slide shows of your images.

PowerPoint includes many themes and templates to help get you started quickly. It also gives you great flexibility as you design your slide layout. You can put multiple images on a single slide, and even have those images slide onto or off the slide based on specific event triggers. In addition, you can add text or shapes and even animate them. You can also add background music to your slide show.

These features are not typical slide show fare, but they do offer a way to add some creativity to your presentations. Photographers who create educational presentations will find these features invaluable. Those wanting to present a simple slide show of their photographs may find that all the bells and whistles add unnecessary complexity to the software.

## Photodex ProShow Gold

ProShow Gold (Windows only) from Photodex (photodex.com) provides a simple way to create slide shows quickly using a drag-and-drop interface to add images into the show timeline. You can also choose from more than 280 transition effects. In addition to still images, this feature-rich software

is also capable of integrating audio and video clips into its slide shows. Photodex also has a ProShow plug-in for Lightroom that lets you export images directly into ProShow Gold.

# The Benefits of Sharing

Sharing and presenting your photography to family, friends, students, fellow photographers, and interested audiences can be incredibly rewarding, not only for you, but also for those who get to see your images. It can also help make you a better photographer because—as all three of us know—it teaches you about your own photography and confirms what works and what doesn't. From this knowledge, you gain insights into how to make better images.

Any selection of images you share, whether it is a traditional portfolio box of prints, a digital slide show, or an online portfolio, is how you present yourself to the world as a photographer. The most important detail to keep in mind when choosing images to share is to only show your best work. Edit, edit, edit! Five good pictures will outshine 15 weak images every time. Edit for impact and sequence, and for rhythm and narrative. When someone is looking at your portfolio and enjoying your work, resist the urge to explain every detail, error, or back story associated with the picture. Photography is a visual language. Let your images speak for you.

# Get Out and Photograph!

After hundreds of pages, illustrations, and a wealth of information, our journey in this book is finally at an end, but your journey as a photographer continues. Every photo you take is another step in that journey. Every new photo has the potential to be better than the one before it. Each new potential image you see on your journey is a story waiting to be told, a canvas waiting to be filled with the language of light.

The best advice we can give you is to get out there and photograph! Do it a lot and do it often. Practice your craft; explore new types of images and

techniques; push yourself to become a better photographer. Writers become better writers by practicing their craft and the same is true for photographers, or any artist. If you feel doubtful, tired, or have that sinking feeling that it's all been done before, "shoot through it!" Go ahead and take that photo that has already been done a million times, but then find new ways of creating a compelling image. You have to take pictures to create images. Being a photographer is a very rewarding and enriching experience that adds to your experience of life and the world, and showing people how you see the world is a gift that is uniquely yours. So get out there and shoot!

# Index